THE ARTIST AND THE BRIDGE

The Artist and the Bridge
1700–1920

John Sweetman

ASHGATE

Published by
Ashgate Publishing Limited Ashgate Publishing Company
Gower House Old Post Road
Croft Road Brookfield
Aldershot Vermont 05036-9704
Hants GU11 3HR USA
England

British Library Cataloguing-in-Publication data

Sweetman, John, 1929–
 The artist and the bridge, 1700–1920
 1. Bridges in art 2. Painting, Modern – 17th–18th centuries
 3. Painting, Modern – 19th century
 I. Title
 758.7

 ISBN 0 7546 0013 0

Library of Congress Cataloguing-in-Publication data

Sweetman, John (John E.)
 The artist and the bridge : 1700–1920 John Sweetman
 p. cm.
 Includes bibliographical references and index.
 ISBN 0-7546-0013-0 (acid-free paper)
 1. Bridges in art. 2. Symbolism in art. I. Title
 N8217.377S94 1999
 704.9′44–dc21 99–36155
 CIP

ISBN 0 7546 0013 0

Printed in Singapore on acid-free paper by Kyodo Printing Co.

Typeset in Palatino and Palatino SC by
The Running Head Limited, www.therunninghead.com

Contents

To my friends
John Rodway and John Morris

Bridges unbroken after fifty years

Illustrations

Acknowledgements

The author and publishers would like to thank H.M. The Queen (Royal Collection Enterprises) for permission to reproduce Fig. 16; also the Trustees of the Goodwood Collection, West Sussex, all private owners who wished to remain anonymous, and the following for permission to reproduce illustrative material. While every effort has been made to contact owners of copyright, we take this opportunity of offering apologies to any owners who have proved uncontactable.

Galleria dell'Accademia, Venice, 2
© ADAGP, Paris and DACS, London 1999, 97
© Art Resource, New York, 103
Ashmolean Museum, Oxford, 69a
Bibliothèque Nationale de France, 29, 74, 87a
Bildarchiv Preussischer Kulturbesitz, Berlin, 98
Birmingham Museums and Art Gallery, 60
Bridgeman Art Library, 2, 79, Pls. I, III, IV, VI, VII, X, XI, XIV
British Library, 4, 18, 44a, 58a
© The British Museum, 3, 7, 9, 11, 13, 14, 17, 18a 19, 25, 39, 51, 52, 53, 68, 75, 76, 80a, 87, 104, Pl. X
Brücke Museum, Berlin, 98a
The Burghley House Collection, 28a
Courtesy of the Camera di Commercio, Industria. Artigianato, Agricoltura, Milan, 100
Christie's Images, 93, 95
Cleveland Museum of Art, 85
County Museum of Art, Los Angeles, 72
Courtauld Institute of Art, London, 6, 48, 90, Pl. XV
City of Derby Museums and Art Gallery, 40, 41, 42, Pl. V
© Design and Artists' Copyright Society, 96, 97, 99, 102
Dulwich Picture Gallery, 20, Pl. I
Collection of the Earl of Pembroke, Wilton House, Salisbury, UK, 31
Fitzwilliam Museum, Cambridge, 46, 68, 79a, Pl. VI
Foundation E.G. Bührle Collection, Zürich, 50
Giraudon, Paris, 16, 81
Governor and Company of the Bank of England, 22, 23
Guildhall Art Gallery, Corporation of London, 30
Hearn Family Trust, New York, 94
© Ingeborg and Dr Wolfgang Henze-Ketterer, Wichtrach/Bern, 98, 98a
© Hunterian Art Gallery, University of Glasgow, 78a
Ironbridge Gorge Museum Trust, 36, 37, 37a
Kimbell Art Museum, Forth Worth, Texas, 89
Collection Kröller-Müller Museum, Otterlo, The Netherlands, 91
Kunstmuseum, Bern, 34
City Museum and Art Galleries, Leeds, 70
Metropolitan Museum of Art, New York, 73
© The Munch Museum/The Munch-Ellingsen Group/DACS, London 1999, 96

Musée Carnavalet, Paris: © Photothèque des Musées de la Ville de Paris, 12, 26
Musée d'Orsay, Paris: © Réunion des Musées Nationaux, Paris, 83 (photo H. Lewandowski), Pls. XI, XII
Musée des Beaux-Arts, Le Havre, 27, Pl. III
Musée du Louvre, 1, 10, 35, Pl. IV
Museen der Stadt Köln, Rheinisches Bildarchiv, 91
Archivo fotografico del Museo de Bellas Artes, Bilbao, 84, Pl. XIII
Museo Thyssen-Bornemisza, Madrid, 54
Museum of Fine Arts, Boston, 54a, 77, 82
Nasjonalgalleriet, Oslo, 96
National Gallery of Canada, Ottawa, 71
National Gallery, London, 65
Nationalmuseum (Statens Konstmuseer), Stockholm, 28
National Trust, Photo Library, 8
New York Public Library, 78
The Newark Museum, New Jersey/© Art Resource, NY, 103
Ny Carlsberg Glyptotek, Copenhagen, 56
Oskar Reinhart Collection, Winterthur, 47
© Mrs Anne Patterson, 104
Paul Klee-Stiftung, Kunstmuseum, Bern/© DACS, London 1999, 102
Paul Mellon Centre for Studies in British Art, London, 33
Petit Palais, Geneva, 88, Pl. XIV
Philadelphia Museum of Art, 57, 81, Pl. VIII
Rijksmuseum, Amsterdam, 5
Royal Academy of Arts, London, 67
Science Museum, London (Science and Society Picture Library), 45
Trustees of Sir John Soane's Museum, London, 32
Stiftung Preussische Schlösser und Gärten, Berlin-Brandenburg/Bildarchiv, 55
Sunderland Art Gallery (Tyne and Wear Museums), 38
Tate Gallery, London, 24, 58, 59, 61, 62, 63, 66, 80, 97, Pls. II, IX
Ulster Museum, Belfast, reproduced with kind permission of the Trustees of the National Museums and Galleries of Northern Ireland, 64
Van Gogh Museum, Amsterdam, 79
Victoria and Albert Museum, London, 14a, 32a, 43, 44, 69
Waddesdon, The Rothschild Collection/National Trust, photo Courtauld Institute of Art, 6
Washington University in St Louis, Missouri, 99/© DACS, London 1999, 99
© Whitney Museum of American Art, New York 1999, 101, Pl. XVI
Yale Center for British Art, New Haven CT, 21
Yale University Art Gallery, New Haven CT, 86
York City Art Gallery, 49, Pl. VII

Preface

This book develops an idea that I presented in an earlier work on the eighteenth and early nineteenth centuries in the Western world, *The Enlightenment and the Age of Revolution 1700–1850* (Harlow: Longman, 1998). I suggested there that the bridge might arguably be regarded, in that period, as the most representative building form in the West. Over a number of years I have come to believe that this is true. The claim is borne out, I think, by the acceleration of engineering technology after 1700 – that application of means to ends of which bridges afford particularly vivid visual reminders. But it is also borne out by the devotion of artists – who are among society's most visually sensitive members – to exploring the bridge's many forms, old and new, and diverse implications in the modern age.

As the new millennium approaches, much attention has been paid to bridges as structures that link people and communities. The exhibition 'Living Bridges' at the Royal Academy of Arts, London, in 1996, took the idea of the inhabited bridge, indeed, as its theme. Advertising makes continuous use of the bridge as a 'leading form' attracting the hesitant traveller to cross it. The new euro banknote designs show famous bridges as symbols of unification. But – surprisingly – no book has been devoted to the responses of artists to this, one of the most familiar and indispensable building forms in any human environment, urban or rural. The present book attempts to fill this gap by focusing on the period from Canaletto and the 'view-painting' after 1700, to the artists of Die Brücke (The Bridge), the Futurists and others working before and after the First World War.

I have been helped by many friends as well as by custodians of pictures: most of these are mentioned in appropriate places in the text. I am grateful to Professor Peter Morice and members of the Civil Engineering Department at Southampton University for technical information. I also want to thank Dr Sylvia Landsberg, Professor 'Sam' Hackett and Professor John Wilton-Ely. I alone am responsible for mistakes. I am grateful to the Leverhulme Trust for an Emeritus Fellowship for the original research, and to the British Academy for a grant towards illustrations.

Two friends of long standing, John Morris and John Rodway, gave me valuable help, not least on railway history. It is a pleasure to dedicate this book to them. I am as grateful as ever to the care, efficiency and accuracy of Pam Dawson, who typed revisions of the manuscript, as a whole or in part, at least three times over the last eight years. Special thanks must also go to my publishers, Pamela Edwardes and Sue Moore of Ashgate, to David Williams, Carlos Sapochnik and Philippa Youngman of The Running Head, and to Gwynn-fyl Lowe, who compiled the index.

Introduction: The approaches

The origins of bridges are lost in the history of humanity's earliest needs. Reliance on them remains, despite the transformation in communications that has occurred during the twentieth century. Bridges are still among the earliest targets for destruction in war; overpasses multiply over every motorway that is built; and the transport directives of the European Commission require all major bridges in its area to be made strong for the juggernaut. The bridge, it is obvious, is still an indispensable part of the articulation of the world's surface that humankind has built up for convenience and use.

If bridges meet an unchanging need in everyday life, artists have nevertheless used them for very various expressive ends in the making of works of art. The bridge is an 'exposed' structure, which must by definition perform a lone function and therefore dominate as well as transform its setting. In this sense Joseph Gies's seductive observation that 'a bridge is to a road what a diamond is to a ring' has its truth.[1] Plainly the bridges of Rome, Florence, or Paris which are judged to be beautiful as well as useful provided more than enough reason for making pictures of them. But the diamond analogy does not fully meet the case. Prominently placed bridges inevitably can be so compared, but they also invite a variety of views in elevation, at a distance, in close perspective, from below. And they highlight the space beneath them. Even for the non-artist, the notion of spanning space by means of the arch-form, so fundamental a part of the Roman achievement in ancient times, acquires added compulsion when the space concerned is over water or another natural barrier. Palladio (1508–80) observed that 'the place . . . for building bridges ought to be . . . where the river has a direct course, and its bed equal, perpetual, and shallow'.[2] A bridge is built when the nature of the obstacle has been duly weighed and where there is the point of greatest advantage. Whole towns have grown round them. And so it has become a matter of course to speak metaphorically of 'bridges of opportunity' and for a literal bridge builder like Thomas Paine, author of *The Rights of Man* (1791–2), to refer to his 'political bridges' also.

But there is still more to the bridge than just usefulness and looks. However shallow the water, the smallest stream can seem a Rubicon. Our other aim must be to consider the bridge as symbolic marker, denoting a stage that the traveller has reached on a journey that may not, perhaps, be reversed. We may think, with the music historian Burney (touring Italy in 1770), of Constantine, the first Roman emperor to become a Christian, advancing across the Milvian Bridge in AD 312 to take Rome; or, with Byron (in Venice in 1817), of the prisoners of the Venetian state crossing from palace to prison over the Bridge of Sighs. And here again we have metaphor to help us: we commonly speak of bridges being 'crossed' or even 'burned'.

Of all architectural forms, therefore, it might be said that the bridge confronts humanity with nature – and perhaps human nature – in a particularly direct way. Building and landscape seem equally matched in the drawing by Gandy of John Soane's design for a huge neoclassical 'Triumphal Bridge' of 1776, crossing a broad rural river. On the other hand, nature dominates overwhelmingly in Turner's view of the perilous Devil's Bridge in the Alps. The measuring up to natural barriers by human will, daring or rashness forms a sub-theme of all the chapters of this book, as we examine the eighteenth and nineteenth centuries. But first we must look back:

32
58

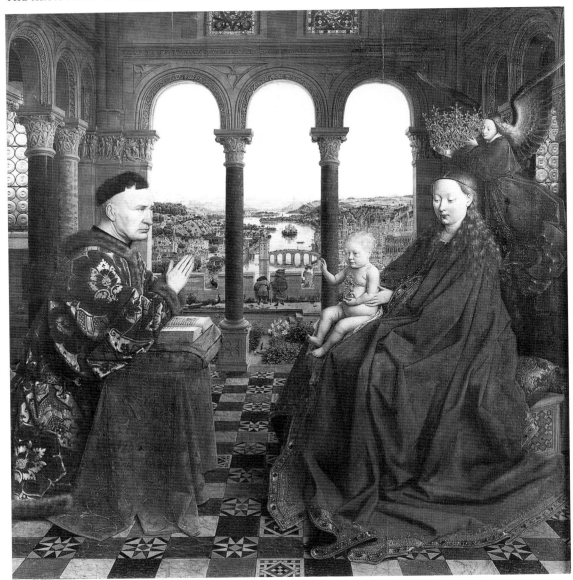

1 Jan VAN EYCK (*c.* 1395–1441) *Madonna and Child with Chancellor Rolin*. Oil, 66 × 62 cm (26 ¹/₄ × 25 in.), 1433–4

for the bridge-form, combining the classical values of repetition of parts, and a fundamental stability, with the value of directional movement which is a constant preoccupation of the Romantics, had offered to artists, over many centuries before 1700, a wide and diverse range of formal and expressive possibilities.

Two pictures, one from the fifteenth century and the other from the early sixteenth, provide examples of this range. The painting by Jan van Eyck (d. 1441), *Madonna and Child with Chancellor Rolin*, is justly famous for its background as well as its foreground. The artist has offered an inexhaustible richness of information in each. When we move beyond the densely alive devotional scene within the elaborate interior, it is to find ourselves with two small figures, seen from the back, looking out over a highly populated town and along a river which winds away to mountains. Generations of students have attempted to identify the town that is catalogued in such detail. But there is yet another choice for us. Looking at the multi-arch

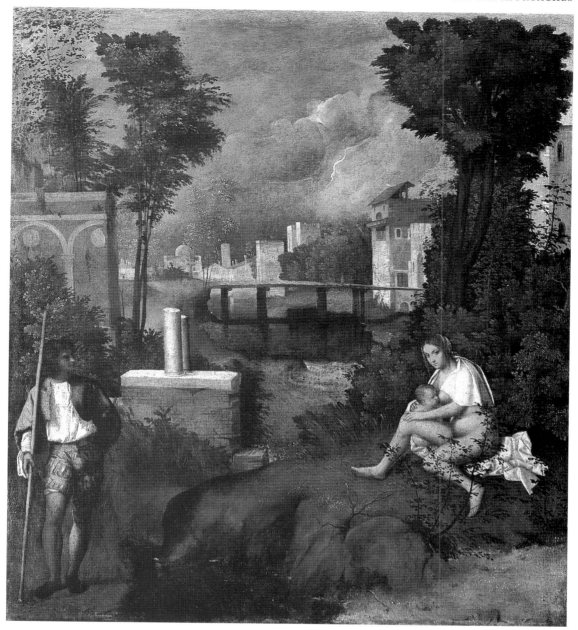

2 GIORGIONE (*c.* 1475–1510) *The Tempest*. Oil, 83 × 73 cm (33 × 29 in.), 1505–10

bridge filled with the figures of distant townspeople, and also at the way in which its lines connect the hand of the Child to the kneeling man, we may reflect further on the nature of communication, in both figurative and literal senses, that is represented by the bridge itself.[3]

 A hundred years later, in 1530, the Venetian writer Marcantonio Michiel saw, in the house of Gabriel Vendramin in Venice, a painting of 'the tempest, with the gypsy and the soldier' by Giorgione (*c.* 1475–1510). In this picture it is the significance of the figures, apparently so diverse in kind and divided from one another, that has been most actively sought after. Many answers have been proposed, including, recently, Adam and Eve expelled from the Eden of the city beyond the river.[4] But however opinion on the point may vary, and will continue to vary, it

is undeniable that the mood of uncertainty induced by the separateness of the figures and the onset of a summer storm is underwritten also by the prominent bridge. Like van Eyck's bridge, Giorgione's is centrally placed and as such is a compositional 'binder'. But it cannot be looked on, as in van Eyck's picture, as fulfilling, or even indicating, a direct role of communication. Though once substantial, its planks are now uneven, and no-one is using it. Its desertedness, in front of the storm and above the shadowy depths of water that hardly invite us to navigate beneath it, notably increases the tension that the mood of the scene sets up. Whoever the figures are, the bridge does nothing to lessen the gap between the space in which they are located and the city on the far side of the river. Indeed, its derelict state even increases that gap. Here we have a second role for the bridge: not as link, but as separator.

The two different emphases in the use of the bridge that we find in van Eyck and Giorgione – as topographical and compositional link but, in Giorgione particularly, as symbolic isolator or marker – will be crucial in what follows. The principal centuries for bridge subjects in European art are the eighteenth and nineteenth, and that is why this book is devoted to them. Between 1700 and the First World War the nature of communications was transformed as networks of canals, roads and then railways spread across Europe. The face of the Western world was restructured as never before. In 1772 the stone Pont de Neuilly was inaugurated in the presence of the king and a large crowd as a symbol of French initiative in civil engineering, and in 1779 the Iron Bridge in Shropshire was opened to provide a crossing for the accelerating volume of traffic and goods produced by the Industrial Revolution that was by then under way. Bridges by the hundred were built in the ensuing decades.

In the same years the category of European art known as landscape painting was consolidating its credentials as a genre. With the Romantic period, indeed, landscape became the major mode of expression that in Britain sustained Turner and Constable. Both these artists, however, painted human themes in landscape, and each had an interest in the bridge. In 1844 Turner produced his canvas *Rain, Steam and Speed*, depicting a train of the new era crossing a new bridge by the engineer Brunel. An age of major bridge-building by engineers was now in being, in large part designed to facilitate the movement not only of goods but of people from countryside to urban centres. In reaction, and almost simultaneously, an enhanced regard for the countryside was to develop. The smoke and sprawl of towns were to turn attention back to the countryside that had been left behind. Increasing numbers of paintings and prints – now joined by photographs – were devoted to the railway bridges that were to enable trainloads of city-dwellers to find their way to the country or seaside. From this process the French Impressionist painters would take an important part of their subject-material. Modern bridges and modern landscape painting, it might be said, grew up together. This is a further sub-theme of the present book.

Part of the fascination of the bridge as a subject in art – as of the horse in art – is that it can lead from what is close and familiar to what is removed and unfamiliar, and beyond human control. Indeed in the case of the bridge it can literally lead beyond the world of the near to that of the far, from what is close and familiar to what is removed and unfamiliar. In Florentine painting of the early Renaissance, for instance, concern for building close-knit figure compositions and for linking figures through gesture, means that the bridge plays on the whole a subsidiary role in backgrounds, in common with landscape (compare Fig. 9).[5] But as we approach 1500, and the interest of artists, particularly Leonardo da Vinci (1452–1519) and the Venetians, extends ever more insistently into landscape *beyond* figures, more imaginative use of the bridge is made.[6] Leonardo included a round-arched bridge in the background of the *Mona Lisa*: a small but important ingredient which continues the line of the scarf on the sitter's shoulder and so

26

36, 37

65

72

9

3 Giulio Fontana (*fl.* 1570) after TITIAN (*c.* 1489–1576) *The Battle*. Engraving, 42.5 × 57.5 cm (16 ³/₄ × 25 in.), *c.* 1569

connects her with the landscape setting. As the only man-made form in that otherwise deserted landscape it makes an effect of some unexpectedness, and some ambiguity. Where is it leading, and what if someone seeks to cross?

Giorgione, as we have seen, used the bridge motif shortly afterwards to induce a sense of ambiguity even more thought-provokingly. It was in Venice, too, that one of the great pictures on the theme of military action on a bridge came to be painted. Here, in this public work, there would be no ambiguity. But the idea of near and far, of what is and what might be, and of the bridge as the pivot of the distinction between the two, would be raised in the sharpest terms. In 1513, a few years after Giorgione's death, the young Titian was given permission by Venice's Council of Ten to paint a battle scene for the Sala del Gran Consiglio. The scheme was delayed, but the large canvas was eventually finished in the summer of 1537. This famous presentation of the battle of Spoleto gave prominence to the bridge, placing it high in the picture with horsemen both on it and skirmishing at the sides. The painting was destroyed by fire in 1577, but is known through the artist's drawings: an engraving from it adds horsemen on the right and other details. The composition by Rubens of *The Battle of the Amazons* (1615), now in Munich,[7] was developed from it. The symbolic role of the bridge as the strategic key to battles was given the clearest of statements by Titian's work and was to continue to be recognized by artists. The Venetians, we may note, resorted to the bridge for such purposes frequently in their history.

In Titian's battle painting the bridge was used as a pivotal feature of the entire composition. In the same sixteenth century, however, as interest in geographical enquiry and travel

Perche si e passato a tanto eccesso di contesa, che con i legni seguono spesso grand.^{mi} incōuenienti la battaglia la e ridotta ai pugni, la qual cosa passa con molto diletto de riguardanti et ardire de combattonti Giacomo Franco Forʹ Con Priuilegio

4 Giacomo FRANCO (1550–1620) 'Fighting on a Bridge in Venice'. Engraving, 26.7 × 14.2 cm (10 1/2 × 5 1/2 in.). From Franco's *Habiti d'Uomini e Donne Venetiane* (1610–14)

unfolded, topographical views in which bridges were incidental rather than pivotal began to multiply, especially in northern Europe. Michelangelo was credited by a contemporary with a well-known outburst against Flemish artists for what was seen as over-concern with 'external exactness' and for the making of pictures of 'rivers and bridges, which they call landscapes . . . done without reason or art, without symmetry or proportion, without skilful choice or boldness . . .'.[8] The protest pointed to the essential divergence between the central interest of Italian Renaissance artists in idealized effects cohering round the human figure and its trials and triumphs, and north European tastes for the proliferating detail of everyday human settings. But in northern Europe too, as van Eyck's painting had shown, the bridge's explicit compositional value as a linking form was at once recognized. And in the topographical work of the sixteenth-century Flemings the human reference was also made: the vigorous civic pride which demanded detailed town-views included a taste for panoramas that would also focus attention on those features of landscapes – harbours and bridges – where man's interference with nature in the interests of convenience and freedom of movement was most obviously expressed.[9]

This aspect can be followed particularly in the work of Pieter Bruegel the Elder (c. 1525–69) and his followers. The activities of travellers in the sixteenth century (continued to an even greater degree in the seventeenth) promoted an association of landscape with travel which is not hard to account for in a period of slow, difficult journeys, undertaken in all probability once in a lifetime, through unfamiliar scenery. Pieter Bruegel was himself an indefatigable traveller who journeyed from Antwerp as far south as Sicily in the years 1552–4. His experience of the Alps was expressed in numerous drawings, many of which were made into engravings.

Though Bruegel's travels had given him the experience of great distances and of other terrains (notably mountains) which he could use in his work, his painting was largely devoted to the indigenous and stay-at-home character of life for the ordinary inhabitants of his native Low Countries. While he characteristically portrays there man's flimsy hold on survival at testing moments when nature is hostile, he also suggests a human pertinacity which enables man to maintain his purpose against misfortune or anything that the outside world may conjure up against him. Some of Bruegel's paintings accordingly celebrate the theme of the harbour. But, perhaps by the same token, there are relatively few bridges in his work. Perhaps he wishes us to see that his peasants live circumscribed lives, and bridges, by their very nature, lead beyond boundaries. It is interesting to note that one of Bruegel's few bridges in fact leads over one of the most fateful boundaries of all, into the Tower of Babel (in his Vienna painting of that subject).[10] In other works he shows distant bridges, and bequeaths an enormous legacy of ideas on the contrasting notions of nearness and distance, which is one of the basic constituents of the experience of panoramic landscape. In his drawings of Alpine subjects and in Hieronymus Cock's engravings of them these ideas were presented with immense verve. Distant mountains which keep to themselves, but also nearer ones which show travellers toiling up their sides, form their principal ingredients.

Sometimes accessibility to distant places is suggested. There were many artists, not least the younger members of Bruegel's own family, to carry on these ideas after his death, and we meet them in the works of Jan Bruegel the Elder and Paul Bril into the seventeenth century. One of the means of suggesting the accessibility of nature was for the artist to place his figures in landscape observed at close quarters, adopt a low viewpoint and include a bridge. An example of this, which shows all these ingredients, is a work by the Flemish artist Roelandt Savery engraved by Aegidius Sadeler. Here the artist is depicted in a valley bottom, pursuing quite clearly a close-up view of his subject. This has the added interest of a bridge, a somewhat

5

5 Aegidius Sadeler (1570–1629) after Roelandt SAVERY (1576–1639) *The Draughtsman at the Foot of the Rocks Facing the Bridge.* Engraving, 20.3 × 26.3 cm (8 × 10 3/8 in.), *c.* 1610

shaky-looking structure of wood spanning a stream and having its central support on a rocky islet. Two small figures are shown crossing it. The artist is apparently drawing the bridge itself, which from his position would occupy the top of his picture. H.V.S. and M.S. Ogden noted that in composition this work could have been a '"detail" from a more extensive mountain view'.[11] But if this is the case, the fact that it attained a separate existence is of some interest. In any event this is an enterprising picture, recognizably a product of the Bruegel tradition, but reflecting a distinct shift towards making the rustic bridge a prominent, even the main, feature of the landscape. Its perilous diagonal almost hangs over us: but not quite. We shall meet a similar structure which does this later, in the work of Wright of Derby.

By the time of Savery's work the Dutch word *landschap* had begun to refer to landscape art.[12] And in the seventeenth century the implications of bridge-painting are broadened and deepened in both the north and south of Europe. Holland, from 1609 independent of Spain and in part retrieved from the sea by its inhabitants, was prominent in this. All aspects of the country would be depicted, not least its waterways and the innumerable bridges which crossed them.[13] Artists were quick to see that Dutch bridges are often the highest visible feature in a given landscape, especially if they occur in a relatively treeless area. The landscapist Aelbert Cuyp (1620–91) is apt to make the high slant of a bridge walkway provide an angle for the parallel backs of crossing cows or even for clouds.[14] Even in the case of a structure as low in the landscape as the bridge in Rembrandt's etching called *Six's Bridge* we have the impression of actually looking up at it from a point below a grassy convexity which fills the centre of the picture. We are placed just where the receding lines of its two wooden sides – one steeply foreshortened, the other wide-angled – oblige us to look through the gap between them. Giving this sense of

6 Aelbert CUYP (1620–91) *A Herdsman Driving Cattle over a Bridge.* Oil, 70.5 × 91 cm (27 × 36 in.), late 1640s

being below bridge level is one of the preoccupations of Dutch artists, and some of its effect recurs in the paintings of Wright of Derby. 41, V

The more ambitious seventeenth-century bridge landscapes in oils are couched in the dramatic chiaroscuro of the prevailing Baroque, but take advantage of the special characteristic of the bridge to collect light and direct it diagonally and laterally across water to points low down in the picture. Besides the oil landscapes of Cuyp, those of Rembrandt (1606–69), relatively few 6 in number but interesting in the fact that they usually include a bridge, explore this, as do the bridge subjects of Jacob van Ruisdael (1629–84).[15] These dark bridges seem to lean against the light that passes through them: Turner would learn from this, as Constable would from the more incidental treatment of the bridge by Rubens.[16]

But the greatest influence during the period on the theme of the bridge in landscape, as in matters of landscape generally, is Claude Lorrain (1604/5–82). A native of the independent dukedom of Lorraine, Claude turned his back on France and preferred to spend his working life in Rome. There he built his life-work on observation of the Roman countryside with its ruined temples and working farms, but in his painting these become caught up in an affirmation of ideal landscape which carries unmistakable echoes of the popular pastorals of Virgil, and makes constant use of the bridge as a joining, reconciling motif. With Claude the bridge – and the aqueduct – frequently occupy the middle distance, and are parallel to the picture plane: their horizontals are often the furthest indications of man's implied ordering of landscape, before Claude's poetic understanding of natural light draws the eye beyond.

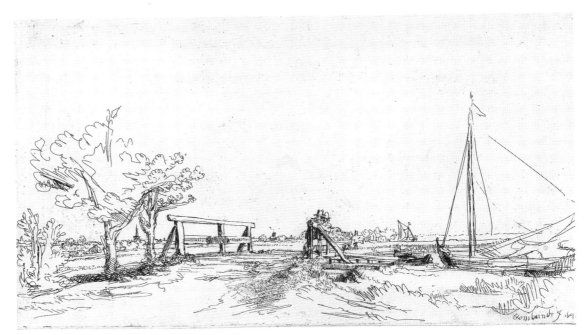

7 REMBRANDT VAN RIJN (1606–69) *Six's Bridge*. Etching, 12.9 × 22.3 cm (5 × 8 3/4 in.), 1645

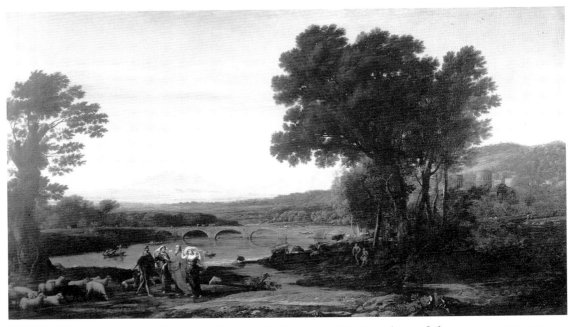

8 CLAUDE LORRAIN (1604/5–82) *Jacob with Laban and his Daughters*. Oil, 143.5 × 251.5 cm (56 1/2 × 99 in.), 1654

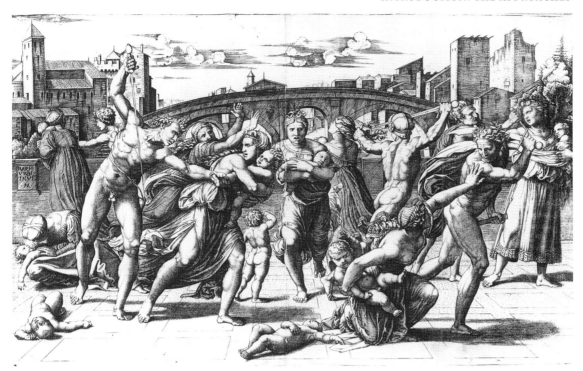

9 Marcantonio Raimondi (*c.* 1480–1527) after RAPHAEL (1483–1520) *The Massacre of the Innocents*. Engraving, 25 × 41 cm (11 × 17 in.), *c.* 1519

Good examples of Claude's approach, both with prominent bridges, are two works which were to be influentially present in Britain: the *Landscape with Hagar and the Angel* (oil, 1640–47, National Gallery, London, formerly in the collection of John Constable's patron, Sir George Beaumont, and copied by Constable) and the *Jacob with Laban and his Daughters* (oil, 1654, Petworth House, in the collection of J.M.W. Turner's patron Lord Egremont, and used by Turner as the basis of a work of his own, *Apullia in Search of Apullus* of 1813). In the *Hagar* a single-span bridge with a semi-circular arch occupies the middle ground and extends about a third of the width of the picture. In the *Jacob* a bridge, of which six arches are visible (that at the left with shorter span), defines a long horizontal about a third of the way up the canvas. It will be noticed, moreover, that the central spans in the *Jacob* are in approximate ratio to the total shape of the picture. Though the area occupied by the bridges in Claude's works is relatively small, it is commonly by the use of a unit such as an arch-span provided by a bridge that Claude establishes the relationship of parts to the whole that is fundamental to his sense of pictorial design.

Claude paints bridges of many kinds, flat-topped as well as arched.[17] Stone arched bridges, however, had greater adaptability as elements in composition because of the rhythmic mobility of their lines and, even more important, because of the profound regard of seventeenth-century artists for contrasting light and shade. A particular favourite of Claude's was the Milvian Bridge, where Constantine secured his Christian victory. Its modern name was Ponte Molle and we shall encounter it again later. Two paintings of armies meeting on a bridge may well refer to Constantine's battle: a *Pastoral Landscape* (*c.* 1645, Museum and Art Gallery, Birmingham) certainly includes the Ponte Molle against light.[18] But in the case of the very different, almost horizontal bridge that is used in the *Jacob*, the effect is more complex. There the long, shallow arches are placed as a light against dark, but are themselves half in shadow, half in sun. It is a remarkably controlled performance: no wonder Turner painted his own version of it.

8

59

8

59

9

10

46, VI

73

31

The bridges of Claude's fellow-Frenchman in Rome, Nicolas Poussin (1594–1665), are few, but full of the artist's individuality. Claude's middle-distance bridges lead to what lies beyond, Poussin's reinforce the business being enacted in his foregrounds. Raphael had shown a clear lead: in Marcantonio's engraving after *The Massacre of the Innocents*, we notice how the groups of the single mother and child in the centre, and the two more laterally extended groups on either side, are answered by the varying arch-widths of the bridge behind. In spite of his long residence in Rome, Poussin rarely uses the Tiber bridges directly.[19] He prefers building units which are cubical solids, a characteristic which is of interest to Cézanne, as we shall later have to notice (p. 129 below). Where Poussin does use the bridge, however, it is in forthright fashion. In the influential *Finding of Moses* it is the piers rather than the arches which claim attention, as background equivalents of the powerful figures who enact the event portrayed. Poussin's rigorous paralleling of the bridge motif to the picture-plane was to evoke responses in the bridge-subjects of later French artists, around and after 1800. His use of the bridge-horizontal, so quietly stabilizing a factor in the *Moses*, will also need further comment: artists of the whole French classical tradition, including Cézanne, were to find it instructive.

The more tree-filled, matted landscapes of Poussin's brother-in-law, Gaspard Dughet (Gaspard Poussin, 1615–75), and the wild ones of Salvator Rosa (1615–73), were meanwhile to reinforce the influence of Claude in that process of creating actual landscape layouts in the gardens of Europe in the eighteenth century.[20] Claude's bridge landscapes with subjects like *Rest on the Flight into Egypt*, or of Hagar and other Old Testament wanderers in wildernesses, remind us of the closeness of the idea of the bridge to that of the journey or quest. Eighteenth-century garden elysiums, helped into being by the study of Claude's pictures – notably in England – were to feature bridges. And so were paintings of such elysiums: Richard Wilson, in particular, was to contribute his own original thinking to this tradition. Such developments were encouraged, as is well known, by patrons' knowledge of classical literature, not only the *Georgics* of Virgil but also the letters of the younger Pliny,[21] and by the vastly enhanced interest of artists and patrons alike in nature. But the attractive notion of the earthly paradise and of the bridge as part of the means of access to it, in the Renaissance gardens of the sixteenth century, must not be overlooked. Not only was the erection of arched stone and wooden bridges part of this but, by an astonishing reversal of context, even the drawbridge, which had kept the medieval castle secure against the outside world, might now admit to further extensions of the gardens, or to a different kind of security, that of an island retreat, as in the garden of the Château of Gaillon in the 1550s.[22]

This move to private solitudes to which a bridge might lead is, it is interesting to observe, contemporary with the erection of bridges of the utmost public prestige and sophistication in the thriving business and cultural centres of both Italy and France. Some of these were to become famous throughout the world, especially the Santa Trinità Bridge in Florence, by Bartolommeo Ammanati (1511–92), completed in 1569; the Rialto Bridge in Venice, built by Antonio da Ponte in 1588–91; and the Pont Neuf in Paris, begun under Henri III in 1578, and completed under Henri IV in 1606. No account of the bridge in art can ignore them.

In medieval times town bridges might well have houses or shops on them: Florence's Ponte Vecchio (1345) had goldsmiths' shops. The neighbouring Ponte Santa Trinità, Ammanati's masterpiece, was from the first an open road bridge. Its elegance became a byword: in 1785 Mrs Piozzi (lately, as Mrs Thrale, the friend of Samuel Johnson) noted that it was 'said to be the most beautiful Bridge in Europe' and was 'our public walk till twelve o'clock'.[23] Residents at Schneider's popular hotel beside the river could take it in from their windows. The use

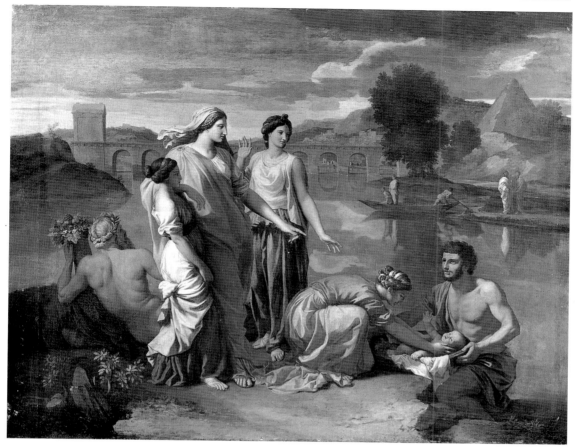

10 Nicolas POUSSIN (1594–1665) *The Finding of Moses*. Oil, 93 × 120 cm (39 × 49 in.), 1638

in its arches of parts of two parabolic arcs meeting at an obtuse angle concealed by a cartouche, and a relation of 12 to 83 in the rise-to-total-span ratio, produced a curve that some artists would never tire of drawing.[24] Turner, working up James Hakewill's drawing for the latter's *Picturesque Tour of Italy* (1818–20), sensed the beauty of this curve even before he had actually seen it at first hand. Shattered in the Second World War, it was painstakingly rebuilt.

11

The Rialto area of Venice, site of the city's earliest settlement, had long relied on wooden bridges which had frequently given way. The imposing new bridge of stone embodied four rows of shops and exterior stairways for quicker crossing, together with a classically pedimented viewing opening. Dramatically straddling the Grand Canal, it became one of the two or three most popular subjects for painters. Paris's Pont Neuf was planned from the first as a monument of royal and civic prestige, to link the Left Bank's university sector with the administrative buildings on the Ile de la Cité and on the Right Bank. It was to have houses and triumphal arches at each end, which were omitted by Henri IV. As we shall see (p. 23), it was to become a place for open-air markets: but the two sequences of its freestanding arches, divided by the tip of the Cité and observed from along the river, were also to fascinate artists.

15, 61

76

The sixteenth century also saw the activity of Andrea Palladio (1508–80), the most influential architect of the modern era in the West. He, as we saw at the outset, attached special importance to bridges. Having studied Roman stone bridges and the reliefs on Trajan's Column of Roman wooden bridges, he designed examples of his own in both materials, including a Rialto project,

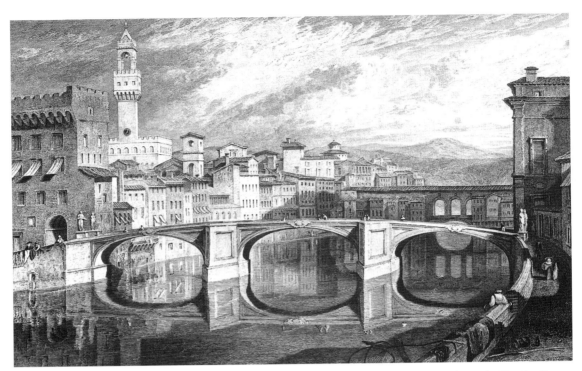

11 Samuel Rawle (1771–1860) after J.M.W. TURNER (1775–1851) *Florence, from the Ponte alla Carraia*. Engraving, 14 × 21 cm (5 5/8 × 8 5/8 in.), 1818

16 and devoted a major section in Book III of his *Quattro Libri dell'Architettura* (1570) to the form. In this way the prestige of the bridge of authority would be handed on to coming generations from Palladio and his heirs, a circumstance which will become obvious in Chapters 2 and 3.

The most daring bridge concept of the Renaissance age, however, had no public impact. For this we must return to Leonardo da Vinci. While it is no surprise to discover that the great artist and student of mechanics had concerned himself with portable bridges and the swing bridge and had made calculations on materials and stresses involved in bridge construction, it is still astonishing to reflect that he planned a bridge to cross no less a space than the Bosphorus and connect Europe and Asia by a single span. This breathtaking scheme is detailed in a letter of *c.* 1502–3 (probably, therefore, contemporary with the *Mona Lisa*), written by Leonardo to the Sultan of Turkey, Bajazet II, and now preserved in translation in the archives of the Topkapi Saray, Istanbul.[25] It proposes a construction 350.5 metres (1150 feet) long and with a single arch 40.8 metres (134 feet) high above the water, supported by curving 'swallow's nest' abutments: a bridge which would indeed have been of unequalled scale and singularity. Alas, it was never built, and the Bosphorus was only bridged in modern times, in 1836. (The suspension bridge which now crosses the Bosphorus was opened in 1973.) How would European–Turkish relations have been affected by such a construction as Leonardo's and what, one wonders, would Western observers in the age after the end of the Ottoman military threat to Europe, from Lady Mary Wortley Montagu to William Burges, have made of it?

What indeed would Leonardo himself, author of optimistic irrigation and canalization schemes on the one hand, and fateful Deluge drawings on the other, have made of it? The

psychology of bridge crossings is an interesting subject. It does not need pointing out that with no architectural or building form (other than the tunnel) do we enter with our minds more pointedly fixed on the idea of a successful exit. Leonardo is the artist who recognizes the human propensity not only to seek out goals and find the ultimate truth (which should, Leonardo thinks, silence discussion) but also to cry out in controversy.[26] Human beings are always looking beyond the point they have now reached. And so it is with the bridge, whether indeed it is approached by water, broadside on (and seen as a gate, as with the Golden Gate Bridge at San Francisco or the Iron Bridge at Coalbrookdale), or by land, as an elevated path. In each case, expectation is the watchword. This is why the disappointment of both the gateway and pathway understandings of the bridge in Giorgione's *The Tempest* adds so much to the picture's tensions.[27]

36

2

 The bridge's role in the spiritual journey that informs the religions of the world is important here. In the medieval account of the Fall and final redemption of humanity through Christ, the wood of the future Cross, originally carried by Adam out of Eden as a branch of the Tree of Knowledge, is built into the bridge of Siloh by Solomon, and later recognized by the Queen of Sheba, who kneels beside it in Piero della Francesca's famous fresco in the church of San Francesco at Arezzo, Italy. In the Renaissance centuries humanity's hope of reaching its long-sought spiritual objective was most graphically recalled in the pope's title of 'pontifex', 'bridge-builder'.[28] In *Paradise Lost* (1667) Milton seems to have drawn a certain irony from this in the image of a bridge built by Sin and Death over chaos, which John Martin was to represent so memorably.[29] While a bridge features in several Creation myths (p. 151), a fateful bridge that has to be crossed at the end of earthly life exercises a power of its own.[30] The traditional Muslim belief in a bridge over Hell from which sinners can easily slip was to be recalled by William Beckford in that classic statement of spiritual crisis in the age of Enlightenment, the novel *Vathek* (1786), and also by Byron in his widely read oriental poem *The Giaour* (1813).[31] And in the demythologized context of modern anxieties concerning human safety, if not salvation, the bridge image persists, as the last few illustrations in this book may suggest.

53

 One of the most moving pages of the writer and airman Antoine de Saint-Exupéry, in *Flight to Arras* (1942), tells of a bemused man brought up into the light from being buried beneath a bombed house.[32] Those who gather round to comfort him try to 'unlock his secret with bungling keys – for who is there can formulate the right question? They asked him what he had felt, what he thought of, what he had done in that grave. They flung bridges at random across an abyss, like men seeking to reach the night of the mind of one blind and deaf and dumb, and bring him help.' Here in the written word, and in metaphor rather than visible actuality, we catch as vivid an impression as any of the bridge as a practical pathway for target-seeking humanity through the uncertainties of the air–earth dimension against which we move. Focusing on bridges real and imaginary, and taking humankind in all moods and conditions, the artist applied himself for centuries to this idea.

The four chapters which follow deal with themes which overlap in time rather than run according to strict chronology. An introduction to each chapter precedes a series of plates (with commentaries) which illustrate each theme. Chapter 1 concentrates on four cities: Venice, Rome, Paris and London. It begins in late eighteenth-century Paris with the 'uncovering' of the old bridges (the removal of the houses) and ends with an artist's view of plans for a new London bridge. The main purpose here is to relate the increasing effectiveness and diversity of bridge paintings and prints of the period after 1700 to the familiarity of artists, Grand Tourists and other visitors to Italy with the bridges of Venice and Rome, and the pictures in particular of

Canaletto (1697–1768) and Giovanni Battista Piranesi (1720–78). Samuel Scott (*c.* 1702–72), rivalling Canaletto in London, and the Frenchman Hubert Robert (1733–1808), following Piranesian ideas and developing his own approaches in Paris, are outstanding exponents.

Chapter 2 considers the overlap in the period 1750–1800 of the neoclassical Bridge of Triumph, descending from ancient Rome through Palladio, with the new Bridge of Industry, built in stone, brick and especially metal by engineers, particularly in Britain. Both 'modern' forms tend to simplicity and the movement of the single span across space, ideas which are taken up in the bridge-pictures of artists. The early Romantics, with their deepening interest in nature, seek out bridges in wild locations. Telford poses visual challenges with his north Wales aqueducts and his design for an all-metal bridge for London.

Chapter 3 discusses the Romantics after 1800. Wordsworth's sonnet composed on Westminster Bridge and Byron's lines on the Bridge of Sighs, Venice (as already mentioned, p. 1), are the points of departure. A denial of the linking function of the bridge, or a sense of separation – 'missed connexion' – is one of the main concerns here.

Chapter 4 follows the ways in which the bridge, against the background of industrialization, lends its simplicities and dynamism to ideal landscape composition in painting. Materialism and spiritual crisis later in the century, however, revive the Romantic fear of the 'missed connexion', and the imaginary nightmare bridges of Piranesi's *Prisons* series appear to become real in the big cities and urban railway stations. We end with C.R.W. Nevinson crossing the engineer Roebling's mighty Brooklyn Bridge, New York, after the First World War.

Notes

1. J. Gies, *Bridges and Men* (London: Cassell, 1964), p. 303.
2. Palladio, *Quattro Libri dell'Architettura* (1570), Bk III, ch. iv. Words are quoted from the second English translation of Isaac Ware (1738).
3. The identifications that have been proposed for the city in the background include Autun, Lyons, Maastricht, Prague and Utrecht (the panel, and Chancellor Rolin himself, came from Autun). See also M.J. Friedländer, *Early Netherlandish Painting: vol. I, The van Eycks – Petrus Christus*, 11 vols (Leyden: A.W. Sijthof, 1967), p. 60.
4. S. Settis, *Giorgione's Tempesta, Interpreting the Hidden Subject* (Cambridge: Polity Press, 1990). Against the identification is the tradition of Michiel and the Vendramin inventory of 1569 which repeats that the woman in the painting is a gypsy; as well as much later scholarship on the theme of the gypsy in art (summarized by F. Vaux de Foletier, 'Iconographie des "Egyptiens"', *Gazette des Beaux Arts*, 68 (1966), pp. 165–72. What seems unquestionable is that the figures are excluded from the town, and that a bridge is used to reinforce this idea. Settis (p. 113) cites from Sabellico the story of Crassus on his way to the Parthian war and about to step onto a bridge, when a storm arises which prevents him crossing. A bridge sometimes enters into the depiction of the Expulsion of Adam and Eve from Eden, e.g. in Thomas Cole's picture, Fig. 54 below. On the bridge as separator, it is worth remarking that it occurs in the only marginally religious setting of Goya's *Pradera* or *Picnic on San Isidro's Day* (oil, 1788, Prado, Madrid), where, besides the very distant Segovia Bridge which the crowds have crossed, a very uninviting and near-deserted pontoon bridge stretches between the people on the near bank and the city (of Madrid) beyond. But the city here can in no sense be seen as a paradise; indeed the implication for Goya is probably that the people have escaped into nature from the constraints of the city, an idea more in keeping with the artist and his times.
5. But earlier artists, using a convention by which architecture was reduced in scale compared with people standing on or in it, could draw value from the bridge-idea. An early example which may allude to the bridge as a place of decision, as well as simply a connector, is given by Giotto (Arena Chapel, Padua, 1303–5), when he makes the Virgin's future parents, Joachim and Anna, reunited at

the Golden Gate of Jerusalem, actually meet on a small bridge. The arch of the Gate straddles Anna's friends and neighbours, the bridge supports the embracing couple. Once bridges became their natural size, i.e. large in relation to people, under the influence of Renaissance naturalism, the effect was all but unrepeatable.

6. The small but significant bridge, however, in Dürer's large line engraving *St Eustace* (1501) is also worth noting. Its placing on the extreme left separates the place where the saint meets the stag from the 'outside' world. The bridge is a sign therefore of the saint's means of access to the place of his conversion, and also a marker, no doubt (placed just behind him), of the turning-point in his life which is thus reached.

7. The composition is recorded in Titian's drawing (Louvre, Paris, Inv. 21.788) reprod. H.E. Wethey, *The Paintings of Titian*, III 'Mythology and History Painting' (London and New York: Phaidon, 1975), where the painting is fully discussed, pp. 225f. It was used by Rubens in 1600–1605, in his drawing (ink and bodycolour on paper, Antwerp, Stedelijk Prentenkabinett, reprod. M. Jaffé, *Rubens and Italy*, Oxford: Phaidon, 1977, fig. 51) after Titian's now destroyed battle picture. Rubens clearly developed much sympathy with the bridge format in this kind of composition, for he included it in his *Battle of the Amazons* (panel, Alte Pinakothek, Munich, 1615, KdK 196, reprod. Wethey, op. cit., fig. 58).

 Raphael's *Battle of Constantine and Maxentius on the Milvian Bridge* (Vatican, Rome) also attracted Rubens to copy part of it (see Jaffé, *Rubens and Italy*, p. 30): for this subject see n. 18 below.

8. Francisco da Hollanda, *Four Dialogues on Painting*, trans. Aubrey F.G. Bell (London: Humphrey Milford, 1928), p. 16.

9. Printing – of woodcuts and line-engravings – would obviously supply the main demand for topographical art, but the paintings of Venetian canal scenes, *c.* 1500, by Carpaccio and Gentile Bellini – often having religious subjects but set in Venice – afford numerous glimpses of the bridges of the city. These are also included in the decorative designs of Italian city subjects in inlaid wood (*intarsie*), such as those in the sacristy of St Mark's of the 1490s. In 1500 Jacopo de'Barbari (d. 1515/16) produced his great bird's-eye view woodcut of Venice, measuring 132 cm by 280 cm (52 × 110 1/4 in.): this includes the predecessor of the present Rialto Bridge. In the north of Europe, Anthonis van den Wyngaerde's bird's-eye view of London in chalk on fourteen sheets (Ashmolean Museum, Oxford) dated from *c.* 1543, and included London Bridge. Marcus Gheeraerts the Elder (*c.* 1525–*c.* 1590) produced an etched bird's-eye view *Map of Bruges* on ten copper-plates in 1562. From 1572 until 1598 five volumes appeared of Braun and Hogenberg's *Civitates Orbis Terrarum*, with a sixth in 1617. These featured many map-like river views with bridges. A panoramic view over London near London Bridge was issued by Vischer of Amsterdam in 1616 and was followed by that of Merian in 1638. For a useful account of all these developments, and illustrations, see J.G. Links, *Townscape Painting and Drawing* (London: Batsford, 1972), pp. 66–9, 87–128. For the taste for topographical art see H.V.S. and M.S. Ogden, *English Taste in Landscape in the Seventeenth Century* (Ann Arbor: University of Michigan, 1955), esp. ch. 7, citing the recommendation of it by Robert Burton (*Anatomy of Melancholy*, 1621).

10. Bruegel has a two-arched bridge leading into his Tower. There is a small town bridge on the left of the picture. Bridges do occur in his more optimistic works, such as the famous *Hunters in the Snow* (Kunsthistorisches Museum, Vienna), but only in a relatively unimportant way. His *Dark Day* (Vienna) contrasts the seasonal human activities of the foreground with the perennial flow of the river beyond: though there is a sizeable town on the bank it is boats, but not bridges, that indicate the possibility of reaching the other side. Bruegel's other rivers tend to be unbridged: even the vigorously active herdsmen in *The Return of the Herd* (Vienna) drive their animals parallel to the river: they could not cross it if they wished to, as it is unspanned and it looks too deep for fording. We are left with the feeling that Bruegel's country-dwellers operate in locales as fixed by circumstances as their own lusty physique.

11. H.V.S and M.S. Ogden, *English Taste in Landscape*, p. 45.

12. The idea of proliferating and ever more inclusive landscape was to be a complex challenge for the artist. The establishing of the edges or frontiers of human control was an early necessity. Painting

based on the garden enclosed against the outside world, *hortus conclusus*, had been developed in the late Middle Ages in Europe; by then the long history of the walled garden enclosure in China and in the Muslim world had had fundamental effects on certain artists of these traditions, and in Persia the enclosed hunting park or paradise came to be depicted within the borders of carpets which were laid on the open ground at religious festivals. These carpets were entering Europe in increasing numbers in the sixteenth century (see John Sweetman, *The Oriental Obsession: Islamic Inspiration in British and American Art and Architecture 1500–1920*, Cambridge: Cambridge University Press, 1988, pp. 30f.). The notion of the enclosed, geometrically subdivided garden provides a basis, as C. Thacker comments (*The History of Gardens,* London: Croom Helm, 1979, p. 84), for the subsequent formal gardens on a grand scale in Europe. The Dutch gardens of the later seventeenth century were to take over many aspects of the French formal garden, but with a notable extra element: the inclusion of the canals near the borders of the garden that were necessary for drainage in the Low Countries. This aspect of gardens draining into the landscape clearly sees them as part of a larger whole: and the process of interchange between land and water is greatly enriched, particularly in this Dutch context, by the role of the bridge as a co-ordinator of landscape and human activities within it.

13. The Dutchman Claude de Jongh is relevant in this connexion for England, as he visited London from Holland. His *View of London Bridge in 1630* (Kenwood House, London, reprod. Links, *Townscape Painting*, pp. 130–31) was based on a drawing (pen, sepia and grey wash, dated 1627, now Guildford Library, London, reprod. M. Warner, ed., *The Image of London*, exh. cat., London: Trefoil Publications and Barbican Art Gallery, 1987, p. 103). The arches of the bridge are shown rounded by de Jongh, when in fact they were pointed, and less regular than he depicts them. But he departs utterly from the bird's-eye or elevated view, painting the bridge much as an approaching waterman on the river would have seen it. He repeated his view in later years, even when a block of houses at the north end of the bridge had burned down in 1632–3. Though other Dutchmen, notably Abraham Hondius, were to paint London Bridge a generation later, nothing so delicate in its feeling for air and atmosphere as de Jongh's picture at Kenwood was to be seen in a London bridge-picture before the arrival of Canaletto in 1746.

14. Aelbert Cuyp (1620–91) and Adam Pynacker (1622–73) are the two most remarkable presenters of the 'high profile' bridge, either Dutch or (as often in Pynacker's case) Italianate. See S. Reiss, *Aelbert Cuyp* (Boston: New York Graphic Society, 1975), p. 108. Their influence goes through to Thomas Gainsborough (1727–88), not only in their prominent placing of bridges in countryside, but in their regard for the bridge as a basic co-ordinator of country activities, as in Gainsborough's *Mountain Landscape with Peasants Crossing a Bridge*, oil, *c.* 1784, National Gallery of Art, Washington DC, reprod. E.K. Waterhouse, *Gainsborough* (London: Hulton, 1958), fig. 287.

15. The visual curiosity of Rembrandt (1606–69) is focused mainly on human subjects, and it is not therefore surprising that, in his relatively few landscape paintings, bridges play a positive part. The *Landscape with Stone Bridge* (1637, Rijksmuseum, Amsterdam) is his best-known example: the rim of the parapet is light above the dark mass of the bridge, and in the light below the arch he places a boat with figures. In *River Landscape with Ruins* (*c.* 1646–54, Hessisches Landesmuseum, Kassel) the bridge is the pivot of the whole composition, lines of movement leading from it left to a rider, right to boats and directly upwards to a skyline tower. The bridge is not one element among many, as in Claude, but *the* deciding factor in the play of the light and shade, seen as complementary forces. The strong dark/light effect of the famous *Coup de Soleil* landscape (1670s, Louvre, Paris) by Jacob van Ruisdael (1629–84), is probably an instance of Rembrandt's rather rare influence on Ruisdael. Ruisdael seems to have learned from Rembrandt's treatment of bridges as structures which collect and isolate light low in the picture.

16. Peter Paul Rubens (1577–1640) needs less extended consideration in the present context than might be expected. Though he had shown interest in the heroic role of the bridge in human affairs (see n. 7), his landscapes come late, many in the 1630s, and are remarkable not so much for bridges as for his sense of the transient in nature, particularly revealed in the treatment of rainbows. It might be said in fact that what in his imagination led him to paint the rainbow inclined him to take very much

less interest in the bridge. The rainbow as a phenomenon, an *effet de lumière*, evanescent and elusive rather than permanent and gravity-ridden, like the bridge, clearly meant much to him. Such bridges as we can discover in his turbulent landscapes (see W. Adler, *Corpus Rubenianum Ludwig Burchard, Part 18, i, Landscapes*, London: Harvey Miller assoc. with Oxford University Press, 1982) are fallen logs (as in *The Park of a Castle*, Vienna) or the contorted tree in the *Boar Hunt* (Dresden). There is no alternative to taking horse and cart through the actual waters of the ford in the Hermitage painting (Adler, op. cit., pl. 62) and in the famous Vienna *Stormy Landscape with Philemon and Baucis* (Adler, op. cit., pl. 86) a tree collapsed on an ox in the middle of the torrent helps to persuade us that there is no easy means of crossing it.

 Nevertheless in *Landscape with a Tower* (Adler, op. cit., pls 147, 149: sketches in Ashmolean, Oxford, and Berlin) Rubens dramatically plays the stone bridge as a horizontal feature against the vertical. Furthermore his broad and tranquil stream in *Pastoral Landscape with Rainbow* (Adler, op. cit., pls 113, 114: versions in Hermitage, St Petersburg, and Louvre, Paris) is spanned by two bridges, one wooden and the other stone, and several other examples of the simple wooden bridge come up in his work. These tend to be little more than incidents which reinforce the rhythms of the land, however, and it is as a master-presenter of the contrast between the powerful forces of nature at ground level and the insubstantial rainbow that we seem to approach closer to the individuality of the artist. Constable certainly responded to this, as an artist with the same interests (cf. p. 91 below).

17. Claude's most prominent flat-topped bridge, supported in the middle by a single masonry pier, is recorded in his *Liber Veritatis*, 67, 'Imaginary View from Tivoli'. This again is parallel to the picture plane, and is offset on the right by the verticals of towers and the Temple of Vesta. An interesting bridge with wooden uprights and angle-braces occurs in *Liber Veritatis*, 52.

18. Cf. *Coast View with Battle on a Bridge*, oil, 1655, Pushkin Museum, Moscow; another version, oil, *c.* 1655, Virginia Museum, Richmond, Virginia, both reprod. M. Röthlisberger, *Claude Lorrain, The Paintings*, 2 vols (New Haven, CN: Yale University Press, 1961), figs 229, 231. Both are based on *Liber Veritatis*, 137. No cross is shown, but Röthlisberger, vol. I, p. 329, notes that Constantine's battle on the Milvian Bridge (described in Eusebius of Caesarea, *De Vita Constantini*, I, 27–34) was a common theme which was suitable for a papal commission; he also notes a drawing of a battle on a bridge (Gabinetto Nazionale delle Stampe, Rome, reprod. *Bollettino d'Arte*, Rome: Ministero della Pubblica Istruzione, 1931, p. 177), by Jacques Courtois, an artist who was patronized by Pope Alexander VII.

 Röthlisberger, *Claude Lorrain*, vol. I, p. 239, lists Claude's representations of the Ponte Molle, including paintings at Birmingham and the Prado, Madrid, and drawings in the British Museum (Hind 2, 181, 182, 252).

19. The relationship of the Ponte Sant'Angelo to the Castel Sant'Angelo at the end of it is recalled in Poussin's *Orpheus and Eurydice* (oil, *c.* 1650, Louvre, Paris). But the bridge is not used as a foil to the castle, but rather as a connecting element between light buildings on the left and dark ones on the right, as part of the chiaroscuro pattern of the picture.

20. Gaspard shows Claude's concern with Roman landscape, but has an interest in stormy weather conditions: and he prefers the wild cascades of Tivoli to the bridged streams of the Campagna. Bridges tend to be incidental: but Gaspard's name was on Henry Hoare's lips when the Stourhead bridge view with village behind was planned: see Fig. 31, n. 2. Salvator Rosa specialized in landscapes of yet more violent storm and tempest in which rocks predominate. Bridge features may be of greater or lesser prominence: for example, there is the prominent diagonally placed structure in *Landscape with Bridge* (oil, late 1640s, Palazzo Pitti, Florence), or the incidental feature high up in *A Rocky Landscape* (oil, probably late 1640s, Holkham Hall, Norfolk); the latter painting is still in that *locus classicus* of mid eighteenth-century taste in landscape painting, Thomas Coke's Landscape Room at Holkham.

21. Pliny does not mention bridges in either of his long descriptions of his gardens at Laurentinum near Ostia (*Epistolae* II, xvii) and Tuscum in the higher reaches of the Tiber (*Epistolae* V, vi). But in his description of the source of the river Clitumnus (*Epistolae* VIII, viii), he reveals that a bridge was built over the place where the separate streams issuing from the rocks joined to form a navigable river. (It was in fact a marker bridge, denoting the point to which boats could advance and above

which no swimming was allowed.) Robert Adam, perhaps reflecting this source, was to be conscious of the exact siting of his bridges in landscape (Syon House, 1762, unexecuted).

22. Charles VIII of France, who invaded Italy in 1494, was sufficiently impressed by the elegant gardens with ingenious water effects, notably those of Alfonso II at Poggio Reale, Naples, to use the phrase 'earthly paradise' in a letter to his brother-in-law Pierre de Bourbon: see W.H. Adams, *The French Garden 1500–1800* (London: Scolar Press, 1979), p. 10. The park at Gaillon, developed from the early years of the sixteenth century by the Italian Pacetto de Mercogliano for Cardinal Georges d'Amboise, incorporated a bridge which led into it from the central gate to the château. The development of the 1550s, commissioned by Cardinal Charles de Bourbon (perhaps from Jacques du Cerceau, who engraved prints of the complex), included an artificial mountain or hermitage built in a square pool and reached by a drawbridge: see Adams, *French Garden*, p. 26 (ill.).

23. Hester Lynch Piozzi, letter to Samuel Lysons, 27 July 1785, in *The Piozzi Letters, Correspondence of Hester Lynch Piozzi, 1784–1821* (formerly Mrs Thrale), vol. I, 1784–1791, ed. Edward A. Bloom and Lillien D. Bloom (Newark, NJ: University of Delaware Press, 1989), p. 161.

24. In the eighteenth century Thomas Patch (1725–82) had done several versions and showed the bridge in the background to his *Musical Party* (oil, 1774, Duchess of Roxburgh coll., London). For the Florence bridges see also Fig. 46 and Plate VI.

25. V.P. Zubov, *Leonardo da Vinci* (Cambridge, MA: Harvard University Press, 1968), p. 27. L. Reti, ed., *The Unknown Leonardo* (London: Hutchinson, 1974), pp. 265–6 (ills). I am grateful to Professor Martin Kemp.

26. The contrast made by Leonardo between the truth reached by those who reason from direct sense-experience and the contention waged by those who reason without it appears in his notes on painting (Vatican, Codex Urbinas Latinus, 1270). See Leonardo's *Treatise on Painting*, trans. and annot. A.P. McMahon (Princeton, NJ: Princeton University Press, 1956), vol. I, p. 11 (sect. 19).

27. Various traditions reflect a fear element in relation to bridges, seen both as places of crossing and passage beneath. The first is well illustrated in the Korean festival of 'treading the bridges', and also 'stepping the bridge' day (the fifteenth day of the first month), when it is believed that a person who crosses seven bridges will be free of misfortune for a year. See W.E. Griffis, *Corea, the Hermit Nation*, 7th edn (New York: Charles Scribner's Sons, 1904), and F.W. Robins, *The Story of the Bridge* (Birmingham: Cornish Brothers, 1954), p. 200. The factor of the narrow path implied by a bridge – the corridor of confined space in which evil spirits will be at a disadvantage – may be underscored by the idea that such spirits cannot cross running water: both are present at the climax of the story of Tam o'Shanter, see Fig. 50. In the West, medieval bridges were often provided with chapels for prayer, as well as with wardens, who collected taxes but were often also clerics. Avignon's famous bridge was a case in point: see Gies, *Bridges and Men*, p. 31. From a pre-Christian past, however, the notion that rivers, or river gods or spirits, were hostile to bridges and expressed this hostility through floods which weaken bridges, or cause them to collapse, gave substance to fears when bridge-structures were navigated from below. Such ideas appear to lie behind the children's 'London Bridge' game, in which two participants preside over a procession of children singly or in twos, and form a 'bridge' which 'falls' on one child or couple as it goes through. The words which are chanted as this happens significantly refer to the mysterious rebuilding of the bridge:

> London Bridge
> Is broken down
> Dance over my Lady Lea . . .
> How shall we build
> It up again?

The later verses, with their reference to the 'prisoner', may recall the age-old practice of walling up human beings in bridges in order to placate river gods. According to I. and P. Opie, *Oxford Dictionary of Nursery Rhymes* (Oxford: Oxford University Press, 1966), pp. 272–6, the need was voiced for a child to be buried in the foundations of a new bridge at Halle as recently as 1843. The earliest printed text of the 'London Bridge' words appears to be that recorded in *The Fashionable Lady*

or *Harlequin's Opera* (1730) and in *Tommy Thumb's Pretty Song Book* (c. 1744) (see Opies, ibid.). These publications coincide with years in which old London Bridge (completed in 1209) was giving concern for safety: Thomas Pennant, *Account of London* (1791), p. 320, records that in the period before their removal in the 1750s the houses on it were leaning, and that parts were in danger of falling into the river, while the street was 'narrow, darksome and dangerous to passengers'. See also W. Thomson, *Chronicles of London Bridge* (1862), p. 347. For Samuel Scott's pictures of the old bridge, the sporting risks of shooting the rapids under the narrow arches, and popular nostalgia for the structure, see Fig. 22 below.

28. Cf. R. Schieffer, 'Der Papst als *Pontifex Maximus*. Bemerkungen zur Geschichte eines päpstlichen Ehrentitels', *Zeitschrift der Savigny – Stiftung für Rechtsgeschichte*, vol. 88, 1971, pp. 300–309. I am grateful to Professor Colin Morris for this reference.

29. John Milton, *Paradise Lost*, X, lines 312–13, 'Now had they brought the work by wondrous art / Pontifical . . .', see *Poems of John Milton*, ed. J. Carey and A. Fowler (Harlow: Longman, 1968), p. 94.

30. A representation of souls attempting to cross a bridge over the river of death and showing some falling off it, while others reach the far end of it, appears in a well-preserved fourteenth-century fresco in the church of Santa Maria Loreto, Aprutino, Italy: reprod. R. Cavendish, *Visions of Heaven and Hell* (London: Orbis, 1977), pp. 52–3. In Ireland, an island on Lough Derg, County Donegal, is associated with a story recounted in a medieval French text, *Le Purgatoire de Saint Patrice*, which tells of a knight Owein. He enters a cave and traverses a high, narrow bridge. It becomes broader as God answers his prayers and he finally comes to paradise. In England the Lyke-Wake Dirge, sung at Yorkshire funerals as late as the seventeenth century, tells of the dead having to cross a wild tract of country (the Whinnymuir) to reach the 'Brig o'Dread' which is no wider than a thread. If they cross successfully they attain Purgatory and the reception of their souls by Christ. A bridge may, therefore, itself be the setting of an implied Last Judgement. An enigmatic fifteenth-century wall painting in Cleeve Abbey, Somerset, depicting a bearded man facing out from the centre of a bridge, with a lion and a dragon to left and right respectively and fishes beneath the bridge, may reflect some aspect of this idea. Memories, perhaps unconscious, of the bridge's role in a 'final reckoning' appear to linger 300 years later in the outwardly secular painting by Hubert Robert, *The Fire at Rome* (Fig. 27 and Plate III).

31. For the precise words of Beckford and Byron, see discussion of Fig. 53, p. 101. below. But some general points about the Muslim bridge over hell are worth noting here. All the dead had to cross it, no easy feat as it was thinner than a hair and sharper than a sword. Angelic beings assisted the good across it. Sinners fell into flames below, though the worst offenders were said to spend 25,000 years in pain on the bridge before they fell. The Muslim hell-bridge may derive from the ancient Persian religion of Zoroaster (Zarathustra) (660–583 BC), who promised to lead his followers into the afterlife across a bridge of judgement. The Zoroastrian concept of the 'Bridge of the Separator' survives among the Parsees of India. The influence of Nietzsche's view of Zarathustra on bridge-ideas in the late nineteenth century is noted in Chapter 4, p. 132.

32. Antoine de Saint-Exupéry, *Flight to Arras*, trans. L. Galantière (London: Heinemann, 1942), p. 47. Saint-Exupéry, in the original text of *Pilote de Guerre* (New York: Éditions de la Maison Française, 1942), p. 68, uses the word *passerelle*, 'foot-bridge', which heightens the personal meaning.

1 Views and sightlines 1700–1800

Some cities turn their backs on their rivers and bridges: others, notably Paris, are unimaginable without them. The story of the French King Henri IV, seeing through the completion of the Pont Neuf in 1606, and leaping the gap between two of its sections in front of an applauding crowd of citizens, seems to sum up an attitude. Affection for the city's central bridges has been commemorated in song, and has lasted to the present day. It has helped to ensure that several of the earliest have been reconstructed to preserve their original lines. The Pont des Arts, connecting the Louvre and the Institut de France, was not built until 1801–3. Made of the relatively new material of metal and placed among much older and much respected stone neighbours, it might well have gone beyond recall when the question of its replacement arose, most recently in the 1980s. But here also the original design was renewed, with fewer arches. 75 76

It is no surprise to discover that Roman Paris (Lutetia) originated on a site which depended for outside communication on the presence of bridges. This was the Ile de la Cité, the tip of which was to provide the site for the statue of Henri IV between the two lengths of the Pont Neuf as it crossed the Seine. Here on the island the Palais de la Cité had in medieval times become the seat of monarchic power: and the kings traditionally took a close interest in the bridges. Five medieval structures led from the island, notably the (later reconstructed) Pont au Change and the Pont Notre Dame, with their lines of housing. 12

The road on the Pont Neuf, at the time of its completion, was wider (at 28 metres, 92 feet) than any on the existing bridges of Europe: and there were no houses. But the time-honoured practice of using this bridge as fairground and marketplace must often have frustrated contemplative viewing: as indeed, according to the notary in Laurence Sterne's travel-fantasy *A Sentimental Journey* (1768), did the winds that were met with on the bridge. A 'cap-full of wind' (Sterne clearly knew this from experience) was 'more blasphemously *sacre Dieu'd* there than in any other aperture of the whole city'.[1] But Sterne, along with innumerable others, admired the Pont Neuf, and it has always attracted artists.

Shortly after Sterne made his comment, a fresh phase opened in the history of the Paris riverfront. In 1787, in line with the associations of French monarchs with the bridges, a new five-arch open structure was planned to bear the name of Louis XVI. A medal was struck in 1788 by Duvivier showing the original design by Perronet, the famous engineer responsible for the much-praised bridge downstream, the Pont de Neuilly, which we will examine later. Political revolution intervened, and the bridge finally emerged in altered form as the Pont de la Concorde. But the events of the 1780s, before the Revolution, had also begun to sweep away the past. The houses on the ancient foundations of the Pont au Change and the Pont Notre Dame had become decrepit and overhung the road between. Under the supervision of Bernard Poyet, Maître des Bâtiments de la Ville, they were demolished, and the bridges became 'ponts découverts'. Hubert Robert (1733–1808) recorded these events in canvases of 1786 and 1788. In his 12 monumental *Tableau de Paris* (1782–8) Louis-Sébastien Mercier was clear about the value of making the bridges true vantage points. 'Behold the view we have made for you,' he enjoins the visitor, 'I pace these unshackled bridges in triumph.' And he points the 'finger of scorn' at the houses of the Rue de la Pelleterie, 'which still dares to obstruct my view!'[2]

Paris was not alone in providing new views of, and views from, its bridges. London too had recently (1757) dismantled the housing on its single medieval bridge, and a second bridge (Westminster, 1739–50) and a third (Blackfriars, 1760–69) had been constructed.[3] For a city which for six hundred years had managed with one bridge and had resisted all initiatives to build another, these events, in the teeth of opposition from ferrymen and other interested parties, were little short of momentous. The bridge at Westminster had been portrayed, both at different stages of construction and completed, by Canaletto (1697–1768) and Samuel Scott (c. 1702–72), and that at Blackfriars in a memorable print by Giovanni Battista Piranesi (1720–78), working in Rome and seeing in its design evidence of London as a modern successor to his city (p. 45). Wordsworth, viewing London from Westminster Bridge in 1802, was to turn an English form of Mercier's bridge elation into a sonnet, also to be discussed later (p. 87).

21
24, 11
25

The four artists who have now been mentioned – Canaletto, Scott, Piranesi and Robert – produce the dominant bridge images of the eighteenth century, and these, based on the four cities they portrayed, Venice as seen by Canaletto, Rome by Piranesi, London by Scott and Paris by Robert, must be our starting point. The artists' choice of such subjects might, indeed, be expected as part of the experience of working in such cities. But it is noticeable that Canaletto's presence in London (1746–56) appears to have prompted Scott, an established marine painter, to make something of a speciality of his own bridge and river views; while Hubert Robert, who combined wide interests in landscape, garden design and urban scenes, developed in France an almost obsessive concern with bridge subjects, in part from the direct stimulus of Piranesi that he had received in Italy. Piranesi's direct involvement with a British bridge subject has already been mentioned. His etching of Blackfriars was done a few years after 1757, when the artist had become a Fellow of the Society of Antiquaries in London.

The eighteenth century, as a vitally important period for improvements in communications, placed special importance on bridges. Writing in his *Tour through the Whole Island of Great Britain* (1724–6), Defoe describes the extensive road-making programme that was carried through under the supervision of road commissioners. He also refers to 'abundance of bridges to be repair'd and enlarg'd, and new ones built where they find occasion', and to the building of 'above three hundred new [bridges], where there were none before, or where the former were small and insufficient to carry the traveller safe over the waters'.[4] In France the name of the Ecole des Ponts et Chaussées is sufficient to point to the interdependence of bridges and roads: from 1747 the reorganization of the Ecole was to give France an unmatched reputation in both. Jean-Rodolphe Perronet (1708–94), the famous engineer, was the school's director. The technical expertise contained in the standard work on bridge construction, Henri Gautier's *Traité des Ponts* (1716), encouraged adventurous thinking, to which Perronet was to add. His five equal, flattened stone arches supporting an absolutely level roadway at Neuilly (1768–72)

26

deeply impressed contemporaries such as Thomas Jefferson and Arthur Young. Perronet's *Description des Projets* (1782–3), containing illustrations of this bridge, made its innovations generally available.[5]

Though roads might improve, travel along them remained slow. When it took three-and-a-half days to reach Marseilles from Lyons by mule-drawn diligence, many Grand Tourists were tempted to take the swifter river-boats down the Rhône. If they did, they would have to negotiate, like Tobias Smollett in 1763, the passage of the 'famous' Pont Saint-Esprit, with its twenty-five arches spanning the fast-flowing waters.[6] The *Gentleman's Magazine* of 1755 devotes a plate to comparing it and the medieval Pont de la Guillotière at Lyons with the new bridge at Westminster.[7] At 914 metres (3000 feet), the twelfth-century Pont Saint-Esprit was still the

longest bridge in Europe. Dickens in 1844 comments on 'the famous Pont d'Esprit, with I don't know how many arches'.[8] Thirty kilometres (20 miles) downstream the Tourist came to another celebrated medieval bridge, that of Saint Bénézet at Avignon. This had been built from 1178 by the Frères Pontifs, with twenty-two arches. Flood waters had destroyed much of it in the seventeenth century, but, long celebrated in music (a medieval chanson formed the basis of a mass by Certon published in 1553, and a children's song had since become popular), its remaining spans were one of the sights of Europe.[9]

Alternative routes to Italy over the Alps presented obvious problems. The passage of the Saint Gothard involved crossing the notorious Devil's Bridge, which will detain us later (pp.59, 61, nn. 11 and 111). Though all the high, main Alpine roads in Switzerland were only built after 1800, lowland roads there were often much improved by 1750, and the bridges were sometimes provided even at higher altitudes (for example those built in 1738–9 to service the mule-tracks along the Via Mala).[10] But in 1739 Horace Walpole laments the precarious state of the old footbridges on the way to the Grande Chartreuse.[11] And in 1770 Charles Burney, returning across the Ligurian Apennines north of Genoa (hardly less of a challenge than the Alps), flicked by overhanging trees and kicked by his mule, vociferates with feeling: 'Such bridges! Such rivers! Such rocks!'[12]

'Such aqueducts!' was also the cry of the eighteenth-century traveller who might be moved by the thought of watercourses high in the air. The Roman aqueducts near Lyons, admired by Philip Thicknesse in 1776, and the Pont du Gard near Nîmes, under which he ate his lunch, will have alerted visitors to remarkable engineering feats in the past.[13] Rousseau, Smollett and others had memorable experiences at the Pont du Gard, as we shall see (pp. 60, 68). And anyone using the 240-km (150-mile) Languedoc Canal (now called Canal du Midi), built by a labour force of 8000 men in the short space of fifteen years (1666–81) and connecting the Garonne valley with the Mediterranean, will in turn have sensed the achievements in aqueduct and tunnel construction of the modern world. In 1756 Nugent, the historian of the Grand Tour, called it the greatest work of its kind in Europe.[14] Thomas Jefferson, who sailed along it in 1787, was one of thousands of tourists to do so.[15]

But the main object of the Grand Tourist was to arrive in Italy, and see Rome. Having gained the north Italian plain, many travellers took the Brenta canal to Padua and Venice, an obvious target if Carnival time was near. Verona, where in 1770 Burney was gratified by the '3 fine bridges' over the Adige, might also attract. Most travellers wanted to see Florence. Thomas Patch painted the Ponte Santa Trinità there from Hadfield's English inn, a popular haunt of English visitors in the late eighteenth century. In 1797 the American Allen Smith had himself painted beside the Florentine bridges.

South of Tuscany the main routes led through aqueduct country to Rome. Most visitors approaching from the north will have crossed the Ponte Molle (Pons Milvius) in the wake of the Emperor Constantine long before. Whatever route was taken to the city, it tended to lead to a bridge over the Tiber.[16] Conspicuous among these was the Ponte Sant'Angelo (Pons Aelius), the Roman bridge subsequently named after Pope Gregory the Great's vision of angels. At the peak of the popularity of *veduta* or view painting in the eighteenth century, this bridge provided a classic subject, as did, to a lesser extent, the Ponte Rotto (Pons Aemilius) or Broken Bridge. And all educated visitors wanted to trace the elusive bridge which Horatius had defended in remote antiquity. In 1645 John Evelyn claimed that he had found 'those admirable pilasters supposed to be of the foundation of the pons Sublicius over which Hor: Cocles passed'. He was not looking in the right place; but the search went on.[17]

58

35, IV

46, VI

13

But if Rome relayed unique historical associations, Venice presented special scenic excitements, and had a very particular use for bridges. Built upon water, it was literally joined together by them. Indeed, if the city offered the semblance of an exotic garment, part sumptuous, part threadbare, its hundreds of small bridges might seem to stitch it together. John Evelyn seems to have thought so when he wrote in his diary (June 1645) of the city being 'tack'd' by bridges, 450 of them, by his calculation.[18] Any journey on foot involved crossing some – if a pitched battle was not taking place (a practice commemorated by the names of the Ponte dei Pugni and Ponte della Guerra).[19] Above all the Rialto Bridge over the Grand Canal, and in fact before the nineteenth century the only physical link across it, offered a constant point of reference that was of necessity geographical as well as visual.[20] Finally, if the Tourist was lucky, he might see a festival with a bridge of boats, such as that which undulated on the third Sunday in July in front of Palladio's gleaming white Church of the Redeemer.[21]

The Tour of Italy attracted the French, the Germans, the Russians, the Americans and above all, from early in the century, the British. In addition, the special links of Canaletto and Piranesi with Britain meant that their work could be seen and studied by artists who had never been to Italy themselves. George Dance, architect of the visionary scheme for a double London Bridge near the end of the century, had made his Italian journey, and never forgot it. The painter William Daniell, who recorded the scheme, had not, but his view has all the spaciousness and professionalism of an Italian *veduta* as developed by Canaletto, together with echoes of the more wilful world of Piranesi.

Notes

1. Sterne, 'The Fragment, Paris', *A Sentimental Journey*, 1768, ed. I. Jack (Oxford: Oxford University Press, 1984 [1968]), p. 103.
2. Mercier, *Tableau de Paris*, 12 vols (Amsterdam, 1782–8), tome XI, 1–2, unnumbered chapter, 'It fait bon crier un peu'.
3. A detailed account of Westminster Bridge is given in R.J.B. Walker, *Old Westminster Bridge: the Bridge of Fools* (Newton Abbot: David and Charles, 1979). The technicalities of both Westminster and Blackfriars Bridges are discussed in Ted Ruddock, *Arch Bridges and their Builders 1735–1835* (Cambridge: Cambridge University Press, 1979).
4. Daniel Defoe, *A Tour through the Whole Island of Great Britain*, 'Appendix to the Second Volume', ed. G.D.H. Cole and D.C. Browning, 2 vols (London: Dent, 1962 [1724–6]), pp. 129–30.
5. Ruddock, *Arch Bridges*, pp. 176–7. Perronet's book contained sixty-seven plates, illustrating all his bridges in detail.
6. Smollett, *Travels through France and Italy*, ed. F. Felsenstein (Oxford: Oxford University Press, 1979 [1766]), pp. 72, 74, 78.
7. *Gentleman's Magazine*, XX (1755), facing p. 588.
8. Dickens, *Pictures from Italy*, ed. D. Paroissien (London: Andre Deutsch, 1973 [1846]), p. 52.
9. The children's song as it is now known appears to date from the seventeenth or eighteenth century. I am grateful to Dr Jeanice Brooks for help on the history of the earlier *chanson*. Four arches of the bridge survive.
10. W.A.B. Coolidge, *Swiss Travel and Swiss Guidebooks* (London: Longmans Green, 1889), p. 113.
11. 'To Richard West, from a Hamlet among the Mountains of Savoy', 28 September 1739, *Letters of Horace Walpole*, selected by W.S. Lewis (London: The Folio Society, 1951), p. 38.
12. *Music, Men and Manners in France and Italy 1770, being the Journal written by Charles Burney, Mus. D.*, ed. H. Edmund Poole (London: Eulenburg, 1974 [1969]), p. 66.
13. Philip Thicknesse, *A Year's Journey through France, and Part of Spain* (London, 1777), vol. II, p. 92.

14. Thomas Nugent, *The Grand Tour* (London, 1756), vol. I, p. 326. For the Canal du Midi see P. Wolff, ed., *Histoire du Languedoc* (Toulouse: Privat, 1967), p. 400.
15. See George Green Shackelford, *Thomas Jefferson's Travels in Europe 1784–1789* (Baltimore and London: Johns Hopkins University Press, 1995), pp. 112f.
16. For the bridges of Rome cf. R. Krautheimer, *Rome, Profile of a City, 312–1308* (Princeton, NJ: Princeton University Press, 1980), p. 3.
17. *Diary of John Evelyn*, ed. E.S. de Beer, 6 vols (Oxford: Oxford University Press, 1955), vol. II, p. 357. The account of Horatius' defence of the wooden Pons Sublicius came from Livy (*Annales*, II, 10). The event was not infrequently depicted in Italian art, e.g. a version attributed to Polidoro Caldara da Caravaggio (*c.* 1500–43), at Narford, Norfolk, but thought to be Florentine rather than Roman: see A.W. Moore, *Norfolk and the Grand Tour* (Norwich: Norfolk Museums Service, 1985), p. 108.
18. Evelyn's *Diary*, vol. II, p. 446. See T. Rizzo, *I Ponti di Venezia* (Rome: Newton Compton Editori, 1983) and the catalogue by G. Zucchetta, *Venezia: Ponte per Ponte* (Venice: Stampieri di Venezia, 1992). Also see the article by A. Woodward, 'Structures, Rituals and Romantic Visions: Bridges and Eighteenth-century Venice', *Apollo*, vol. 140 (1994), pp. 52–7.
19. Fist-fighting was permitted on the Venetian Bridges from September to Christmas. See Evelyn's *Diary*, vol. II, p. 414; P. Molmenti, *La Storia di Venezia nella vita privata*, 4th edn, 3 vols (Bergamo: Istituto Italiano d'arte Grafiche, 1905–8), vol. I, pp. 204–5, ill. pp. 207–8.
20. R. Cessi and A. Alberti, *Rialto: L'Isola, Il Ponte, Il Mercato* (Bologna: Zanichelli, 1934).
21. The first recorded bridge of boats (probably pontoons or floating supports) is that of Xerxes across the Hellespont, built *c.* 480 BC and described by Herodotus, VII, 36. But it was especially a feature of modern Venice, painted by many artists, e.g. Joseph (Giuseppe) Heintz the Younger (Heintzius), a native of Augsburg, who worked in Venice for many years and died there some time after 1678 (see Correr Museum, Venice, reprod. in W.G. Constable, *Canaletto, Giovanni Antonio Canal 1697–1768*, 2nd edn rev. J.G. Links, 2 vols (Oxford: Clarendon Press, 1976), vol. 1, pl. 2b. Topographical art had arisen as a distinct genre in the north of Europe, notably in the Netherlands and Germany, in the sixteenth century (see Introduction), and northern ideas of it were transmitted southward by Gaspar van Wittel (Vanvitelli, 1653–1736), a native of Holland who worked in Italy for most of his life and was in Venice in 1697. The popularity and frequency of festivals, ceremonies and regattas in Venice and the habit of making the Grand Canal the focus for them also led to the development of a vein of Venetian topographical painting by Italian artists before 1700. Prominent in this was Luca Carlevaris (1663–1730); he also issued an influential collection of 104 engraved views which included Venetian bridges, *Le Fabriche e Vedute di Venetia Disegnate, Poste in Prospettiva, et Intagliate da Luca Carlevaris* (1703).

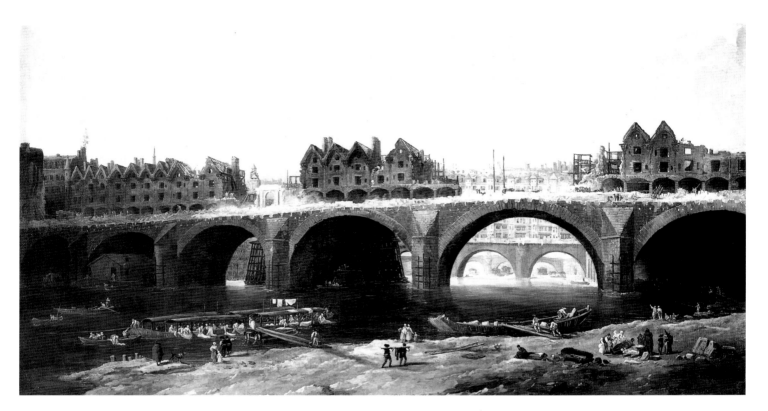

12

12 Hubert ROBERT (1733–1808)
The Demolition of the Houses on the Pont Notre Dame
Oil, 86 × 159 cm (34 × 62 ¹/₂ in.), 1786

Both the Pont Notre Dame and the Pont au Change
(visible in the distance in Robert's picture) preserve
unusually close reminders, in the massive forms of their
semicircular arches, of the Roman origins of Paris on the
Ile de la Cité, which they connect to the Right Bank.
Rented houses and shops on the bridges and watermills
beneath them earned money for maintenance. The Pont
au Change, first settled by butchers, was in 1142 made by
Louis VII into the Bridge of the Moneychangers. The
early French kings traditionally passed over it after their
coronation at Saint-Denis. But the Pont Notre Dame was
also important: after its rebuilding in the early sixteenth
century François I, the first French king of the modern
age, crossed it on his way from the Porte Saint-Martin. In
the early eighteenth century the picture dealer Gersaint,
a friend of Watteau, had his shop-sign on this bridge.

In the 1780s the housing on both bridges was taken
down to make them the 'ponts découverts'. On the title-
page of his book of Paris views published in 1792, while
the city was still in the grip of Revolution but Louis XVI
was still alive, the printmaker Janinet celebrates the new

Pont Triomphale which was to bear the king's name, and
which was seen on Duvivier's medal of 1788. He lists the
'ponts découverts' as among the positive achievements of
the king's reign.[1]

Demolition, renewal: the removal of the non-functional
to reinstate the functional: these were guiding ideas of the
new Classicism. While Robert shows city life going on in
the foreground – linen is washed, statuary is packed,
gang-planks are crossed – in the stripping away of
superfluity on the bridge itself we sense a new departure:
if not the taut reductiveness of the arches in David's
canvas *The Oath of the Horatii* – so admired by the Salon
crowds in 1785 – then a workaday counterpart of the
engineering simplicities of Perronet's Pont de Neuilly,
which Robert had also depicted (Fig. 26).

1. Janinet, *Vues pittoresques des principaux édifices de Paris* (Paris
 1792). The title page carries the profile of the king at the top
 with the Paris improvements listed at both sides, 'Ponts
 Découverts 1787' on the right, 'Pont Triomphale 1787' on the
 left. A view of the uncovered Pont au Change is in the middle.
 The title page is reproduced in H.C. Rice Jr, *Thomas Jefferson's
 Paris* (Princeton, NJ: Princeton University Press, 1976), p. 8.

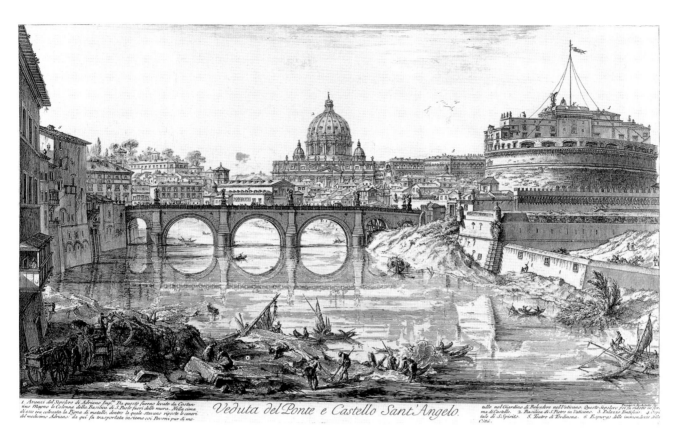

1 Avanzi del Sepolcro di Adriano Imp.re Da questo furono levate da Costan-
tino Magno le Colonne della Basilica di S.Paolo fuori delle mura. Nella cima
di esse era collocata la Pigna di metallo, dentro la quale stavano riposte le ceneri
del medesimo Adriano: da qui fu trasportata insieme coi Pavoni pur di me-

Veduta del Ponte e Castello Sant'Angelo.

talle nel Giardino di Belvedere nel Vaticano. Questo Sepolcro
ma di Castello. 2. Basilica di S.Pietro in Vaticano. 3. Palazzo Pontificio.
tale di S.Spirito. 5. Teatro di Tordinona. 6. Espurgo delle immondezze della
Città.

13

13 Giovanni Battista PIRANESI (1720–78)
The Ponte and Castel Sant'Angelo, Rome
Etching, from *Vedute di Roma*, c. 1750,
38.5 × 58.5 cm (15 × 23 in.)

Entering Rome at the end of a complicated journey which
had certainly involved crossing innumerable bridges –
beautiful, ugly, safe, hazardous – the Grand Tourist will
speedily have realized, if he had not already done so (and
in London, with just one bridge before 1738, the British
Tourist might be forgiven for not realizing it), that main
roads tend to converge on bridges. The Pons Sublicius,
which Horatius had defended, might be unidentifiable,
but the Via Cassia, which the traveller might have
followed from Florence, led to a structure that he would
perhaps have seen in paintings or engraved views. This
was the Ponte Sant'Angelo, originally the Roman Pons
Aelius, praised by Palladio and connecting Hadrian's
great mausoleum, the Castel Sant'Angelo (a fortress since
the Middle Ages) with the east bank. It was on this bridge
that Pope Gregory the Great, in the late sixth century, had
had a vision of angels which had given it its modern

name. Frequently restored, it remained in essential form
as it had always been, with the addition of angels sculpted
by Bernini's pupils in the seventeenth century. The view
of it, with the mausoleum, was one of the classic prospects
of Rome, drawn by innumerable artist-visitors to the city
as well as by residents such as Piranesi.

It is hard to reconcile the imaginative flights of
Piranesi's Carceri (*Prisons*, Fig. 19) with the more down-
to-earth documentary preoccupations of their creator.
But it is essential to do so, as it is his sense of the
structural daring that had entered into ancient Roman
bridges, combined with the imaginative desire to see
modern counterparts of them (compare Fig. 25), which
gives Piranesi his share of importance in the bridge-
awareness of his time. In one of his most archaeologically
committed bridge engravings, the 'Section of the
Foundation of the Pons Aelius and of Castel S. Angelo',
from the *Antichità Romane* (1756), IV, Piranesi produced a
fold-out plate, nearly 1.5 metres (4 feet) across, giving
cross-sections of the famous tomb of Hadrian, and the
bridge joining it to the Campus Martius. The exactitude
that Piranesi brings to the drawing of the bridge that we
see in Fig. 13 is equalled in the fold-out only by the
precision with which he records in figures, under the
three main arches, the differing depths of the Tiber
beneath it in December, June and August. When the
visible factual evidence gives out, the unquenchable
imagination moves in: delving to the level of the
cyclopean foundations, the artist indicates a yet more
basic zone where hundreds of iron-tipped stakes,
rammed into the earth, are delineated.[1] The cogency of
knowledge is backed by keenly weighed hunch.

Beside the imaginative artist and the inquisitive
archaeologist in Piranesi, there was also the recorder of
what anyone could see if they took the trouble to look.
The view of the same Ponte Sant' Angelo in Fig. 13 neither
dramatizes nor delves beneath the surface: Piranesi is
content to let Rome, ancient and modern, speak for itself.
No doubt the fact that he specialized in black and white
helps to concentrate the message. And visitors, standing
in front of this scene to watch the dredging in the river or
the fireworks over it, were ready to hear that message.

1. The section of the engraving showing the foundations of the
 Ponte Sant'Angelo is reproduced in J. Wilton-Ely, *The Mind
 and Art of Giovanni Battista Piranesi* (London: Thames and
 Hudson, 1978), p. 58. The whole plate is reproduced in J. Scott,
 Piranesi (London: Academy Editions, 1975), pp. 124–5.

14 Giovanni Battista PIRANESI (1720–78)
Ponte Salario
Etching, from *Vedute di Roma*, c. 1757–61
41 × 62.5 cm (15 7/8 × 24 1/4 in.)

The Ponte Salario was situated over the river Anio
(Aniene) at the point two miles from Rome where the Via
Salaria came in from the east through the Sabine Hills.
With its distinctive outline it became a favourite feature
with landscape painters who based themselves on the
Roman Campagna. The artist who taught Piranesi to etch,
Giuseppe Vasi, did a much tamer view of it from a
distance.[1]

While Piranesi produced relatively calm, documentary,
en face views of bridges (compare Fig. 13 or his engraving
of the famous Bridge of Augustus at Rimini of the late
1740s), he was by temperament drawn to dramatically
foreshortened views of them contrasted with the
movement of boats and water beneath. In the rearing
image of the Ponte Salario this movement is set against
the steep diagonal of road and staircase leading into the
tower. He also shows the structure from its shadowed
side, accentuating the height of the Roman main arch and
the medieval tower itself, and reminding the viewer that
here is a bridge that has served for defence as well as
passage, exclusion as well as accessibility.

The plate became a popular choice for the Print Rooms
that were created in English country houses in the
eighteenth century, reflecting memories of their owners'
Grand Tours. Its combined reflection of the Roman arch
and medieval battlementing would have doubly
confirmed its continuing acceptability at the end of that
century, when Paul Sandby (1731–1809) was drawing the
towered Old Welsh Bridge at Shrewsbury (Fig. 14a) at a
time of antiquarian interest in Anglo-Welsh border
relations (see also p. 74). This was a favourite subject of
Sandby's; another view of it by him is in the Fitzwilliam
Museum, Cambridge.

1. See J. Wilton-Ely, *The Mind and Art of Giovanni Battista Piranesi*
 (London: Thames and Hudson, 1978), fig. 48.

14a Paul SANDBY (1731–1809)
The Old Welsh Bridge, Shrewsbury
Bodycolour on canvas, 29 × 37 cm (11 1/2 × 14 1/2
in.), c. 1800

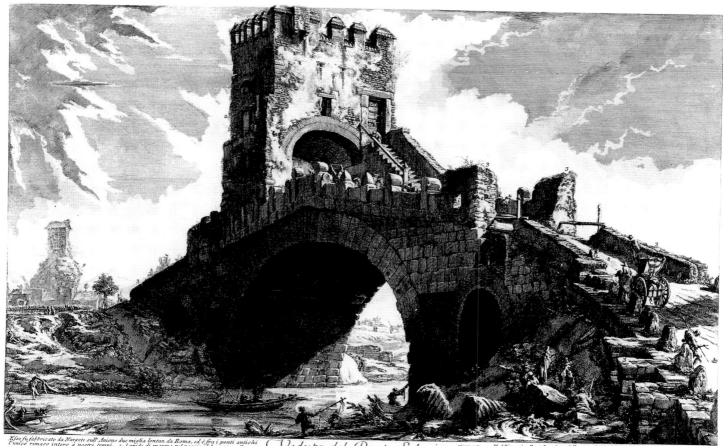

Esse fu fabbricato da Narsete sull'Aniene due miglia lontan da Roma, ed è fra i ponti antichi l'unico rimaso intero a nostri tempi . 1. Lapide di marmo nel poggio del ponte colla memoria di Narsete scolpita dalla parte interna . 2. 3. Torricella ed altri muri fabbricati poste

Veduta del Ponte Salario

riormente. 4. Modelli usati nella costruzione dell'arco, e lasciativi per comodo ne' di lui fortuiti risarcimenti . 5. Cavo in cui era uno de' detti modelli caduto . 6. Archi fatti in difesa del Ponte dall'impeto delle acque nelle apprescenze del Fiume . 7. Fiume Aniene, overo Teverone . 8. Via Salaria . 9. Avanzo di antico Sepolcro investito da fabbriche moderne .

14a

15

15 Antonio Canal, called CANALETTO (1697–1768)
Grand Canal, Rialto: The Rialto Bridge from the North
Oil, 46 × 58.5 cm (18 × 23 in.), 1727–9

Canaletto's appraising eye, looking for inflection of line
and angle either to tighten a view or expand it sideways,
was fully engaged in his views of his city's most famous
bridge, the Rialto. Much of the vitality of the 44-metre-
long (144 feet) Rialto Bridge as a form is generated by the
tension between its two contours, the curve of the arch
and the steeply sloping, angled skyline. Canaletto's
responsiveness to this fact is shown nowhere better than
in this small picture on copper, begun before November
1727.

The great height of the Rialto's elevated centre (more
than half the width of the arch) is also at its most obvious
viewed, as here, in silhouette from the northern side. The
artist is concerned to make it as high as the block of the
Palazzo dei Camerlenghi on the right. Canaletto's
drawings took painstaking note of true topographical
relationships, and he developed what has been called a
'knowing measure of optical contrivance', employing
ruler and dividers.[1] But at the time of painting, in the best
of his early renderings of the Rialto, a freer manner of
thought animates the 'contrivance': a sense of the

bridge's exuberance and drama is allowed to come
through. While bridges frame light close to water the
Rialto, with its viewing platform, distributes it at two
levels. In this picture, light falls brilliantly through this
opening on to two or three figures who stand on the near,
northern side, as on a stage. Turner, a hundred years later,
would use this same opening to contain the very source
of reflected light, the moon, in a well-known nocturne
(Fig. 61): and this framing and distribution of light by a
bridge over water is an effect we shall see again when we
discuss Turner's works. Turner will surely have valued
Canaletto for his analyses of it.

1. M. Kemp, *The Science of Art, Optical Themes in Western Art from
 Brunelleschi to Seurat* (New Haven and London : Yale
 University Press, 1990), p. 144.

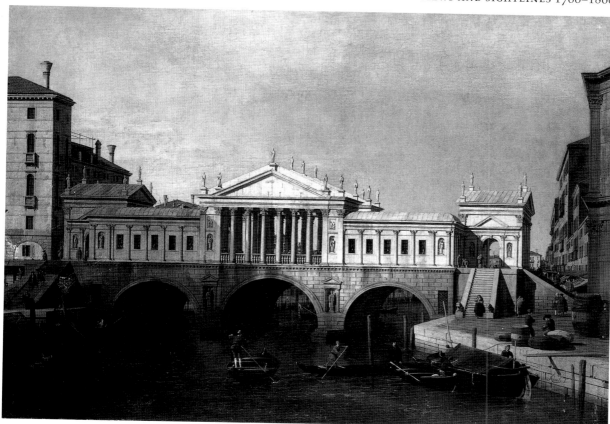

16

16 CANALETTO (1697–1768)
Venice: Caprice View with Palladio's Design for the Rialto
Oil, 90.8 × 130.2 cm (35 3/4 × 51 1/4 in.), prob. 1743–4

Canaletto's use of the Rialto Bridge's pictorial merits might be expected to flavour his work in the area of the fanciful architectural *capriccio*. And a *capriccio* does exist in which the extravert Rialto is aligned with Palladio's inwardly construed facade of San Giorgio Maggiore.[1] But it is perhaps evidence of the nature of the *capriccio*, an art-form which deals in ultra-sophistication and contrivance, that the unbuttoned Rialto as built hardly ever appears in Canaletto's large *capriccio* output. Instead, we find him imagining as built, in this painting for his patron Joseph Smith, the unrealized Rialto design by Palladio, with its stairways leading to arched entrances, imposing colonnaded central area for the meeting of merchants, and classically regular rows of shops along each side.[2]

Smith, as the English Consul in Venice, commissioned from Canaletto thirteen overdoor paintings for his house. These were to commemorate both Palladio and Venice. The scale of the commission, and the proposed distance from the eye of the paintings when viewed in their destined settings, may account for the lack of incident in this picture and its companions in the series when compared with Fig. 15. It is of coincidental interest, in

view of Smith's taste for English Palladianism and Canaletto's view of Palladio's Rialto, that the picture should have entered the collection of the English king George III in 1770, by which time views of the so-called 'Palladian' bridge at Wilton had been painted by the British artist Richard Wilson (Fig. 31).

It is also worth noting that a second version of the painting, for Count Algarotti, included two such prominent Palladio buildings as the Basilica and Palazzo Chiericati in Vicenza, one at either end of the bridge.[3] It was thus placed in the company of two canonical (and actually realized) works by one of the most admired of architects, and the sobriety of this particular fusion of the real and the invented is no doubt all the greater for the fact. Both Rialto caprices express the idea of a town bridge that we most readily associate with it: as a public amenity wearing a public face, as a place of congregation, as an extension of man's habitable domain over water.

1. N. Carolina State Art Museum, see W.G. Constable, *Canaletto: Giovanni Antonio Canal 1697–1768*, rev. J.G. Links, 2 vols (Oxford: Clarendon Press, 1976), vol. I, no. 463; vol. II, pl. 86.
2. See MS catalogue by Smith of his collection, now at Windsor Castle: Constable and Links, *Canaletto*, vol. I, no. 457. Smith calls no. 1 of this series (the present picture) 'the Design given by Palladio for the Rialto Bridge'.
3. Possibly that illustrated from the Conti Collection, Milan, in Constable and Links, op. cit., vol. I, no. 458.

17

17 CANALETTO (1697–1768)
Mountain Landscape with Three Bridges
Etching, 14.3 × 20.9 cm (5 3/4 × 8 3/8 in.), *c*. 1740

Nothing could be further from Canaletto's measured statement of the design by Palladio for the Rialto (Fig. 16) than this bridge picture that seems likely to have been nearly contemporary with it. Sometime after 6 June 1744, Canaletto published his set of thirty-one etchings, with a dedication to Joseph Smith. While sundry bridges appear singly in this series (for example, no. 9, *Town on a River Bank* and no. 22, *Landscape with a Pilgrim at Prayer*), in one of the smaller etchings (no. 25), the present *Mountain Landscape*, there are no fewer than three bridges and parts of a fourth and fifth, all within a few metres of each other in the middle of a rocky wilderness.

Mountain Landscape is something of an exception in the set, and may have been among the earliest to be executed.[1] Whereas most of its companions present everyday life in towns, albeit seedy corners of towns, no. 25 , an obvious *capriccio* or invented composition, is concerned with wild nature and includes a violent end to life in the macabre presence of a hanged man (on the right). Perhaps this suggested the idea of a conglomeration of bridges, of different types, there to aid the living. One, low in the foreground and empty except for a leaning post bearing a small shrine, is a footbridge: a

man sprawls nearby. Another, to the left, is a wooden structure over rushing water: it ends in columns which were once, perhaps, gate-posts, and a coach drawn by two horses moves across it. The third, a high, humped stone bridge, has at mid-point a large shrine, which a country waggon is passing. Each bridge, therefore, has a human theme attached and is in some sense a marker as well as a link. None is broken or blocked: the caprice does not go as far as Piranesi's imminent dream-works, the *Carceri* (*Prisons*, Fig. 19). But if this small, even slight, etching lacks the tension of those works, it evokes in a positive way the stimulus of the primitive in nature, and human nature, which is a growing part of the imaginative life of Canaletto's period, and a small aspect of his own sophisticated art.

1. See Ruth Bromberg, *Canaletto's Etchings* (London and New York: Sotheby Parke-Bernet Publications, 1974), no. 22.

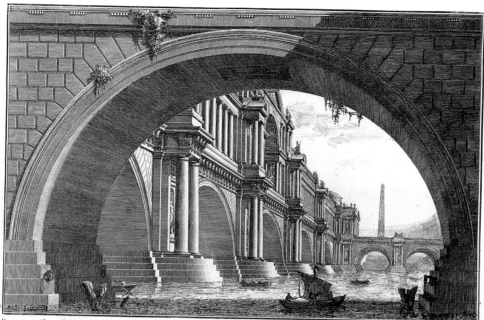

Ponte magnifico con Logge, ed Archi eretto da un Imperatore Romano, nel mezzo si vede la Statua Equestre del medesimo. Questo ponte viene veduto fuori di un arco d'un lato del Ponte che si unisce al sudetto, come si vede pure nel fondo un medesimo arco attaccato al principal Ponte.

18

18 Giovanni Battista PIRANESI (1720–78)
'A Monumental Bridge' (*Prima Parte di Architettura e Prospettive*, 1743)
Etching, 24 × 34.8 cm (9 1/2 × 13 3/4 in.)

Apart from Piranesi's views of actual bridges, one other individual bridge image by him made its own unique impact: this view of a 'Monumental Bridge' (also included in *Opere Varie*, 1750). If Canaletto had heaped up three different kinds of bridge in his *Mountain Landscape*, Piranesi here has three sequences of the same kind of classical arch at right angles to each other, and apparently built across a limitless expanse of water. Everything is prodigal and overwhelming. The main structure, seen in foreshortening, has five semicircular arches with two tiers of freestanding columns against the piers, and pavilions at the ends and in the middle, the latter enclosing an equestrian statue.

The plate makes the most of Piranesi's two mental worlds: the framing arch is severely Roman in character, but the lighter lines for the scene beyond help to convey a more visionary effect. The combination of Rome and personal vision was to influence a large number of neoclassical bridge designs (compare Fig. 32).[1] Moreover, the device of looking across water through a single massive foreground arch was to have immense appeal to artists during the following decades. Piranesi's intensity contrasts with the more relaxed approach by Canaletto in his London period (1746–7, Fig. 18a) which was to be taken up by Scott (Fig. 24 and Plate II), De Loutherbourg,

Agasse (Fig. 47) and Turner, to mention only the most famous, were also attracted by the motif.

1. 'Neoclassicism', a modern term, denotes the eighteenth-century style that sought a return to the simplicities of Greek and Roman architecture, emphasizing severe form and bulk above small-scale ornament and detail. It grew up in the wake of extensive archaeological activity, especially from the 1750s, in the course of which fierce arguments broke out on the respective merits of Greek and Roman architecture. As a passionate partisan of Roman achievements, Piranesi was to use his archaeological and imaginative regard for the bridges of Rome (Fig. 14) to powerful effect in expressing his beliefs.

18a Remigius Parr (1723–active *c.* 1750) after CANALETTO (1697–1768) *London Seen through an Arch of Westminster Bridge*. Engraving, 10.6 × 17.5 cm (4 1/4 × 7 in.), 1746–7

18a

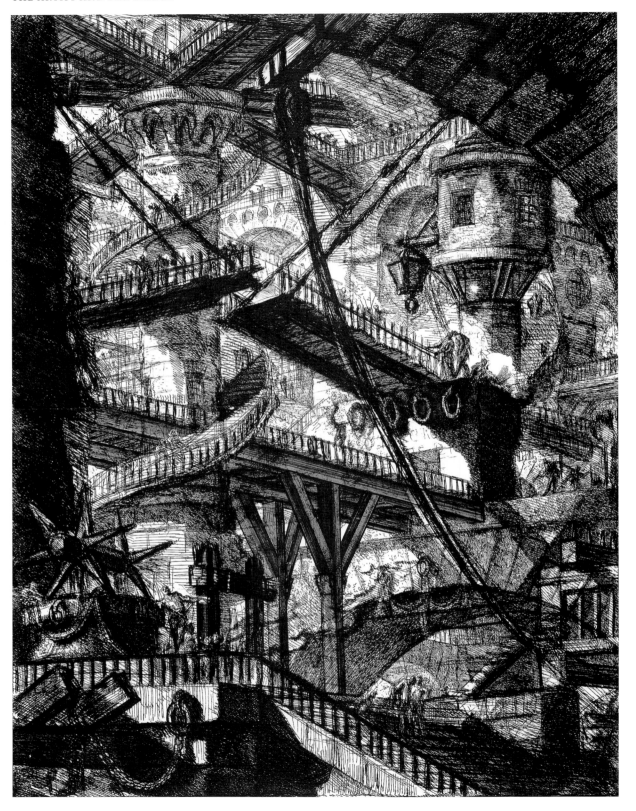

19

19 Giovanni Battista PIRANESI (1720–78)
Plate VII from the *Carceri* (c. 1760–61)
Etching, 51 × 44 cm (20 × 17 1/4 in.)

It is in the celebrated designs of the *Carceri* (*Prisons*) that
we feel the full intensity of Piranesi's special brand of
bridge-consciousness. This series came out in two
editions. The first, *Invenzioni Capric di Carceri*, of c. 1750,
stressed the elements of invention and stagecraft,
and contained fourteen plates. They were not popular,
but Piranesi, undeterred, went on to issue *Carceri
d'Invenzione*, c. 1760, with the original plates reworked
and two more plates added. These two were both
uprights, which points the direction in which Piranesi's
imagination was moving, for although the first nine
plates were vertical images and the last seven horizontal,
linking them all was the invitation to the observer to
leave ground level altogether and essay the experience, at
great height but still at close quarters, of structures which
were nothing if not bridge-like.

In the *Carceri* Piranesi conjures with the twin poles of
claustrophobic mass and nightmare release across space:
nowhere had these two extremes been combined in the
same work of art to such effect. Human life is of little
account in this world of massive walls and ominous
instruments of the torture-chamber, and in fact, as has
often been noticed, Piranesi advances here to his greatest
extreme of rejection of the idea of classical architecture
scaled to human proportions. The nearest predecessor
to these plates in regard to the bridge form was the
Mountain Landscape with Three Bridges etching of
Canaletto (Fig. 17), with its strange piling up of bridges
of different forms, stone and plank-like, and aura of
violence (wheel, gallows, hanged man). But particular
Piranesian devices greatly intensify the sense of dread:
it is notable that in plates I, II, III, IV, VI, XII, XIV and XV
the compositions severely compress foreground space in
order to open it up to an alarming extent higher up (the
other numbers present a more 'normal' space recession,
though without suggesting bounds, so that the dreamlike
sensation of being pitch-forked into infinite space, if not
so strong, is still compelling).

In several of the *Carceri* plates it is often hard to decide
if what we are looking at are arched openings or bridges,
but the presence of figures on top of the structures (for

example in the dramatically dark arch running
diagonally into the top right hand corner of plate II,
or the arch to the right of centre in plate XIII, second
state) makes the bridge reference unmistakable.

In plate I (second state) huge stone arches fly out of the
composition above a flat, grid-like bridge which runs
counter to them. Plate IV has a bridge of a grandiloquent
kind topped by a parapet, with two arches opening
below. Plate VII (illustrated) presents another with two
arches, and with corbelled parapet, high up to the right,
as well as the single-arched structure below (which
occurs also in plate IV and elsewhere). In this same plate
prominence is given to a huge drawbridge, which has
people on each leaf: but it cannot be crossed as the two
halves are partly drawn up, leaving a gap in the centre.[1]
This is perhaps the most uneasy space in the entire series.

The psychic disquietude of the *Carceri* series as a whole
would have repercussions on the Romantics of the next
century. But in a very specific way, so would Piranesi's
treatment of the bridge-idea. The semicircular arch of the
Roman baths had had the gigantic scale which released it
imaginatively from the realm of human-scaled geometry
of smaller Roman structures: in Piranesi's *Carceri* plates
the overwhelming semicircular arch is invested with
unease through being projected over a space that seems
hazardous and indifferent to human safety. When we
approach a bridge in ordinary life we seek completeness
and the certainty of the farther side, but with the *Carceri*
we are not vouchsafed them: plate VII is a particularly
extreme instance of this. Piranesi's title *Carceri
d'Invenzione* proclaims his awareness of the polarities
of freedom and constraint: is it not likely that in these
bridge-subjects he intends to invert, not without irony,
the linking role of the bridge by giving expression so
freely to it in a context, the prison, which is one of
repression?

1. The drawbridge, as a form which is accessible at certain times
and inaccessible at others, is a theme of some consequence.
See Chapter 3, Fig. 56; Chapter 4, Fig. 91 and Plate XV, also
Fig. 92.

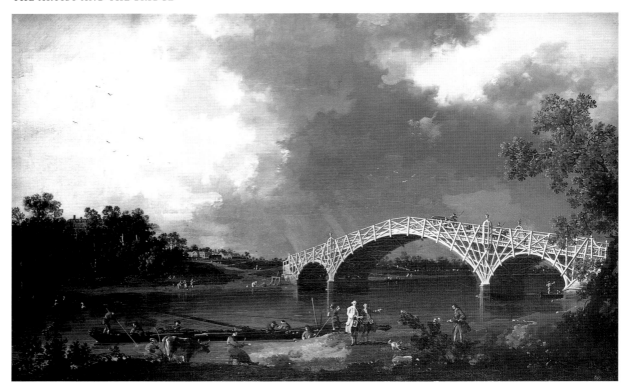

20

20 and Plate I CANALETTO (1697–1768)
Old Walton Bridge over the Thames
Oil, 48.8 × 76.7 cm (19 1/4 × 30 1/4 in.), perhaps 1754

The bridge shown here, opened in 1751, was built to the design of William Etheridge at the instigation of Samuel Dicker, MP, who had paid for it in 1747. Etheridge had worked ten years previously with a specialist in timber bridge construction, James King, on an early design in wood for Westminster Bridge. This was criticized then as unlikely to last, and in fact Dicker's Walton Bridge had to be replaced in 1780–83. At the time that Canaletto painted it, however, its skeletal character was the subject of much conjecture: the theory was held that any one of its wooden members could be replaced without disturbing the others. The lattice-like design reveals the interest in the trussing of wooden bridges which is reflected in the article CHARPENTE ('Timberwork') in Diderot's contemporary *Encyclopédie* with its illustrations.[1] It looks back to Palladio's own bridge designs in timber (*Quattro Libri*, Book III), all reproduced and discussed, with others, in Henri Gautier, *Traité des ponts* (1716), and forward to the early iron bridge designs.[2] The central span at Walton was 39 metres (130 feet), claimed – just ahead of Edwards's Taaffe bridge (Fig. 39) – to be the widest in Britain.

Canaletto depicts an artist, presumably himself, in the centre foreground drawing the bridge with, in front of it,

the two prominent figures of Thomas Hollis, who had commissioned the picture in 1754, and his friend Thomas Brand, to whom Hollis bequeathed it. The bridge is shown sunlit against a stormy sky: in an imaginative passage the splaying diagonals of light falling in front of the cloud meet the spoke-like timber uprights. The slight convexity which the bridge appears to have was not there in fact, but was presumably introduced by the artist to give greater elegance.

The picture (which may have been painted at the time of the opening, although an inscription on the back of the original canvas gives the date 1754) is one of the masterpieces of Canaletto's ten-year English period (1746–56). Another version of the same subject by him, painted in 1755 (Yale Center for British Art), includes the old multi-arch stone bridge over marshy fields on the Surrey side of the river. This version was commissioned by Dicker. The effect of many arches is millipede-like and much less successful, though Turner and others – after the Picturesque movement had popularized rambling structures, half merging with their landscape – painted the whole complex. Canaletto stays with the newly-minted product of the 1750s.

1. *Encyclopédie*, vol. II, 1751, publ. January 1752, pl. 178.
2. T. Ruddock, *Arch Bridges and their Builders 1735–1835* (Cambridge: Cambridge University Press, 1979), pp. 132f.

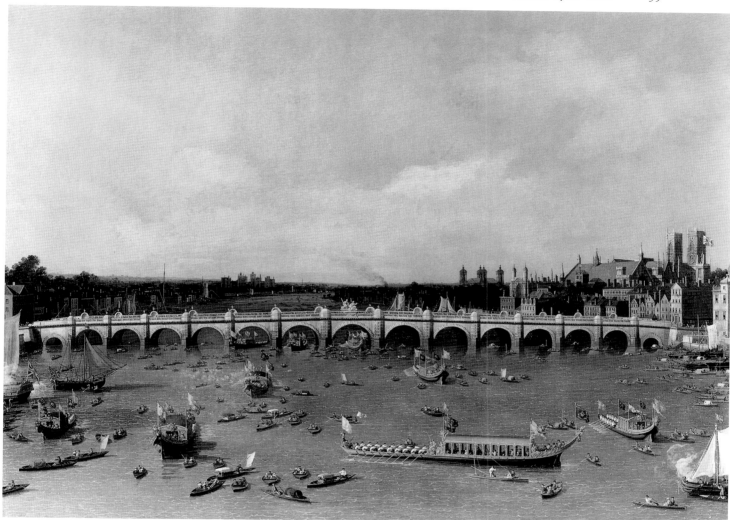

21 CANALETTO (1697–1768) 21
Westminster Bridge, London, with the Lord Mayor's Procession on the Thames, 1747
Oil, 96 × 137.5 cm (37 3/4 × 54 in.), 1747

Designed by Charles Labelye, a Swiss-born expert in harbour works and river drainage, who won the competition in the teeth of opposition from Palladian architects (Colen Campbell and Thomas Ripley submitted designs), this was the structure which was rising before the eyes of London through the 1740s, overlapping into the period (from 1746) of Canaletto's stay.[1] No doubt drawn to the Thames as the feature of the British capital that came closest to his familiar Grand Canal (though with only the Lord Mayor's Day and sundry other occasions to remind him of its pageants), he clearly found Labelye's bridge a congenial subject, even if the demand for replicas induced a certain mechanical

brilliance into some of the resulting canvases. Constable and Links list six paintings that deal with the bridge, either under construction or completed, and five drawings.[2]

Two paintings of the bridge appear to date from 1746, soon after Canaletto's arrival. One (National Gallery, Prague) shows the panorama of the river downstream to St Paul's on the far right, with much scaffolding and timber centres under five arches at the Surrey end.[3] The present picture of 1746 was engraved in the following March. It presents the entire fifteen-arch bridge (shown completed, though this was not to be until 1750) from above at a point in midstream, together with nine richly decorated barges of the City Livery Companies, all identifiable. In his valuable study *Old Westminster Bridge: The Bridge of Fools* (1979), R.J.B. Walker points out how idealized the view is, with domes shown over all the balustrade recesses and (unexecuted) statues of Thames and Isis over the middle arch. But it is clear that the idealism matched the mood of optimism which sought to prevail against the detractors who were using every opportunity to criticize.

There were construction problems, especially those associated with the subsidence of a pier in 1747,[4] which have given rise to difficulties in dating Canaletto's pictures of the bridge and arranging them chronologically. A picture entitled *Westminster Bridge from the North, Lambeth Palace in the Distance* (commissioned by Thomas Hollis in 1754, now private collection, but known in other versions) shows the repairs in progress that had in fact been made several years earlier. What emerges, besides the obvious fact of the bridge's importance as a major building enterprise of its time, is the continuing interest, even after its opening, in the heroics of its period of gestation. Most important of all, Canaletto's Westminster Bridge pictures reveal how decisively the additive bird's-eye 'long view' over a city or town has been left far behind, to be replaced by an effect of light, buoyant unity-with-expansiveness that a bridge subject over water is beautifully fitted to express.

1. Labelye was of French Huguenot descent and had probably come to England *c.* 1725: see *Dictionary of National Biography*, XXI (London: Smith, Elder, 1895), p. 365. See R.J.B. Walker, *Old Westminster Bridge: The Bridge of Fools* (Newton Abbot: David and Charles, 1979), pp. 92–4, 109; Ted Ruddock, *Arch Bridges and their Builders 1735–1835* (Cambridge: Cambridge University Press, 1979), pp. 8–10. Westminster Bridge was built from the proceeds of a state lottery, one of many instituted in the eighteenth century for projected public amenities. The novelist and magistrate Henry Fielding, deeply mistrustful, along with others, of the practice of state lotteries and their attendant evils in his day, saw posterity

being provided with 'a monument at Westminster that may be called THE BRIDGE OF FOOLS through all generations' (*The Champion*, 15 November 1739).

2. W.G. Constable, *Canaletto, Giovanni Antonio Canal 1697–1768*, rev. J.G. Links, 2 vols (Oxford, 1976), vol. I, paintings, cat. 412, 426, 427, 434–6, some with similar versions; drawings 749–53, some with similar versions.

3. The picture was bought by a Bohemian nobleman, Prince Lobkowitz, who is recorded as being in London by Dr Burney in 1745 and by the *Westminster Journal* (6 September 1746) as being in England in the summer of 1746 to acquire horses for his stable.

4. The subsidence of a pier in 1747 brought forth, among other criticisms, a ballad 'The Downfall of Westminster Bridge, or my Lord in the Suds' (referring to Lord Pembroke). The architect Batty Langley's *A Survey of Westminster Bridge as 'tis now Sinking into Ruin* (1748), published after this defect had shown itself, is very scathing: he prints a frontispiece showing his own earlier recommendations on securing the piers published in 1736. An anonymous writer who was more sympathetic to Labelye published a 144-page pamphlet, *Gephyralogia*, in 1751. This lists early bridges from Babylon onwards, including Trajan's bridge over the Danube, and introduces the Westminster Bridge project in the succession, using Labelye's first two pamphlets and a supplement to the *Gentleman's Magazine* of 1746, and illustrating, from the last-named, Thomas Jeffreys' 'South View of Westminster Bridge' (pl. IX in the *Magazine*). See Walker, *Old Westminster Bridge*, p. 182. A writer in the *Gentleman's Magazine* 1761 (p. 610) criticizes the bridge for its proportions ('top heavy and too narrow for its height'), yet concedes that it is 'perhaps the most majestic pile . . . in Europe' (quoted in full in Walker, p. 269).

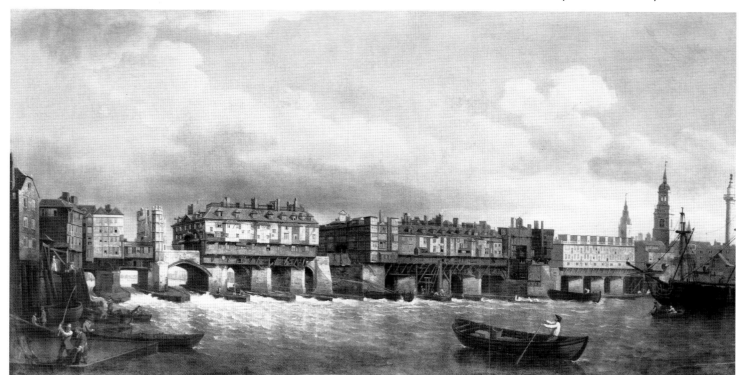

22

23

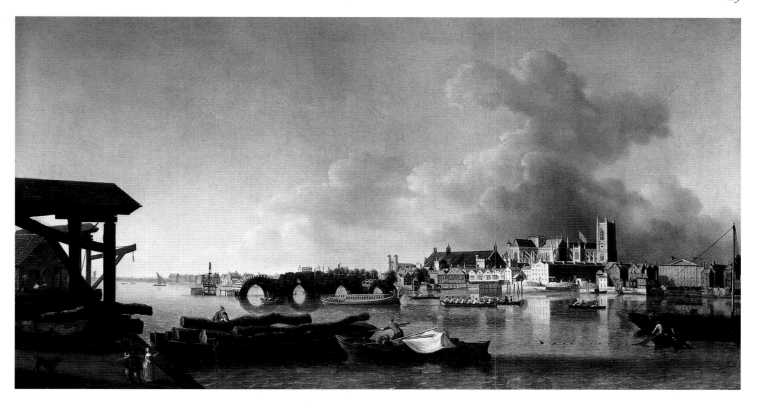

22 and **23** Samuel SCOTT (*c.* 1702–72)
Old London Bridge and *The Building of Westminster Bridge*
Oils, each 78.7 × 149.8 cm (31 × 59 in.), 1748

Commissioned by Sir Edward Littleton for his seat Pillaton Hill, Staffs, these two pictures throw light on a piquant episode of eighteenth-century taste.

In 1746 Antonio Joli (*c.* 1700–77), a compatriot of Canaletto who had arrived in London a little time before him, painted two Thames views (National Westminster Bank plc) showing in one an old bridge (London) and a 'new' church (St Paul's), and in the other a new bridge (Westminster) with its nearby ancient church (Westminster Abbey). The two constituent nuclei from which London had grown (the City in the east and Westminster in the west) were thus paired.

It fell to Samuel Scott, however, to contrast the bridges more specifically and paint pictures of Old London Bridge as well as of Labelye's bridge at Westminster, some as pairs, at a time when the old bridge as well as the new was being debated. In 1747 a Court of Enquiry was set up to decide on the future of London Bridge. The outcome was a major scheme of rebuilding and alteration which began in 1757 and continued till 1762: this resulted in the removal of the remaining old houses which had stood on it for centuries. Kingzett cites eleven repetitions of Old London Bridge, with its housing intact, made by Scott between 1747 and 1761, some indication of evident demand.[1] Five of the eleven are still in the company of pendant views of Westminster Bridge. Kingzett lists six Scotts of the building of Westminster Bridge and five with 'neighbouring houses'. The doubling of the two subjects of London and Westminster in prestigious collections opened the door to what Scott clearly saw as a golden opportunity. The two subjects were paid for on 20 March 1749 by Jacob Bouverie, 1st Viscount Folkestone, and still remain as overdoors in the Green Drawing Room at Longford Castle, Wiltshire. In June 1750 Scott reported the completion of 'The two Bridges', which are 'thought to be the two best Pictures I ever Painted' in a letter to Littleton. Both subjects were issued as engravings by P.C. Canot in 1758, and the plates were used by John Boydell the publisher, and later as book illustrations, in copied form, as late as 1853.[2]

The paired paintings of the old-established London Bridge, with its housing intact, and Westminster still incomplete on its modern pile-driven supports, make an effective and moving foil to each other. There was much nostalgia for the old bridge, and it is easy to see how the images of the only crossing-points in the capital at the time could represent for Scott and others of his generation aspects respectively of past and future. Why else should the artist have contrasted the lighting so boldly in the two works? London Bridge looks luridly indestructible against dark cloud and the foam that surges about its narrow arches and starlings: the robust, heroic baroque of the Dutch seventeenth-century topographical painters consolidates it. It is no surprise to find that shooting the rapids beneath the bridge was a favourite exploit.[3] By contrast the Westminster sky is all light and space behind the bridge's pragmatically centred, repeating humps. These appear all the more part of their setting for being shown against a view of the familiar Abbey. We see that work on its western towers is still proceeding (only one is shown), and have a sense of the diverse entity that is modern London taking unified shape. Indeed the pictures symbolize the complementary aspects of the old City in the east and Westminster in the west, each now with its own bridge, straddling both the flow of river to sea and the contrary movement of tide from sea to river. Not that this seemingly auspicious state of affairs was without problems: optimism would be tempered with anxiety as wear and tear was caused on the supports of each bridge by the altered flow of the river.

1. R. Kingzett, 'A Catalogue of the Works of Samuel Scott', *Walpole Society*, vol. XLVIII (1980–82), pp. 43f.
2. They were welcomed in the *Critical Review*, vol. V (March 1758), pp. 265–6.
3. Cf. R.J.B. Walker, *Old Westminster Bridge: The Bridge of Fools* (Newton Abbot: David and Charles, 1979), p. 31.

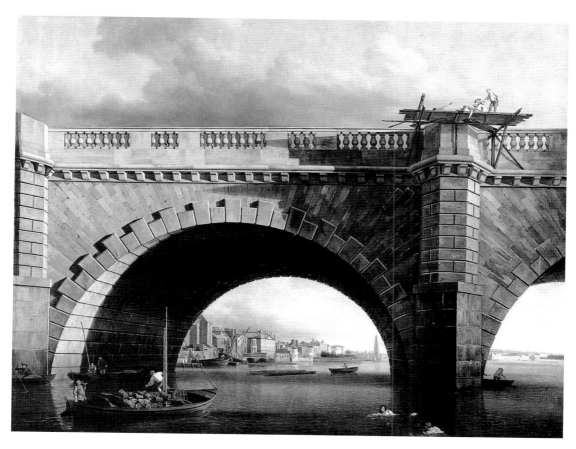

24

24 and Plate II Samuel SCOTT (*c.* 1702–72)
An Arch of Westminster Bridge
Oil, 135.5 × 164 cm (53 ¹/₄ × 64 ¹/₂ in.), *c.* 1751

Besides Scott's pictures of the building of Westminster Bridge, and the paintings and line engraving showing the bridge apparently complete, five views depict a section of it in close-up. Among these the present version of *An Arch of Westminster Bridge* is in a class by itself.[1]

This beautifully judged work shows the second and part of the third arches on the Westminster side of the river, with an extensive view (without the Banqueting House, which is out of sight to the left) along the river frontage towards the City, as far as St Clement Dane's church on the right. The symbol of the modern bridge at Westminster thus allows us to reflect on the old mercantile world. Boatmen ply their craft and carry their goods; swimmers range freely near the almost protective-looking bridge; most tellingly the bridge is shown as still incomplete (without its parapet domes or lamp-holders), and a workman who is about to carry out the completing work on the right-hand pier pauses on his scaffolding to receive a flagon of beer from a workmate. The date of the painting is put by Kingzett as the early 1750s, although it shows the bridge a short while before its opening in November, 1750. The possibility that Scott was responding to Canaletto's painting of an arch of the bridge of 1746–7 (Fig. 18a) must be a strong one: but it is also most suggestive that Piranesi's etching of a 'Monumental Bridge' (Fig. 18) came out in the *Opere Varie* in 1750. The soft light on the river-front buildings is Scott at his best, but the strong shadow extending midway across the main arch and the sharp accentuations of shadow (the rustication in Scott, the sculptural enrichments in Piranesi) may reflect an encounter with this (or another Piranesi) print. In the end, however, we come back to Scott's light and the delicately observed painting of the two materials, stone from Portland and (in the radiating ashlar blocks of the spandrels) Purbeck.

1. The other versions are in the National Gallery of Ireland, Dublin; the Lewis Walpole Library, Farmington, Connecticut; the Yale Center for British Art, New Haven, Connecticut; and the Tate Gallery, London. For evidence allowing approximate dating see R. Kingzett, 'A Catalogue of the Works of Samuel Scott', *Walpole Society*, vol. XLVIII (1980–82), pp. 62–3.

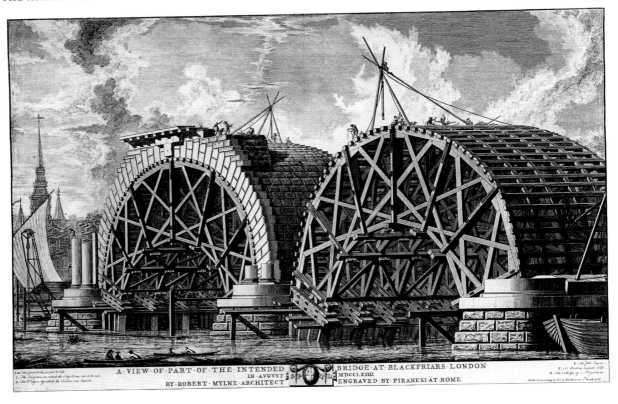

A · VIEW · OF · PART · OF · THE · INTENDED BRIDGE · AT · BLACKFRIARS · LONDON
IN · AVGVST MDCCLXIIII
BY · ROBERT · MYLNE · ARCHITECT ENGRAVED · BY · PIRANESI · AT · ROME

25

25 Giovanni Battista PIRANESI (1720–78)
Blackfriars Bridge under Construction
Etching, 38 × 60 cm (15 × 23 ¹/₂ in.), 1764, published
1766

Against the spacious and luminous effects of Westminster
achieved by Canaletto and Scott, the congested proximity
of Blackfriars Bridge under construction, as imagined by
Piranesi, looks aggressive. The etching shows two of the
immense arches of Robert Mylne's new bridge, which
was built between 1760 and 1769, after a competition in
which established architectural and experimental
engineering interests contended (see pp. 59, 64).

The family of Robert Mylne (1733–1806) had been
bridge-builders in Scotland since the Middle Ages: he
distinguished himself as a student of architecture at St
Luke's Academy in Rome (1755–8) and on his return won
the competition for Blackfriars from sixty-eight rivals. In
Rome he had become friendly with Piranesi, who may
have helped Mylne in his archaeological investigations
into the ancient Roman water system. Not surprisingly
Mylne sent Piranesi a description of his Blackfriars
design. The bridge was to span the river in nine arches
(against Westminster's fifteen); these were to have a near-
elliptical rather than a semicircular profile. The piers
were also to be built on caissons, but coupled Ionic
columns would give them a decided architectural

refinement. The bridge as a whole would present a subtler overall curve than Westminster.

The project was greeted by Piranesi as a work of 'grandeur' – a notion which would redound in the thinking of many neoclassical architects for the rest of the century – and as 'one of the most glorious works of English magnificence'. He requested a drawing and Mylne seems to have sent one: Piranesi's engraving was presumably a development of this.[1] Piranesi's use of the word 'magnificence', a concept which he connected with Roman building, was in no way idle. Beneath the engraving he gives a Romanized version of the City of London arms with the letters SPQL, a variant of the Roman SPQR (the Senate and the People of Rome). Warner plausibly suggests that Piranesi was comparing here the magnificence, declining but still discernible, of the ruins of Rome with that manifesting itself freshly in the new bridge in London.[2] At all events the view of London as a new Rome is unequivocally expressed in the letters beneath the picture, and the implication that the bridge-building activity in the capital is part of the life-flow of the contemporary Enlightenment seems irresistible.

But Piranesi's image of the bridge itself, with its radiating centres, enables the print to create and sustain its own life-flow, without any borrowed energy. The effect seems to forecast the spirit of a phrase to be written under an engraving of one of Goethe's drawings showing the development of plants: 'Evolution rayonnante et centrifuge'. While the context of Piranesi's print remains, of course, one of construction rather than of organic growth, the expansiveness of his thought cannot be missed: Mylne caused his timber centres to spring diagonally from the pier foundations, and Piranesi makes his tiny workmen continue their spoke-like lines on the skyline. He darkens some of the spokes by emphasizing the copper-covered wedges that were also devised by Mylne.[3] Like the ladies and gentlemen in the rowing boats below, the workmen on top have complete freedom of action: the poles and pulleys around them hold no terrors, as in the *Carceri*. By depicting two stages of a major constructional form, one a centring which has not yet received its arch and one on which the cap of masonry lies complete, Piranesi implies the whole gestation of the bridge. Moreover, in adding the incomplete shafts of the decorative columns, he raises in us an irrational portent of its eventual demolition: its end is in its beginning.[4] And so this print conveys in full measure two quite distinct ideas. The first is the enlarged civic vision of what a bridge might be, which so sharply distinguishes late eighteenth-century interest in bridge-building (e.g. Fig. 29). The second is an adumbration of it as a vehicle of

human life, a theme which will work its effect on the Romantics and their successors (e.g. Fig. 62). The result amounts to a tour de force, all the more remarkable for having been executed a thousand miles from the structure it celebrates.

1. See C. Gotch, 'The Missing Years of Robert Mylne', *Architectural Review*, vol. CX (1951), pp. 179–82; R.J. Woodley, 'Robert Mylne: The Bridge between Architecture and Engineering', Ph.D. thesis (1999), University of London, ch. iii.
2. M. Warner, 'The City of the Present', in M. Warner, ed., *The Image of London, Views by Travellers and Emigrés 1550–1920*, exh. cat. (London: Trefoil and Barbican Art Gallery, 1987), pp. 42–3 (cat. 69–70).
3. Gotch, 'Missing Years', p. 182.
4. Mylne's Blackfriars was replaced by Joseph Cubitt's metal bridge in 1869.

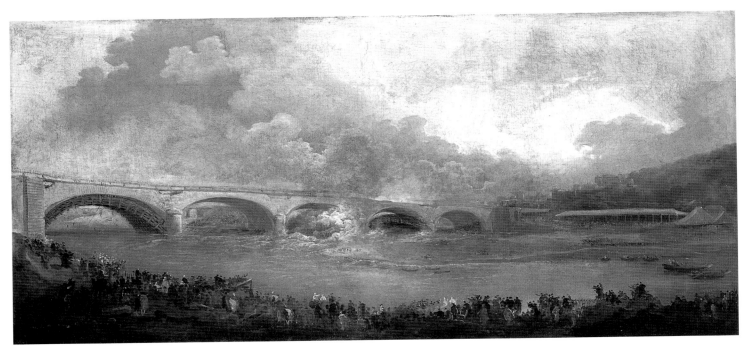

26

26 Hubert ROBERT (1733–1808) Sketch for *The Opening of the Bridge at Neuilly*
Oil, 71 × 144 cm (28 × 56 3/4 in.), 1772

If Piranesi had seen drawings of the Pont de Neuilly as he had of Blackfriars, would he have made a print? One would like to think he would. But Neuilly, for him, would probably have lacked the true reverberations of Rome that – like the wrestler Antaeus, who grew stronger when he touched the earth – he drew strength from and that Mylne's bridge, he must have felt, also embodied. Neuilly was a work of technical innovation by the engineer Perronet that moved far from Roman practice. It is fortunate, nonetheless, that a picture of its opening in 1772 survives from the hand of Robert, who had been close to Piranesi in Rome and who developed affinities with his style. Fifteen years after the Pont de Neuilly opened, Benjamin Franklin was recommending to Tom Paine, then designing a bridge of his own, that he study it and visit the Repository of the Ecole des Ponts et Chaussées, which Perronet headed and which contained a model of his masterpiece.[1] Two years after this Thomas Jefferson, out riding in the Bois de Boulogne, drew the attention of his companion, Gouverneur Morris, to the Pont de Neuilly that 'he says is the handsomest in the World'. Arthur Young also hailed it.[2]

The level roadway and equal arches of Neuilly distinguished it from the tradition of bridge-building in

stone and from Westminster and Blackfriars.[3] The nature of its construction, with wide arches and slim piers, demanded that all the centres remained in situ until all the arches were built. The opening, attended by Louis XV and a large crowd on 22 September 1772, was therefore a matter of some spectacle, as the centres were all released into the river. This was the subject of Robert's picture, commissioned by Trudaine, Intendant Général des Ponts et Chaussées. The structure's horizontality (the Pont de Neuilly was 230 metres – 750 feet – long) is reflected in the very shape of the canvas. The bridge clears the river like a racehorse, the river water flies upwards as the centrings enter it, the line of the foreground crowd makes a fitful and restless foil to both. The final painting, shown at the Salon of 1775, measured 270 cm (106 in.) across. It has been lost, but it seems appropriate that the sketch, looking forward to the accelerated painting techniques of the next century, should have survived.[4]

1. Letter of Benjamin Franklin to Thomas Jefferson, 19 April 1787, in *The Papers of Thomas Jefferson*, ed. J. Boyd (Princeton, NJ: Princeton University Press, 19 vols, 1950–74), vol. II, 1950, pp. 301–2. H.C. Rice Jr, *Thomas Jefferson's Paris* (Princeton, NJ: Princeton University Press, 1976), p. 138, points out that the model of the Pont de Neuilly could be seen at the Ecole des Ponts et Chaussées, then located in Perronet's house, the Hôtel Bruant, Rue de la Perle, in the Marais.

2. Morris, *Diary*, vol. I, p. 83, entry for 19 May 1789. Arthur Young praises the bridge as 'by far the most beautiful I have anywhere seen' and as 'incomparably more elegant and striking than our system of different sized arches', *Travels in France during the Years 1787, 1788 and 1789*, ed. Constantia Maxwell (Cambridge: Cambridge University Press, 1950 [1929]), pp. 187–8. Thomas Blaikie had recorded in 1777 'the new and fine bridge at Neuilly which is supposed one of the finest existing', *Diary of a Scotch Gardener at the French Court at the End of the Eighteenth Century*, ed. F. Birrell (London: Routledge, 1931), p. 130.

3. Many traditional stone bridges incorporated unequal, relatively narrow arches, often with the widest and highest arch in the middle or over the deepest water. The roadway had therefore been humped over the centre and the flow of water beneath varied by the wide piers needed to sustain the weight from above. Even where an overall symmetry could be maintained, the bridge curved: Westminster Bridge curved, as Canaletto shows (Fig. 20). Perronet's Neuilly, however, was near horizontal: see ills. in his *Description des Projets et de la Construction des Ponts de Neuilly, de Mantes, d'Orléans et autres* (Paris: Imprimerie Royale, 2 vols and supplement, 1782–9). The arches at Neuilly were interdependent: their near-elliptical form enabled thrusts to be taken along their line to abutments at the ends of the bridge. Piers took vertical loads only, and could therefore be much slimmer. They were 4 metres (13 feet) thick, with a 37-metre (120-foot) span for each arch, thus giving a ratio of

1 to 9, compared with 1 to 3.5 or 5 recommended by Palladio, using semicircular arches. All these features made for a new dynamism, which commended itself to artists.

4. Other sketches exist or have existed. A sketch of an arch in close-up with the centring falling into the river (Galerie Cailleux, Paris), may have remained with Robert, and be the one that is recorded in his sale. I am grateful to M. J.-M. Bruson of the Musée Carnavalet for help.

27 and Plate III Hubert ROBERT (1733–1808)
The Fire at Rome
Oil, 77 × 95 cm (30 1/4 × 37 1/2 in.), *c.* 1780

Robert had developed his feeling for bridges in Italy: an absorbing, undated picture *Bridge in the Campagna* is in the Musée des Beaux Arts, Strasbourg.[1] Typically, he makes this bridge crowd upwards, as Piranesi had done and, as the centre of the arch is filled with wooden poles that replace the original stone, the effect here strongly recalls the older artist. Robert has taken to heart the Piranesian message which values Roman architecture both for its pragmatically conceived strength and for its contest with time. He paints, however, not only ruins resistant to time but the swifter drama of flames attacking them: in this *capriccio*-like picture a great single-arched bridge is silhouetted. It supports a statue which raises its arm as if presiding over a Last Judgement. People scatter in all directions. Through the arch flames flutter and a Colosseum-like building can be glimpsed.

Robert had in fact stayed long in Italy, from 1754 to 1765, when he returned to Paris. The Roman bridge was an indelible influence on him. Beside the fantasy views of single or multiple bridges (often two or three seen one behind the other), which stem from the *capriccio* tradition and often owe more than a little to Piranesi's 'Monumental Bridge' (Fig. 18)[2] or the *Carceri*, there were his pictures of Roman monuments in France, in particular in and around Nîmes, including the Pont du Gard (see Fig. 35 and Plate IV).

1. Ill. in J. Thuillier and A. Châtelet, *French Painting from Le Nain to Fragonard* (Geneva: Editions d'Art Albert Skira, 1964), p. 237.
2. E.g. *Le Pont* (oil, Yale University Art Gallery), reprod. *Apollo*, vol. 99 (1974), p. 405. This is a particularly Piranesian composition, with several bridges at right angles and a long, broad flight of steps.

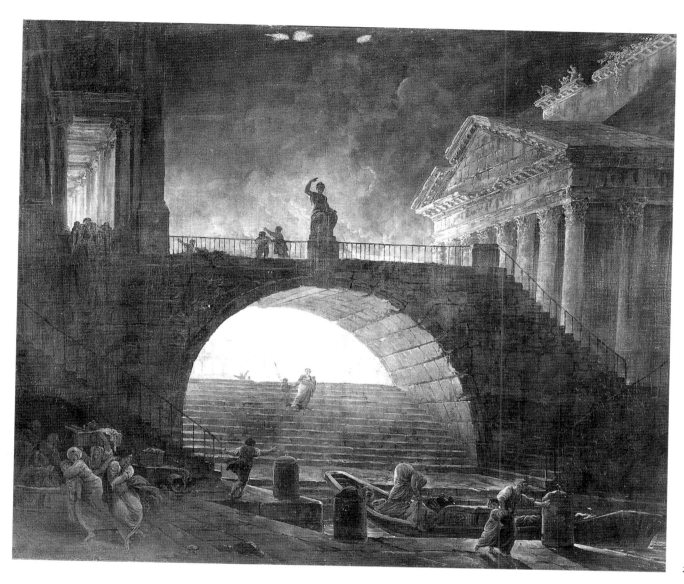

27

28

28 Hubert ROBERT (1733–1808) *Draughtsman Drawing the Wooden Bridge in the Park of Méréville* Oil, 65 × 81 cm (25 1/2 × 32 in.), *c.* 1786–91

The inventiveness which marks Robert's bridge pictures in the form of *capricci* was also channelled into real-life landscape garden designs.[1] Robert was made landscape designer to Louis XVI in 1778, an apt choice in an age when the link between pictorial composition and landscape design was a close one. English garden layouts, in which the paintings of Claude were used as models to create 'pictures' in landscape, had followed these models in introducing the bridge-form over water as a focal feature (see Fig. 31). A young artist in the left of the present picture is studying the effect of a 'Chinese' bridge built on poles. By the 1770s, in part as a response to the nature philosophy of Rousseau, a gardening fever had developed in France which involved English, Chinese, and native French ideas in gardens close to the cultural hub of Paris or even within the city.[2] The aim of escape into nature, combined with the

means of easy return to civilization, could hardly overlook the usefulness of the bridge, of natural rock or wood, rustically linking islands or daringly placed high over cascades. It was perfectly realized in the 'ideal' garden farm of Claude-Henri Watelet (1718–86), which was created on an island site, the Moulin Joli in the Seine at Colombe between 1754 and 1772: here bridges linked the island retreat to the rest of the estate and the outside world.[3]

Robert was a friend of Watelet, and he and the leading landscape architect François-Joseph Belanger (1744–1818) each took part in the designing of another estate close to Paris, that of Méréville, which had been acquired by the banker Jean-Joseph de Laborde in 1784. Belanger himself is of exceptional relevance in the broader context of bridges in landscape. He had studied English gardens at source, and in one of his earlier commissions, the garden of the Château of Bagatelle in the Bois de Boulogne (for the Comte d'Artois, 1777), he had ornamented a meandering stream with a triangular Bridge of Love in brick and a large

Chinese bridge, as well as a small Chinese bridge and two rock bridges.[4] The respective contributions of Belanger and Robert to the 'picturesque' garden effects at Méréville are almost impossible to disentangle, but pictures by Robert such as the present painting possibly record ideas which were presented to Laborde before work was begun on the actual estate. A later dating in 1790–91 has also been proposed.[5] Here, at Méréville, bridges abounded. Belanger was hardly less a devotee of the form, it seems, than Robert. Stern cites a letter from Belanger to a client eulogizing the function of the bridge as an enrichment of the experience of landscape, and calling up Milton as an authority for a poetic account of a garden of Eden which includes a high bridge leading to a grove of myrtles.[6] But wooden bridges isolated against sky or water between rocks, with a hut at or near one end, occur frequently in Chinese and Japanese painting, and also in 'Master of the Rocks' landscapes painted in underglaze blue on Chinese porcelains between *c.* 1640 and 1700, and in seventeenth-century Japanese Aríta porcelains (Fig. 28a).[7] Such effects were familiar in Europe through trade imports.

1. For this aspect of Robert's work see J. de Cayeux, *Hubert Robert et les Jardins* (Paris: Herscher, 1987); and the same writer's paper, 'The Gardens of Hubert Robert', in Monique Mosser and Georges Thyssot, eds, *The History of Garden Design: The Western Tradition from the Renaissance to the Present Day* (London: Thames and Hudson, 1990), pp. 40–43 (no discussion of bridges).

2. E.g. the Paris garden of the playwright Beaumarchais (1788) near the Porte Saint-Antoine and the Bastille: here the architect Belanger made a central feature of a Chinese bridge. See W.H. Adams, *The French Garden 1500–1800* (London: Scolar Press, 1979), p. 135.

3. Ibid., p. 116.

4. The plan of Bagatelle, engraved by Boullay after J.C. Krafft (1812), is reprod. in A. Braham, *The Architecture of the French Enlightenment* (London: Thames and Hudson, 1980), p. 224.

5. Pontus Grate, *French Paintings II, Eighteenth Century* (Stockholm: Swedish National Art Museums, 1994), p. 309.

6. Jean Stern, *A l'Ombre de Sophie Arnould. François-Joseph Belanger, architecte des Menus Plaisirs, Premier Architecte du Comte d'Artois*, 2 vols (Paris: Plon, 1930), pp. 29–30.

7. For a Chinese example in 'Master of the Rocks' style, see the cylindrical brush-pot in Sir Michael Butler, Margaret Medley and Stephen Little, *Seventeenth-Century Chinese Porcelain from the Butler Family Collection*, exh. cat. (Alexandria, VA: Art Services International, 1990), no. 89.

28a

28a Flat-rimmed porcelain dish, underglaze blue decoration. Japanese, Arita ware, ht 2.6 cm (1 in.), diam. 15.2 cm (6 in.), late seventeenth to early eighteenth century

29

29 Claude-Nicolas LEDOUX (1736–1806)
Pont de la Loüe
Engraving by Edmé Bovinet, illustrated (pl. 4) in
Ledoux's *L'Architecture considérée sous le rapport de
l'art, des moeurs et de la législation*, vol. I, 1804, 17.2 ×
30.8 cm (6 ¾ × 12 ⅛ in.)

Méréville (Fig. 28), close to Paris, recalls the search for an
earthly paradise that was to be one of the recurrent
themes of the nineteenth-century Romantic Movement.
But the ideas of the City, Nature and the Bridge were to be
linked by Ledoux, another searcher for an earthly
paradise, and an almost exact contemporary of Robert, in
a location nearly 320 km (200 miles) to the south-east of
Paris, near the forest of Chaux. Here he planned an 'ideal'
town to be served by the bridge he designed to span the
neighbouring river Loüe.

Ledoux was an active bridge-designer in Burgundy in
his early years.[1] In the 1780s he drew up the new wall
round Paris that was intended to check customs
infringements, and he had also designed the perimeter
toll-houses that went with this objective. But he
nourished ideas of a social utopia that would dispense
with surrounding walls. A new Eden demanded
unspoiled or virgin land that was nevertheless accessible
to people (the two villages of Arc and Senans lay to the
south-west and north-east of the proposed site). The
resulting scheme (published in 1804) has all the solemnity

of an initiation rite, and it is no surprise to discover that Ledoux was a Freemason. A building for the peaceful settling of all quarrels and a temple for sex-instruction were to be key ingredients of this new world order.[2] To the south-east of the town, with its centralized plan, a straight road connected with the massive bridge. All remained visionary and unrealized.

Comparison between this and the lightweight rusticity of the bridges of Méréville needs no underlining. Rococo and idealist seriousness could have no better contrast. Beyond the bridge, in the architect's perspective view, stretches the Eden-like river and townscape. The men on the raft beneath the bridge pole (a little uncertainly) into it, past the carved prows of the boats which make up the piers – an oblique reminiscence of the old idea of the bridge of boats. Yet if we sense a fairly opaque future for a community living in this preternaturally combed and tidied landscape, we also hear Piranesian rumbles from the Rome that Ledoux never saw. The difference is that Ledoux seems to have gone beyond Piranesi's love of foundations and buildings worn down to them by time, to suggest a structure that appears impervious to time's actions. It seems to have reverted to an age so buried in myth as even to pre-date the round arch.

1. A.Vidler, *Claude-Nicolas Ledoux: Architecture and Social Reform at the end of the Ancien Régime* (London and Cambridge, MA: MIT Press, 1990), p. 16.
2. For Chaux see A. Braham, *The Architecture of the French Enlightenment* (London: Thames and Hudson, 1980), pp. 204f. Ledoux designed a saltworks and associated buildings between Arc and Senans in 1773; building was in progress in 1775–9. The ideal plan of Chaux appears to be a development for this, dating largely from the time of Ledoux's imprisonment under the Revolution in 1793. One of the most remarkable buildings, the 'House of the Inspectors of the River Loüe', was planned as a kind of bridge over the river, which is shown in the engraving in *L'Architecture* (pl. 6) issuing in spate from below it (ill. Braham op. cit., p. 206: also in John Sweetman, *The Enlightenment and the Age of Revolution 1700–1850* (Harlow: Longman, 1998), fig. 33).

30 William DANIELL (1769–1837)
Proposed Double London Bridge
Oil, 92.3 × 181.6 cm (36 1/4 × 71 1/2 in.), 1800

After the building of Westminster and Blackfriars Bridges, London would have to wait till the decade 1810–20 for further bridges across the Thames: the metal Vauxhall, the metal Southwark and the stone Waterloo, all originated by John Rennie.[1] But before this, around 1800, there was a remarkable outburst of designing in both materials for a successor to London Bridge: designs not fulfilled, but leading to highly successful and popular images by artists. Telford's proposal for an all-metal 185-metre (600-foot) arch (Fig. 45) looks forward to the engineer's initiatives, which are discussed in Chapter 2. But the architect George Dance's magisterial design for a double London Bridge looks back as well as forward, and, in the painting by William Daniell, strongly suggests that Piranesi's optimism about the advent of London as another Rome was still alive as the eighteenth century closed.

The issue of London Bridge remained a sensitive one in the 1790s. The old medieval structure, much modified since 1209 – most recently in 1757 when its houses were removed – was to survive another thirty years. But despite the nostalgia it aroused, schemes for its replacement were being actively discussed. At first, in 1796, Dance proposed to strengthen the great central arch with nine baulks of timber beneath the waterline. The move was made following the discovery that the piers of the old bridge were being damaged by worsening scour: this in turn was the result of pressure of water that had increased since the building of Mylne's Blackfriars Bridge. By 1800 the issue had moved on, and Dance was to put forward his scheme to replace the old bridge with not one but two structures, each of six equal arches, sited further to the east. These were to have central drawbridges, the theory being that while one was raised to admit shipping the other could still ensure the continuity of road traffic. The scheme excited great interest in high places.[2] And so Dance's friend William Daniell not only devoted a large canvas to it but published two aquatints.[3] If Dance's scheme was over-elaborate in its bridging arrangements, the painting does lucid justice to his planning, with its cross-wise

perspectives and a distant canalized vista contrasting with the vast hemi-cycles of his housing, one half-circus sprouting a column (Wren's Monument in the City) and the other an obelisk.

But not the least important point about this picture – one that qualifies it for a chapter on views and sightlines – is that it makes a true *veduta* or view, in the eighteenth-century sense, calculated and compounded out of factual observation of light over buildings and a sense of the coup de théâtre that are observed in both Canaletto and Piranesi.[4] Its panoramic and dramatic qualities were recognized in its day when, within a year, a simulation of Daniell's image formed a backcloth for a pantomime at Sadler's Wells theatre.[5] To these qualities Dance's double bridge itself contributes much: the driving horizontals are à la Perronet and more than a tinge of the prodigal lingers on from Piranesi's 'Monumental Bridge'. Neither of these factors would be lost on the bridge-artists of the ensuing few years, as Rennie's three new bridges were added to the Thames.

1. All these were built by companies operating under private Acts of Parliament. Rennie's plan for Vauxhall (Regent's Bridge 1811–16) was to use blue Dundee limestone: in the end James Walker built nine iron arches. For Waterloo (1813–17) see Fig. 66. Southwark (1814–19) was revolutionary in crossing the river in three spans of iron; see Fig. 88, n. 2. All these bridges were supported by tolls, although access to Westminster and Blackfriars was now free.

2. Joseph Farington saw the 'double bridge' drawings at Dance's house on 1 June 1800, when he understood that the cost would be about a million pounds. On 28 June he recorded that 'His [Dance's] design for a Bridge in the place of London Bridge has been most favorably recd. by a Committee of the House of Commons – Lord Liverpool & Lord Hawkesbury are warm for it.' Cost, however, proved too great an obstacle. See Dorothy Stroud, *George Dance Architect 1741–1825* (London: Faber and Faber, 1971), p. 154.

3. William Daniell had travelled in India for seven years with his uncle, the painter Thomas Daniell, and between 1795 and 1808 the two were publishing *Oriental Scenery*, consisting of 144 aquatint views. William also built up a considerable reputation for views in Britain, producing *Views of London*, six large coloured aquatints, which included the subjects of London and Westminster Bridges, 1804–5, based on his own watercolours (see L. Hawes, *Presences of Nature, British Landscapes 1780–1830*, New Haven, CN: Yale University Press, 1982, pp. 98, 191). Between 1814 and 1825 he planned *A Voyage round Great Britain*, in eight folio volumes, containing 308 coloured aquatints.

4. The wide water-filled vista in the middle of Daniell's picture recalls Canaletto's etching of Mestre from his set of thirty-one etchings: there are even flights of steps on each side, where Dance's steps also appear.

5. In 1801 R.C. Andrews mounted a theatre panorama of George Dance's double bridge proposal and used Daniell's painting as source: see R. Hyde, *Panoramania! The Art and Entertainment of the 'All-embracing' View*, exh. cat. (London: Barbican Art Gallery, 1988), no. 36.

30

'Thus in the beginning all the world was America', wrote the English philosopher John Locke.[1] Europe's sense of a New World of vast scale and interest across the Atlantic was all the greater for conceiving of that world as in a state of uncorrupted nature, an Eden still alive with God's handiwork. European Enlightenment figures, such as the famous French naturalist Georges Buffon, might be quick to assert that the heat and humidity of the climate, and the very rawness of that state of nature, had kept the wild life of the New World in a state of inferiority from which that of the Old had long emerged. Some Europeans might represent the figure of America allegorically in art accompanied by the primitive alligator, beside the brighter image of Europe with her bull. But the immense influence of Jean-Jacques Rousseau (1713–78), and the gospel of unspoiled Alpine nature proclaimed in his bestselling novel *La Nouvelle Héloïse* (1761) – possibly the most popular book of its day – consecrated the Eden image, along with that of liberty. On both counts North America seemed full of possibility. American landscape appeared to be limitless as the immigrant settlers pushed westwards. From distant Europe, moreover, the native Indians could be hailed as living representatives of the 'noble savage'. And the most influential American scientific observer of the period, Thomas Jefferson (1743–1826) – soon to be third president of the independent United States – would write a spirited vindication of American flora and fauna, studied at first hand, in his *Notes on the State of Virginia* (1785).

Among Jefferson's descriptions in this work was an account of the 'Natural Bridge', a huge arch across a chasm in his estate at Rockmount (see p. 103). Such features were to become a source of excitement to American painters as they began to explore their own landscape. The English-born landscape painter Thomas Cole was working in America after 1820, and we shall return to a natural bridge by him in Chapter 3. Though a natural bridge in Europe makes an appearance in the present chapter, we shall mainly be concerned here with European man-made structures and their message to artists and other observers, sometimes in wild rural locations, sometimes close to the sources of iron and coal which through industry would transform landscape, notably in Britain. The appearance of the modern engineer's bridge, beside the authoritative Roman heritage of bridges in Europe, provides the underlying theme of the chapter.

34

Late eighteenth-century America, nonetheless, affords a highly significant episode with which to begin. In 1789, the English-born Thomas Paine (1737–1809), soon to be author of the *Rights of Man*, wrote important letters to Sir Joseph Banks, botanist and president of the Royal Society in London, and to Sir George Staunton of the Society of Arts. Paine's subject was his own design for a 120-metre (400-foot) single-arch iron bridge which he intended to cross the wide, fast flowing Schuylkill River at Philadelphia. Its thirteen ribs were to commemorate the thirteen states which had recently united after the American Revolution. 'Great scenes inspire great ideas,' Paine wrote, '. . . as one among thousands who had borne a share in that memorable Revolution I returned with them to the re-enjoyment of quiet life, and that I might not be idle, undertook to construct a bridge of a single arch for this river.'[2] A model had been shown at the Academy of Sciences, Paris, in 1787 and later in London. However, his American financial

backer failed, the French Revolution broke out, and he never built his great arch in Pennsylvania. The firm of Walkers in Rotherham made a trial 28-metre (90-foot) rib and a model was shown on a bowling green at Paddington, London, from August 1790 to October 1791. By then politics increasingly beckoned: the need to rebut Edmund Burke's attack in 1790 on the French Revolution absorbed him, and the first part of his *Rights of Man* had appeared in 1791. Though he had projected bridges for the Thames, the Seine and the Liffey (in Dublin), these too were not realized. Nevertheless if Paine's enthusiasms were translated into politics, it is noticeable that he referred to his *Rights of Man* as his 'political bridge'. And the political idealism of his plan for an iron arch to span the floating ice-floes, at a place as laden with associations as Philadelphia, 'city of brotherly love', cannot be missed. The bridges of Europe commemorating the divine right of king and emperor were about to be succeeded by those celebrating the immortality of democratic man. The three-dimensional classical forms of the past were gradually – and not without a long period of visual adjustment – to give way to the tensely linear engineering vision of the future. Philadelphia was to contribute much to the development of the American bridge.[3] American artists, still regarded by their fellows in 1800 as little more than tradesmen, were not to interpret the early stages of this in any spirit of invention, but the engineer Roebling's great Brooklyn Bridge (1883) was to draw forth a remarkable response, as we shall see in Chapter 4.

In Britain, meanwhile, the innovating and subsequently widely acclaimed architect John Soane (1753–1837) was to register the backward pull of antiquity and the forward tug of modernity in a variety of ways. One of the most original architects of his time, he inherited Robert Adam's intention to use classical forms with 'novelty and variety', but simplified those forms to the point of diagrammatic austerity. It must certainly have been the same preference which led him to take an interest in Paine's work on metal bridges. The Soane Museum, London, possesses a drawing of 1791 by him, inscribed 'A slight sketch of Thos. Paine's patent cast iron Bridge proposed to be erected over the River Wear near Sunderland'. He is also known to have proffered advice on this to its designer, Rowland Burdon, a former pupil.[4] For Paine's Arch was not entirely lost to view: using a different constructional principle, Burdon was to erect a version of it in this, the second iron bridge to be erected in the world (after the Iron Bridge, Coalbrookdale, Shropshire, completed in 1779, and ahead of Telford's Buildwas Bridge of 1796). Sunderland Bridge, shown under construction by Robert Clarke, was completed in 1796.

Just before the Shropshire ironmasters planned the Iron Bridge, Soane, as a student at the Royal Academy Schools, had designed his great Triumphal Bridge. Here indeed is architecture going to school: the design won him the Academy's Gold Medal. The influence of Palladio is obvious, and indeed eighteenth-century Europe as a whole was to acknowledge this, albeit in two different ways. English Palladianism had produced the colonnaded 'Palladian' bridge as an adornment to landscape parks: the Wilton example of 1737, painted in its landscape by Richard Wilson twenty years later, was followed by other versions, including one built for Catherine the Great near St Petersburg. Robert Adam built his Pulteney Bridge – another clearly inspired by Palladio – with shops, at Bath in 1769–73.[5] But on the Continent the authority of the classical bridge had passed, in the age of royal absolutisms, through the writings of the architect Fischer von Erlach (1721) to the French Academy in Rome in the 1740s, and attained an aggrandized, monumental character which bore the stamp of Piranesi and became a staple of the French Grand Prix tradition.[6] Soane's Triumphal Bridge is the product of both

streams, especially the second. He always had an affection for it. But it was unrealized, though he went on to build other, smaller bridges.[7]

Two years after winning his medal Soane was on his way to Italy, stopping on the way out in Paris, however, to meet the engineer Perronet, and on the way back in 1780 to study in detail the 'hanging' wooden bridges built in one span, or at most two, over Alpine rivers by the Swiss brothers Hans Ulrich and Johann Grubenmann in the 1750s and 60s. The functional efficiency of these structures, conceived in an organic material, wood (sanctioned by Palladio and the English Palladians), and improved by a modern engineer's material, metal, was manifest to Soane: 'Very well put together & no want of iron,' he writes. It was a time for reflection: while neoclassical theory was advocating an architecture of functionally essential parts (the supporting classical column, strongly emphasized in the designs of the French at Rome, fitted admirably with this demand), the problem-solving activities of Alpine designers building over fast-flowing rivers in wood, with a single span, were conveying a vivid practical expression of efficiency in action.[8] While there was an uneasy rivalry between architects and engineers (as the Westminster Bridge schemes amply showed) it was through bridge design that engineers would, in the main, demonstrate their capabilities. Soane is alive to all he has inherited or observed: on the one hand the grandiose, multi-arching monumentality of the traditional triumphal bridge, and on the other the reductive simplicity of silhouette which neoclassical architects such as John Carr in his bridge at Rokeby and students of engineering like Tom Paine and Burdon were alike aiming for.

68
38

Support for the simple uncluttered span was also to come from a very different quarter. In 1798 the popular writer Uvedale Price somewhat solemnly hailed the stone bridge (as Adele Holcomb noted in an important article) as 'of all buildings . . . that which will bear the greatest degree of plainness and simplicity, without the danger of baldness'.[9] Such a remark comes unexpectedly from an advocate of the textural intricacies and irregularities in building that made Price so powerful an influence on the tourist of the picturesque. Price went on to rate the arched bridge over water as 'among the noblest efforts of architecture', and described the way it appears 'to pass from one side of a river to another' as 'something analogous to motion'. The stone bridge was in his mind: though it is interesting to note that he had visited the Iron Bridge, not far from his Herefordshire estate, in 1797.[10]

Price's comments confirm for us that in the second half of the century the popularity of travel and a deepening regard for wild landscape sharpened a sense of the variety of rural bridges – man-made, half man-made/half natural or wholly natural. At the same time the need for better communications, to help industry carry goods over difficult terrain, produces celebrated single-arch bridges such as William Edwards's exceptionally long stone arch over the unruly river Taaffe at Pontypridd (New Bridge), Wales (1756), as well as the first iron bridge in the world, over the Severn gorge at Coalbrookdale. In turn the visual relationships of such structures to their landscapes stimulate the artists who depict them, as the very different versions of the Iron Bridge in its gorge that are reproduced here suggest. And such relationships reinforce the already quickening regard for older, man-made bridges in remote places such as the Alps, the coast near Sorrento, or the Lake District of Britain. Perilous bridges ascribed to the agency of the Devil or associated with heroic exploits in difficult natural settings find their mythic reputations enlarged. The Devil's Bridge on the St Gothard pass enjoys, from Scheuchzer to Turner and beyond, a long climax of attention enhanced by the descriptions of the bridges in Dante's *Inferno*, much read from the 1770s.[11] Alongside all this, entirely natural rock- and ice-bridges

39

36, 37
33
40, 42
43, 33
58a, 58

34 were seen to link the spectator to remote geological time-periods before man's appearance, when nature alone was 'artist'.[12]

As observers, however, savoured the ways in which the architecture of the ancients had given a lead once man arrived on the scene, Roman bridges still claimed their due. From the miraculously intact Pont du Gard near Nîmes to the broken bridge of Augustus at Narni north of Rome, the scale of man's bridge-building achievement threw into relief, in the age of Gibbon and beyond, a full realization of departed Roman glory. Rousseau, at the Pont du Gard about 1738, longed for the primitive strength of mind which had built it.[13] Smollett in 1763 was moved to glowing point, and amazed at its state of preservation, though he promptly compared it with Westminster Bridge.[14] Edward Rigby in 1789, on a different tack, pointed to a kind of collusion between nature and man, noting how the surroundings of rocks piled up by nature

35, IV complemented the arches piled up 'by the skill of the Romans'.[15] By then Hubert Robert and William Marlow (Graves Art Gallery, Sheffield) had painted it memorably. And in Italy the Narni bridge, with its single standing arch, was attracting repeated eulogies in the guide books.

71 This structure stimulated artists from Richard Wilson to Corot as compulsively as any headless classical torso.

Had these Roman skills anything new to say in the age of the modern engineer? From the 1760s Britain's Canal Age, besides revolutionizing transport, was drawing fresh attention to the relationship of art and nature. The (aptly named) Duke of Bridgewater (1736–1803) was to be a prominent canal builder: 'Bridgewater triumphs – art has conquered nature', wrote James Ogden in his *Description of Manchester* (1783). At the end of the century the major aqueducts of Thomas Telford (1757–1834) – metal decks on masonry supports – make their appearance. While tourists seeking the picturesque could enjoy the effects of sun and shadow on the aque-

44, 44a duct of Pontcysyllte or even square up to the round-arched severity of Chirk, no major artist, apart from Cotman, appears immediately to have taken up the visual challenge of these gleaming intrusions into the Dee and Ceiriog valleys of north Wales. Presumably Telford's massive contributions to the scenery introduced too clear a note of contest. These sharp-edged, monumental products of the industrial age made no concessions to tastes for dilapidation and intricacy. Indeed a visual challenge was raised, which would find its interpreter only with

69, 69a Cotman.

Nonetheless, there is evidence of attempts to come to terms. The writer John Stoddart, in front of the largest aqueduct in Britain before Telford's, the 140-metre-long (445 feet) Kelvin aqueduct (1787),[16] comments that 'where objects of art enter into a direct rivalship, as it were, with the objects of Nature, and are of sufficient magnitude and importance, to maintain the competition, the suspense, in which the mind is held, is of the most pleasing kind'.[17] Cotman would have recognized the force of this argument, and so would the photographers of the later

74 railway age. About 1800, however, most observers needed a new eye for the abruptnesses of the large-scale engineering. Robert Southey, a bridge aficionado, saw Sunderland Bridge as an 'arch of monstrous span'.[18] Followers of the picturesque tour of Italy were to continue to

11 demand the famous view of the Ponte Santa Trinità at Florence (pp. 12–13). Years after Tom

46, VI Paine had conjured with his great iron Arch for America, Allen Smith, an American in Europe, preferred to ruminate on the multi-arched old stone bridges of that city.

Notes

1. John Locke, *Two Treatises of Government* (1690), II, para. 49.
2. Letter to Sir George Staunton (dated 'Spring of 1789'), in P.S. Foner, ed., *Complete Writings of Thomas Paine*, 2 vols (New York: Citadel Press, 1945), vol. II, p. 1045. Paine's bridge models (all of single arch construction, suitable for rivers which carried ice-floes) are discussed in a letter by him to Benjamin Franklin of 6 June 1786: see Foner, ibid., pp. 1026–8.
3. The dynamism of the great wooden bridges of the eastern north American states took particular vitality from the need to bridge wide rivers and the numerous coastal inlets. The German-born bridge builder Lewis Wernwag (1769–1843) settled in Philadelphia from 1786 to 1813, and built the famous 'Colossus' at Fairmount (1812–13, burned 1838). This is illustrated, with discussion of these bridges, in John Sweetman, *The Enlightenment and the Age of Revolution 1700–1850* (Harlow: Longman, 1998), pp. 156ff.
4. It is now generally recognized that the Sunderland iron bridge as built differed greatly from Paine's design. See p. 73 and A.O. Aldridge, *Man of Reason, The Life of Thomas Paine* (London: Cresset Press, 1960), pp. 108–17. Soane's drawing is reprod. in T. Ruddock, *Arch Bridges and their Builders 1735–1835* (Cambridge: Cambridge University Press, 1979), fig. 134.
5. Views by Thomas Malton (cf. Fig. 45) of Pulteney Bridge appear in P. Murray and M.A. Stevens, eds, *Living Bridges* (Munich: Prestel-Verlag and Royal Academy of Arts, London, 1996), pp. 72–3.
6. See *Piranèse et les Français 1740–1790*, exh. cat. Académie de France à Rome (Rome: Edizioni dell'Elefante, 1976), nos. 78, 132 (ills); Helen Rosenau, 'The Engravings of the Grands Prix of the French Academy of Architecture', *Architectural History*, III (1960), pp. 15–180, esp. pls. 60 and 121 (bridges of Lefebure and Wagniat). See also Annie Jacques, 'Triumphal Bridges', *Rassegna* 48 (Bologna: Editrice Compositori, 1991).
7. See P. de la R. du Prey, *John Soane, The Making of an Architect* (Chicago and London: Chicago University Press, 1982), pp. 83f., 235. This illustrates Soane's Great Bridge at Tyringham (stone, single arch), 1795, and another, Blackfriars or St George's Bridge at Norwich, 1783–4: a simple arch strengthened with metal.
8. See Du Prey, *John Soane*, pp. 102–4, also the same author's article 'Eighteenth-century English Sources for a History of Swiss Wooden Bridges', *Zeitschrift für Schweizerische Archäologie und Kunstgeschichte*, vol. 36 (1979), pp. 51–63. The Grubenmanns' special joinery method of laminated wooden beams and 'hang' posts to give stability was perfected in the 1750s and 60s in designs at Reichenau, Schaffhausen and Wettingen, all destroyed *c.* 1799, during the Napoleonic invasions.
9. Uvedale Price, *An Essay on the Picturesque* (ed. 1796–8), vol. II, pp. 330–34. Adele Holcomb, 'The Bridge in the Middle Distance: Symbolic Elements in Romantic Landscape', *Art Quarterly*, vol. 37 (1974), pp. 50, 58. For Price's special treatment of bridges (included in the second edn of his vol. II, publ. 1798), see Marcia Allentuck, 'Sir Uvedale Price and the Picturesque Garden', in N. Pevsner, ed., *The Picturesque Garden and its Influence outside the British Isles* (Dumbarton Oaks, Washington, DC: Trustees for Harvard University, 1974), pp. 64–7.
10. Price reports to Sir George Beaumont about his plan to visit Coalbrookdale to see the bridge, 5 September 1797. See Allentuck, 'Sir Uvedale Price', p. 64.
11. The Devil's Bridge had tested the nerves of travellers for generations. No one, wrote Andreas Ryff in 1587, was 'man enough not to be terrified'. The Infanta Doña Isabel Clara in 1589 remarked that in spite of being little more than twenty paces across, it was 'most dangerous' to pass. J.J. Scheuchzer in 1705 prefers to note his exhilaration at the sight of it in its surroundings: fifty years before Edmund Burke's *Sublime and Beautiful* (1757) analysed the positive human response to the excitement of danger while it does not directly threaten the observer. Andreas Gualandris in 1775 finds fear mixed with pleasure: 'In a situation sufficiently horrible from the height of the mountains, the depth, narrowness and inequality of level, there is a bridge named after the Devil . . . Between all these horrors, the situation of the bridge is most pleasing' (*Lettere odeporiche*, Venice, 1780). E.S. de Beer, *Travellers in Switzerland* (Oxford: Oxford University Press, 1949) has information on those who encountered this bridge. For Scheuchzer, see Fig. 58a. R. Hentzi, *Vues remarquables des Montagnes de*

la Suisse, première partie (Berne, 1776) includes illustration by Caspar Wolf (see Fig. 34 below). The revival of interest in Dante in the 1770s almost certainly contributed to the fame of the Devil's Bridge, as Dante had indicated similar bridges in his *Inferno* (see Fig. 51 below). Malte-Brun (Malte-Conrad Bruun, 1775–1826) relates this bridge to Dante's description: see his *Travels*, ed. R.G. Thwaites (Cleveland, 1905), XVIII, p. 378.

12. On the background to this idea by which 'the natural object becomes the true work of art', see Barbara Maria Stafford, 'Toward Romantic Landscape Perception: Illustrated Travels and the Rise of 'Singularity' as an Aesthetic Category', *Art Quarterly*, New Series, vol. I (1977), pp. 89–124.

13. J.J. Rousseau, *Confessions*, Bk 6, tr. and intro. J.M. Cohen (Harmondsworth: Penguin, 1953 [1781]), p. 243.

14. Tobias Smollett, *Travels through France and Italy*, ed. F. Felsenstein (Oxford: Oxford University Press, 1979), p. 247: Letter X (written from Montpellier, 10 November 1763).

15. *Dr Rigby's Letters from France &c in 1789*, ed. Lady Eastlake (1880), p. 128.

16. This aqueduct, by Robert Whitworth, carried the Forth and Clyde canal.

17. J. Stoddart, *Remarks on Local Scenery and Manners in Scotland during the Years 1799 and 1800* (1801), vol. I, p. 199.

18. R. Southey, *Letters from England*, ed. J. Simmons (London: Cresset Press, 1951 [1807]), p. 43. Southey did, however, admire Telford's iron Craigellachie Bridge over the Spey in Scotland: '. . . something like a spider's web in the air . . . and oh, it is the finest thing that ever was made by God or man!' (quoted, and the bridge illustrated, in David J. Brown, *Bridges: Three Thousand Years of Defying Nature*, London: Mitchell Beazley, 1993, p. 49).

31

31 Richard WILSON (1713?–82)
Wilton House, looking East
Oil, 100.3 × 146 cm (39 $^1/_2$ × 57 $^1/_2$ in.), late 1750s

This is a picture which pleasantly explodes conventions. The house in elusive sunlight and the bridge in luminous shadow are compressed against the sides, each behind a tree, allowing an enormous space between them to run out to Salisbury on the skyline. Yet the buildings have a relationship reflecting Italianate architectural planning and English arm's-length inventiveness around its themes. A set of first floor, *piano nobile* windows in the tightly contained block of the house surveys the open park; a classical bridge with open colonnaded sides leads over water into wooded parts of it. The mid-seventeenth-century classical south facade of Wilton House, inspired by Inigo Jones, was the most advanced of its time in England, and seminal for the eighteenth-century Palladians. The bridge design of the 1730s, by the owner of Wilton, the ninth Earl of Pembroke, and Roger Morris, was evolved from Alberti, Palladio and a drawing for a

Rialto project by Palladio's follower Scamozzi.[1] Its prestige was borne out by the variations of it that were built at Stowe, Buckinghamshire, completed in 1739 during the period of extensive landscaping there for Lord Cobham; at Prior Park in 1756 for Ralph Allen; and at Tsarskoe Selo near St Petersburg by Vasily Neelov, finished in 1774, for Catherine the Great.[2]

Bridges were desirable elements in the eighteenth-century landscaped garden, which was in part concerned with thought-trails of focus and release: bridges performed both functions. The Wilton bridge was also a summer-house; when it was built, grand in its use of classical motifs if not physically big, and with its Mediterranean echoes that were modern as well as ancient, it must have had the freshness of an air by Handel: Italianate but acclimatized to new purposes. Placed in artfully improved but, by Versailles standards, informal surroundings, such a bridge could satisfy the desire for arcadian associations but in a novel presentation that shrugged off precedents. Wilson's picture is in the same spirit: in opening out Claude's composing principles to the point of virtual

disembowelment (compare Fig. 8) he is alive to the
reciprocal roles of house and bridge.

1. Though the term 'Palladian bridge' is by habit associated with
the designs in stone, John Harris, *Andrea Palladio 1508–1580,
The Portico and the Farmyard*, exh. cat. (London: Arts Council,
1975), p. 214, illustrates the Palladian architect Lord
Burlington's design for a 'Garden Bridge' (Chatsworth
Settlement) and notes that architects of the eighteenth century
often understood the term 'Palladian bridge' to refer to
simpler wooden types 'without', in Palladio's words, 'fixing
any posts in the water' (*Quattro Libri dell'Architettura* (1570),
vol. III, viii). Chambers's Palladian bridge at Kew *c.* 1760 was
like this. See J. Harris, *Sir William Chambers, Knight of the Polar
Star* (London: Zwemmer, 1970), p. 38.
2. Cf. C. Hussey, *English Gardens and Landscapes 1700–1750*
(1967), ch. iv, 'On Palladian Bridges', pp. 49–53. Also Tim
Mowl, *Palladian Bridges: Prior Park and the Whig Connection*
(Bath: Millstream Books, 1993), pp. 35–6. On the Russian
example see M. Craig, 'The Palace of Tsarskoe Selo', *Country
Life*, 139 (1966), pp. 108–12. Vasily Neelov, its builder, had
visited England in 1771. It is worth noting also that Henry
Hoare of Stourhead, Wilts., built a five-arch stone bridge
based on a Palladio design which had no top storey. Hoare
thought very pictorially about the view that was framed by
this bridge. He wrote: 'When you stand at the Pantheon the
Water will be seen thro the Arches & it will look as if the River
came down thro the Village & that this was the Village Bridge
for publick use; the View of the Bridge, Village & Church
altogether will be a charming Gaspd [i.e. Gaspard, a reference
to the painter Gaspard Poussin, 1615–75] picture at the end of
that Water.' Letter to Lady Bruce, 23 October 1762, quoted K.
Woodbridge, *Landscape and Antiquity, Aspects of English
Culture at Stourhead 1718 to 1838* (Oxford: Clarendon Press,
1970), p. 53.

32 Sir John SOANE (1753–1837)
Design for a Triumphal Bridge, 1776
Watercolour by J.M. Gandy, 65.3 × 98.6 cm (27 3/4 ×
38 3/4 in.), 1799

When Soane made this design, the Palladians' proposals
for Westminster Bridge (1739–50) and Blackfriars
(1760–69) had lost out to those of men who thought, in
whole or in part, as engineers. But the English 'Palladian'
bridge (Fig. 31) and the Piranesian monumental bridge
(Fig. 18) were not to be denied, any more than the
aggrandized classical structures coming out of the French
Grand Prix tradition (see introduction to this chapter,
p. 58). Dr Johnson might be forced into the fray to defend
the semicircular arches of the Palladians against new-
fangled elliptical ones.[1] But Roman classicism remained at
the heart of the Academies of Europe: in London, the
Royal Academy students were brought up on designs
such as Thomas Sandby's (unrealized) 'bridge of
magnificence' (Fig. 32a).

Soane, himself an Academy student, produced his own
plans for the grandest of all triumphal bridges, shown
here in a later watercolour: it won him a Gold Medal at the
Academy, and remained a favourite work of his.[2]
Designed to be 360 metres (1186 feet) long, with a vast
central carriageway, side footways and immense
frontispieces at the ends, it infuses Palladio's Rialto (Fig.
16) with all the monumental earnestness of current
teaching.[3] But this is by no means all: the design literally
sits athwart nature in the form of an ample river flowing
through a plain. In the repeating colonnades there are
reminders of contemporary French stress on the column
as the basic functioning support (corresponding to the tree
trunk in nature), combined with Burke's reflections on the
sublime effect of 'succession' in visual experience.[4] The
overall effect is compounded of the same ingredients:
man-made forms are brought into dramatic relationship
with those qualities of vastness and shadowiness which
Burke had pointed to in nature; and Soane reflects the
tendency for French and Italian entries for architectural
competitions to be related to virgin sites.[5] Sophistication
and simplicity contrast with each other. Soane presented a
severer version of his 1776 Triumphal Bridge, substituting
the more 'primitive' Greek Doric for Corinthian, and still

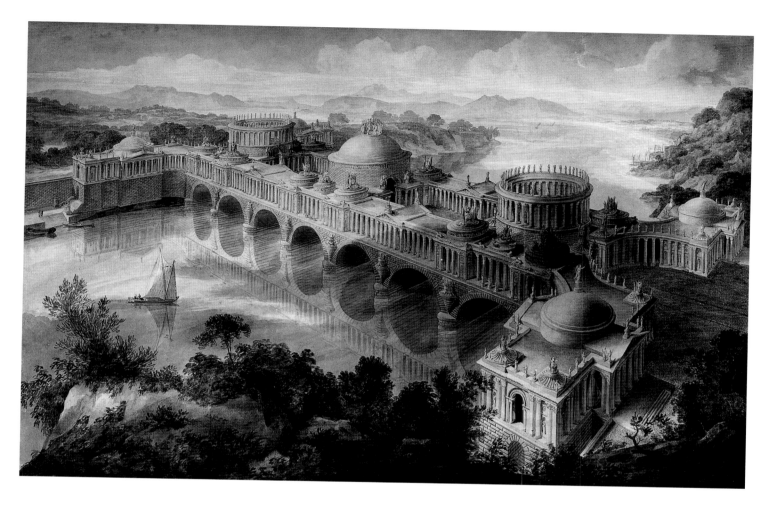

32

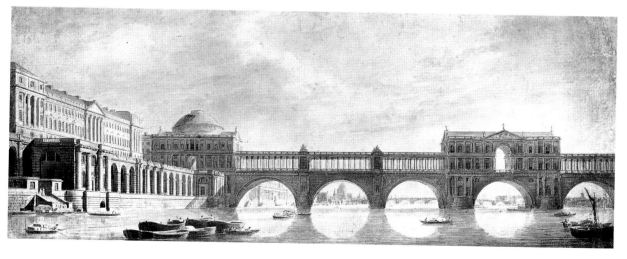

32a

showing it in a wild landscape, to the Parma Academy during his Italian stay.

Though the design was not carried out, it undoubtedly lives in the atmospheric watercolours done for Soane in the 1790s by his draughtsman (himself an architect), Joseph Michael Gandy (1771–1843), whose own imaginatively charged watercolours set classical aqueducts into huge primeval landscapes.[6] Soane, passionately interested in light-fall (the 'poetry of architecture') needed to exploit the painter's ability to control it. He and his friend Turner occasionally meet on adjoining if not common ground (Fig. 63 and Plate IX).

1. John Gwynn, the bridge architect who drew out a bridge of magnificence with semicircular arches for Blackfriars in 1759, was supported by Johnson in three (unsigned) letters written to the *Gazeteer and New Daily Advertiser*, reprinted in R.W. Chapman, ed., *The Letters of Samuel Johnson*, 3 vols (Oxford: Clarendon Press, 1952), vol. I, pp. 446–52. See also A.J. Sambrook, 'Dr Johnson – Civil Engineer', *The New Rambler* (*Journal of the Johnson Society*) (1966), pp. 18–23.

2. It appears with Soane's other major projects in a watercolour by Gandy, *Architectural Visions of Early Fancy and Dreams in the Evening of Life*, shown at the Royal Academy in 1820 (col. reprod. in *John Soane*, Architectural Monographs (London: Academy Editions, 1983), pl. V).

3. For the plan and other details of the Triumphal Bridge see P. de la Ruffinière du Prey, *John Soane, The Making of an Architect* (Chicago and London: Chicago University Press, 1982), pp. 83f.

4. Burke cites here colonnades which repeat the same simple form to apparent infinity: see *Sublime and Beautiful* (1757), pt III, xiii.

5. An extreme example is V. Poma's proposal in the 1780 Parma competition for a *Castel d'acqua* or waterworks for a Doric building to be carved from a rock-face: see D. Stillman, 'British Architects and Italian Architectural Competitions 1758–1780', *Journal of the Society of Architectural Historians* (America), XXXII (1973), pp. 43–66.

6. For Gandy see J. Summerson, 'The Vision of J.M. Gandy', in *Heavenly Mansions and Other Essays on Architecture* (Norton Library edn, New York and London: W.W. Norton, 1963[1948]), pp. 111–34; also *Joseph Michael Gandy 1771–1843*, exh. cat. (London: Architectural Association, 1982).

32a Thomas SANDBY (1731–1809)
Design for a Bridge at Somerset House: View Looking East
Pen, ink and watercolour over pencil, 25.1 × 61.9 cm (9 3/4 × 24 1/2 in.), after 1780

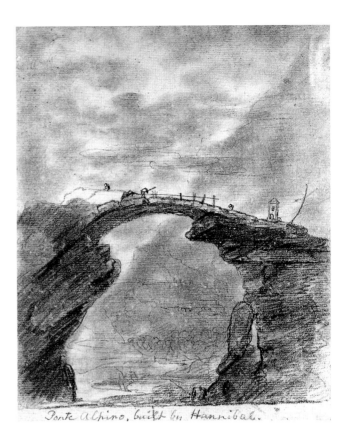

33 Richard WILSON (1713?–82) 33
Ponte Alpino, Built by Hannibal
Black chalk and stump, 28.9 × 21.6 cm (11 1/2 × 8 1/2 in.), c. 1751

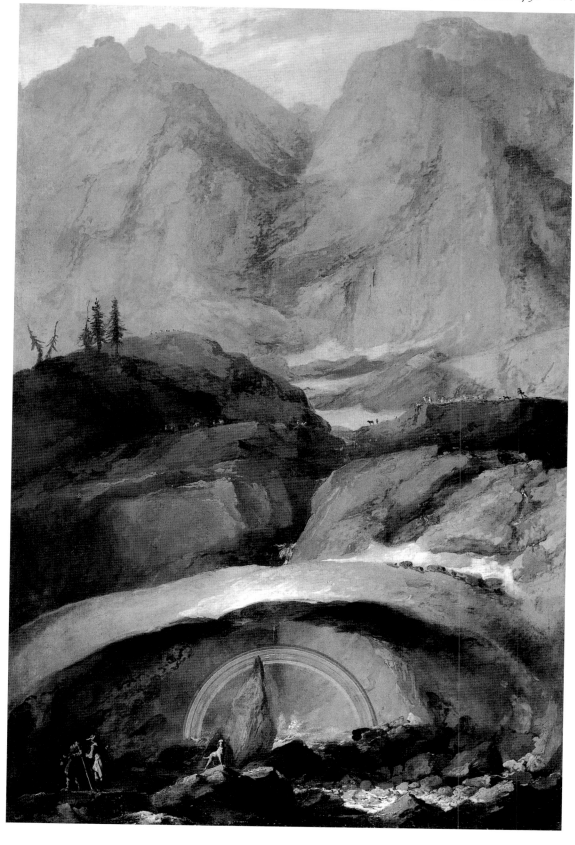

34 Caspar WOLF (1735–83)
Snow-bridge and Rainbow
Oil, 82 × 54 cm (32 ¼ × 21 ¼ in.), *c.* 1778

As early as 1706–8, Johann Jakob Scheuchzer (1672–1733), natural historian and biblical scholar, had published a description of the Alps based on a journey of 1705 (*Beschreibung der Natur-Geschichten des Schweizerlands*), which includes (in Part III) detailed accounts of the Panten (or Banten) Bridge (paper 7) and the 'Pons Diaboli' or Devil's Bridge (Teufelsbrücke, paper 11).[1] We shall later compare his artist's illustration of the latter with Turner's (Figs 58, 58a). Scheuchzer looks for the shaping hand of God, or the Devil, while Richard Wilson, as he stops to draw a rocky bridge on his journey to Italy (Fig. 33), looks for that of Hannibal. Any such bridge, part-formed by nature and strengthened by man, was likely to be attributed to the Carthaginian general, whose audacious crossing of the Alps was to be famously portrayed in 1812 by J.M.W. Turner. Man's puny size might set the odds against him in such a place, but Wilson's inscription on this drawing reminded him, and reminds us, that on occasion he might prevail. A Welsh bridge that was famous for being built against all odds was to occupy him later (Fig. 39).

By the 1770s tourism was well advanced in Switzerland, and Caspar Wolf was specializing in pictures of visitors enjoying the sites. But he is also a painter of rock and ice formations. His *Snow-bridge and Rainbow* of 1778 is at once real and, as we would now say, surreal. The composition is divided from top to bottom by the gulleys between the distant mountains and the river deep in a cleft of the rocks in the middle ground. All this is totally objective, though we wonder at the formidable scale of the landscape in relation to people and animals on the right-hand ridge. The foreground, however, is a world on its own. A natural ice-bridge completely spans it, greenish-grey against the warm background. It frames the perfect arc of the rainbow against water. Two people stand under the arch. A strange rock, also greenish-grey, juts upward to pierce the rainbow. A dog echoes the rock's shape. The dramatic interplay of path-like arch and rainbow is clearly something that the artist has personally sensed and exaggerated in a calculated way. If Hannibal's bridge showed that man might prevail, Wolf's seems to leave the matter, at the very least, open to question.

1. Scheuchzer's detailed account is conveniently accessible, in more modern German spelling than his original edition (Zurich, 1708) in the edition of J.G. Sulzer, 2 vols (Zurich 1746): in this the description of the Panten Bridge is in vol. II, p. 76, and that of the Devil's Bridge, vol. II, p. 92.

35 and Plate IV Hubert ROBERT (1733–1808)
Pont du Gard
Oil, 242 × 242 cm (95 ¼ × 95 ¼ in.), 1787

As improving communications intensified interest in the way that natural obstacles in remote places had been overcome in the past, the Roman Pont du Gard, near Nîmes in southern France, came to impress even more as an achievement.[1] Here was an immense, dry-stone double bridge supporting an aqueduct 275 metres (900 feet) long and 45 metres (148 feet) high over the seasonally fast flowing river Gardon (or Gard). Traditionally held to have been built under Agrippa, the son-in-law of Augustus, in the late first century BC, it was part of a 40 km-long (25-mile) supply system bringing water from Roman Ucetia, modern Uzès, to Roman Nemausus, modern Nîmes. The boldness of this conception was only matched by the accuracy of its planning. Henri Gautier analysed the ratio of piers to arch-spans in 1717:[2] one-fifth, rather slimmer than most Roman bridges, where it was one-third. The French engineer Perronet, later in the century, was to go much further, however, making the ratio in his modern bridge at Neuilly one-ninth (see Fig. 26).

Hubert Robert was one of a number of French artists who were concerned to record the antiquities of Nîmes, seen as a 'second Rome' in his time.[3] Like Piranesi he subjects factual reporting to dramatic presentation in this memorable account of the Pont du Gard, a canvas commissioned, with three others depicting Languedoc monuments, by Louis XVI in 1787 for his dining room at Fontainebleau, and shown at the Salon of that year. In the same year Jefferson was writing of 'the Pont du Gard, a sublime antiquity'.[4] Another visitor was Arthur Young, who admired the 'Spirit of exertion' which went into its making, as Rousseau, fifty years earlier, had imagined he had 'heard the loud voices of the men who built it'.[5] Robert contrasts the ever-present human need for water in the foreground, where women are filling jars from the river, with the mighty perforated wall which ensured its supply to Nîmes in the distant past. At the same time the detail of the structure's frayed edges, picked out in the sunset light under an enormous sky, conveys a lingering rococo *délicatesse*. The combination makes this, of all the versions of the subject by this artist, the most surprising, in a quite un-Piranesian way.

1. It had attracted attention, of course, for centuries. Inigo Jones visited it in the summer of 1609, although the drawing of it by him (British Architectural Library, Drawings Collection, RIBA) is a modified copy of the woodcut view in Jean d'Albinas's *Discourse historial de l'antique et illustre cité de Nismes* (Lyons, 1560). See G. Higgott, 'Inigo Jones in

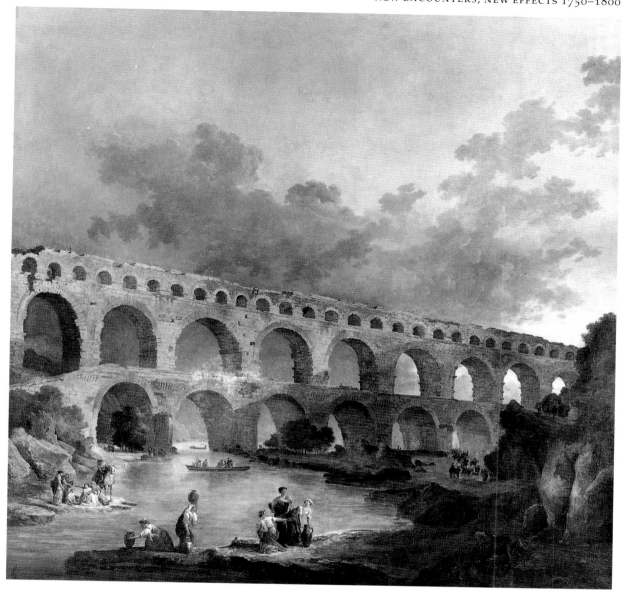

35

Provence', *Journal of Architectural History*, vol. XXVI (1983),
pp. 24–34, and J. Harris and G. Higgott, *Inigo Jones: Complete
Architectural Drawings* (London: Zwemmer, 1989), pp. 40–42
(ills). But archaeological interest in the Pont du Gard
increased dramatically in the eighteenth century (see note 3).
Ambrose Phillipps of the Society of Dilettanti drew it *c. 1730*:
see M. Girouard, 'Ambrose Phillipps of Garendon', *Journal of
Architectural History*, vol. VIII (1965), pp. 25–31.

2. H. Gautier, *Dissertation sur les culées, voussoirs, piles et poussées
des ponts* (Paris, 1717). Cf. also J. Spence, *Letters from the Grand
Tour*, ed. Slava Klima (Montreal and London: McGill-Queen's
University Press, 1975), p. 159.

3. Robert was working on the Roman monuments of Nîmes in
1772; he showed paintings of them at the 1785 Salon: see
J. Cayeux, *Hubert Robert* (Paris: Fayard, 1989), pp. 339, 389.
C.-L. Clérisseau's engraved series *Les Antiquités de Nismes*

appeared in 1778. The English artist William Marlow
(1740–1813), in Europe in 1765–6, painted the Pont du Gard
memorably (Graves Art Gallery, Sheffield).

4. Letter to Mme de Tessé, 20 March 1787; see J. Boyd, ed., *The
Papers of Thomas Jefferson*, 19 vols (Princeton, NJ: Princeton
University Press, 1950–74), vol. II (1950), p. 226.

5. J.J. Rousseau, *Confessions*, Book 6, tr. and intro. J.M. Cohen
(Harmondsworth: Penguin, 1953 [1781]), p. 243. A. Young,
Travels in France during the Years 1787, 1788, and 1789, ed.
Constantia Maxwell (Cambridge: Cambridge University
Press, 1950 [1929]), entry for 28 July [1787].

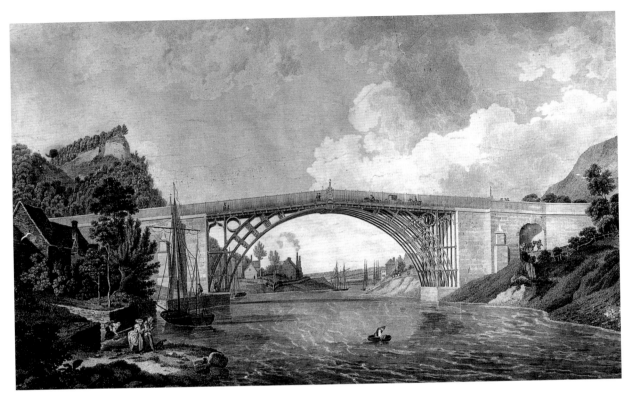

36

36 William Ellis (1747–d. before 1810) after Michael Angelo ROOKER (1743–1801)
The Iron Bridge, Coalbrookdale
Line engraving, hand-coloured, 44.6 × 66.1 cm (17 ½ × 26 in.), 1782

This famous bridge (1779, opened 1781) was the first in the world to be made up entirely of cast-iron parts. A Shrewsbury architect, Thomas Farnolls Pritchard (died 1777, during its construction) and the ironmaster Abraham Darby III collaborated in designing its single span of 30.6 metres (100 feet 6 inches).[1] While the 12-metre-high (40-foot) arch-shaped ribs have pierced spandrels to gain lightness, the bridge embodies in all 384 tonnes (378 tons) of iron. But its height above the water and the contrast with the steep sides of the gorge give an impression of buoyancy. Spanning the Shropshire furnaces, the bridge came to symbolize the optimism of the early Industrial Revolution, and its image quickly appeared on trade tokens, letter-heads, pottery mugs and around the ash-holes of cast-iron cottage grates. Models were made of it in the 1780s, one of which was presented by Darby to the Society of Arts. Thomas Jefferson bought the present engraving of it in 1786 for thirteen shillings

and eventually hung it in the White House at Washington.[2] A smaller iron version of the bridge was built at Raincy near Paris, and another was placed in 1791 in the park of Wörlitz near Magdeburg in Prussia.[3]

Visitors from abroad included one Count Comasco, who described the bridge as a 'gate of mystery'.[4] And the sense of a kind of entrance to Coalbrookdale's particular blend of the natural and man-made is borne out by early views which make it central to the composition. Several include a smoky skyline beyond, but the chimneys in Rooker's picture are relegated to the distance and, as Klingender notes,[5] the intention seems to have been to show how little violation was being done to the countryside by industrial developments. Rooker was paid £29 by the Coalbrookdale Company for the original drawing: the engraving was dedicated to George III in 1782 and circulated widely. At the time of the commission Rooker was a scene-painter at the Haymarket Theatre, and no doubt this centralized design repeats a convention of theatrical scenery: a fore-stage (river bank), main stage (occupied by the coracle, a speciality of generations of Severn Gorge craftsmen), and inner stage (framed by the bridge).

This 'gateway' approach to the Iron Bridge (see Introduction, p. 15) was also widely reflected in

broadsheets, and (without the chimneys) in such items as the vase from the Worcester porcelain factory (Fig. 36a). It contrasts with the 'picturesque' view of it, by George Robertson, which follows (Fig. 37).

1. For discussion of the authorship of the bridge see J.R. Maguire and P. Matthews, 'The Ironbridge at Coalbrookdale: a reassessment', *Architectural Association Journal*, vol. LXXIV (1958), pp. 30–45. Essential general books are N. Cossons and B. Trinder, *The Iron Bridge, Symbol of the Industrial Revolution* (Bradford-on-Avon: MoonrakerPress, 1979), and S. Smith, *A View from the Iron Bridge* (Ironbridge: Ironbridge Gorge Museum Trust, 1979): both illustrate many artists' views of the bridge. Smith reproduces Iron Bridge mugs, convex glasses, a snuff-box in Birmingham enamels (*c.* 1790), and a Coalport mug (*c.* 1856) which combines a transfer-printed view of the 'modern' Bridge with one of the medieval Buildwas Abbey nearby.

2. See W.H. Adams, ed., *The Eye of Thomas Jefferson*, exh. cat. (Washington, DC: National Gallery of Art, 1976), no. 110.

3. See Cossons and Trinder, *The Iron Bridge*, p. 66. The Raincy structure, put up near the château de Raincy (for the Duc de Chartres), north-east of Paris, has long vanished, but the bridge (in *wrought* iron) at Wörlitz (for the Furst Leopold Friedrich Franz von Anhalt-Dessau, 1740–1817), remains. It has a span of 7.75 metres (25 feet): see ill. in Cossons and Trinder.

4. See *Salopian Shreds and Patches* (1890), p. 337. For Comasco and other visitors to the Iron Bridge, see also B. Trinder, *'The Most Extraordinary District in the World', Ironbridge and Coalbrookdale* (Chichester: Phillimore, 1977).

5. F.D. Klingender, *Art and the Industrial Revolution* (St Albans: Paladin, 1972 [1947]), p. 76.

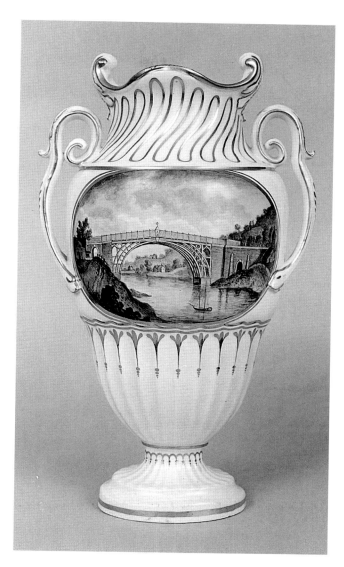

36a

36a Vase. Worcester porcelain, painted in sepia by J. Baker, 23.5 cm (9 ¼ in.) high, *c.* 1820

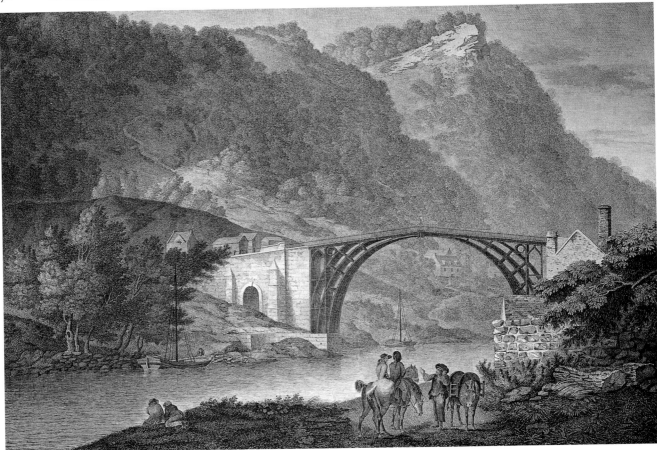

37

37 James Fittler (1758–1835) after George
ROBERTSON (1724–88)
*The Iron Bridge from the Madeley Side of the
River Severn*
Line engraving, 37.9 × 53.3 cm (15 × 21 in.) (print
size), 1788

Besides Rooker's 'gateway' view (Fig. 36), another much
more overtly 'Romantic' approach to the bridge set it *into*
its landscape. In 1788, John and Josiah Boydell published a
series of six engravings of Coalbrookdale after paintings
by George Robertson, landscape painter and drawing
master. One of these is the present view, which adopts the
'picturesque' principles of composition that were
fashionable. Though the angle of sight hardly differs from
that in Rooker's work, there are more shadowed surfaces,
and the bridge, strongly lit to the left, is asymmetrically
placed with dark, shaggy woods behind it. There is more
than a nod in the direction of the sublime also: the hills are
exaggeratedly high to act as a foil to the bridge but also to
make it look part of a larger landscape. But this view of so
up-to-the-minute a subject does more than this alone
might suggest. The result is richly atmospheric, involving

a decidedly dramatic confrontation of the works of man
and nature. It is not surprising that this widely circulated
engraving became, with Rooker's picture, the most
famous version of its subject.

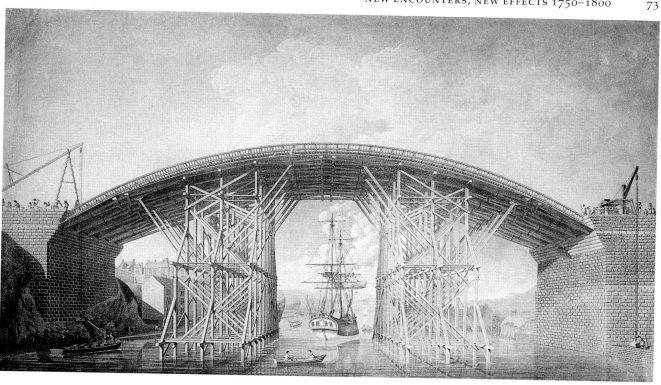

38

38 J. Raffield after Robert CLARKE (both fl. 1795)
*East View of the Cast Iron Bridge over the River Wear at
Sunderland . . . Previous to the Centre Being Taken
Down.* Aquatint, 43.7 × 73.8 cm (17 1/4 × 29 in.) (print
size), *c.* 1795

As with scaffolding and centring in prints of the masonry
bridges such as Blackfriars (Fig. 25), so the soaring and
skeletal lines of iron bridge construction commended
themselves to the makers of popular prints, and the
otherwise unknown Robert Clarke brought out the
breathtaking idea of showing the single 73-metre
(236-foot) span of the great iron bridge of the new age,
built at Sunderland in 1793–6 to a design developed (and
much changed) from one by Tom Paine (as noted above,
p. 58), with its scaffolding still in position.[1] The bridge was
designed by Rowland Burdon MP, a friend of Soane, and
constructed by the engineer Thomas Wilson. Like the
Coalbrookdale bridge, it attracted much attention: it was
now the largest single-span cast-iron bridge in the world.[2]
This view from the east is dedicated to Burdon; a further
view of the completed structure from the west came out
two years later. The second view is inscribed with a
dedication to the 'Society of Arts, Manufactures and
Commerce', established in 1754. It has to be said that it is
a mild affair compared with its companion.

The present print has lively merits. We can sense the
scale of the bridge, which has been carried to the stage of
the arch only, and will be built higher with cast-iron rings

and a timber floor to carry the road. On the skyline we see Burdon's personal system of radial 'key-stones', as he called them: cast iron units, 1.5 metres (5 feet) deep from top to bottom, fixed to adjoining ribs by horizontal tubes, also visible in the print. The effect of strong sunlight, sharpening every line, harks back to Samuel Scott thirty years before, but has its own artistic point in the way that it makes the giant wooden centring frames mediate to excellent effect between the massive stone abutments at the sides and the open verticals and horizontals of the sailing ship in the middle. The ship is itself a reminder of the successful solution to a problem which had been much discussed, how to erect the bridge without interfering with the passage of ships on this busy waterway. Finally, the deep shadow beneath the arch successfully conveys a feeling of the width of the road: at 9.75 metres (32 feet) it was 2.4 metres (8 feet) wider than that of the Coalbrookdale bridge.[3]

1. Clarke was an artist and probably a publisher; J. Raffield 'Architect' exhibited at the R.A. in 1799 an 'Elevation of a new cast iron bridge, proposed to be erected over the River Thames from the Strand in the vicinity of the Adelphi to Lambeth' and in 1805 'Suspended Bridge over the Danube at Vienna etc'.
2. It was illustrated for specialists in J.D. Rondelet, *Traité théorique et pratique de l'art de bâtir*, 4 vols (Paris, 1861 [1802–17]). Its popular fame was through prints, and, notably, transfer views on pottery: a large selection from the Sunderland Museum collection is reprod. in *Sunderland Pottery*, rev. John C. Baker (Sunderland: Tyne and Wear County Council Museums, 1984), pp. 72f.
3. Despite the greater span and width, the bridge was much lighter (264 tonnes, 260 tons) than the Coalbrookdale bridge (384 tonnes, 378 tons).

39 P.C. Canot (1710?–77) after Richard WILSON (1713?–82)
The Great Bridge over the Taaffe in South Wales
Engraving, 41 × 54.4 cm (16 1/4 × 21 1/2 in.), *c.* 1766, published 1775

A contributor to the *Gentleman's Magazine* of 1764 remarks of the new bridge (1756) by William Edwards across the river Taaffe (Taff or Teifi), in South Wales, that it 'has now stood for eight or nine years, and it is supposed that it may stand for ages to come, a monument of the strong natural parts, and bold attempts of an *Ancient Briton*'.[1] To drive home the point he compares Edwards's achievement favourably with that of the builder of Venice's Rialto. The Taaffe bridge was still in use into the late nineteenth century and survives in the modern town of Pontypridd ('new bridge'). The present engraving, issued on 17 July 1775, after Wilson's painting of 1766 or earlier (now lost), commemorates the 'Great Bridge' and evokes its original wild setting.

Though he was a stonemason, William Edwards (born 1719) figures in histories of civil engineering as a pioneer of engineering principle in masonry. The design has a simple functional quality and develops from an earlier bridge by Edwards over the river Towy (1740). It was Edwards's fourth attempt to bridge the fast-flowing Taaffe, hence the high arch (10.7 metres, 35 feet) and single, unprecedentedly wide span (43 metres, 140 feet). A chain and drag was needed for some carts as they crossed, but the bridge did endure the floodwaters.

The view was one of six prints of Welsh subjects published by John Boydell, all after Wilson.[2] The other five were of medieval castles or natural features (Snowdon, Cader Idris). The Taaffe bridge was thus the only 'modern' subject. Wilson makes dramatic play with its uncluttered lines and great scale as it dwarfs the figures. Coming alongside the Italianate works of this artist, whose contemporary reworking of Claude we have seen in his Wilton view (Fig. 31), it projects an uncompromising austerity. It has been convincingly suggested that in this picture Wilson indicated the rugged strength that Wales appeared to stand for at a time of the rapid assault by industry on the rural character of Britain. Presenting this view, Solkin recognized also that the Taaffe Bridge was

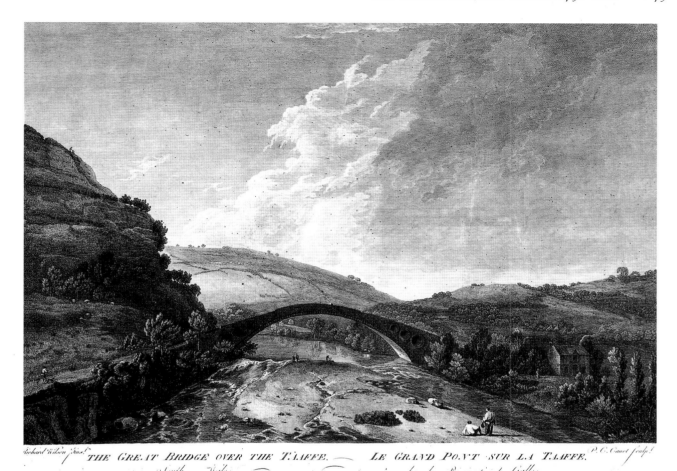

Richard Wilson Jmnl. THE GREAT BRIDGE OVER THE TAAFFE. — LE GRAND PONT SUR LA TAAFFE. P. C. Canot Sculp.
in South Wales. — dans la Principauté de Galles.
Published July 1773 by John Boydell engraver in Cheapside London

39

subsidized by Lord Windsor, who wanted a bridge to enable him to develop mining on his estate.[3] Arguing that Wilson's Welsh views of the 1760s catered for patrons, in England as well as Wales, who felt that Wales represented a relatively unsullied social ideal at a time when in England the lower orders were showing greater resistance to paternalistic rule after the Seven Years' War, he saw Wilson's Taaffe landscape as an Elysium harmonized by a 'graceful' bridge. But the sense of hazard overcome remains striking and what the artist may well have wished to suggest is that the continuity of Welsh country life rests on a primitive strength on which Edwards, the 'Ancient Briton', has drawn to create a 'modern' workaday monument. This would account for its presence among Wilson's other medieval or natural subjects. It is true that contemporaries were struck by the bridge's apparent 'lightness'. Benjamin Heath Malkin, observing it from the Llantrisant road, recalls that its appearance 'has generally been likened to that of a rainbow, from the lightness, width and elevation of the arch . . .'.[4]

Whatever Wilson's intention, he created out of the circumstances of the bridge's inception and creation, and his own feeling for his native country, an unforgettably convention-free image.

1. T.M. (Thomas Morgan), 'Account of a Remarkable New Bridge in Glamorganshire', *Gentleman's Magazine*, vol. XXXIV (1764), pp. 564–5. A somewhat shortened version appeared also in the *Annual Register*, vol. VII (1764), pp. 147–8.
2. Though the six prints were published in 1775, the Wilson painting of the bridge must date before 1766, when Canot's print was shown at the Society of Artists, London. The reasons for the intervening delay are obscure, but for discussion see D. Solkin, *Richard Wilson: The Landscape of Reaction*, exh. cat. (London: Tate Gallery, 1982), p. 229.
3. Ibid., p. 102.
4. Benjamin Heath Malkin, *The Scenery . . . of South Wales* (London: Longman, 1804), vol. I, p. 132.

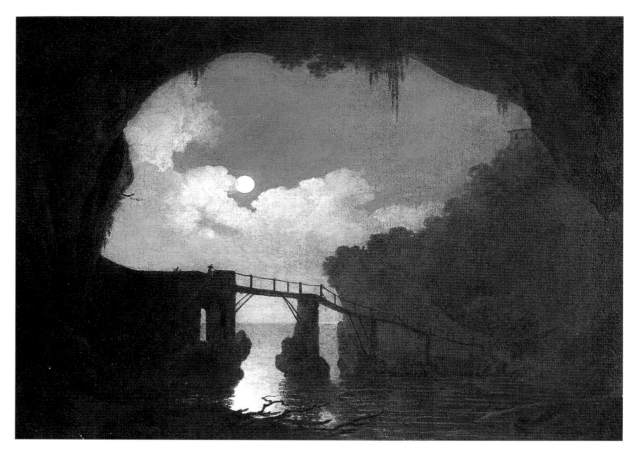

40

40 Joseph WRIGHT of Derby (1734–97)
A Bridge through a Cavern
Oil, 63.5 × 81.2 cm (25 × 32 in.), 1791

This picture, referring to Wright's visit in 1774 to Italy, including the Sorrento coast, manages to suggest, more than most, the passage of time from immemorial beginnings. Our viewpoint is low in the depth of the cavern, and we look towards an irregular ellipse of light at its entrance, across which there is a wooden bridge with a bent railing.

Wright has taken up his position as close to the rock and as far below the bridge as Roelandt Savery's artist of nearly two centuries earlier (Fig. 4); but here we also join the artist and ourselves share his sense of the mysteriousness of nature, as we gaze from our subterranean cell, past the bridge's frail evidence of human effort, directly into the face of the full moon. For this is a night piece, and Nicolson is right to draw our attention to its affinities with Dutch seventeenth-century art, and particularly Aert van der Neer.[1] The language of

the painting is, however, transformed by Wright, focused on a few contrasting essentials and totally candid. In this work he not only presents two of his favourite images of remoteness in nature, the cavern and the full moon, but trails between them, as it were, a single man-made element, the bridge, which is in silhouette.

1. Benedict Nicolson, *Joseph Wright of Derby, Painter of Light*, 2 vols (Paul Mellon Foundation for British Art, Routledge and Kegan Paul, 1968), vol. I, p. 92.

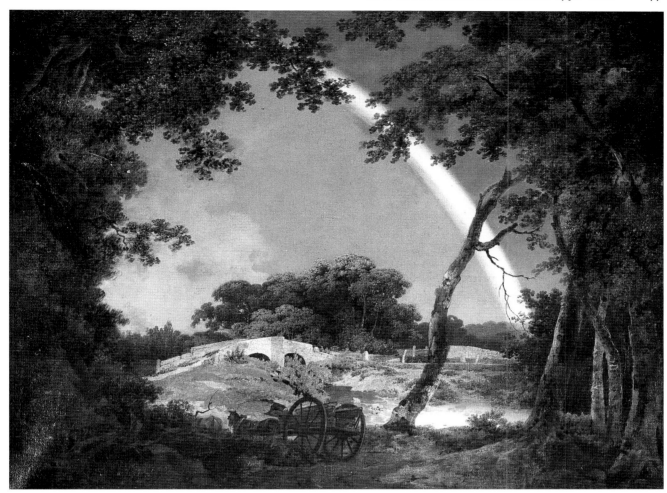

41

41 and Plate V Joseph WRIGHT of Derby (1734–97)
Landscape with a Rainbow
Oil, 81.2 × 106.7 cm (32 × 42 in.), 1794

The effect in the much reproduced but perennially fresh *Landscape with a Rainbow* is very different from that of *A Bridge through a Cavern* (Fig. 40). Wright again completely frames the main motifs, though this time with foliage. We look through into the light of the sun immediately after rain. The stone bridge, low-lying and as carefully described as Rembrandt's *Six's Bridge* (Fig. 6), straddles an unobtrusive stream. A further bridge lies beyond. Beyond these earth-bound elements, against grey sky, a rainbow bends steeply down. A man on a horse-drawn cart in the shadowy foreground leans forward, unaware, it seems, of it. Like Rubens, and the Romantics to come, Wright senses the curve of the rainbow as something quite other than that of the bridge, immaterial, but, like Cuyp and the Dutch, he is moved by the materiality of ordinary things and the way that light can transmute them. The result is a dazzling essay in immediacy which goes far beyond

contemporary 'picturesqueness'. The mood is closer to Giorgione's *Tempesta* (Fig. 2), which transmits the same light conditions, but is significantly different in its melancholy sense of loss. In Wright's picture the bridge is the most permanent-looking element. It has so far not been identified, although a location near Chesterfield seems possible.[1]

Ahead lies a period of enhanced responsiveness to the phenomena of weather. Rubens had pointed the way (Introduction, note 16), though this will be a very much more complex phase of awareness, with the work of Constable eventually revealing its complexity. Wright's *Landscape with a Rainbow*, its abnormal light transforming a 'normal' landscape, with a workaday bridge, almost takes us there. And so, set in what was to be the heartland of English Romanticism, does the Rydal waterfall subject of a year later (Fig. 42).

1. I am grateful to David Fraser and Jane Wallis of Derby Art
 Gallery for help on this point.

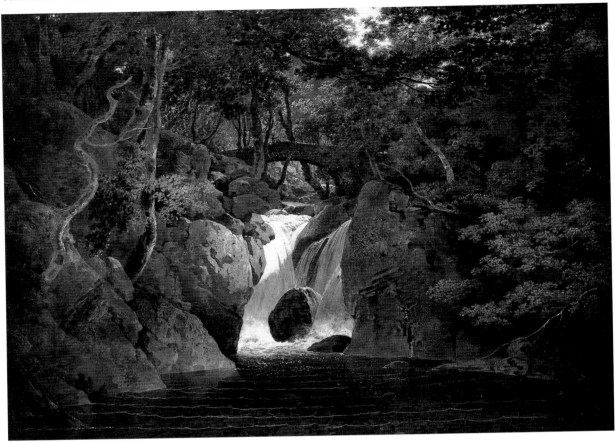

42

42 Joseph WRIGHT of Derby (1734–97)
Rydal Waterfall
Oil, 57.2 × 76.2 cm (22 ¹/₂ × 30 in.), 1795

In the summer of 1795 Wright visited the English Lake
District with his two daughters. He was deeply stirred by
the experience: a marginal note in a letter to his brother
refers to the 'stupendous scenes' as the equivalent to the
eye of 'what Handel's Choruses are to the ear'. This oil
was one of the works that came out of the visit.

Here is yet another aspect of this infinitely inquisitive
artist: a subject deep in woods, with a transparent stream
spreading pool-like in the foreground and revealing
innumerable pebbles in its bed, which Wright was at great
pains to show accurately. Rydal waterfall, which had been
the model for the cascade in Wordsworth's early poem
'The Evening Walk' (1793), was already, by the time of
Wright's picture, a popular stopping place for the
Picturesque Tourist, with tastes formed on William
Gilpin's travel books. It was well known that Gilpin had
found the noise of the falls 'peculiarly favourable to
meditation and philosophic melancholy'. A rustic cabin
formed a viewing hut, maintained by the owner of the
land, Sir Michael le Fleming, fourth Baronet of Rydal. A
window in the cabin, as an anonymous contributor to the

Topographer of 1790 recounts, framed the cascade for the
questing tourist. Wright has, however, his own individual
response, not only to the foreground pebbles but to a
middle distance which to us appears as a T-shaped pair of
motifs central to the picture: the advancing waterfall as
the leg, and the simple stone bridge, on which two figures
converse, as the crossbar facing the spectator. The
conventional wayfarers beloved of Picturesque taste at
once become more than decoration, rather presences with
whom we want to identify, locked as they are into the
cross-movements of bridge and stream. A contemporary
Tourist, Mrs Cobbold, expressed her delight at the bridge
in particular, 'which, if I were a Landscape Painter, I
should certainly introduce into the view as its appearance
does not exceed the simplicity of the Pastoral Ages'.[1]
Wright seems to have felt an even simpler collusion
between the bridge as viewing platform and nature as
view, playing off the straight, illuminated lines of the
parapet against the geometric curve of the arch and
contrasting both with the irregular central boulder in
midstream in a way prophetic of Cotman at Greta Bridge
(Fig. 68 and Plate X).

1. Mrs Cobbold, 'Tour in the Lake District' (1795), British Library
 Add MS 19, 203.

43

43 John Sell COTMAN (1782–1842)
The Devil's Bridge, Cardigan
Pencil and watercolour, 27.9 × 18.6 cm (11 × 7 1/4 in.),
1801

Wright's clarity and incisiveness of touch kept his *Rydal
Waterfall* (Fig. 42) well clear of picturesque convention,
although remote waterfalls below bridges deep in
wooded country were among the most popular subjects
sought by students of the picturesque.[1] Another work
which breaks the mould, though less conspicuously, is
Cotman's watercolour of 1801 of the Devil's Bridge,
Cardigan. In this notorious location near the Falls of
Mynach 'the Sublime and the Picturesque mingled', as
Andrews comments, 'in some of the finest scenery in
Wales'.[2] There were two bridges over the Mynach, at the
point where it descended 100 metres (300 feet) through a
gorge. The lower bridge was regarded as the Devil's work,
completed in a single night.[3] Cotman responds to the
interplay of the geometrical arches and zigzagging
branches in front of them, and exploits the concealment by
foliage of the bridges' supports. Devil's work appears to
float in a mysterious limbo which does full justice to the
story. Yet this almost claustrophobic watercolour was
produced in the year in which Chirk aqueduct was
completed a few miles away by Telford: Cotman was to
allow his natural response to the clear expansive shapes of
this kind of subject to lead his imagination to strikingly
original results (Fig. 69).

1. M. Andrews, *The Search for the Picturesque: Landscape Aesthetics
 and Tourism in Britain 1760–1800* (Aldershot: Scolar Press,
 1989).
2. Ibid., pp. 148f
3. Probably eleventh or twelfth century. The upper bridge is
 eighteenth century.

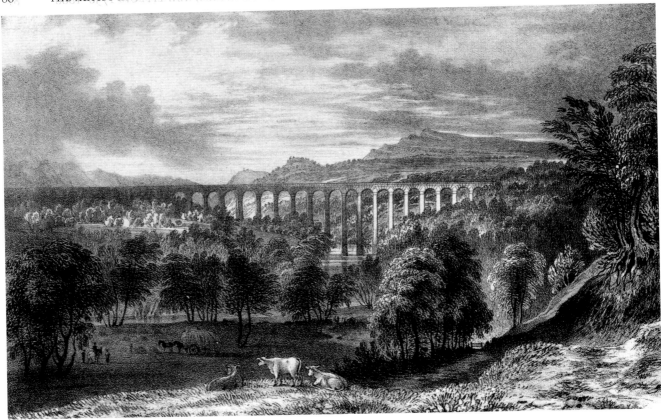

44

44 After George PICKERING (*c.* 1794–1857)
Pontcysyllte Aqueduct
Lithograph, 12.5 × 19.8 cm (5 ¼ × 7 ¾ in.), undated

Telford's impressive reconciliation of Roman forms with the use of metal helped to make his Menai road bridge (opened 1826, linking London and Holyhead at Anglesey) his most famous work. The German architect Schinkel (see Fig. 55) visited it in that year. Such a reconciliation was achieved much earlier, however, in Telford's aqueduct at Pontcysyllte (1795–1805), in a rural setting in which water from the system associated with the Ellesmere canal was carried across the wide, steep-sided valley of the Dee. A cast-iron trough over 300 metres (1000 feet) long is supported on nineteen cast-iron arches, which are in turn carried on masonry pillars 37 metres (121 feet) high. A contemporary record states that crowds at the official opening mingled cheering with intervals of 'silent astonishment'.[1] That Telford chose to be portrayed by Samuel Lane with this structure behind him is evidence of his regard for it: the portrait (Institution of Civil Engineers) was engraved for the Atlas of Telford's works that accompanied the *Life* written by himself, edited by John Rickman and published posthumously in 1838. Walter Scott is said to have described this aqueduct as the 'most impressive' work of art he had seen.[2]

Telford's smaller aqueduct across the valley of the Ceiriog at nearby Chirk (1796–1801), with ten arches of 12.3-metre (40-foot) span, each 21.5 metres (70 feet) high, had masonry arches as well as pillars, and an iron bottom plate lining the waterway. Phillips, in his *General History of Inland Navigation, Foreign and Domestic*, 4th edn (1803), hailed the two structures as 'among the boldest efforts of human invention in modern times'. Robert Southey, in his review of Telford's autobiography in the *Quarterly Review*, also praised them: Telford is the 'Pontifex Maximus of his age'.[3]

Both aqueducts became favourite subjects for topographical book illustration, and Pickering published the present lithograph in *Four Picturesque Views in North Wales* (no date).[4] The result is a well-judged re-use of the old Claudean device (compare Fig. 8), much employed in picturesque illustration, of variations of sunlight and shadow on the linking form of a bridge to tie the picture together. By contrast, the drawing 'A Cloudy View at Chirk, Aug. the 4th, 1802' (Fig. 44a), is much more exploratory. The elaborate, pen-looping, linear detail and light/dark contrasts of picturesque tradition are discarded (though other drawings in the same sketchbook show the artist firmly sticking to elaboration). Instead, we find greater reliance on flat, economical wash, and we sense the artist thinking for himself. Cotman, operating at a far higher intellectual and technical level, would go much further.

1. 'Oration on the Opening of Pontcysyllte Aqueduct', from a Report of the Ellesmere Canal Company, 1805 (Ironbridge Gorge Museum).
2. Scott was in the vale of Llangollen in August 1825, on his way back from Ireland. His opinion of the Pontcysyllte aqueduct is unrecorded in J.G. Lockhart's great biography of Scott, but is contained in a letter from Robert Southey to John Rickman, see Sir A. Gibb, *The Story of Telford* (London: Maclehose, 1933), p. 35.
3. Review (anonymous, but by Southey), of *Life of Thomas Telford, Civil Engineer, written by Himself*, in *Quarterly Review*, 63 (1839), p. 420.
4. The 'Handlist of Topographical Prints of Clwyd' (Clwyd Record Office, 1977) lists thirteen prints of Pontcysyllte and five of Chirk, the best known of the latter being the line engraving by T. Barber after H. Gastineau, published in *Wales Illustrated* (1830). I am grateful to Mr A. Geoffrey Veysey, Clwyd County Archivist, for help.

44a ANONYMOUS
'A Cloudy View at Chirk, Aug. the 4th, 1802'
Pen and wash, 11.3 × 18.3 cm (4 1/2 × 7 1/4 in.)

44a

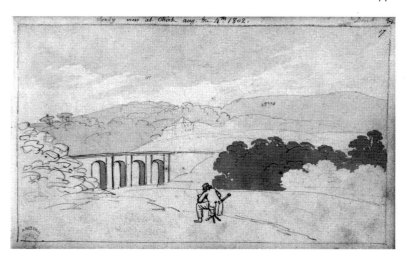

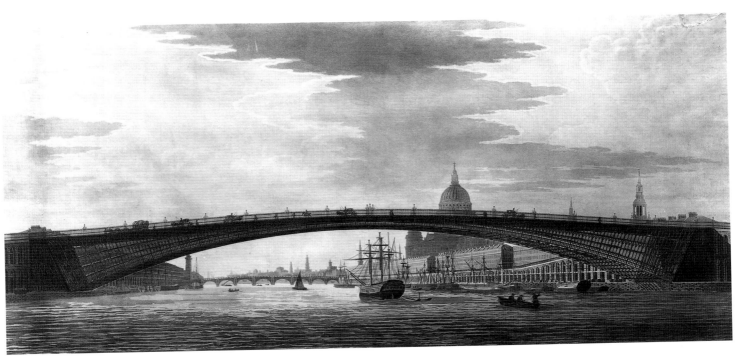

45

45 Thomas MALTON (1748–1804) with Wilson
LOWRY (1762–1824)
Telford's design for a replacement of London
Bridge
Engraving and aquatint, 54.8 × 119.8 cm (21 $\frac{1}{2}$ ×
47 $\frac{1}{4}$ in.), 1801

While working on the Welsh aqueducts, Telford
developed what was visually a far more radical idea for
the centre of London. His spectacular design (with James
Douglass) for a replacement of London Bridge
(1800–1801) in cast-iron consisted of a single 185-metre
(600-foot) arch.

 Headroom of 19 metres (65 feet) from the water, to
ensure the passage of shipping, had been asked for by the
commissioning committee. Dance's design (see Fig. 30)
avoided a high profile by incorporating drawbridges: but
Telford's single arch was to rise to the height required.
A model was placed in the Royal Academy. A drawing of
the bridge was engraved by Wilson Lowry against a river
view of Thomas Malton, who is remembered as a
topographical artist of some individuality as well as one
of the teachers of J.M.W. Turner. The engraving, to which
Malton himself added the aquatint, no doubt dramatizes
the strength of line of this arch by taking a very low
viewpoint, virtually at river level. But it is a magnificent
propaganda exercise for the new engineering. At a time
when English architects and engineers were eyeing each

other nervously, and a club had been founded in 1791 to defend the interests of architects, here was a design which would have made the engineering vision abundantly clear to London. Detailed uncompromisingly in a stylistically alert Gothic, it breaks completely with classicism. The bridge's mass even sails unabashed, from the viewpoint chosen for the print, across the outlines of the Wren City churches and St Paul's. Too unabashed, it seems, for the design (for a variety of reasons) remained unrealized.[1] The engraving, however, went on. First published by Ackermann in October 1801, it was reissued with a dedication to George III in 1802, and was still being reprinted in 1818.[2]

1. One reason seems certainly to have been the planning and cost of high-level ramps of masonry in the form of arcades in order to achieve a design which provided for so high a rise to the crown of the arch. Malton's aquatint shows these arcades beyond the bridge. A further reason must have been the unfavourable economic climate for such a publicly financed venture in time of war.
2. A.W. Skempton, 'Telford and the Design for a New London Bridge', in A. Penfold, ed., *Thomas Telford: Engineer* (London: Thomas Telford Ltd, 1980), p. 71. This article contains an excellent analysis of the technical aspects of Telford's design, with illustrations. An impression of Malton's print with an 1818 watermark exists in a private collection (the early impressions are on paper with no watermark). The print was still being advertised in the publisher John Taylor's list of 1820. I am grateful to Professor Skempton for help.

46 and Plate VI Francois-Xavier FABRE
(1766–1837)
*Joseph Allen Smith contemplating Florence across
the Arno*
Oil, 70.9 × 90.5 cm (28 × 35 ¹/₂ in.), 1797

This picture, painted only four years before Telford made
his daring proposal for a London of the future (Fig. 45),
focuses very firmly on the artist's past experience. Fabre
had been a pupil of Jacques-Louis David before the
French Revolution. He had gone to Rome in 1788 as a Prix
de Rome winner and left there in 1793 for Florence, where
he remained until 1824.[1]

The Arno and the bridges such as the Ponte Vecchio
and the Ponte Santa Trinità (Fig. 11) were admired by
innumerable artists and visitors to Florence. For Fabre
there were also the indelible associations of Italy itself,
the country where Poussin had lived and worked, and of
its past. Not even a Revolution as spiritually far-reaching
as that of 1789 could diminish the authority of classical
art in France. The French Academy at Rome continued to
receive pupils during the Revolution, while at home
many of the institutions of the *ancien régime* were
recreated in the Revolution's wake. The Academy of
Painting, closed by David in 1793, re-opened in another
guise (within the Institut National) and was rejoined by
him within two years.

David, that remarkable exponent of a reinvigorated
classical art, left us no paintings of bridges. We must look
to pupils like Fabre and Agasse (Fig. 47) for these. Fabre's
portrait of Smith, an American who commissioned three
history paintings from him as well as another portrait,
shows the patron sitting like a philosopher in profile, and
three bridges, the Ponte alla Carraia (1320), the Ponte
Santa Trinità (1566–9) by Ammanati and the Ponte
Vecchio (1345), representing Florence on the right,
beyond a large Corinthian capital. The picture has the
rigour and calm that came in large part to Fabre from his
involvement with the Davidian style, but also shows a
neo-Poussinist sensitivity to tone in the clear forms of the
bridges: the shadow placed on two arches of the Ponte
alla Carraia in the centre of the picture is one of the means
by which the composition is held together. Released from
this shadow into light, the bridges extend like life-lines

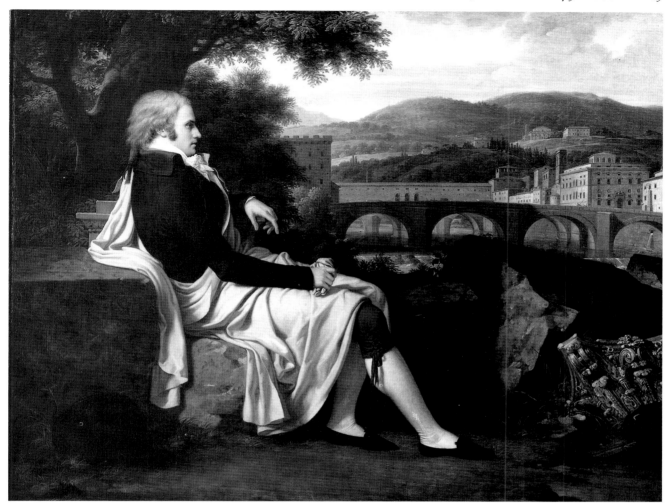

46

that link the philosopher to the unseen regenerative presence of Florence beyond and around him.[2]

Despite the many developments and pressures that make for change, from a kind of bridge-making dominated by architects to one in which engineers take up important initiatives, from a Britain, in particular, in which pride and wellbeing are expressed not only by the stone bridge of triumph but also by the metal bridge of industry, Fabre's picture unmistakably demonstrates the persistence of old ties. For all the deep disturbances of the European consciousness caused by the French Revolution, and despite the new attitudes which will arise as the Romantics explore their own separate individualities, Italy's magnetism is still strong. Turner, aged 25 as the century ends, will spend much time by the Arno, and, as a lifelong student of bridges, will reflect back all the diversity of the eighteenth century that we have been following.

1. See *Apollo*, vol. CXXVII (1988), p. 256. For Allen Smith see E.P. Richardson, 'Allen Smith, Collector and Benefactor',
American Art Journal, vol. 1, no. 2 (Fall 1969). For his commissions from Fabre, see Holland Papers, British Library MS. 51. 637, ff. 69–70 and f. 90, and *Treasures of the Fitzwilliam Museum*, exh. cat. (Cambridge: Fitzwilliam Museum, 1988), p. 128. I am grateful to David Scrase of the Fitzwilliam for help.

2. The idea of regeneration may well have been in Smith's mind. Parallels have been drawn between this painting and that by Tischbein, *Goethe in the Roman Campagna* (1786, Städel Inst., Frankfurt, Inv. 1157). Fabre owned a drawing by Tischbein (Musée Fabre, Inv. 837–1–991), which is connected with the Tischbein portrait. Smith may have asked Fabre for a portrait in the manner of that work, but whether he or Fabre decided to introduce the view of Florence in the background is uncertain, as is the reason that the river and bridges rather than the public buildings of the city dominate the composition. See *Treasures of the Fitzwilliam*.

'The world is a bridge: pass over it; but build no house there.' These words, attributed to Jesus, and inscribed on the Gate of Magnificence (completed *c.* 1600) in front of the Jami Masjid (Great Mosque) in Fatehpur Sikri, India, built by the Mughal emperor Akbar, belong to a Muslim context. But inasmuch as they evoke the idea of human life as a journey, in terms of concrete symbols, they relate to the thought of the more mystically minded Romantics of nineteenth-century Europe. These later men are apt to see a large truth in a minute manifestation of nature. Blake's famous words on seeing 'the world in a grain of sand' are the most familiar instance; and his vision of 'eternity in an hour' is echoed by Akbar's 'who hopes for an hour, hopes for eternity'. And in the Muslim inscription we have not only the sense of life as a journey, which belongs to much European Romantic art, but also the idea of the bridge as a special kind of link between man and his destination. Most important, furthermore, there is the paradoxical notion of the bridge itself as a world: not a place to build one's house on, but more than simply a place of passage. Romantics – particularly northern Romantics, as we shall see – spend much time on bridges.

The English Romantics dominate this chapter, for reasons that are not hard to discover. Lord Byron (1788–1824) was too young at the time of the French Revolution to have appreciated it as William Wordsworth (1770–1850) had, at first hand: but both, in different ways, were seekers after new experience in the spirit of freedom which flowed from the revolutionary idealism of 1789. Wordsworthian and Byronic strains of European Romanticism have long been recognized: Wordsworth's perception of nature as the repository of slow change over permanence, and Byron's very different preoccupation with restlessness and instability, had become fundamental ingredients of international Romantic feeling well before 1820. Each poet had by then delivered himself of his thoughts from the vantage point of a bridge: Wordsworth from Westminster Bridge, and Byron from the bridge which from his time became famous as a symbol of irreversible fate, the Bridge of Sighs, in Venice.

Wordsworth crossed Westminster Bridge early on 31 July 1802 – as his sister Dorothy's journal establishes[1] – on his way by coach to Dover. Though Pierre-Jean Grosley's *A Tour to London* (1765) suggests that it was difficult to view the river from road level, through the balustrade, we learn from the journal *Low Life* that hundreds of people used it 'for the benefit of the air, looking at the boats going up and down the river and sitting on the resting benches'.[2] The precise circumstances in which Wordsworth wrote his famous sonnet 'Composed upon Westminster Bridge, September 3, 1802' are obscure. But the wide view up- and down-river from a coach must have been decisive in helping him to realize on 3 September that reconciliation he describes between the Old City under the morning light, which on another day fifty years before had attracted Canaletto, and the river 'gliding at his own sweet will'. The bridge is not mentioned in the poem, but it cannot be doubted that the fact of the poet's presence on it, given in the title, is meant to be no less specific than the date, and time of day.

No painted equivalent of Wordsworth's poem exists, though Thomas Girtin's great panorama the *Eidometropolis*, the 'Great Picture of London' (1802) – prepared from a viewpoint near the south end of Blackfriars Bridge but now lost – perhaps came near to it.[3] In the painting

47 by Agasse we are not so very far from the documentary intentions of Samuel Scott in the eigh-
teenth century. London is awake to its daily life and activity, some of which is here seen in
close-up. But though there is nothing here of Wordsworth's sleeping city 'open unto the fields
and to the sky', the picture catches something of the sunlit freshness of the sonnet.

Wordsworth's optimism impelled him to think in terms of links rather than separations: to
see man joined to the natural environment, or, as he expressed it in another poem: 'The gravi-
tation and the filial bond / Of nature that connect him with the world.'[4] This bond was most
evident in rural locations: and Cornelius Varley seems to have experienced his own version of

48 it, which included a bridge. While north Wales was to present many subjects which could lay
hold of the viewer's sensations as intimately as Varley makes Cader Idris and the Mawddach
valley do here, the English Lake District was to be equally prominent. Varley was only a
decade younger than Wordsworth, whose descriptions of the scenery of the Lakes came out in
various editions in the next few years. These were to claim them as 'a sort of national property,
in which every man has a right and interest who has an eye to perceive and a heart to enjoy'.[5]
Meanwhile, on Westminster Bridge in 1802 Wordsworth had seen even the City of London as
part of a larger whole: 'Ne'er saw I, never felt, a calm so deep', he had written, in a year which
had seen an end (destined to be temporary) to the war with France.[6]

From 1815, with the end of the Napoleonic Wars, Europe was to enjoy a more lasting peace.
But political settlements often merely papered over serious cracks. Venice's power as an inde-
pendent republic and empire, long declining but enduring for centuries, was over, and the city
was occupied by Austria. In contrast to Wordsworth's Westminster Bridge, the Bridge of Sighs
at Venice formed the subject for very different musings by Byron as he stood on it and medi-
tated upon the fateful, constricting proximity of a palace on one hand and a prison on the
other, in lines that were to begin Canto IV of *Childe Harold's Pilgrimage* (1818).[7] Here the specific
location gave rise to wider and essentially pessimistic reflections on its past. Those who made
their way over the Bridge of Sighs were not seen as they crossed, and might emerge only as

49 corpses for burial. Etty's picture catches the mood precisely.

The contrasting elements of Byronic and Wordsworthian feeling have often been linked,
respectively, with the work of the two great landscapists Turner (1775–1851) and Constable
(1776–1837). Their bridge paintings to some extent bear out the point. Turner paints the Bridge
of Sighs more than once and becomes imbued with the notion of the decline of Venice; while
Constable spends thirteen years (1819–32) working on the theme, not of Westminster Bridge,
but of John Rennie's new structure across the Thames that was named after the battle of
Waterloo and that was also painted by Agasse. These two themes, it could be said, point to
basic affinities in each painter: of Turner with the fatalism of Byron's *Childe Harold*; of
Constable with accommodating his art of cornfield and hedgebottom to the 'mighty heart'
that Wordsworth had characterized in his sonnet on modern London. Cautionary notes need
to be sounded: Turner was no tormented wanderer, and Constable seems to have preferred
Cowper to Wordsworth on 'Religion and Nature'. There is, perhaps, more that their bridge
pictures can show us.

Before coming to Turner and Constable, we need to look more widely at a variety of other
artists: Blake and some younger contemporaries – Delacroix, John Martin, Thomas Cole,
Schinkel, Købke – each of whom takes up the idea of the bridge as a crossing-place, and finds

50 something different there. Delacroix, painting *Tam o'Shanter*, chooses a story in which the
main character (he is no 'hero') is pursued to the centre of a bridge by witches and nearly loses

51 his life. Blake's *Pit of Disease*, depicting Dante's *Inferno*, shows human beings turning to stone

inside rock-bridges. Martin powerfully projects Milton's bridge over Chaos, from *Paradise* 53
Lost. Cole makes Adam and Eve flee from Eden across a natural rock-bridge. Schinkel, on the 54
other hand, shows a bridge which leads people to a cathedral. Both Cole and Schinkel use the 55
time-honoured idea of the bridge as link. But Købke brings humanity before us on a draw- 56
bridge, the kind of bridge which is crossable only when it is lowered.

In Chapters 1 and 2 we saw many examples of the bridge as link, though in the case of Tom
Paine's iron arch we noticed an idealistic scheme which remained unrealized. This might
seem a classic example of what could be called the bridge as 'missed connexion'. 'The world is
a bridge: pass over it; but build no house there,' Akbar the Great's inscription enjoined. But
many of Europe's artists who lived through the Napoleonic Wars and their disillusioning
aftermath would have found difficulties with the second and third parts of this. What their
very diverse uses of the bridge motif shows is that they were full of a sense of what it was to
attempt to pass over, but also of the constraints which weighed against actually doing it.
Delacroix's bridge is a marker between life and death; Blake depicts it as a tomb in Hell,
Martin as an uncertain path over chaos, Købke as a place of waiting or transition between past
and future. All are conscious of connexions which might be missed or which have been
missed. A final point deserves notice: all these artists are operating as northern individualists.
Though none could ignore the cultural legacy of Italy, all were primarily motivated by their
own imaginations. In *Tam o'Shanter* Delacroix imagines the nightmare climax of Burns's
Scottish poem; Blake's vision of the Italian Dante's *Inferno* has his own brand of Gothic as well
as classically derived energy; Martin recreates Milton in the London subterranean tunnels that
he knew; the young Dane Købke paints his own boyhood world. Of all these artists, only
Købke was to go to Italy where, cut off from his native surroundings, his personal vision was
to lose much of its vitality.

One major artist of the period, however, did go to Italy – repeatedly – and savoured the
notion of classical triumph, while devoting much thought also to the themes of the perish-
ability of human aspiration and the uncertainties of the path ahead. This was J.M.W. Turner.

Turner drew bridges wherever he went, in Britain in the 1790s and on the continental trips
that began in 1802 and continued after the Napoleonic Wars for the rest of his life. Much of this
interest in bridge-subjects arose from his work for publishers of picturesque views; but his
concern went far beyond the demands of topography. In particular, the theme of human life
squaring up to the obstacles placed in its way by nature engrossed him. He sometimes liked to
leave the outcome of this in doubt. His Hannibal in *Snowstorm, Hannibal and his Army Crossing*
the Alps (1812) is all but overcome by an onslaught of nature. Hannibal's exploit results in no
bridge-building feats of the kind commemorated by Wilson. But in Turner's two versions of 33
the *Burning of the Houses of Lords and Commons* (Cleveland, Ohio, and Philadelphia), we have 57, VIII
the disturbing impression that the man-made path of Westminster Bridge actually leads into
the flames.

Though the subject of this historic fire in London was bound to arouse a strong response in
Turner, the contrasting uses made of the bridge theme throughout his career point positively
to his awareness of the dramatic contribution it could make to pictorial effect. In fact these
Houses of Parliament paintings are part of a sequence of bridge works which represent a vital
strand in Turner's imaginative life: some earlier examples will be identified later (p. 111). As 58
always with Turner, his imaginative coups were backed up by unremitting observation, as a
copyist of other men's drawings, as a student of Piranesi, as the Royal Academy's professor of
perspective (1807–37) and as traveller in the congenial surroundings of the Alps, or of

Florence, Rome and Venice. A sustained study of Claude leads to a familiarity with the
Italianate bridge before he sees Italy.[8] *Apullia* is based on Claude's great *Jacob and Laban* at
Petworth, but introduces an asymmetrically placed tower on the bridge. Ruskin recognized
'living balance' in Turner's representations of another towered bridge, that over the Moselle at
Coblenz, a favourite of the artist, the only non-Swiss subject among the 'Swiss' group of
watercolours of 1842.[9]

Turner might be said to have turned the bridge subject to advantage in two particular ways.
First, as a natural exponent of the sublime, he sought for exhilarating effects of height over
space: short of making a journey by balloon a sense of this could only be given in his day by
standing, as Turner did in 1802, in the centre of such a structure as the Devil's Bridge in the
Alps. A compounded excitement was offered by the experience of crossing at speed Brunel's
new Maidenhead bridge in a railway train, forty years later. Secondly, Turner is interested in
extending ways of making sunlight advance by beaming, framing and re-concentrating it,
with all his command of colour, either towards the spectator (as in the *Blenheim* or *Rialto* draw-
ings) or sideways (as in *Ancient Rome*, with its marvellous pearly greys).

The sheer number and variety of Turner's bridges – single-arch, multi-arch, complete,
broken, ranging from Scotland to the Danube – invite us to see him as a more optimistic figure
than he is often made out to be. Pessimism, as Ruskin contended, is there: Caligula's bridge of
Baiae (1831) relapses into a twilight of time, and is hardly recognizable for what it was; it is
now the archetype of the missed connexion. But *Ancient Rome*, eight years later, shows the
'Triumphal Bridge and Palace of the Caesars Restored'. And *Rain, Steam and Speed* of 1844 is
manifestly a celebratory coup. In *The Dawn of Christianity* (1841), another late work, the bridge
is broken, but, as we shall see, the implications for humanity do not seem to be without hope.
However grounded in factual observation, Turner's bridges in such works become constructs
of his imaginative world, revealing, in their building, human daring, or, if broken over water,
human vulnerability. Keenly responsive to his own sense of displacement – at sea, on a moun-
tain pass – he found the bridge-experience indispensable.

Where bridge-pictures jostle for attention with Turner, it is very different with Constable. In
Constable's case only two really matter: *Waterloo Bridge* and *The Leaping Horse*. These, how-
ever, make a compelling, if unlikely, combination. *Waterloo* took him thirteen years, *The
Leaping Horse* six months, plus, as was his wont, time for small revisions. *Waterloo* is about a
specific occasion, the opening of a new bridge, with appropriate pageantry, in London; *The
Leaping Horse* is about an everyday event in Constable's own rural Suffolk. *Waterloo* is full of
signals of the location, but has no single dominant action. Though it has been contended that
the horse-rider jumps from Essex into Suffolk, *The Leaping Horse* has no certainly identifiable
landscape; but it does have, supremely, an heroic central action. Both works belong to
Constable's busy maturity in the 1820s. There is no doubt about which gave him greater satis-
faction: his complaint about *Waterloo Bridge* was that 'it has not my redeeming voice ("the
rural")'. But he persevered with it to the end.

If bridge subjects which develop beyond open-air sketching into major works are far fewer
in Constable than in Turner, we might consider two possible reasons. First, his feeling for 'wil-
lows, old rotten banks and slimy posts' expressed in a famous letter of 23 October 1821.[10] The
rurality of such themes took in primitive structures of the kind shown in *The Leaping Horse*,
but, *pace* Waterloo, questioned bridges of pretension. There are no equivalents of Cotman's
Greta Bridge in the oeuvre of Constable. Second, the greater and more intense Constable's
feeling for the small, secreted constituents of his Suffolk scene, the more selective and indeed

59, 8

58
65

60, 61
63, IX

62
63
65
64

66, 67

exclusive became his attitude to those larger contributions of man which made nature subordinate. His favourite landscapes were certainly inhabited, but evidence of human power to change them never calls attention to the fact. There is no equivalent of Cotman's *Chirk Aqueduct* in his work. It is no accident that he valued Rubens's landscapes so highly. Here, bridges are rather rare except as incidents.[11] And so it is with Constable's most considered work.[12] But in *The Leaping Horse* the conditions are met: the bridge is both primitive and a working part of its landscape.

The improved transportation facilitated by new bridges in the nineteenth century was to make many older bridges in out of the way places more accessible. From Turner down to Brangwyn artists would visit them.[13] Romantics and post-Romantics spend much time raising question-marks on them. In Turner's *Rain, Steam and Speed* the forward surge of the train's passengers away from the ploughman and the old road bridge suggests, on the whole, a positive move that is taking place from countryside to city. On the other hand, Constable's leaping horse asserts the continuity for him of his boyhood's rural life. In both pictures the Romantic dilemma of the forward movement that might prove a missed connexion appears to receive an optimistic answer. Constable's rider, indeed, also surmounts a positive barrier.

The questions, of course, were not over. The railway age would accentuate the prevalence of the bridge in landscape and its role as conveyor: and the railway bridge and viaduct would be two of the formal presences which would fascinate the artist. In a period of rapid acceleration in the pace of life, the exposed nature of the bridge would prompt further reflections. How this would be so is the business of Chapter 4.

Notes

1. *Journals of Dorothy Wordsworth*, ed. W. Knight (London: Macmillan, 1930), p. 144.
2. Pierre-Jean Grosley, *A Tour to London or Observations on England and its Inhabitants* (1766), p. 27; *Low Life* (1764), p. 72. Quoted in R.J.B. Walker, *Old Westminster Bridge, The Bridge of Fools* (Newton Abbot: David and Charles, 1979), pp. 265–6.
3. This was in oil, but the British Museum possesses five sheets of watercolour drawings (1797–8) for it, including a prospect along the river towards London Bridge, repr. in colour in J. Wordsworth, M.C. Jaye and R. Woof, *William Wordsworth and the Age of English Romanticism*, exh. cat. (New Brunswick and London: Rutgers University Press, 1987), p. 136.
4. Wordsworth, *The Prelude*, Book II (publ. 1850 [written 1805]), lines 243–4.
5. The first version was written as an anonymous introduction to the Rev. Joseph Wilkinson's *Select Views in Cumberland, Westmorland and Lancashire* (1810); a revised text under Wordsworth's name came out in 1820, and a freshly revised pocket guide with folding map in 1822. This sold out quickly and a fourth edition, *A Description of the Scenery of the Lakes in the North of England*, was published in 1823. A fifth appeared in 1835.
6. For discussion of Wordsworth's sonnet in the context of seeing the city 'like the country' see Wordsworth, Jaye and Woof, *William Wordsworth*, pp. 135–6.
7. Byron, *Childe Harold's Pilgrimage*, canto IV (1818), lines 1–2.
8. For various reasons – the Napoleonic Wars, the extent of his own commitments to publishers – Turner was to be 44 before he saw Italy. But the years 1802–14 afforded ample opportunity for his study of Claude's Roman landscapes, including the Petworth *Jacob* (Fig. 8). His first-hand study of Walton bridges near London is related to the Claude-like composition in the print 'Bridge in the Middle Distance', 1808, from Turner's *Liber Studiorum*, with its echoes of Claude's idealizing of Italian light and landscape. In *Dido and Aeneas* (oil, 1814, Tate Gallery, Butlin and Joll 129) – his first picture on a theme connecting life, love and the destinies of Carthage and Rome, which was to recur – the Claudean bridge is brought forward to the lower right. It is a triumphal bridge: lightly

drawn figures surge across it to join the royal party in the foreground, underlining the bridge's function as means of escape from city to country. Queen and hero stand at the near end of it, about to enter the 'shady woods', as they are described in the verses from Dryden's translation of Virgil's *Aeneid*, which Turner appended to the Royal Academy catalogue of the summer exhibition. In *Crossing the Brook* (oil, 1815, Tate Gallery, B and J 130) an Italianate middle distance is again reined in by a stone bridge, identified by Charles Eastlake as 'Calstock Bridge' (but more probably Gunnislake Bridge) on the river Tamar. Cyrus Redding tells us that 'Turner was struck with admiration at the bridge above the Wear, which he declared altogether Italian'. It is a classic instance of Turner's marrying together a first-hand encounter with the Claudean ideal.

9. Cooke and Wedderburn reproduced a copy of this made for Ruskin (probably by William Ward) in E.T. Cooke and A. Wedderburn, eds, *Works of John Ruskin*, 39 vols (London: George Allen, 1903–12), vol. XIII, pl. xxii. In his *Elements of Drawing* (1857) Ruskin sets out his responses to Turner's drawing of this bridge, with its tower and unequal arch-widths (see Cooke and Wedderburn, op. cit., vol. XV, pp. 166–76).

10. Constable, letter to Archdeacon Fisher, 23 October 1821, in *John Constable's Correspondence*, ed. R.B. Beckett (Ipswich: Suffolk Records Society, 1968), vol. VI, p. 77.

11. See Introduction, pp. 18–19.

12. An exception is the prominent, high (but rather distant) wooden bridge in *View on the Stour at Dedham*, one of the great 'six-footers' (oil, 1821–2, Henry E. Huntington Library and Art Gallery, San Marino, California).

13. Sir Frank Brangwyn (1867–1956) was to devote a whole collection of his drawings to the bridge, published as *A Book of Bridges* by the Bodley Head, with text by Walter Shaw Sparrow, in 1915 (reprinted 1925). This would take in a great range of examples, as Turner had done: from Roman structures in the Campagna to the dramatic medieval bridges reaching over chasms, as at Laroque on the river Lot near Cahors.

47

47 Jacques-Laurent AGASSE (1767–1849)
Landing at Westminster Bridge
Oil, 35 × 53.5 cm (13 3/4 × 21 in.), 1818

Agasse, born in Geneva, had had a Paris training under David, and had settled in London in 1800. A large picture with this title shown in the Academy in 1818 is untraced. A pendant to the present small version, looking upriver towards Lambeth, is in the Fondación Thyssen-Bornemisza, now in Madrid. Both pictures make use of the Canaletto formula of the view through an arch of Westminster Bridge (1746–7, Fig. 18a), which Scott also employed (Fig. 24 and Plate II).

Agasse's classicist turn of mind is reflected in the long, bright horizontal Waterloo Bridge, which comes precisely halfway up the canvas (contrast Canaletto enjoying the curve of Westminster Bridge in the interests of movement, Fig. 21). The strict horizontality of the new engineers' bridges also attracts Constable (Fig. 66), Cotman (Fig. 69), Cézanne (Fig. 73) and Seurat (Fig. 90).

The picture depicts the nature of river life in the populous reach between Westminster and the new bridge at Waterloo, completed by John Rennie with nine granite arches in the previous year (see also Fig. 66). In the tonally subtle scene beyond the arch a group of figures prepares to depart, while on the open river we see sailing ships, a rowing boat and a rowing four. Somerset House, respectably established symbol of eighteenth-century classical authority in architecture, is shown beyond Rennie's bridge that is so new to the London scene.

The picture also concentrates action near to us under the Westminster arch. A boy pulls a boat in; a boatman offers his arm to the woman who steps ashore. A solemn-looking boatman with an oar like Father Time's scythe over his shoulder, comes in from the left. 'All experience is an arch,' Tennyson (perhaps thinking of a bridge-arch) was to make his hero Ulysses say thirteen years later, adding 'wherethrough / Gleams that untravelled land.'[1] Agasse's uncomplicated characters are plainly much travelled, and his landing is an everyday happening. And yet the glint of light falling on our side of the arch and the unexplained shadow cutting it off, add an unexpected touch of mystery.

1. Tennyson, 'Ulysses' (written 1833, published 1842).

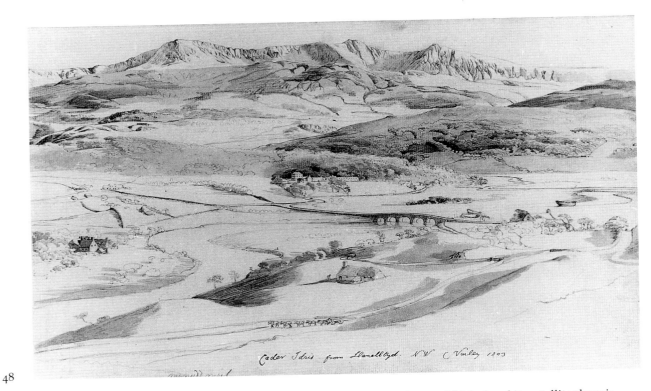

48

48 Cornelius VARLEY (1781–1873)
Cader Idris from Llanelltyd
Pencil and wash, 25.5 × 42.3 cm (10 × 16 ½ in.), 1803

In the early part of what has become known as
Wordsworth's 'great decade', 1797–1806, Thomas Girtin
(1775–1802) was introducing a new spontaneity in
watercolours of country and town that offers certain
parallels to the poet's work. In 1803 Cornelius Varley,
touring Wales, wrote in his journal about the 'increasing
brilliancy and grandeur of the scene' as he climbed Cader
Idris, and produced a number of rapidly brushed-in
watercolours, as well as some pencil drawings with wash.
These combined large and small forms in big, panoramic
effects.

In the present picture the bridge over the Mawddach
river is the compositional key, receiving the lines of the
foreground slopes and redirecting the road that crosses it
into depth. But Varley has also made it one of a series of
horizontal motifs which are placed one above the other:
its five strung-out arches link the minute waggon train
with five horses below and the immense, buttressed
spread of the mountain above. There is an affinity with
those Chinese landscape paintings in which minimized
foregrounds appear to be overlooked by highly focused
features further off. The detail that Varley reveals on the

distant crest of Mynydd Moel and its satellites here is
almost touchable. And so it is with the bridge, which he
brings forward by tonal accentuation and by suppressing
surrounding forms (only the boathouse and hulk are
near). But the effect is only quasi-oriental: the essential
debt is to the way of linking the observer with nature of
his own and Wordsworth's generation (see p. 88).

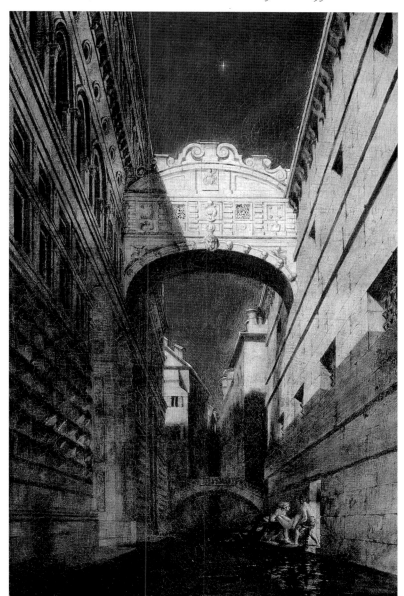

49 and Plate VII William ETTY (1787–1849)
The Bridge of Sighs, Venice
Oil, 80 × 50.8 cm (31 ¹/₂ × 20 in.), R.A. 1835

The Bridge of Sighs (Ponte dei Sospiri), by A. Contino (1589), led from the offices of the State Inquisition in the Doge's Palace to the prisons.[1] It was an obvious subject for artists and writers. William Beckford had shuddered as he passed beneath it in August 1780.[2] Byron was there in 1817, and his famous lines that begin Canto IV of *Childe Harold's Pilgrimage* (1818) were read by all educated Europe:

> I stood in Venice, on the Bridge of Sighs;
> A palace and a prison on each hand.[3]

Among artists who drew the Bridge of Sighs we must note Samuel Prout, who sold a view of it to Charles Holford in 1825,[4] and Turner, who also exhibited a painting of it at the Royal Academy in 1840, with a misquotation of Byron's lines.

Etty's sombre painting comes closest, however, to capturing the feeling of regret that many of his generation associated with the decline of Venice from its former greatness. Etty had made a drawing of the Bridge of Sighs in 1823, and, with this oil twelve years later, showed the effect of it in a nocturnal composition which could not differ more from Canaletto's response to the daylight spaciousness of Westminster Bridge or Wordsworth's later sense of that bridge's openness. On the contrary, Piranesian fears congregate here. The walls of palace and prison come quickly forward to include us in a scene where, below, the body of an executed criminal is placed in a boat for burial in the lagoon. Above, the bridge hangs aloof, like the symbol it was. Shadow divides it. A single star introduced for contemporaries a further note of awe.[5] 'It is to me poetry on canvas', reported the actor Macready, who bought Etty's picture in 1840: 'The story of that gloomy canal and its fatal bridge is told at once; there is a history before you, and a commentary upon it in the single star that is looking down upon the dark deeds below.'[6]

1. M. Muraro, *New Guide to Venice and her Islands* (Florence: Arnaud, 1956), p. 251.
2. *Travel Diaries of William Beckford of Fonthill*, ed. Guy Chapman, 2 vols (London: Constable, 1928), vol. I, p. 98.
3. *Lord Byron: The Complete Poetical Works*, ed. J.J. McGann, 7 vols (Oxford: Clarendon Press, 1980–93), vol. II (1980), p. 126. Cf. Byron's *The Two Foscari* (1821), act iv, scene 1: 'In Venice "but"'s a traitor. / But me no "buts", unless you would pass o'er / The Bridge which few repass' (ibid., vol. VI, 1991, p. 183).

4. R. Lockett, *Samuel Prout 1783–1852* (London: Batsford with Victoria and Albert Museum, 1985), p. 29.
5. Lindsay Stainton, *Turner's Venice* (London: British Museum Publications, 1983), p. 49, comments that a watercolour on brown paper by Turner, probably of 1833 (TB CCCXIX.5), appears to take up Etty's symbolism (the star above and the criminal's corpse below).
6. *Macready's Reminiscences*, ed. Sir Frederick Pollock, Bart (1885), vol. II, pp. 161–2, entries for 24 and 25 June 1840. William Charles Macready (1793–1873) was to develop a keen interest in Venetian history through his acting roles. Having played Shylock at Christmas 1841, he took the main part five months later in Byron's *Marino Faliero*, with its Venetian setting and violent ending.

49

50

50 Eugène DELACROIX (1798–1863)
Tam o'Shanter
Oil, 25.6 × 31.7 cm (10 × 12 ¹/₂ in.), *c.* 1829

This subject, reflecting contemporary French interest in Scottish life and literature, was first approached by Delacroix, it appears, in 1825, although his own account of reading Robert Burns's famous poem *Tam o'Shanter* (1791) comes in a letter of 1831: 'J'ai lu l'histoire de Tam O'Shanter dans la ballade même de Burns, écrite en écossais avec le patois très difficile à comprendre, qui m'était expliqué à mesure par une personne du pays.'[1] Delacroix was evidently not put off by the Scottish dialect but went to the trouble of having it translated for him.

Tam o'Shanter's story, part of oral folk tradition, had been written down and first published in F. Grose's *Antiquities of Scotland* in 1791.[2] The climax involves pursuit across a bridge. Tam is a farmer of Carrick who,

drunkenly passing Alloway kirk in the middle of the night, surprises witches and warlocks celebrating their Sabbath in the churchyard to the music of the Devil. He offers ribald comment and they pursue him. Safety lies in reaching the centre of the Brig o'Doon, as the power of the hellish pursuers cannot carry across running water. The bridge is thus a decisive divide at the moment of the dénouement, marking the very line between life and salvation on one hand, and death and damnation on the other. Tam narrowly escapes on his mare Maggie: but the animal's tail is pulled off just short of the centre of the bridge by the foremost witch.

Three versions of the subject appear to have been painted by Delacroix.[3] The present picture, probably the second and exhibited at the Salon in 1831, introduces an upright post on the 'safe' bank of the river to back up the bridge's role as marker. It is noticeable how the extended curves of horse and bridge complement each other close to the picture plane, assisting the loosely brushed-in

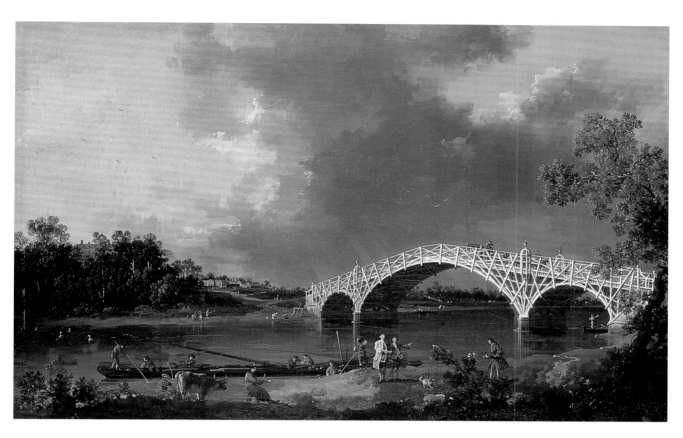

I CANALETTO (1697–1768)
Old Walton Bridge over the Thames
Oil, 48.8 × 76.7 cm (19 1/4 × 30 1/4 in.), perhaps 1754

See p. 38

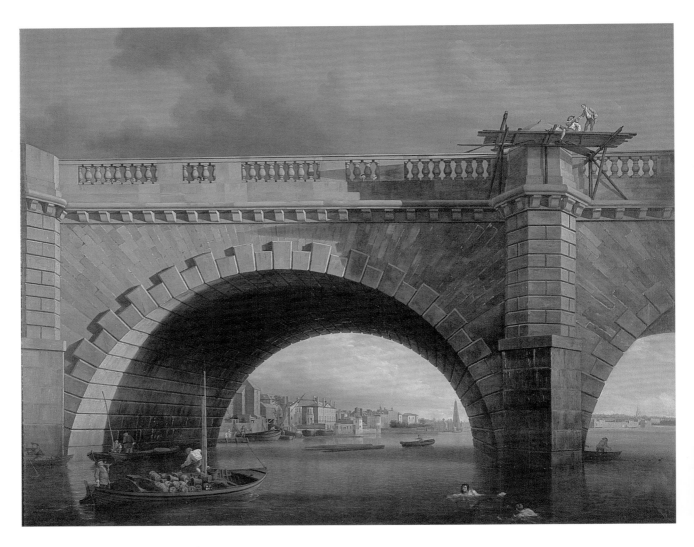

II Samuel SCOTT (*c*. 1702–72)
An Arch of Westminster Bridge
Oil, 135.5 × 164 cm (53 ¹/₄ × 64 ¹/₂ in.), *c*. 1751

See p. 43

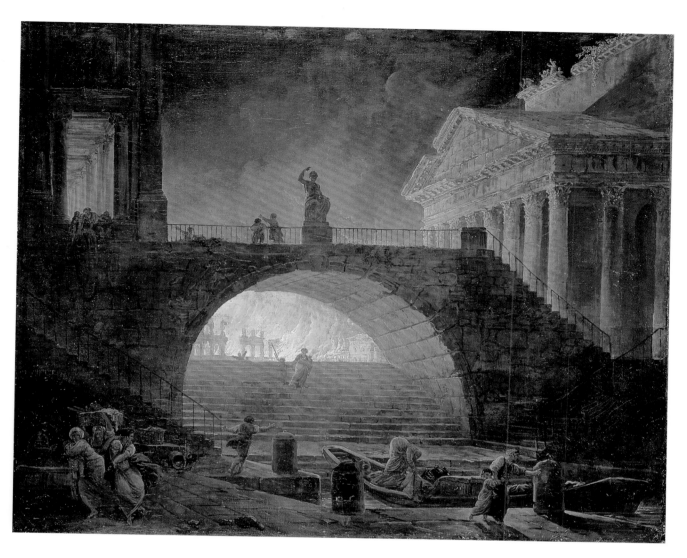

III Hubert ROBERT (1733–1808)
The Fire at Rome
Oil, 77 × 95 cm (30 ¹/₄ × 37 ¹/₂ in.), *c.* 1780

See p. 48

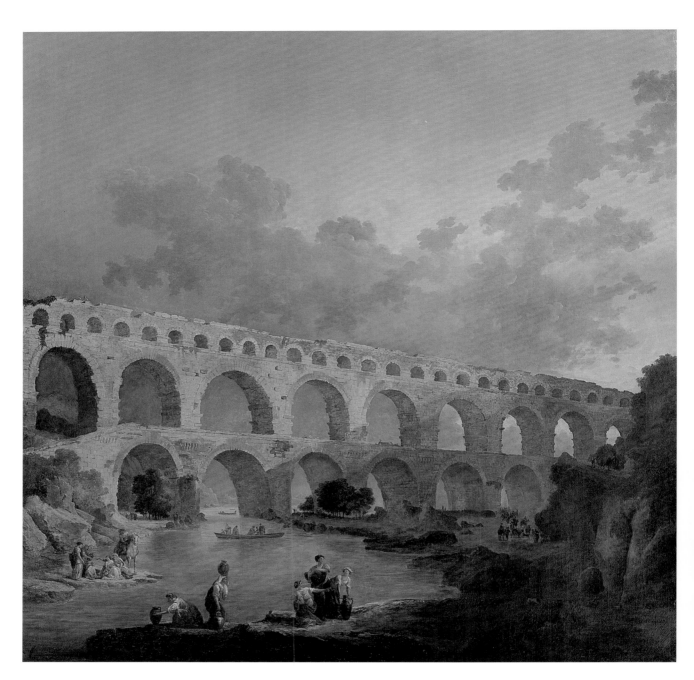

IV Hubert ROBERT (1733–1808)
Pont du Gard
Oil, 242 × 242 cm (95 ¹/₄ × 95 ¹/₄ in.), 1787

See p. 68

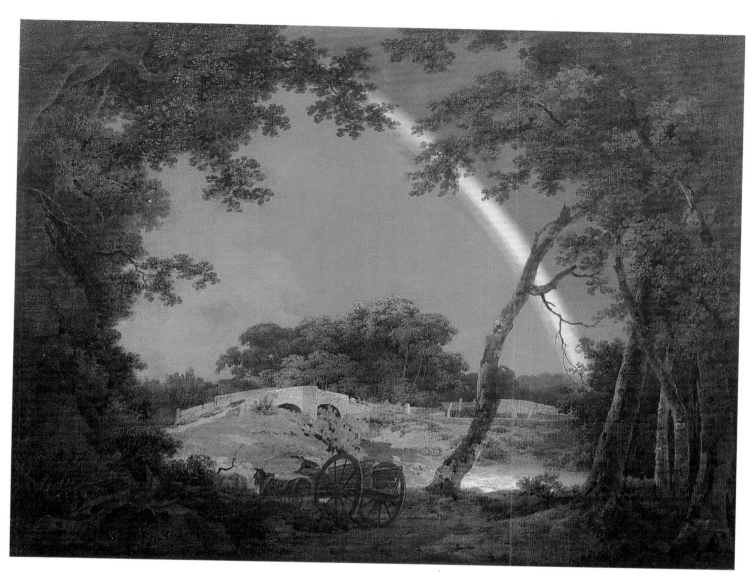

V Joseph WRIGHT of Derby (1734–97)
Landscape with a Rainbow
Oil, 81.2 × 106.7 cm (32 × 42 in.), 1794

See p. 77

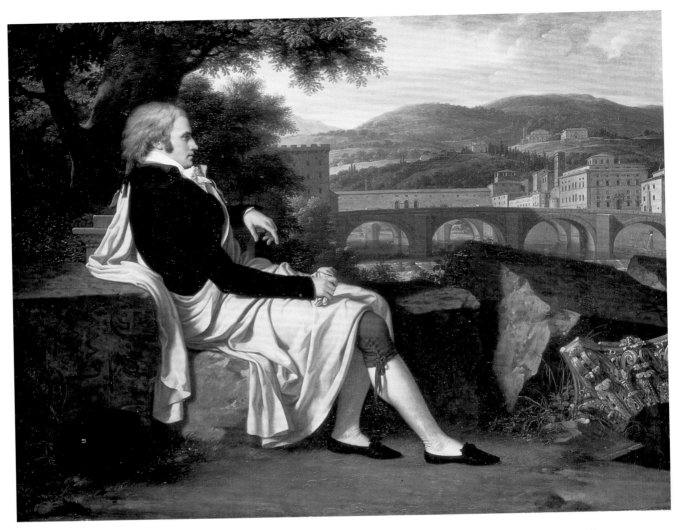

VI François-Xavier FABRE (1766–1837)
*Joseph Allen Smith contemplating Florence across
the Arno*
Oil, 70.9 × 90.5 cm (28 × 35 ¹/₂ in.), 1797

See pp. 84–5

right **VII** William ETTY (1787–1849)
The Bridge of Sighs, Venice
Oil, 80 × 50.8 cm (31 ¹/₂ × 20 in.), R.A. 1835

See p. 95

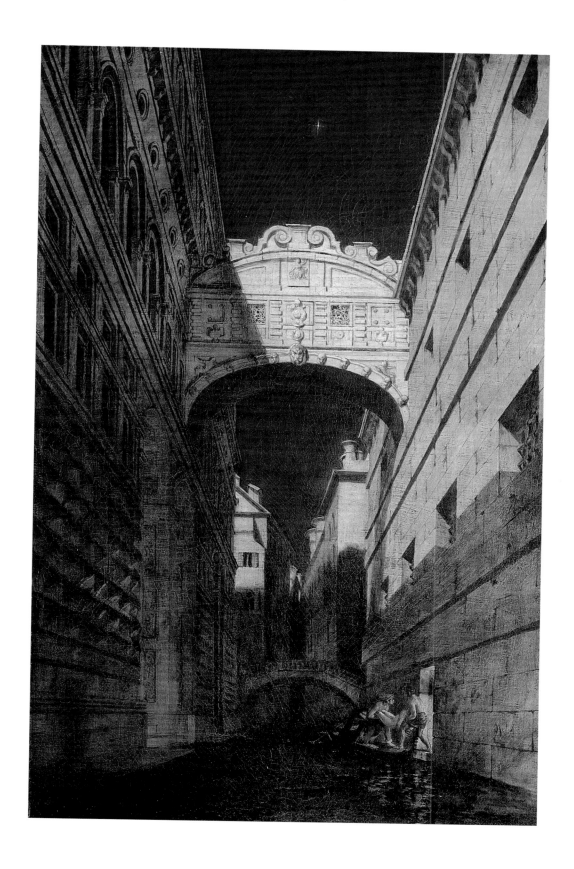

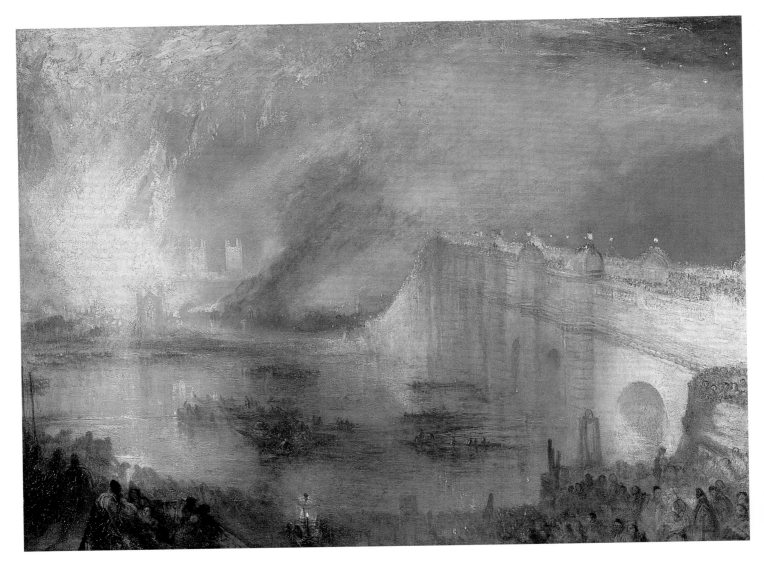

VIII J.M.W. TURNER (1775–1851)
*The Burning of the Houses of Lords and Commons, 16th
of October, 1834*
Oil, 92.5 × 123 cm (36 1/2 × 48 1/2 in.), 1835

See p. 108

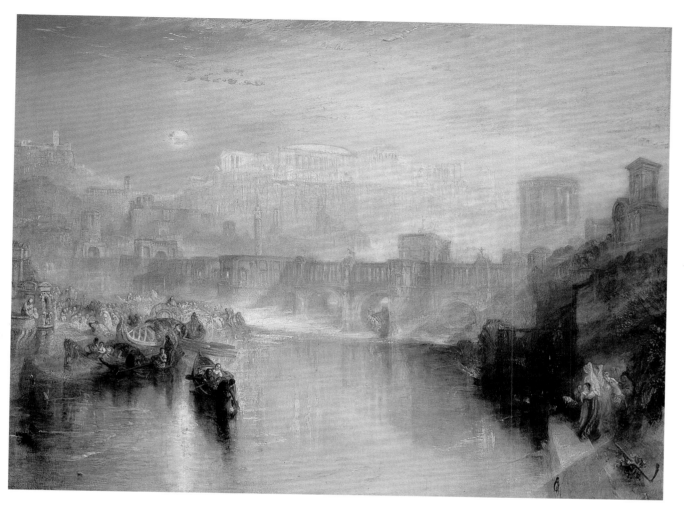

IX J.M.W. TURNER (1775–1851)
Ancient Rome: Agrippina Landing with the Ashes of
Germanicus. The Triumphal Bridge and Palace of the
Caesars Restored.
Oil, 91.5 × 122 cm (36 × 48 in.), 1839

See p. 116

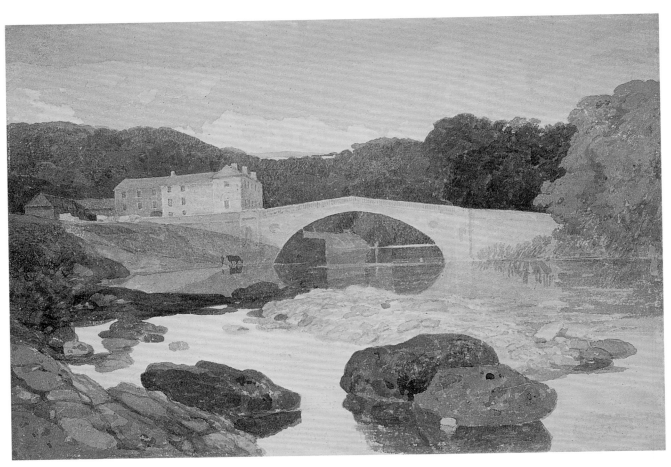

X John Sell COTMAN (1782–1842)
Greta Bridge, Durham
Watercolour, 22.7 × 32.9 cm (9 × 13 in.), 1807

See p. 137

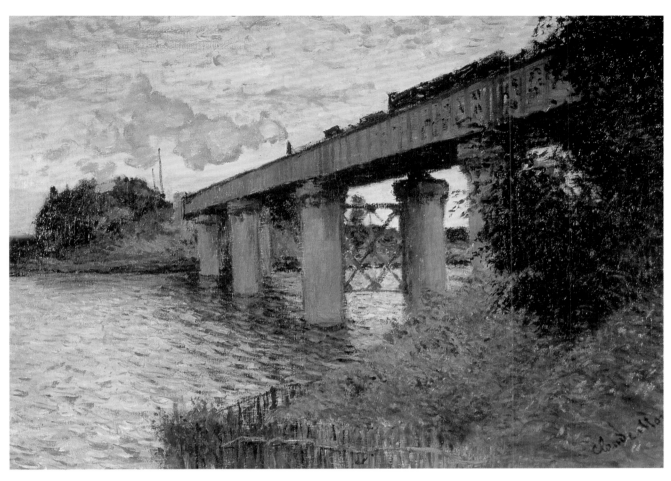

XI Claude MONET (1840–1926)
The Railway Bridge at Argenteuil
Oil, 54.3 × 73 cm (21 ¹/₂ × 28 ³/₄ in.), *c.* 1873–4

See pp. 154–5

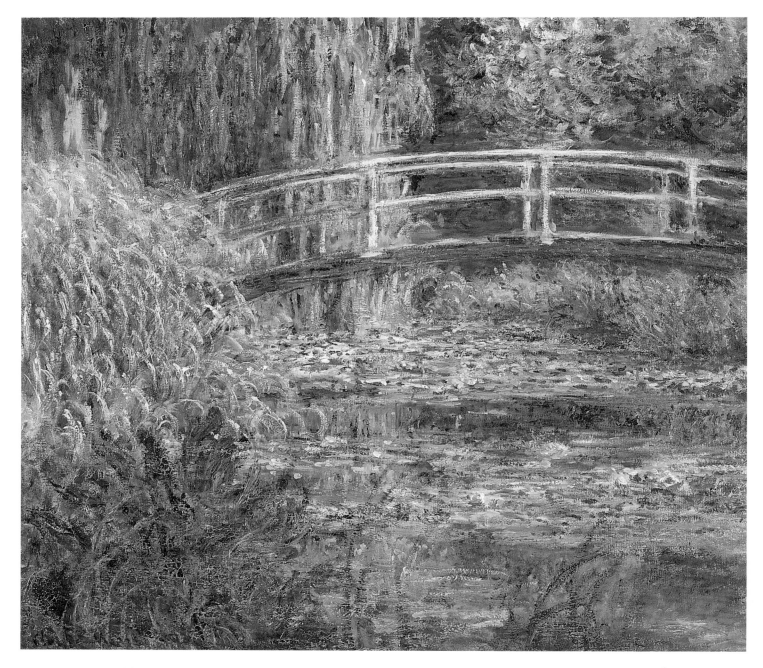

XII Claude MONET (1840–1926)
The Water Lily Pond (Japanese Bridge), Harmony in Rose
Oil, 89.5 × 100 cm (35 ¹/₄ × 39 ¹/₂ in.), 1900

See p. 159

right **XIII** Darío de REGOYOS VALDÉS (1857–1913)
Good Friday in Castile
Oil, 81 × 65 cm (32 × 25 ¹/₂ in.), 1904

See p. 160

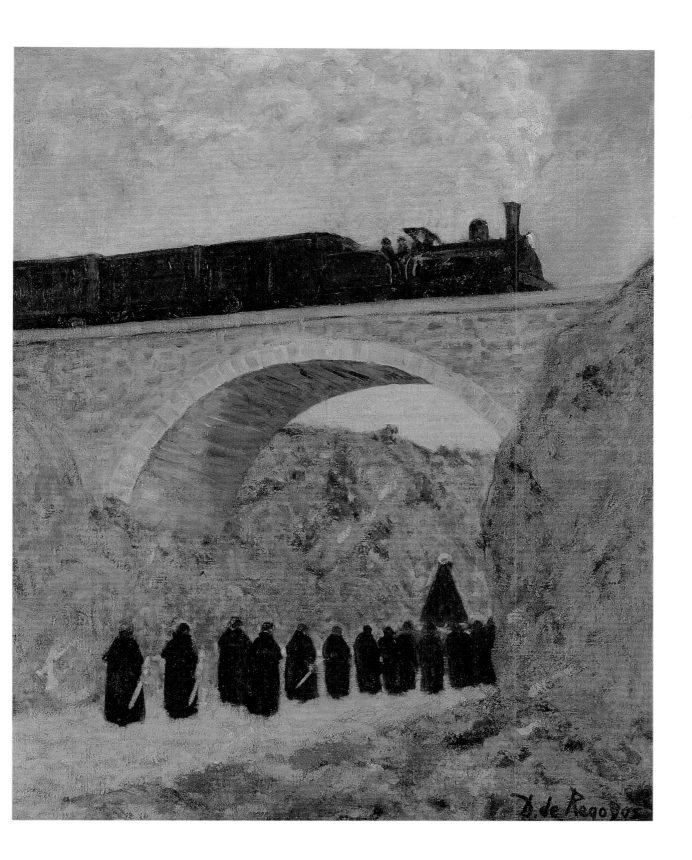

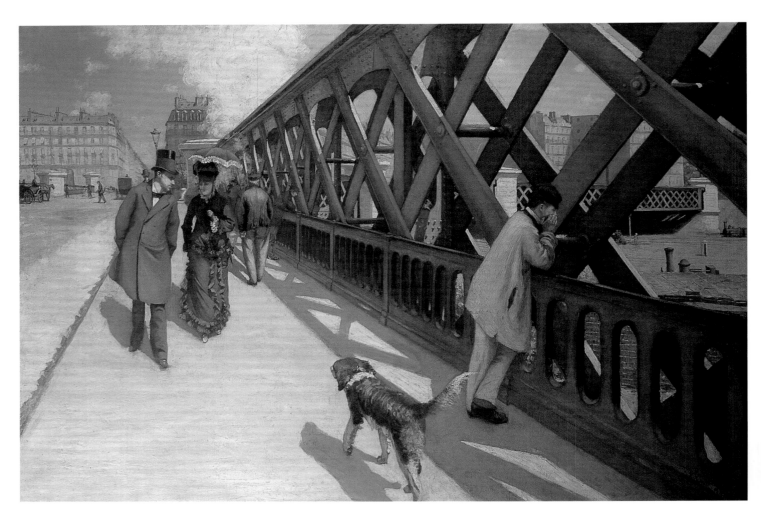

XIV Gustave CAILLEBOTTE (1848–93)
Pont de l'Europe, Paris
Oil, 124.7 × 180.6 cm (49 × 71 in.), 1876

See pp. 168–9

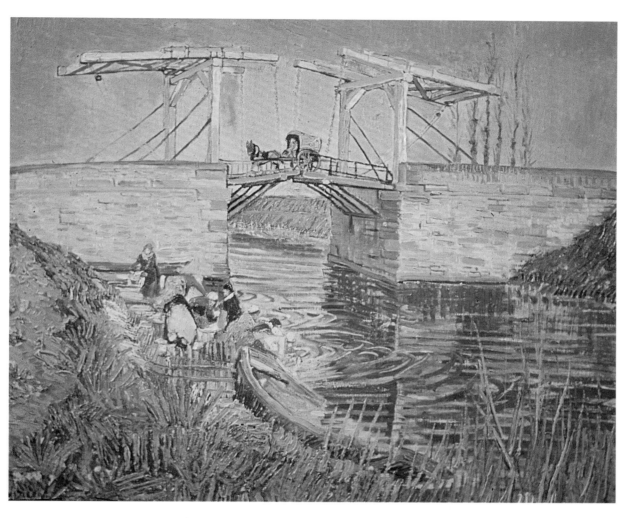

XV Vincent VAN GOGH (1853–90)
Drawbridge at Arles, 'Pont de Langlois'
Oil, 54 × 65 cm (21 ¼ × 25 ½ in.), March 1888

See p. 174

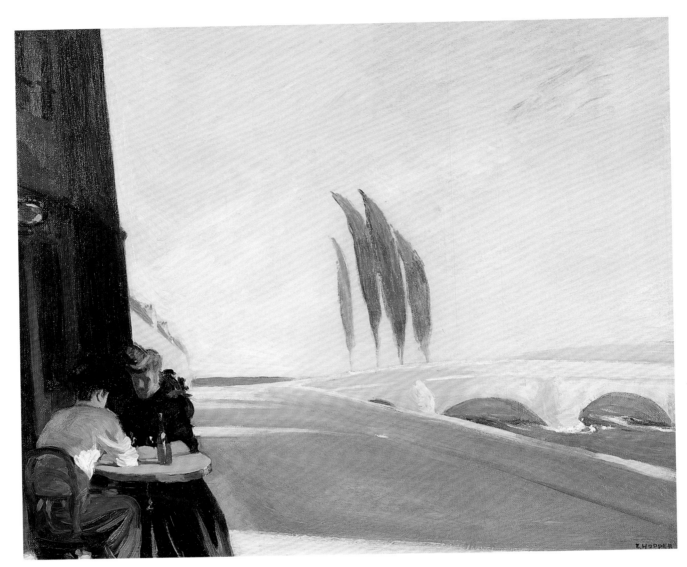

XVI Edward HOPPER (1882–1967)
Le Bistro or *The Wine Shop*
Oil, 59.4 × 72.4 cm (23 ¹/₂ × 28 ¹/₂ in.), 1909.

See p. 186

notations of paint to stress the essentials of the story
across the width of the picture.

Burns, as an Enlightenment figure and ready for the
supernatural to be laughed at, has a sceptical 'narrator' to
represent this in his poem. Delacroix, bound to the
moment he has chosen to paint, is concerned simply to
project the terrifying pace set by the hellish pursuers, and
the near-fatal contact that is being made. Tam is no hero
and, if he is saved, it will not be by any merit of his own,
but through the energy of his mare. It is possible that
Tam's story had an added attraction for Delacroix,
especially by the time of his third version of 1849, as part
of his pessimism about the drift of his times to
materialism. He had by then (1847) completed the ceiling
paintings in the library of the Chambre des Deputés at the
Palais Bourbon, Paris, in which he had depicted the story
of civilization, with the destruction of it by Rome's
enemy, Attila, at the end. It is worth recalling the words of
Kenneth Clark, near the end of his study of civilized
achievement in the West: valuing Delacroix for his sense
of man's need to sustain his creative energies in the face
of barbarism, he remarks that 'no-one realised better than
Delacroix' that we had so far got through by 'the skin of
our teeth'.[4] Perhaps Tam's involuntary deliverance, at the
centre of a bridge over water, acquires a certain irony.

1. *Correspondance générale d'Eugène Delacroix*, ed. A. Joubin,
 5 vols (Paris: Plon, 1935–8), vol. I, pp. 277f.
2. Announcing his intentions of gathering material for his book
 at Alloway, Grose was urged by Burns to make a drawing of
 the kirk: Grose asked the poet to provide a 'witch story' to go
 with it. See J.W. Egerer, *A Bibliography of Robert Burns*
 (Edinburgh and London: Oliver and Boyd, 1964), p. 342.
3. L. Johnson, *The Paintings of Eugène Delacroix, A Critical
 Catalogue*, 6 vols (Oxford: Clarendon Press, 1981–9), vol. I,
 pp. 94–6, 136–7, pls 95, 121. The first version, probably *c.* 1825,
 was reputedly for a Madame Dalton (now probably that in a
 Swiss private collection). The third, much larger, is lost and
 known only through a line drawing by Paul Chenay; it is
 probably that referred to by Delacroix, at Champrosay on
 17 June 1849, as among pictures in progress.
4. K. Clark, *Civilisation: A Personal View* (London: British
 Broadcasting Corporation and John Murray, 1969), p. 314.

51 William BLAKE (1757–1827)
'The Pit of Disease: The Falsifiers' (No. 58,
illustrations to Dante's *Divine Comedy*)
Line engraving, 24.1 × 33.8 cm (9 $^{1}/_{2}$ × 13 $^{1}/_{4}$ in.), 1827

Together with its share of optimism, Romantic art reflects
in full measure the idea of man at odds with his
surroundings (adrift, for example, on the open sea).
William Blake's depictions of Dante's rock-bridges, as
described in Canto XVIII of his account of the most
menacing of all locations, the Inferno, provide a
marvellous gloss on this. Dante writes of 'Malebolge' in
the Eighth Circle as composed of ten concentric trenches
(bolges), spanned from the centre by rock-bridges
(broken over the sixth trench).[1] Panders and seducers are
seen being driven in opposite directions by the whips of
demons; an effect that has been compared to the 'rule of
the road' enforced to control pilgrims on the Ponte
Sant'Angelo in Rome in the jubilee year of 1300, the year
of Dante's vision.[2] But Blake has his own revelation, in
the drawing 'The Devils under the Bridge' (no. 34 of his
series of 102 illustrations to Dante): the damned are
shown walled up in these rock arches as a symbol of
mental petrifaction. The design of no. 58 of the series
makes the idea even more vivid, since it was transferred
to the sharp burin line of engraving. Here separate stages
in the process of absorbing decomposed human bodies
into the immobility of rock are shown in the bridges. The
notion of reduplicated bridges as means of
communication in the sealed-off world of the prison,
ironically presented earlier by Piranesi (Fig. 19), achieves
an even more chilling statement in these designs by
Blake, in which the bridge-forms themselves become a
prison for fallen humanity.

While Blake rejected Dante's message of endless
retribution as the penalty for sin, he identified the Inferno
with Experience,[3] and evidently recognized Dante's
account as abounding, as life abounds, in images of the
unexpected and disruptive. The bridges of Malebolge
help Dante to advance, but immobilize the sinners. No
more extreme contradiction of the bridge's linking
function will be found than this.[4]

1. That Blake depicts bridges, not merely arches, is attested (i)
 by the lead given in Dante, who uses the word *ponte* to

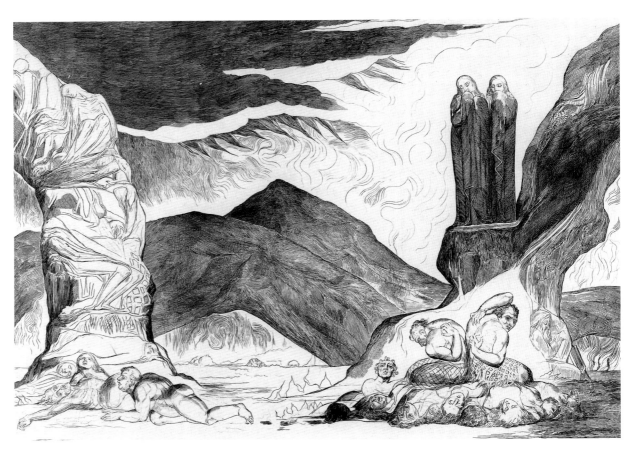

51

describe the structures he makes Dante and Virgil climb to cross over the trenches; and (ii) by Blake's depiction of the two protagonists actually crossing in no. 36, 'The Necromancers and Augurs'. See A. Roe, *Blake's Illustrations to the Divine Comedy* (Princeton, NJ: Princeton University Press, 1953), for discussion of the bridges. The illustration by John Flaxman (1755–1826) of 'The Pit of Disease' shows the sufferers in the foreground with Dante and Virgil viewing the sight from the bridge above. Blake's treatment has the two visitors standing upon a shelf on the bridge; but Flaxman's use of a very obvious bridge as vantage point is taken up by Friedrich Overbeck (1789–1869) in his drawing *The Wise and Foolish Virgins* (pen over pencil, 1846, Lübecker Graphiksammlung) as shown in D. Bindman, ed., *John Flaxman RA*, exh. cat. (London: Royal Academy of Arts, 1979), p. 178.

2. See Canto XVIII, lines 28–33 in *The Comedy of Dante Alighieri the Florentine, Cantica I, Hell (L'Inferno)*, tr. Dorothy L. Sayers (London: Penguin, 1957 [1949]), p. 182. Sayers points out (p. 186) that the Jubilee Year 1300, proclaimed by Pope Boniface VIII, brought congestion to Rome, and two-way traffic was set up on the bridge.

3. D. Bindman, *Blake as an Artist* (Oxford: Phaidon, 1977), p. 216.

4. Bridge myths of the walling up of human victims abound in many cultural traditions: cf. F.W. Robins, *The Story of the Bridge* (Birmingham: Cornish Brothers, 1954), ch. IV, 'The River Gods'. But the idea behind these stories was almost invariably sacrifice to river gods or spirits. Blake's incarcerated humans are there by their own fault, snared by their own crimes or misdemeanours.

52

52 John MARTIN (1789–1854)
'Proposed Triumphal Arch across the New Road
from Portland Place to Regent's Park'
Sepia, 30 × 45 cm (11 3/4 × 17 3/4 in.), 1820

If the bridge denies its linking character for Blake, who
uses it to convey his sense of self-deluding, captive or
fallen man, its public role as monument and vehicle of
heroic authority goes on, as this design to commemorate
the Duke of Wellington's victory at Waterloo shows.

Martin, born at Haydon Bridge on the Tyne, carried
into adult life memories of northern chasms and of
Newcastle upon the same river, a city then in process of
replanning and civic development. The former reappear
in works like his 'Bridge over Chaos' (Fig. 53); but the
latter emerges in the metropolitan planning
improvements that he undertook.

This unrealized design (1820) was in the form of a
triumphal arch to cross the east–west thoroughfare of the
'New Road' at the end of Portland Place. But it would
also have doubled as a bridge from built-up town to the
newly established Regent's Park of John Nash. Flanked
by gun-barrels, the arch was to have at its apex a short
column supporting Wellington's statue. But there were
steps up and over it, following Flaxman's design (1799)

for an arch to commemorate British naval victories
against Napoleon.

The manner in which Martin worked not only on
imaginative visions of ancient cities in dissolution but on
grandiose schemes for beautifying and draining London,
and so fused fantasy and practical proposal, has often
drawn comment. His Arch across the New Road and his
Bridge over Chaos make a piquant contrast. But it is hard
not to feel relief that Nash's picturesquely planned
transition from town to park was never compromised by
Martin's heroic architectural overkill. In its overweening
way, the arch would have provided for posterity a record
of national pride at a time when George IV was applying
his patronage to making the capital splendid. But its
message of glory and conquest would have looked
different to utopian planners as reformers like Robert
Owen strove to balance town and countryside for the
benefit of the common man, on whose behalf Martin
himself was to turn 'violently to politics'. And against the
propaganda value of the arch there was the growing
evidence of London's drift into industrial chaos, the
moral warning of which Martin would also underline
(see Fig. 53).

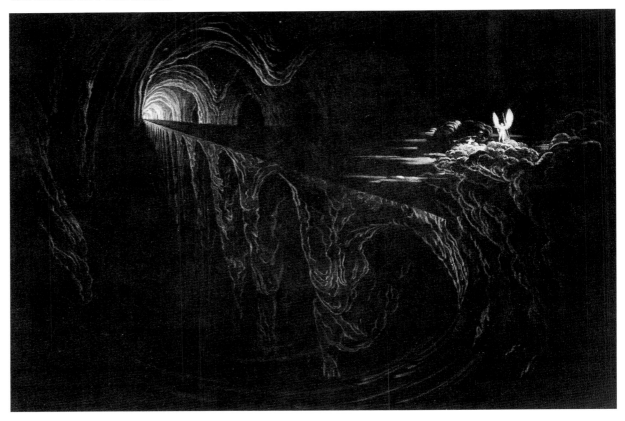

53

53 John MARTIN (1789–1854)
'The Bridge over Chaos', illustration to Milton's
Paradise Lost
Mezzotint on steel, 17 × 28 cm (6 3/4 × 11 in.), 1825

Martin's recreations of Babylon, Pompeii, Sodom,
Gomorrah and Pandemonium made him famous. Vast
distances, in which bridges often play a prominent part,
mark these compositions. Some of his most remarkable
imaginative flights, however, occur in the *Paradise Lost*
designs (1824–7). Here he introduced his knowledge of
the subterranean tunnels and vaults of London's
docklands, to the future planning of which he himself
contributed many ideas. His conception of Milton's
account of the building by Sin and Death of a path from
Hell to Earth, and a bridge inside nothingness, is an
unforgettable essay in that brand of the sublime, which
stresses, as Milton had done, the vertical as well as the
horizontal dimension:

> '. . . And the mole immense wrought on
> Over the foaming deep high arched, a bridge
> of length prodigious . . .'
> (*Paradise Lost* X, 300–302)

The tiny figures of Sin and Death cower before Satan;
parapet and ruler-sharp deck shoot back into the remote

distance, while the arches that have borne them slip away into apparently bottomless depths.

Martin's *Paradise Lost* designs were published in 1827. Parallels between their spatial extremes and railway viaducts, and with Marc Brunel's contemporary work on the controversial Thames Tunnel, have been made by Klingender, Pointon and others. On 10 November 1827 an underground banquet for 120 miners was held in the workings of the tunnel to allay public disquiet about its safety. When, on 10 January following, the tunnel partly collapsed, letting in the river, there must have been many who thought of Milton's Chaos as a living reality. Indeed Coalbrookdale under its Iron Bridge had already reminded some of it.[1]

The Bridge over Chaos idea had likewise been taken up as a figment of the taste for Gothic horror which had run for over a generation. Beckford, the builder of the neo-Gothic Fonthill Abbey (1796–1807), had previously introduced such a bridge into his oriental fantasy *Vathek* (written in 1782, published in English and French in 1786). Using the Muslim idea of *al Siral*, the bridge over Hell (see Introduction, p. 15), Beckford had recounted a journey through a weird country: 'Does the fatal bridge cross this lake, whose solemn stillness, perhaps, conceals from us an abyss in which, for whole ages, we shall be doomed incessantly to sink.'[2] Byron too had referred to the Muslim bridge: 'Though on Al-Siral's arch I stood / Which totters o'er the fiery flood.'[3]

After Martin's print the Bridge over Chaos theme was to be re-activated in the railway age. The notion of a railway bridge over a swamp on the route to the Celestial City appeared in Nathaniel Hawthorne's short story 'The Celestial Railroad' (included in *Mosses from an Old Manse*, 1845). This was a modern version of the *Pilgrim's Progress* (1678, 1684) of John Bunyan, whose Slough of Despond was crossed only by stepping stones. Hawthorne's satirical reference to a bridge which, despite foundations made up of books on French and German philosophy, sermons and scriptural commentaries, heaves up and down, is a lively transatlantic updating of a Miltonic image. The construction of railways in the 1840s also bred a sense of chaos in Dickens, as seen in *Dombey and Son* (1848 cf. p. 129).

Through the international popularity of his prints, Martin was a prime mover in spelling out for thoughtful contemporaries the fate that overtook ancient Babylon. London had been compared to Babylon by Cowper in *The Task* (1785, I, lines 722f.). Blake returned to the comparison in *Jerusalem* (1804–20, plate 84), and Byron in *Don Juan*, Canto XI (1819–24). Hugo and Balzac were to make the same parallel in respect of Paris. Blake's damned, as we have seen, were walled up in Hell's

bridges; Martin's schemes for London (Fig. 52) might look to a future Utopia, but his 'Bridge over Chaos' scarcely guaranteed a safe deliverance from life as it seemed to have become.

1. Cf. the Rev. J. Nightingale in J. Britton and E. Brayley, *The Beauties of England and Wales* 13, i, Shropshire (1812). For the Thames Tunnel see F.D. Klingender, *Art and the Industrial Revolution* (St Albans: Paladin, 1972 [1947]), pp. 106–7, figs 54–5; Marcia R. Pointon, *Milton and English Art* (Manchester University Press, 1970), p. 185; W. Feaver, *The Art of John Martin* (Oxford: Clarendon Press, 1975), p. 79; L.C.T. Rolt, *Isambard Kingdom Brunel, A Biography* (London: Longmans Green, 1957), pp. 22f.

2. See Beckford, *Vathek and other Stories: A William Beckford Reader*, ed. with notes and intro. Malcolm Jack (Harmondsworth: Penguin, 1995 [1993]), p. 74. A note to this passage, added to the 1786 edition of *Vathek* by Samuel Henley and approved by Beckford, refers to the Muslim bridge 'said to extend over the infernal Gulph'. Henley's sources were George Sale's preliminary discourse to his translation of the *Koran* (1734), IV, 121; and before this Edward Pococke's *Porta Mosis* (Oxford, 1655).

3. Byron, *The Giaour* (1813), lines 483–4. In his note to this line from one of his best-selling oriental poems, Byron refers to 'the bridge of breadth less than the thread of a famished spider, over which the Mussulmans must *skate* into Paradise, to which it is the only entrance'. See *Byron*, ed. Jerome J. McGann, The Oxford Poetry Library (Oxford: Oxford University Press, 1994), pp. 21, 45.

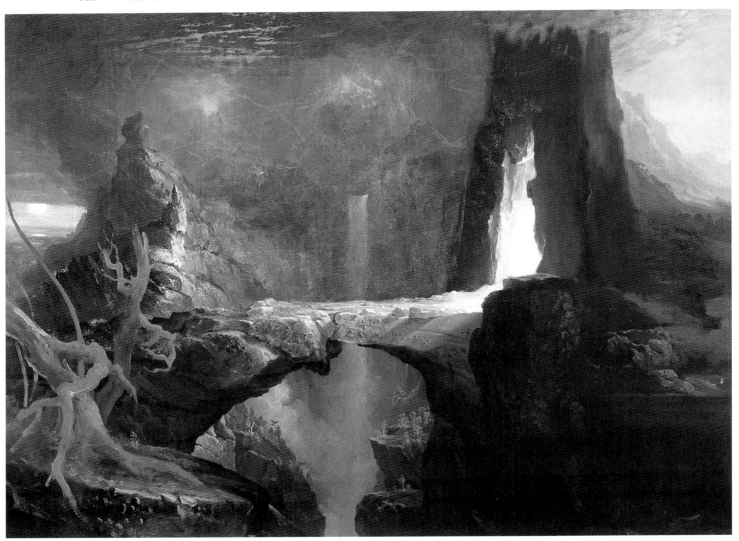

54

54 Thomas COLE (1801–48)
Study for *The Expulsion from the Garden of Eden*
(*Expulsion: Moon and Firelight*)
Oil, 90 × 120 cm (35 ¹/₂ × 47 ¹/₄ in.), 1827–8

This is the large study for the major painting *The Expulsion
from the Garden of Eden* (Fig. 54a).

The landscapes of the New World offered a startlingly
fresh range of shapes and effects to the artist-immigrants
from Europe (p. 57). Thomas Cole came from a Dissenting
background in Lancashire, England. He arrived in
America in 1817 and spent the rest of his life translating
America's immensities of mountain, rock and waterfall –
especially those associated with the Catskill area and the
Hudson valley north of New York – into painting.

Among the more unusual rock formations, the 'natural'
bridge took a place of some notoriety. In his *Notes on the*

State of Virginia (1785), Thomas Jefferson described the natural bridge (Rockbridge) that he owned as 'the most sublime of Nature's works'. Semi-elliptical and bridging the Cedar Creek over a chasm more than 60 metres (200 feet) deep, it had 'a parapet of fixed rocks. Yet few men have resolution to walk to them and look over into the abyss'.[1] In spite of, or probably because of this, the bridge became a tourist attraction.

Cole's ideas for his *Expulsion* are doubly interesting. Not only is there a natural arch forming the portal of Eden to the right, but there is a rock-bridge outside it leading to the dangers of the world beyond. Reminders of Milton's *Paradise Lost*, theatrical spectacle, of Rosa's storm paintings and of John Martin's heady visions multiply in the final painting, now in Boston. Rocks crowd up on the far side of the chasm, a wolf vies with a vulture for the carcass of a stag, and a volcano spouts flame and smoke in the background. But even with the human theme and all these sublime ingredients, the final painting, with its companion *The Garden of Eden*, failed to sell when both works were exhibited at the National Academy of Design in 1828; they were still in Cole's workroom a year later.[2]

In the light of uncertain markets, it is no surprise that the sheer starkness of the present study, giving the bridge central emphasis, using no figures and minimizing Eden on the right, was modified in favour of the more traditional sublimities of the final painting. But the large size and thrilling conviction of the study imply its importance for Cole. And in the final elaborated work, he maintained the device of the rock-bridge as marker, leading away from the portal and signalling the separation of Adam and Eve from the verdant landscape that they are leaving. We should also note that the use of such a motif, certainly derived from observation of the American wilderness, imparted in full measure a startling, pristine originality to one of the most insistently recurring and familiar subjects in the canon of Western art.

54a Thomas COLE 54a
The Expulsion from the Garden of Eden
Oil, 99 × 137.2 cm (39 × 54 in.), 1827–8

1. Thomas Jefferson, *Notes on the State of Virginia*, ed. with intro. and notes by William Peden, publ. for the Institute of Early American History and Culture at Williamsburg, Virginia (Chapel Hill: University of North Carolina Press, 1955), pp. 24–5.
2. Alan Wallach, 'Thomas Cole: Landscape and the Course of American Empire', in William H. Truettner and Alan Wallach, eds, *Thomas Cole: Landscape into History* (New Haven, London and Washington, DC: Yale University Press, 1994), p. 46.

55 Karl Friedrich SCHINKEL (1781–1841)
Die Kathedrale
Oil, 138 × 206.5 cm (54 ¼ × 81 ¼ in.), *c.* 1811

In the absence of political unity, a deep interest developed in the German-speaking part of Europe in the folk origins and early literary record which united it. Many Germans, moreover, drew inspiration from the presence amongst them of so much remarkable Gothic church architecture dating from the age of unified faith before the Reformation. Goethe's experience in front of Strasbourg cathedral had even spurred him to write a pamphlet (*Von deutscher Baukunst*, 1772–3) which claimed that its Gothic architecture had 'sprung from a plain and vigorous German soul'.

The speculative spirit is channelled further in this direction by painting, notably that of C.D. Friedrich (1774–1840).[1] Gothic was also to attract Karl Friedrich Schinkel. A brilliant, widely travelled architect, Schinkel was to work in the Greek Doric style with uncommon effect; his interest in Gothic was fuelled by his belief that architecture should awaken the German public to a feeling for their own identity.[2] As architectural commissions were scarce in a Berlin occupied by Napoleon's army, he turned to stage design and oil painting. In his paintings soaring Gothic cathedrals appear at the end of immense vistas or on island-like fastnesses joined to 'normal life' by bridges. The present painting catches this mood to awe-inspiring effect. An off-centre foreground bridge leads the eye into the picture from the bottom right-hand corner. Small figures are moving along it towards a great towered and pinnacled Gothic cathedral that is silhouetted against a bright sky. The bridge, broad and itself built on pointed Gothic arches, is flanked on both sides by trees of great luxuriance, which also surround the cathedral. A river flows to the sea on the right. The whole effect, painted with detailed realism, is overpoweringly grand: and the bridge's role, as lifeline to a Gothic spirituality, is unmistakably conveyed. This device of a receding bridge, along which the spectator is led into the picture and involved with its mood, was to be used repeatedly by north European artists in the future (compare Fig. 56).

55

1. Friedrich often painted Gothic buildings, and also, towards
 the end of his life, a view of the Augustinerbrücke, Dresden
 (*c.* 1830, formerly Kunsthalle, Hamburg, destroyed 1931).
 This placed the bridge in the middle distance, stretching from
 edge to edge, apparently endlessly. Characteristically for
 him, the bridge is being contemplated from behind a 'barrier'
 (an iron balustrade) by figures in the middle foreground
 (colour reprod. in W. Wolfradt, *Caspar David Friedrich und
 die Landschaft der Romantik* (Berlin: Mauritius Verlag, 1924),
 pl. 19).
2. Within two or three years Schinkel was to become involved in
 the scheme for restoring and completing Cologne cathedral,
 which became a symbol both of the Gothic revival in
 architecture and of the political as well as the religious hopes
 of German patriots. Compare Fig. 98.

56 Christen KØBKE (1810–48)
View outside the Northern Gate of the Citadel (at Copenhagen)
Oil, 79 × 93 cm (31 × 36 ¹/₂ in.), 1834

In Denmark, after the Napoleonic Wars, a middle-class art flourished, as in Germany, celebrating family life and everyday events in a painting style that was descriptive and accessible.

The painter Købke reflects this. In the present *View*, however, we approach this factual world from the end of a bridge. But here we see, as we do not in the Schinkel painting (Fig. 55), the beginning of the bridge, set into the space beyond the foreground gateposts. There are glimpses of moat, the farther bank and a distant meadow. Four boys are on the bridge, gazing into the moat, one of them fishing. The shortness of their shadows shows that the sun is high. A top-hatted man and a woman in a blue dress stand together on the far side of the central drawbridge, partly masked by its wooden framework and cable. No-one moves here: compared with the Schinkel, a strange quiet has descended. Whereas Schinkel's bridge draws the people towards a definite and obvious goal, Købke's, with its privately absorbed occupants, has itself become part of an ambiguous space beyond.

When we look more closely, we see that every detail is in place in this everyday world: the shadows of the railings wrap themselves round the boys, the distant couple wear smart walking-out dress. But Købke also projects a sense of waiting which is his specific subject in other works.[1] In the period between Schinkel's picture and Købke's, the star of the great German painter Caspar David Friedrich (1774–1840) had risen, and all but set, as a more down to earth domestic realism came to supersede it. Købke's picture lacks the mysticism of Friedrich's most typical work, but it does combine the qualities of expectancy and immobility that are part of Friedrich's Protestant strength. Both artists based themselves on subjects which had close personal associations for them. Købke, a native of Copenhagen, had lived with his parents in this very citadel until the end of 1833, just before the *Kunstforening* in the city commissioned a painting from him in January 1834 – the

first commission he had received – which became the present work. It cost him much effort: 'I have woken up every morning,' he wrote to his sister Conradine on 27 October, 'and yearned for the light to come so that I might get to work, then painted all day long until evening . . .'[2] Both the subject and the painting of it evidently held much personal meaning for the artist, and three years later he did a painting of the northern drawbridge from the far bank looking back at the citadel, and dedicated it to his mother, as a souvenir, it may be presumed, of their former home.

The present picture also picks up the idea of a journey from home, another favourite theme of Friedrich's. We look from one space into another, as in Friedrich's views of the Elbe river from his studio: and water and clouds glide past from side to side, here as there. Oars lean against the wall to the right. Nets dry between the trees. The boys look down at the part of the water we cannot see. In all these respects there are links with Friedrich.

The notion of a journey is, however, emphasized by the bridge itself, which has a central drawbridge section. Købke shows the counterpoise construction, with the upright and inclined members of its framework against which the deck, when not in use, was raised. Partially masking the couple behind, it has the severity of a guillotine. Indeed the fact that this is a drawbridge adds a special symbolic value. The association of a liftable drawbridge with the notion of 'crossing at the right time', but making a break with the past, occurs in many cultural traditions.[3] Købke gives no overt hint of his intention here: but an intuition of such a kind was perhaps to contribute to his rapport with the subject. We shall be faced with the same speculation when we come to Van Gogh's fascination with a drawbridge near Arles later in the century (pp. 174–5). It is not hard to see that a castle drawbridge, lowered to connect with the outside world and then retracted against the unknown hazards of that world, could have symbolic value for a painter making his way with his first public commission, as Købke was with this picture, and especially when, like Købke, the 'castle' had been his home. Whether or not he consciously thought of the bridge in this picture as in general a place of transition to a different life beyond it – an idea which the boys near to us and the adults further off appear to symbolize – the autobiographical implications seem unavoidable.

1. E.g. *View of Lake Sortedam near Dosseringen* (oil, 1838, Statens Museum for Kunst, Copenhagen: ill. in colour in R. Rosenblum and H.W. Janson, *Art of the Nineteenth Century* (London: Thames and Hudson, 1984), pl. 31. Two women are shown waiting on a jetty for an approaching ferry.

56

2. See Kasper Monrad's entry for the picture, no. 55, in the catalogue *Danish Painting: The Golden Age, A Loan Exhibition from the Statens Museum for Kunst, Copenhagen* (London: National Gallery, 1984). This makes it clear that the painting was a turning-point for Købke as an artist, in which he achieves a 'new, imposing and monumental conception'. A sketch preceded it.

3. Herodotus (*History*, I, 186) refers to the ancient demountable plank bridge of Babylon (on supporting stones). For a Persian example see J.V. Harrison, 'A Political Officer in Persia', in *Geographical Journal*, vol. XCVII (1941), p. 380. For a Nigerian example see R. Baker, *Men of the Trees* (London: G. Allen and Unwin, 1932). Leonardo designed demountable bridges. But the drawbridge becomes a notable part of the background of Romantic novels about the Middle Ages, especially those of Scott, such as *Ivanhoe* (1819). In *The Monastery* (1820), concerned with rivalry in love and the manipulation of power, Scott describes (ch. 4) double drawbridges to a tower in the middle of the river Tweed. Here the keeper not only extracts toll money (pontage) from intending travellers but keeps the drawbridges raised until they pay more. Innumerable castles of love are stormed in a century which marked a climax of interest in the Arthurian legends and in which, later, Symbolist writers would seek ideal worlds through the overcoming of obstacles. For the symbolism of crossing water by means of a plank bridge, as studied by Jung, see p. 180 (n. 3).

57 and Plate VIII J.M.W. TURNER (1775–1851)
The Burning of the Houses of Lords and Commons, 16th of October, 1834
Oil, 92.5 × 123 cm (36 1/2 × 48 1/2 in.), 1835

Turner, friend of Soane and himself responsible for architectural designs (including some for his house at Twickenham in 1811) had a strong conviction about man's role as orderer, as architect of his destiny as well as risk-taker or potential destroyer. Having painted *Ulysses Deriding Polyphemus* (1829), which best expresses this conviction, Turner was to go on five years later to a more home-based but still momentous challenge, that commemorated in two oil paintings of the burning of the Houses of Parliament. He watched this event from a boat downstream and made numerous drawings.

Both canvases prominently feature Westminster Bridge, which was to survive till 1861 (although the question of its replacement was already under discussion before the 1830s were out). In the Philadelphia version especially, showing the foreshortened bridge from the southern bank, the structure from which Wordsworth had looked out over thirty years before is shown rearing up in a strange distorted perspective, which makes an interesting contrast to Schinkel's bridge in *Die Kathedrale*, Fig. 55. From the high centre its side falls steeply and concavely, reflecting the firelight, to the farther bank. Crowded with spectators, it is made to share in the consuming of man and his institutions by natural forces, an enduring theme with the Romantics and especially with Turner. A further contrast might be made with the feeling of promise in Købke's drawbridge painting of the same year (Fig. 56).

In Turner's other version (Cleveland) we stand back from the length of the bridge, now seeming to lead directly into the flames, which rise diagonally over it into the sky. In both pictures Turner presents a whiff of apocalypse with an immediacy that was new even with him.

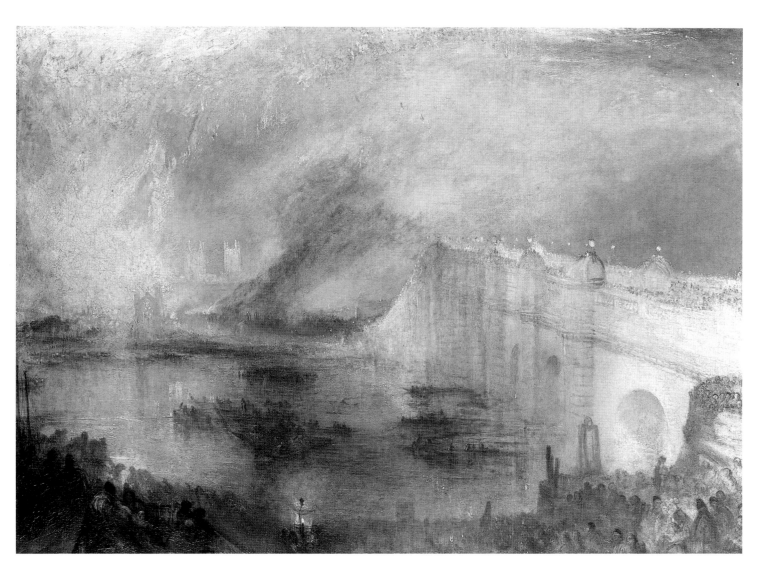

57

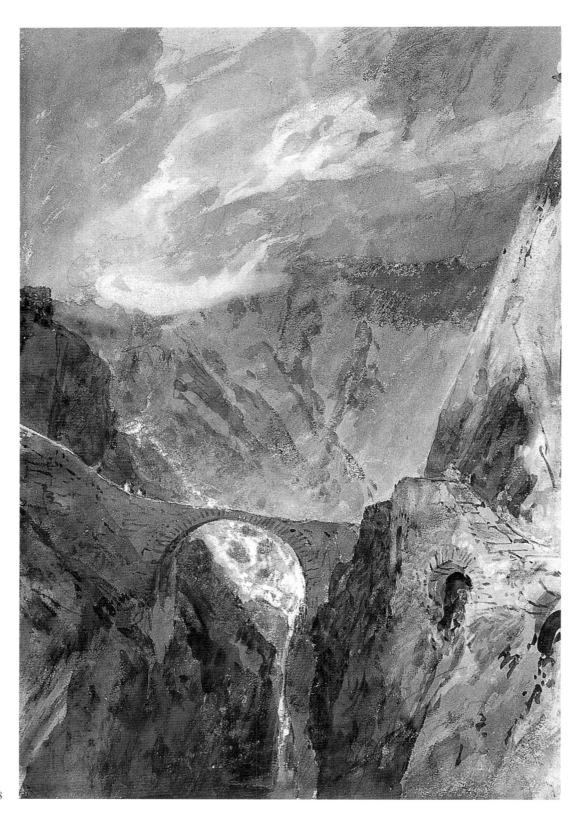

58

58 J.M.W. TURNER (1775–1851)
The Devil's Bridge, Pass of St Gothard
Pencil, watercolour and bodycolour, with scraping
out, on white paper prepared with a grey wash, 47.1
× 31.8 cm (18 ¹/₂ × 12 ¹/₂ in.), 1802

Turner's preoccupation with the bridge motif began
early. Few pictures give such a sense of illimitable space
falling away beneath us as Martin's *Bridge over Chaos*
(1825, Fig. 53). But we must remember the remarkable
large watercolours done over twenty years previously by
Turner: works which arose out of the watercolours he did
in the Alps on his first continental visit in 1802 and which
are located in his 'St Gothard and Mont Blanc' sketch-
book (LXXV). Of crucial interest in this group is the
present subject. We have already seen (Fig. 34) the impact
made on J.J. Scheuchzer in 1705 by this wonder of the
Alps on the pass leading from Luzern to Bellinzona.
Melchior Füssli's illustration of it in Scheuchzer's
Beschreibung des Schweizerlandes (1708) (Fig. 58a) places
the bridge high in his vertical picture in order to
accommodate a painstaking drawing of the Reuss river
foaming round its rocks below. Turner is much more
stimulating: he places the bridge low, opening up the
stormy onrush of clouds, and suggesting the water
behind the arch of the bridge dropping out of our sight –
how far it is impossible to say. The Burkean sublime is
reinforced by the exhilaration of Turner's own experience
of what it was like to stand there. He inserts two tiny
figures, who are actually about to tread onto the bridge,
to complete the impression of the immense scale of nature
in this terrain.

The *Devil's Bridge* is the climactic expression, surely, of
a 'sensation before nature' which had been waiting for its
true exponent for a hundred years. We cannot doubt that
Turner also stationed himself on the bridge itself, as is
borne out by the large watercolour view of the St Gothard
pass based on a drawing in the same sketchbook; this
watercolour was exhibited on at least three occasions in
Turner's lifetime with the title 'The Passage of Mount St
Gothard, taken from the centre of the Teufels Broch
(Devil's Bridge) Switzerland'. Here, depicted in the view
of the bridge and the view from it, was the whole sum of
the excitement he had experienced.[1]

1. By the time Turner came to do his watercolour of the Devil's
 Bridge he had behind him a number of Picturesque
 topographical compositions which involved bridges,
 including the watercolour *Chepstow Castle* (Courtauld
 Institute) and that of Labelye's Westminster Bridge, in steep
 foreshortening, that was engraved for the *Copper Plate
 Magazine* of 1797. He had recorded Edwards's Taaffe bridge,

perhaps as a 'copy' of another artist's drawing. He had done a
sketch of what appears to be a Welsh mountain stream with
stone bridge silhouetted, in vertical format, which is readily
associated with the period and style of the north Wales
sketchbook of 1798. The bridge is almost at the same angle as
in the future *Devil's Bridge*, but the vertiginous plunge out of
the picture is a discovery of 1802.

58a Melchior Füssli (1677–1736)
'Devil's Bridge' (engraved ill. to J.J. Scheuchzer,
Beschreibung, 1708)
21.3 × 15.2 cm, (8 ¹/₄ × 6 in.)

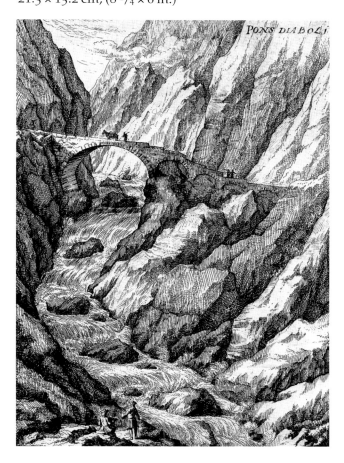

58a

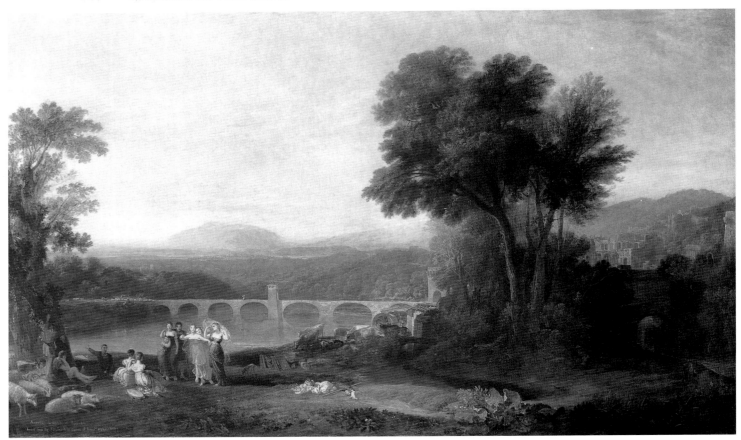

59

59 J.M.W. TURNER (1775–1851)
Apullia in Search of Apullus
Oil, 146 × 239 cm (57 ¹/₂ × 94 in.), 1813–14

A number of Turner's works of the period 1802–14, including *Tummel Bridge* (oil, 1802–3, Yale Center) and *Whalley Bridge and Abbey* (oil, 1811, Loyd Collection), focus on the arch form.[1] Certain pictures in this category, such as the 'Bridge in the Middle Distance' print (*Liber Studiorum*, 1808), tie in compositionally with others in a large group based on the study of Claude or the Dutch. Claude's landscape achievement engaged Turner's competitive spirit directly in these years (and those following) and led to a succession of major oil paintings in which the emphasis is on Italianate or otherwise idealized landscape. Much use is made in this group of the bridge as stabilizer, as a means of defining the middle distance.

At least from 1809, when Turner visited his patron the third Earl of Egremont at Petworth House, Sussex, he was deepening an acquaintance with Claude's great *Jacob and Laban* (see Introduction, p. 11 and Fig. 8). He was to use the picture as a model for his *Apullia*, a work painted in conscious imitation of Claude to the specification of a

British Institution competition. Sir George Beaumont, the connoisseur who revered Claude but spurned Turner, was on the jury which denied *Apullia* a prize, while accepting it for exhibition. Indeed the work was not designed totally to conceal Turner's own independent identity: he follows his prototype closely in matters of composition, including the middle-distance bridge, but places a strong vertical on it in the form of an asymmetrical tower, a feature not present in Claude's *Jacob*. He also makes a visual point of the differences in the arch-widths. Both these devices are indications of ways in which Turner would develop his personal use of the bridge.

1. *Tummel Bridge* and other examples are discussed in Adele M. Holcomb, 'The Bridge in the Middle Distance: Symbolic Elements in Romantic Landscape', *Art Quarterly*, vol. 37 (1974), pp. 31–58.

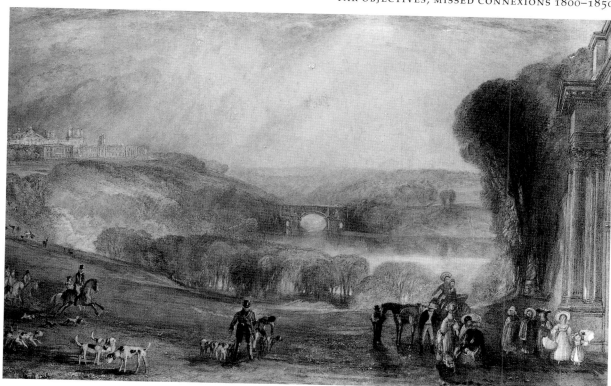

60

60 J.M.W. TURNER (1775–1851)
Blenheim House and Park, Oxford
Watercolour, some scraping-out, 29.6 × 46.8 cm
(11 1/2 × 18 1/2 in.), *c*. 1831–2. Engraved for
Picturesque Views in England and Wales, part XVI,
no. 2, 1833

Turner's feeling for the light-relaying capability of the
stone-arched bridge is powerfully presented here. In the
early 1820s, apparently shortly after he had seen Italian
light for the first time, he had begun to increase his output
of 'colour beginnings' (as Turner's biographer Finberg
dubbed them), in which he explored his interest in colour
and tonal relationships in very fluid applications of paint,
using both watercolour and oil. A 'colour beginning' in
wash exists for the Blenheim subject, showing what the
Tate Gallery *Turner* catalogue of 1974 aptly called the
'sun-like disc' formed by the arch of the bridge and its
reflection. Turner's reference for Blenheim is based on
pencil drawings in the Kenilworth sketchbook of *c*. 1830
(TB XXXVIII, see 11 verso and 12 recto), but the final
watercolour, with its scraping out, plays off the contrast
between light diffused over the parkland and being
collected in an eye-catching circle below Vanbrugh's
bridge.

The centrally placed bridge is perhaps more than
simply the formal key to the composition. The widely
divergent foreground figures – aristocrats on horses to
the left, towards the palace, and a man with a gun in the
centre, and lower-class women and children on the right,
from the town – have plausibly been construed by Shanes
as offering a political or social comment on the
agricultural unrest of the year 1830, with the bridge as a
symbol of reconciliation.[1] The idea that the bridge may be
a symbol of this kind receives support from the fact that it
is not just treated as a picturesque incident, but is made
parallel in the picture plane, as if to make it equally
accessible to all who are present in the picture. Turner's
sympathy for the common man is obvious in many
places, including this series, and in placing the Blenheim
bridge so centrally it is possible that he meant to treat
it as a down-to-earth focal equivalent of the idea
of democratic communication that as yet exists so
imperfectly between the human groupings.[2]

1. E. Shanes, *Turner's Picturesque Views in England and Wales
 1825–1838* (1979), pp. 37–8; *Turner's England 1810–1838* (1990),
 pp. 220–21.
2. Turner used the central placing again, for example, in the
 watercolour of *Zurich* (*c*. 1842), where the motif is made even
 more explicit in the engraved version. In this work, even
 more than in *Blenheim*, it seems likely that the theme of
 human relationships is underscored symbolically by the
 bridge. Jan van Eyck's *Madonna and Child with Chancellor
 Rolin* (Fig. 1) makes a worthwhile comparison.

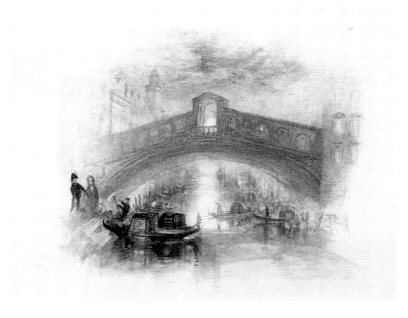

61

61 J.M.W. TURNER (1775–1851)
The Rialto: Moonlight
Watercolour vignette, 11.8 × 13.5 cm (4 3/4 × 5 1/4 in.)
on a sheet of paper 24.1 × 30.5 cm (9 1/2 × 12 in.), *c.*
1832. TB CCLXXX-196 (Wilton 1190). Engraved by
W. Miller, 1833, for S. Rogers's *Poems*, 1834

On Turner's first Italian visit (1819), Rome inspired him
to major works, of which *Rome from the Vatican* (177 ×
335.5 cm, 70 × 132 in.) was the grandest in scope and
physical size. But Venice, seat of a later empire that had
flourished and ultimately passed into history (though not
until 1797, within Turner's own lifetime), was to become
more and more absorbing to him both as symbol and as
visual treasure-store. Already after the first encounter he
planned a Rialto subject on the gigantic scale of *Rome from
the Vatican*: the abandoned ghost of this immense canvas
(Tate Gallery) tells us little, unfortunately, about how he
might have developed it.

 In the Rialto, nonetheless, Turner had found a subject
of much fascination. He had first drawn it in pencil
outline in 1819, from both sides, in the 'Milan to Venice'
sketchbook (TB CLXXV, pp. 73–84). Here, as in *Blenheim*,
is another bridge against bright light, this time containing
the very source of illumination itself: the full moon
caught in the aedicule at its centre. This Rialto does not
cross space as springily as Canaletto's (compare Fig. 15);
in the watercolour its soft brown mystery appears like a
structure of filaments rather than stones, with the moon
as improbable keystone. An idiomatic Venetian presence,
the gondola, is used; the almost volute-like effect formed
by the arch, standing gondolier and counter-curving
gondola with upright prow gave Turner a motif which
would emerge more fluently in the late Venice water-
colours of 1840.[1]

1. See examples reprod. in Lindsay Stainton, *Turner's Venice*
 (London: British Museum, 1985), pls 40, 44, 72.

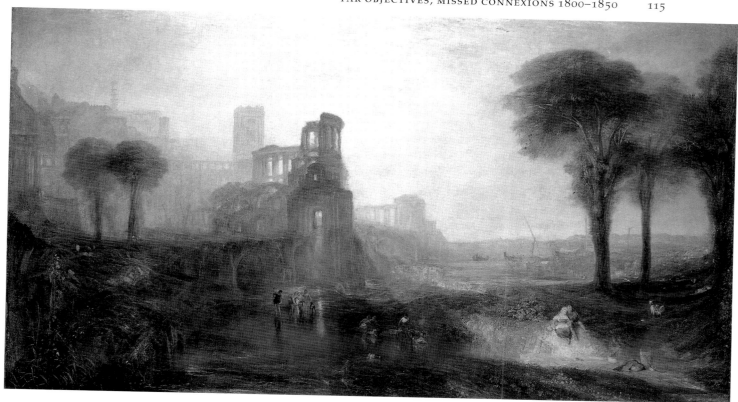

62 J.M.W. TURNER (1775–1851)
Caligula's Palace and Bridge
Oil, 137 × 246.5 cm (54 × 97 in.), 1831

Away from Venice, another aspect of the Italianate bridge claimed Turner's attention. This was the 'bridge of triumph' and its associations. Here he commemorates the immense bridge which Caligula is said to have put across an entire bay, that between Baiae and Pozzuoli, a distance of 3 1/2 Roman miles. It was probably in fact a bridge of boats, ingeniously placed to disprove the prophecy of Thrasyllus that Caligula's chances of becoming emperor were equal to those of driving a chariot across the bay. But Turner makes the gesture into one of *hubris* and the bridge into one of stone, now decayed and ruinous. In the Academy he showed the work with the following lines from his poem *The Fallacies of Hope*:

> What now remains of all the mighty Bridge
> Which made the Lucrine Lake an inner pool,
> Caligula, but massy fragments left,
> As monuments of doubt and ruind hopes
> Yet gleaming in the Morning's ray, doth tell
> How Baia's shore was loved in times gone by?[1]

In concentrating on the idea of decline after previous glory Turner was returning to a theme which he had treated in 1823 in *The Bay of Baiae*, and was to express in a

number of works in the 1830s. The notion of a ruler's extravagance of gesture – personified for Turner's age by the larger-than-life figure of George IV, who had died in the year before *Caligula's Palace and Bridge* – was also long-established: Oliver Goldsmith described Caligula's bridge as 'the most notorious instance of his fruitless profusion'. The piling up of architecture as well as its sideways extension is a feature of this picture. Cecilia Powell draws attention, no doubt rightly, to the likely memory of Piranesi's prints of grandiose buildings, such as those in the *Opere Varie* of 1750 (Fig. 18).[2] Soane also, with his watercolour views of his own vast buildings imagined as they might be in a state of ruin, had given contemporary point to such time-perspectives on the walls of the Academy. But Turner typically has his comment: *hubris* merits its own downfall; and he depicts the bridge not in a single dramatic perspective but in piecemeal, tottering sequences.[3] It is worth noting that Turner thought sufficiently highly of the *Caligula* to include it among five large-plate engravings of his work in 1842.

1. Turner was following a popular belief that the bridge had been of stone. He had in his library Henry Sass's *Journey to Rome and Naples performed in 1817* (1818), which mentions Turner in its introduction. This describes a mole of 25 arches at the end of which Caligula's bridge extended for 3600 feet in a straight line to Baiae. In the middle zone, where the sea was deep, Sass asserts that Caligula resorted to boats fixed by

62

anchors and linked by chains, adding, however, that there was a paved road with parapets at each side. Turner also possessed a copy of the first edition (1769) of Oliver Goldsmith's *Roman History*, which refers to the bridge, and was also aware of James Thomson's poem *Liberty* (1734–6), which mentions the 'Lucrine Lake'. Cf. J. Gage, 'Turner and Stourhead: The Making of a Classicist', *Art Quarterly*, vol. 37 (1974), p. 82.

2. Cecilia Powell, *Turner in the South: Rome, Naples, Florence* (New Haven and London: Yale University Press, 1987), p. 179.

3. Perhaps this is why Turner depicts palace-like structures as part of the bridge: to suggest, in effect, that Caligula had passed over the bridge but had also over-reached himself on it: indeed, had 'built his house there', as Akbar's message would have it (see p. 87). With the last line of Turner's quotation in mind, E. Shanes makes the likely deduction that the figures of lovers in the foreground, and the children and a nanny-goat suckling a kid (motifs added by Turner later), convey allusions to love as a sustaining force which make an appropriate moral point against the background of the Bay of Baiae, associated as the area was with the loves of Roman emperors: see Shanes, *Turner's Human Landscape* (London: Heinemann, 1990), pp. 99–100. Such points may well help to explain the strangely episodic nature of Turner's bridge, all the more strange for being the work of a man who drew such enjoyment from the untrammelled bridge form.

63 and Plate IX J.M.W. TURNER (1775–1851)
Ancient Rome: Agrippina Landing with the Ashes of Germanicus. The Triumphal Bridge and Palace of the Caesars Restored
Oil, 91.5 × 122 cm (36 × 48 in.), 1839

The idea of disintegration that was uppermost in *Caligula's Palace and Bridge* is reversed – as ideas so often are in Turner's complex art – in this work, in which Turner stresses the *completeness* of the Roman buildings he depicts. John Martin's reconstructions of ancient cities may have spurred Turner on here, and the researches of Cockerell into the reconstruction of buildings in ancient Rome seem a likely influence.[1] On the other hand the relating of a sordid subject – the murder of Germanicus reputedly on the orders of his uncle Tiberius – to an architecture of great visual splendour gave Turner a prime opportunity of commenting, as Cecilia Powell suggests, on the coexistence in Imperial Rome of both corruption and magnificence.

The complex bridge shown here consists of solid, rounded sections and sequences of open colonnade which relay the air beyond. It is, moreover, invested with a marvellous sidelong light, which is played off against pearly shadows. A little late daylight is seen, through the nearest arches; some of the windows have artificial lights showing; a white mist froths at the bases of the piers: but over its whole length the tonal scheme shifts only in terms of nuance. A comparable opalescent effect occurs in a number of Turner's large Italian landscapes of the mid- and late 1830s, but in the *Agrippina* it is astonishingly applied to a great bridge of the triumphal type, hitherto seen – by Cockerell and by Soane and his imaginative draughtsman J.M. Gandy (Fig. 32) – as a vehicle of dignified chiaroscuro: here is the novelty.

1. J. Gage, 'Ancient Italy: Ovid Banished from Rome', *Turner Studies*, vol. 3 (London: Tate Gallery Publications, 1983), pp. 58–60. Cockerell's drawing *Idea of a Restoration of the Capitol and Forum of Rome* (R.A. 1819), engraved in 1824, is reproduced there. Cecilia Powell, *Turner in the South: Rome, Naples, Florence* (New Haven and London, Yale University Press, 1987), p. 177, is surely right to mention Piranesi as an influence.

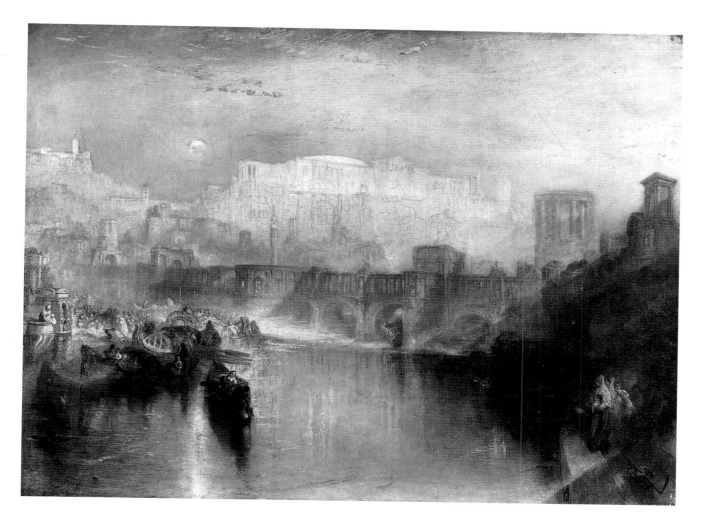

63

64 J.M.W. TURNER (1775–1851)
The Dawn of Christianity (Flight into Egypt)
Oil, 78.5 cm (31 in.) diam., R.A. 1841

It is observable that, at least from *Calais Pier* (1803) on –
commemorating Turner's first major sea-crossing and his
appreciation of man's heroic building of the pier against
the sea – Turner's subjects often turn on the forms which
have been used 'against' nature. Even in what is for
Turner a rare overtly 'religious' work – the present
picture – he brings in, surely significantly, a man-made
bridge.

Unlike the bridges in Claude's numerous 'Rests on the
Flight into Egypt' – which in a general way may have
influenced Turner here to include a bridge – this one is
catastrophically broken. Despite this, Turner seems to set
out an essentially optimistic position using, indeed, the
'perfect', circular format (still visible even now with the
corners exposed) which had contained many Italian
Renaissance versions of the *Holy Family* or *Rest* theme.
Illustrating a poem 'Spring' by the Rev. Thomas
Gisborne, the composition is divided by a central river
and the gap in the bridge. On one bank a serpent rises, on
the other the Virgin and Child are led by an angel towards
a palm tree. The implication seems to be that the holy
persons have crossed and the ruined bridge will no
longer afford a crossing for the serpent. The old
unregenerate world is left behind. Man has another
chance. At the left, dawn (mentioned in the poem) leads
to the brilliant white light surrounding the 'day star' on
the right, behind mother and child.

While Turner was not an outwardly professing
Christian, *The Dawn of Christianity* suggests that he may
have subscribed to certain Christian ideas which perhaps
were tinged with the 'reasonableness' of deism.[1]

1. E. Shanes, *Turner's Human Landscape* (London: Heinemann,
 1990), pp. 228–9.

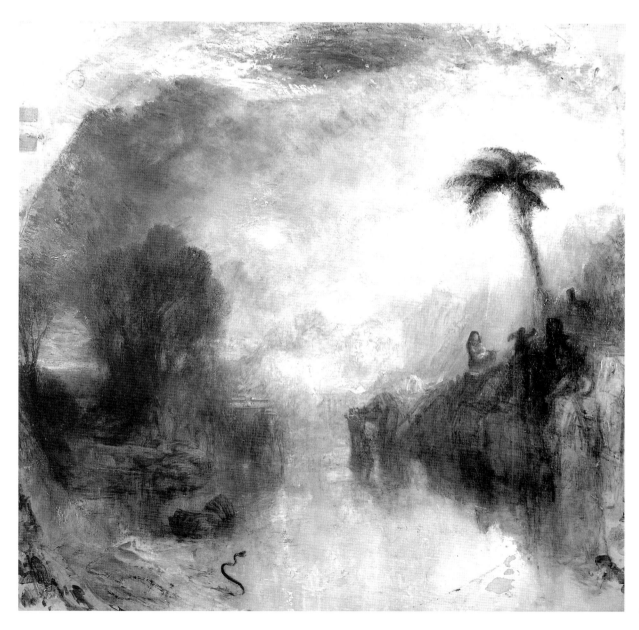

64

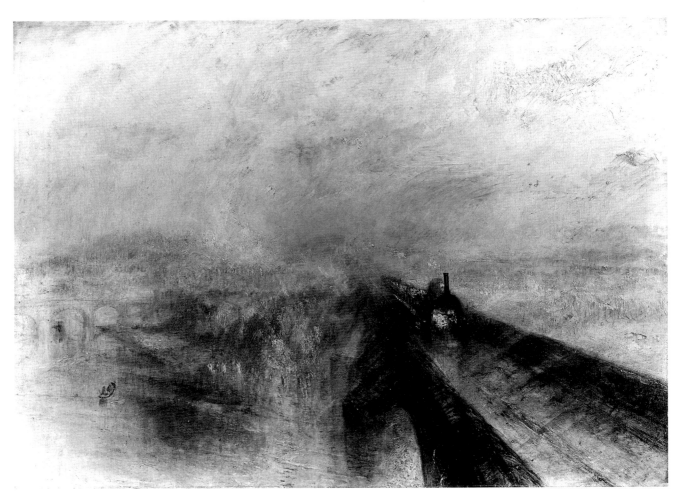

65

65 J.M.W. TURNER (1775–1851)
Rain, Steam and Speed
Oil, 91 × 122 cm (35 3/4 × 48 in.), 1844

Ruskin's silence on this famous work is presumably explained by the fact that he did not see it as a bridge painting at all, but only as the modern subject it undoubtedly was, celebrating the railway engine, for which he felt active revulsion. The picture nevertheless contains two sizeable bridges, the 'old bridge', as it was already called – though it had only been built in 1780 by the architect Sir Robert Taylor – on the left, and the new Maidenhead bridge of the engineer of the Great Western Railway, Isambard Kingdom Brunel (1806–59), on the right. This bridge, completed in 1839 as part of the great railway enterprise that was to link London to Bristol and Exeter, was an original design consisting of two brick arches each 40 metres (128 feet) across but rising only 7.5 metres (24 feet 6 inches). These were elliptical arches, the longest and flattest ever built in brick, and early collapse was prophesied by contemporaries. Yet they were to prove themselves fully capable of meeting the challenge of contemporary and future loading.

Further criticism was directed at Brunel's structure as a railway bridge and therefore inevitably ugly in the eyes of some. Cosmo Monkhouse's commentary on the picture in 1878 compares the 'beauty and peace of the old bridge' with the 'ugly form of the railway-bridge and train', a contrast which Monkhouse suggests was part of the artist's intention.[1] But the matter is by no means so simple. Turner's interest in modern modes of transport, including railway travel – as examined by Gage – might lead us to suppose that Turner would have taken a different view. This is certainly a picture about the challenge and risks of change: the hare as the age-old symbol of speed running in front of the engine that must overtake it, the ploughman (who recalls, as G.D. Leslie noted, the old song 'Speed the Plough') moving in the opposite direction to the train, and therefore reflecting the changing emphasis that was being made on urban rather than rural living. Rain beats diagonally on the tiny boat caught in midstream, and the umbrella held against it, but has no effect on the train's ability to convey its passengers to their long-distance destinations.

Turner is surely concerned here with the novelty of the railway age and what it might mean. The Great Western Railway, with a length already of well over 300 km (200 miles, greater than any other line in the world), represented a revolution in communication, implemented by such works of ingenuity as the Maidenhead bridge. It seems likely that Brunel's bridge-building activities on this much-advertised line – so much more in the public interest than Caligula's in Italy centuries before – will have earned Turner's respect. At all events, in *Rain, Steam and Speed* he includes Taylor's old bridge on the left and sets his crowd of onlookers close to the new, making them acclaim the spectacle of train and passengers sweeping by at high level over Brunel's great construction.

1. C. Monkhouse, *The Turner Gallery* (1878), IV, no pagination. Cf. also J. Gage, *Turner: Rain, Steam and Speed* (London: Allen Lane, The Penguin Press, 1972), pp. 33f.

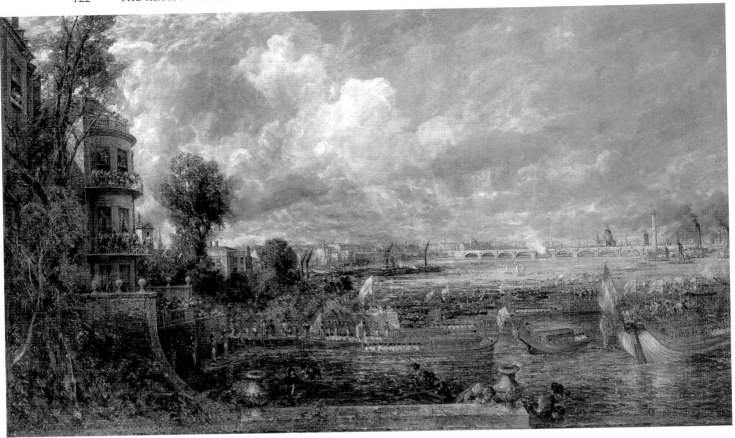

66

66 John CONSTABLE (1776–1837)
The Opening of Waterloo Bridge
Oil, 134.6 × 219.7 cm (53 × 86 ¹/₂ in.), exhibited 1832

The title of this work, given as 'Whitehall Stairs, June 18th, 1817' in the Royal Academy catalogue of 1832, points to the specific nature of the subject, not unusual in itself with Constable, but certainly unusual with him in being a subject which is both urban and overtly festive. The subject was in fact identified with an expression of public rejoicing on the day that the Prince Regent left Whitehall Stairs to open John Rennie's elegant, horizontal, nine-arched new masonry bridge, the third of a trio of Thames bridges (the others were Vauxhall and Southwark) to be completed in this decade and in visual terms Britain's answer to Perronet's bridge at Neuilly (Fig. 26). In so doing the Prince gave it its name, that of the recent battle which signalled so much national pride. On 18 June it was lined by Waterloo veterans. John Constable was in London and presumably witnessed the events of that day. On the 27th he wrote to his wife Maria telling her that he had walked across the bridge on the previous evening.[1]

Nonetheless the work was apparently not begun until 1819. Oil sketches show Constable divided on whether or

not to include the foreground pageantry.[2] One early intention is suggested in a pencil drawing (Victoria and Albert Museum) of the river from a high viewpoint: an oil sketch (private collection) probably followed. A version now hard to identify was shown on 21 November 1820 to the diarist Farington, who advised Constable to make it less of a 'Bird's eye View' and so do more justice to the 'bridge and buildings'. A composition with lower viewpoint developed, with drawing (private collection) and oil sketch (Royal Academy). This last, only 21.5 × 11.7 cm (8 1/2 × 4 1/2 in.), makes much of a foreground of small moored boats with Canaletto-like flicked-in figures, but beyond the city skyline a blue St Paul's presides with a Wordsworthian calm, punctuating the white horizontal of the bridge. In May 1822 Maria reports that the Bishop of Salisbury had sat on the floor to admire a version (perhaps that now at Cincinnati?) and pronounced it equal to Canaletto. Constable himself felt pleased by a sketch of 1824 (likely to be that in the Royal Academy), but by July was fearing that the 'Waterloo' might ruin him. In October 1825, however, Thomas Stothard suggested a 'capital alteration' which, Constable said, would 'increase its consequence, and do everything for it'. In January 1826 Sir Thomas Lawrence reported that the work was 'admirable . . . the line of the bridge was grand'.[3] A mezzotint was being prepared in 1829 with which a small oil sketch in the Yale Center is linked. Besides the final version, a still larger oil of *c.* 1830–32 (148 × 200 cm, 58 1/4 × 78 3/4 in.) was done (National Trust, Anglesey Abbey, Cambridgeshire). Both include the foreground pageantry but also emphasize the line of the bridge. When the final version was shown at the Academy in 1832 its bright golds and reds appeared to outshine Turner's *Helvoetsluys* hung next to it, until Turner painted in his famous 'round daub of red lead' to equalize.[4]

The whole history of the subject, therefore, took up a substantial amount of time in a decade in which Constable was painting his celebrated 'sixfooters', including the *Hay Wain* (1821); exhibiting his work in the Paris Salon (1824); caring for his young family and suffering the loss of his wife from tuberculosis; and painting in Salisbury, Brighton and elsewhere. There is an interesting phrase in a letter from Constable to his engraver Lucas (28 February 1832) just before he completed the final version. 'I am dashing away at the great London – and why not? . . . For who cares for landscape?'[5] This does seem to offer a clue to the artist's persistence with *Waterloo Bridge*. Despite his successes in France and his election to the status of full Royal Academician in 1829, he still felt badly treated in Britain as a landscapist. Town subjects guaranteed a degree of public (and perhaps royal?) interest (St Paul's and Somerset House appear in all versions). Following Farington's advice, however, he would avoid the 'bird's eye view' look of the panoramic paintings which were so popular. And while 'my Harlequin's Jacket', as Constable called his picture (in a letter to Fisher of 4 March 1832), caused him some disquiet, it is noticeable that he did not modify his personal style of painting in impasted dabs, for which he was duly censured by the *Morning Chronicle*.

1. *John Constable's Correspondence*, ed. R.B. Beckett (Ipswich: Suffolk Records Society, 7 vols, 1962–70), vol. II (1964), p. 225.
2. For the early stages see illustrations and discussion in L. Parris and I. Fleming-Williams, *Constable*, exh. cat. (London: Tate Gallery, 1991), pp. 206–11. For the later stages see ibid., pp. 369–72. See also D. Sutton, 'Constable's "Whitehall Stairs" or "The Opening of Waterloo Bridge"', *Connoisseur*, 136 (1955), pp. 248–55.
3. *Correspondence*, vol. II, p. 424.
4. C.R. Leslie, *Autobiographical Recollections* (1860), vol. I, p. 202.
5. Constable's ally Robert Balmanno thought that *Waterloo Bridge* would be Constable's triumph and set the Thames on fire: see G. Reynolds, *The Later Paintings and Drawings of John Constable* (New Haven, CN: Yale University Press, 1984), p. 234.

67 John CONSTABLE (1776–1837)
The Leaping Horse
Oil, 142.2 × 187.3 cm (56 × 73 3/4 in.), 1825

In the middle of his struggle with *Waterloo Bridge*,
Constable created *The Leaping Horse*. This work, in certain
respects – not least that of bridge-treatment – was to take
his landscape art to a new extreme of outspokenness
which even, unaccountably, won praise from critics who
had not previously been generous.

Constable began work on this idea in November 1824,
perhaps after coming across his earlier drawing of the
willow, a favourite motif (see p. 90). He sketched two
possibilities, in pencil and wash (British Museum), one
with the horse standing on a bridge over a floodgate with
the willow inclining close to it; the other, altogether more
dramatic, showing the horse leaping one of the canal
barriers (placed to prevent cattle straying) with a boy
rider astride it: in this, the area under the bridge is much
darker, and the willow is bolder and thrusts up, like the
horse, against the sky. A full-size sketch was done (now in
the Victoria and Albert Museum) and a final version
appeared at the Academy in the spring. Even so, the artist
continued to work on it later in the year, moving the
willow to a position behind the horse, allowing the
animal unrestricted space to leap into. He also made a sail
on a boat to the left slant at the same angle as the horse's
leap. In August Constable described the picture to a
potential purchaser as 'Scene in Suffolk, banks of a
navigable river, barge horse leaping on an old bridge,
under which is a floodgate and an Elibray . . .' (an eel
trap).[1]

It has often been pointed out that the scene has no
absolutely specific location like Constable's other Stour
subjects: though New Fen bridge appeared in the early
wash drawings it has disappeared in the final painting.[2]
Lord Clark saw the work as an essay in the heroic style,
with the main group as in the tradition of the equestrian
monument and the bridge as a plinth.[3] This is an
important insight: yet this is a group in which the plinth
is part of the action in a way suggested by no equestrian
sculpture. Constable's words quoted above suggest that
he saw the group, its support and the void below as a
unit. Even more than in his previous painting of 1824 (*The
Lock*), we are made aware of the very levels from which

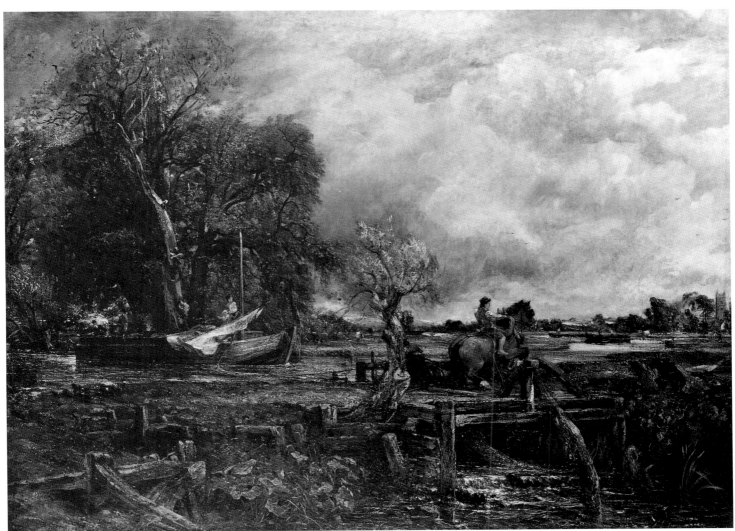

the waters drop away and from which, in this painting, the horse springs. This bridge is a veritable springboard, level with the land and in regular use. There is an immense contrast here to the drawbridge with the fisherboys in Købke's *North Gate of the Citadel* (Fig. 56). They wait before going out into a different world: Constable's boy will return next day and will be witnessing the same thing as a man. However disturbed Constable might be about the changing future of the country life of Suffolk as he had known it, here, in his mind's eye, is a connexion that will not be missed.[4]

1. *John Constable's Correspondence*, vol. IV (1966), p. 368.
2. On the possible location at a spot on the Suffolk/Essex border, near Dedham, see A. Smart and A. Brooks, *Constable and his Country* (London: Elek, 1976), pp. 104–5.
3. K. Clark, *Looking at Pictures* (London: John Murray, 1960), p. 120.

4. Constable's emotional response to Suffolk after he had ceased to live there is well attested in letters: see M. Rosenthal, *Constable* (London: Thames and Hudson, 1987), p. 116. It is likely that the cutting up of land by canal and the regulation of water by sluice, so important for his family's trade as millers, helped by force of contrast to engender in his painting a sense of the release represented by the river Stour itself with its free-moving current, and 'the sound of water escaping from Mill dams'. The springboard-like bridge in *The Leaping Horse* probably had for him a similar connotation of release. R. Paulson, *Literary Landscape: Turner and Constable* (New Haven, CN: Yale University Press, 1982), p. 117, suggests that Constable's was 'a nostalgia for the open field'.

67

The scene is the Court of Exchequer in London, following the libel action brought in 1878 by the American artist James McNeill Whistler against John Ruskin. The critic has accused him of 'charging two hundred guineas for flinging a pot of paint in the public's face' with his picture *Nocturne in Black and Gold: The Falling Rocket*. Another nocturne, *Old Battersea Bridge* (now Tate Gallery, Fig. 80), has been produced in court: it shows the deck of the bridge crossing the picture from side to side, and one gaunt pier. Whistler asserts: 'I did not intend it to be a correct portrait of the bridge. It is only a moonlight scene, and the pier in the centre . . . may not be like the piers of Battersea Bridge as you know them in broad daylight.'[1]

Whistler narrowly won his case, with a farthing's damages: but the victory counted, tacitly, for much more. It recognized that, in his *Nocturnes*, moonlight had converted the 'real' subject of the Thames at night into an ideal one that was personal to the artist. In *Old Battersea Bridge*, moreover, a section of a well-known landmark had become a component in the process. In this chapter the names will recur of John Sell Cotman (1782–1842), Whistler (1834–1903) and Claude Monet (1840–1926). These figures pursued very different paths, possessed very different temperaments, lived against their own backgrounds; Cotman, the earliest, died two years after the youngest, Monet, was born, and was a peculiarly isolated figure, ignored in England to a great extent and relatively little known in France. All of them, however, had in common an interest in turning the real into a kind of personal, pared-down ideal (which nevertheless did not lose touch with its everyday origins), and in using the bridge-shape over water as a way of exploring this. Some reference will also have to be made to Camille Corot (1796–1875) and Paul Cézanne (1839–1906). After this, with the approaches to Van Gogh, the Expressionists and the Futurists, we come back very firmly to the Real.

The Norfolk artist Cotman came briefly into Chapter 2. He is a complex figure: extraordinarily various in his work, devoted to the bridge-idea, but difficult to place satisfactorily in any account of it. Chronologically – and to some extent typologically – his painting falls between the philosophically based regard for the Italianate past that is fixed in Fabre's portrait of Allen Smith (1797) and the modern vernacular of Telford portrayed beside his aqueduct at Pontcysyllte (1838, see p. 80). Cotman never visited Italy, but the hard-edged neoclassical arch meant much to him and emerges unexpectedly from many of his early watercolours of trees and undergrowth. He played no part in Chapter 3, because he does not deal in the multi-layered human subject that concerned the Romantics discussed there. He has no bridge pictures that match in overt public grandeur the late works of Turner or Constable, nor does he have messages, like Delacroix or Blake, for a Europe beset by change and crisis. Though he admired Turner, the Turnerian kind of interdependency between bridge subject and consequential human theme is foreign to him (with some exceptions, chiefly among the slighter early works). Nor does he share Constable's sense of encompassing nature: his interest in the clean lines of man-made constructions is too great for that. Together with the neoclassicism, there are strong touches in his early work at the Sketching Society of London[2] of the emotional world where the eighteenth-century sublime and contemporary Romanticism meet. Yet none of this prepares us

46, VI

for the innovating kind of image that we see in Figures 68 (Plate X) and 69, effects of arresting simplification which truly mark a departure in the history of the bridge picture.

In 1800 Cotman travelled in Wales, and may have seen Telford's Chirk aqueduct, then near completion. In 1803, 1804 and 1805 he visited Yorkshire, and on the first trip drew the famous medieval Ouse bridge at York (wash drawing 1803, Victoria and Albert Museum). Girtin had also drawn this, but, although Cotman's earlier watercolours often reflect Girtin's fluid washes and accents, this particular work is done in a blocky style that forecasts his own maturity. On the last of these north country summer journeys Cotman saw and crossed Greta bridge at the beginning of a three-week stay with the Morritt family of Rokeby. A further period staying at the inn near the bridge will have meant that he saw it every day. The 'classic' watercolours of Greta bridge and the so-called 'Chirk' aqueduct came soon afterwards.

68
69

Cotman's later career is often concerned with architectural subjects and drawing for publication: *The Architectural Antiquities of Normandy* (3 volumes, 1818, 1822) was based on visits to France. The cessation of hostilities with France opens up a period in which British artists visited France and French artists came to Britain. The established interest in picturesque tours naturally took in rivers and innumerable bridge subjects, as Turner's volumes of French river scenery (Loire 1833, Seine 1834–5), based on drawings made in 1826, 1829 and 1832, testify.

Serious antiquarian work on both sides of the Channel was also leading to definitive illustrated publications. Under the influence of the younger Pugin (1812–52) and others, Victorian England leaned towards Gothic and rejected Georgian.[3] France, on the other hand, scrutinized appreciatively its own architectural heritage of Louis XIV, Louis XV and even Louis XVI, as well as the medieval periods.[4] It is true that the balance of nationalistic conviction as reflected in the writings of the historian, Jules Michelet, would increasingly emphasize the achievement of *le peuple*, rather than that of the French monarchs who had given their names to artistic periods. And it is likely that the engraver Charles Meryon's study of the old Paris bridges in the 1850s was undertaken more for their properties of light and shade and their links with a preindustrial age than for any association with the kings who had processed across them, and restored them, for centuries. But in 1850 the statue of Henri IV continued to preside over the recently reconstructed Pont Neuf that he had completed in 1606. And when Renoir came to paint the view from the end of the bridge in 1872 (oil, National Gallery of Art, Washington) the link with *le peuple* was there: he shows them, of all classes, streaming across.

75

The sense of bridges, old and new, as structures of democratic use, funnelling a load of ever-hurrying humanity of all kinds, or providing a viewing platform to river-watchers, was to be vividly recaptured by photography: and the French Impressionists were to devote keen attention to the topic. Before them in time stands Camille Corot, at all times sensitive to the pervading presence of the bridge-form in cities and in the country, intuitively suggesting the rational habits behind France's architectural heritage that historians were disclosing by research.

87a

Corot was half a generation older than the artists of Barbizon in the forest of Fontainebleau who, like Constable, preferred to paint sluices than large-scale bridges. Their Arcadia did not require the regular line of a multi-arched bridge to define it, as Claude's did and as Corot's often came to do. A fallen tree-trunk over a swamp was enough, as it had been for many Dutch seventeenth-century landscapists, notably Ruisdael. Even roads in Barbizon landscapes tend to be rutted tracks very much at the tertiary level of quality as defined by the office of the Ponts et Chaussées. And though some Barbizon artists travelled round France, they differed here also from Corot, who travelled more often and more widely – in Italy, in fact, three times. On his first

visit there in 1825–8, he saw the buildings as round and cubical solids under a steady sun and painted the Roman bridge at Narni. In later life, concentrating on the country bridges that spanned the rivers in France, he enjoyed their ordering possibilities.

71
72

While Corot's relating of real and ideal has been recognized as an influence on the work of Monet, offering a window on the past by which the sense impressions taken in by his eye out of doors could be given substance and enriched, it was, of course, the veritable storehouse of ideas provided for French artists by the forming intelligence of Poussin that afforded the deepest perspectives on that past. Paul Cézanne (1839–1906) is said to have remarked that he wanted to do Poussin all over again from nature. Cézanne's response to the bridge motif was not extensive: he was more interested in the solid forms of houses, sheds and his brother-in-law's prominent pigeon-tower. Like Poussin he preferred shapes that take the eye back in stages rather than suddenly let it through. But each artist knew the value of the bridge in offering a rhythmic succession of voids behind foreground solids. Poussin sometimes placed heroic figures with upraised arms against flat-topped bridges and the descending curves of arches. In Cézanne's case his much-loved pine trees in the Arc valley, near his native Aix-en-Provence, were to be set in almost hypnotic relationship to the streaking horizontal of a distant railway viaduct.

10

73

With Cotman, to a large extent with Corot, and again with Cézanne, we are dealing with artist-idealizers. But it was the growing cities, with their far from ideal realities, that were to draw from other innovating artists of the period, and especially from Whistler and Monet, some of the most remarkable transformations of the bridge form ever painted. Though both artists achieved their own ideality, both were also attracted to Realism, the vigorous new movement that dominates the visual arts, in France especially, from 1840 to *c.* 1880. The commanding metal images of the engineers' bridges, like Robert Stephenson's high-level bridge at Newcastle upon Tyne (painted in 1861 by William Bell Scott[5]), would be prominent, as we see from Caillebotte's work of the 1870s on the Pont de l'Europe in Paris.

88, 89

The visual shock of railways and the structures associated with them is also conveyed in literature, such as the novels of Charles Dickens (1812–70) and Emile Zola (1840–1902). Dickens was fascinated by the Camden Town cutting under construction ('everywhere were bridges that led nowhere . . .').[6] But the lithographic record of J.C. Bourne (1814–96), detailing (1846) the achievement of the Great Western Railway that Turner celebrated more broadly in *Rain, Steam and Speed*, has unique documentary value.[7] And the sense of shock is balanced by one of monumental grandeur as we look at photographs of the French viaducts.

65
74

Whistler (1834–1903) and Monet (1840–1926), work against the changing scenes of Paris and London. London, with its two nuclei, the city and port to the east, and fashionable Westminster to the west, preserved local village centres on its edges, such as Chelsea, where Whistler lived.[8] Paris's single centre had its fortifications re-defined in the 1840s, with the result that the villages beyond only became suburbs in the wake of Haussmann's replanning of Paris in the period 1852–70, a major gesture in favour of a new coherence which had no counterpart in London. Several of the central bridges of Paris were reconstructed in the early 1850s and attracted the eminent engraver Meryon. Whistler depicted the Pont Neuf and the Napoleonic iron bridge, the Pont des Arts (1803), before departing for London. Away from the central bridges of Paris arising from what Baudelaire called 'Architecture's solid body', other bridges in metal were rising from nothing over the tracks that led out from the railway termini and brought visitors in from the four quarters. It would be Monet and Caillebotte who would explore the uncompromising syntax of these structures as they conveyed the almost synonymous notions of steam and speed.

75
76

Simultaneously, Japanese woodblock prints, *ukiyo-e* ('Pictures of the Floating World'), were entering Europe after the opening-up of Japan to trade with the West in 1854. The arrival of these prints was an event of some moment for the bridge-picture. As European artists who depicted street and theatre life found fascinatingly different Japanese counterparts of such interests in the prints, so it proved with bridge subjects. Much has rightly been made of the value given to these prints in the West as compositions which exploited asymmetry and abrupt cut-off, characteristics which Western snapshot photographs were also revealing. Less has been said of the fresh vision provided by these artists of the pictorial usefulness of the bridges of their country. These, along with mountains, waterfalls and the 'stations' along the high roads, constantly exercised their invention as focal points: such landmarks, indeed, counted as 'Famous Places', and warranted whole series of prints devoted to them. The ever-resourceful ways in which bridges might be related to water and river-bank – exploiting side-to-side movement, the diagonal, and elongation – were in themselves a factor for Western artists to ponder: Whistler and van Gogh were to rework these particular ideas for themselves.

78, 78a
79, 79a
80, 80a

Monet, who was to build his own Japanese bridge in his garden in Giverny in 1893, had a lifelong interest in bridges. He treated the railway bridge, especially, as a salient motif in specific subjects of city and suburban life. (He knew Turner's *Rain, Steam and Speed*, though this seems to have had a delayed impact.[9]). In his water-garden series, his Japanese bridge appeared as a piquant, man-made foil that meshed with the luxuriance and exoticism of his own garden. Like Whistler and Turner before him, he was interested in the bridge form as a filtering agent of light. Like Corot, he was attracted to it as a pictorial component, to its shape-value. Also like him, he looked for ways in which this building form, at once in contact with earth, water, air and man's past, could relate to the broad, idealizing objectives of the long French landscape tradition.

81

But it was in London, with its rolling fogs, that he found his greatest opportunities. More particular about season than Whistler, he loved London 'but . . . only in the winter', because then the city had the fog. Scrutinizing the light as it varied within a given day, and no doubt striving to work out how the quality of this light on a given day related to the precise stage of the autumn or winter season (his visit in 1900 lasted three months), Monet equipped himself to extract more and more from the London bridges against sky and reflecting water.

83

It was, perhaps, the capacity of bridges and their immediate surroundings to isolate and expose hurrying crowds which, as much as anything, made them attractive as subjects to the Impressionist painters. Camille Pissarro, at Rouen early in 1896, wrote to his son Lucien of his particular interest in 'the motif of the iron bridge in wet weather, with all the vehicles, pedestrians, workers on the quay, boats, smoke, haze in the distance; it's so full of spirit and life.'[10] He added that he had tried to set down the activity of Rouen's embankments. From the window of his room in the Hôtel d'Angleterre he settled, later in the year, to painting the Pont Boieldieu or Grand Pont, a picture (now in the Museum of Art, Carnegie Institute, Pittsburgh), which misses none of this animation.

82

But the ending of the old century had not led to so nourishing a resolution for other artists. Van Gogh was already dead in 1890 and his personal involvement with the bridge theme had taken a very different course. To follow this we must turn from the bridge as artists' component to the bridge in a less controllable, more volatile atmosphere of social change, that is caught in Regoyos Valdés's painting and in the work of Gustave Caillebotte, and comes to suggest the crisis of human isolation in the work of Seurat, van Gogh and Munch.

84
88, 89
90, 93
96

While the locomotive, La Lison, is the most obvious symbol in Zola's novel *La Bête Humaine* (1890), of what he saw as 'life's furious pace' resounding, modern criticism has recognized an indictment of Second Empire society and its faults symbolized also, in the novel, by the play with voids through which Zola's train rushes, in the end driverless. It is likely that the bridge form in general, and the Pont de l'Europe in particular, took a central place in this thinking.[11] 88, 89

The vast, portentous presence of the Pont de l'Europe, dominating in a way previously suggested, perhaps, only on paper – by Leonardo's bridge design for the Bosphorus and Telford's for the Thames – was not the only pervasive bridge image of this period. In 1872 the young Arthur Rimbaud and Paul Verlaine were impressed by the long, iron bridges of London, and Rimbaud may have introduced memories of them a little later into his visionary poem 'Les Ponts', from *Illuminations* (1886). The images of the poem, 'a strange design of bridges, some straight, some arched, others descending at oblique angles to the first', are part of an ideal cityscape in which the bridges are seen as if suspended over grey water below skies 'the grey of crystal'. While the void through which the bridges are raised is vividly evoked, so too are the tangible elements: poles, ropes, frail parapets. A hundred years have passed since Piranesi's print of Blackfriars, but it is as if Rimbaud has grafted a fantasy by that artist on to his own memories of London.[12]

Rimbaud was associated with the ideas and attitudes that made up Symbolism, a French literary movement in which visual images drawn from the memory were to be prominent. If Seurat, van Gogh and Munch used the bridge in very individual ways to express their own comment on human isolation, the Symbolists invoked it in terms of myth and the inner eye. Intense feeling for the Middle Ages, in particular – seen as a 'spiritual' period contrasting with present-day materialism – could draw attention to the small, enclosed medieval city, with its towers and waterways, as a kind of lost ideal. The Symbolist painter Fernand Khnopff (1858–1921) was to produce mysterious, mist-filled views of the bridged canals of Bruges. But 94
while the bridge with Khnopff is invariably distant and devoid of the life that once thronged it, Walter Crane (1845–1915), also drawn to Symbolism, could use it as a crowded stage for the whole of life and destiny. 95

In part a reaction against naturalism, Symbolism was also a seeking of surrogates for salvation in the vacuum left by the retreat of a common social and religious order in Europe. In the middle of the century Schopenhauer's talk of *das leere Nichts*, 'empty nothingness', could increasingly disturb. Was man in truth no more than a squirrel in a cage? In 1883 Nietzsche asserted that God was dead. Before Nietzsche's final bombshell, the process of seeking ways out of the void into alternative imaginary worlds, and evoking their mythic associations, had also thrown up the promise of the bridge as a space-traversing form. In 1876 Richard Wagner (1813–83), whose opera plots based on Germanic legend were also to influence the Symbolists, staged the first complete performance of his epic music-drama *The Ring of the Nibelung* at his new festival theatre at Bayreuth. At a key moment of *The Rhinegold* on the first evening – when all the haggling over the spoils of greed and theft is for the moment suspended – a note of hope is struck as the gods prepare to enter their new home, Walhalla. A rainbow bridge appears above them as the Rhine-maidens bemoan the loss of their gold. Formed by the god Froh out of the combination of rain and light, it derives from the Norse myth of Bifrost, the rainbow bridge built by the gods as a way from earth to heaven.[13] With or without its Wagnerian associations, the rainbow-bridge makes oddly assorted appearances as the new century begins. In 1910–11, the years when Arthur Rackham (1867–1939) produced his illustration of it as part of his *Ring* series,[14] the Russian artist Wassily Kandinsky (1866–1944) painted one of his tough near-

97 abstracts, 'Cossacks' or 'The Battle', also known as *Composition IV*, which also recognizably depicts a bridge rainbow in an 'heroic' context of struggle.

The most elemental projection of the bridge idea for this period, indeed, was Nietzsche's, in that for him it represented not just human life but the endeavour of every individual human being. And it was to have surprising repercussions on painting. The German philosopher's announcement of God's death early in the Prologue to *Also Sprach Zarathustra* (1883–5) crystallized in the most uncompromising way the awareness of the spiritual void in Europe that many artists and thinkers had felt. Nietzsche's answer, that man achieves fulfilment through self-mastery (becoming Superman), includes the words spoken by Zarathustra: 'What is great in man is that he is a bridge and not a goal.'[15] These words, remembered by four students of architecture – all readers of Nietzsche – in Dresden in 1905, led to their banding together as a group of artist-reformers to be known, after the suggestion of one of their number, Karl Schmidt-Rottluff (1884–1976), as 'Die Brücke', The Bridge. These artists too were conscious of a void in the academic art and social life of Europe and sought to link those who might revolt against it, and what they considered outworn *mores*, to new ideals of a reinvigorated painting based on the instincts and emotions. The title page of their manifesto, designed as a woodcut by the leading member Ernst Ludwig Kirchner (1880–1938) depicted a bridge spanning a void

98a between two dark masses.[16]

The artists of Die Brücke lived and worked together as a community, making their own furniture, painting hectically energized canvases and producing woodcuts in emulation of early examples of the craft in medieval Germany. They responded emphatically to Van Gogh and Munch,[17] and also to the powerful primary colours of Fauve painting. Though one of the Fauves, André Derain (1880–1954) had done some celebratory painting in primary and sec-

98 ondary colours of the London bridges in 1905 and 1906, this vein of Fauvist theme and treatment has no counterpart in the work of Die Brücke. Bridge subjects occur and Kirchner's design for the title-page of the 'Chronicle of the Brücke Group of Artists' (woodcut, 1913) presents angular portraits of the four protagonists – himself, Schmidt-Rottluff, Erich Heckel (1883–1970) and Otto Mueller (1874–1930) – joined by hoop-like shapes which recall the original unifying intentions of which the bridge was symbol.[18] The aim was to affirm the group's unity by describing its shared history: in the event Kirchner, who produced the text, antagonized the others by suggesting that they had shared a definite programme, an idea that they rejected. The group was dissolved in the same year.

The artists of Die Brücke thus went their separate ways well before the outbreak of war in 1914. Individuality has been hard to reconcile with the shared ideas of the artists' groups of the last two hundred years, along with regard for the bridge as a link. Van Gogh's dream of an artists' commune under the tutelary inspiration of the Provençal sun remained a dream: and for him, as we shall see, the bridge motif seems to have come to signify, in the course of the summer of 1888, not so much co-operation and community as separation and isolation. In twentieth-century art it has also, perhaps, more often conveyed the notion of missed or missable connexion, or at least of open-endedness rather than of resolution. The Futurists criticized the French tradition of Poussin, Ingres and Corot for the static qualities of its productions, and as Selz has remarked, saw modern practitioners based in Paris, such as Picasso, Braque and Léger, then close to Cubism, as merely continuing this.[19] It is probable that the fierce Futurist seeking out of experience that which was dynamic rather than static, in the years between 1910 and 1914, will have highlighted the awareness of extreme opposites of location – this end and that end, near and far, above and below – which are signalized by the bridge, in both the

gateway and pathway meanings that we encountered in the Introduction. Paul Klee's fateful drawing appears to reflect this.

In the years up to, and after, the First World War, the bridge, along with other aspects of the objective world, is increasingly absorbed by abstraction: Feininger's beautiful painting *Bridge I* marks this direction. But the American realist Edward Hopper continues to paint memorable bridge-images based on his memories of Paris. After the war the bridge picture with anonymous occupants flourishes afresh.[20] The Austrian painter Kokoschka was to produce some marvellous examples of linking bridges in his great cityscapes of Dresden, Prague and London which included the triumphal bridges of the past. But L.S. Lowry was to use bridges as one device among others (streets, wharves) to evoke the sense of human diaspora which was a central compulsion in his work. In the immediate postwar years it is C.R.W. Nevinson (1889–1946) who keeps in balance the two aspects of linkage and inhibiting isolation. In fact he combines them unforgettably, in a print which comes out of a trip to America.[21]

New York as seen by Nevinson provides this final image. The striding steel trusses of Queensborough Bridge have been painted by Edward Hopper. The peremptory lines of the great suspension bridge of Brooklyn, 'trophy of triumph over an obstacle of Nature',[22] had been painted by Joseph Stella, and photographed by Alfred Stieglitz, who had spoken up for Brooklyn Bridge with the conviction that he was defending America. Kenneth Clark, in the last chapter of *Civilisation* (1969, illustrating artists' views of no fewer than five bridges), was led to recognize such works as emblematic 'frameworks' of the modern world. Artists had their own sense of this, as is pointed out in an essay on the 1980 Hopper exhibition at the Whitney Museum, by Alfred Kazin.[23] A New Yorker brought up with Brooklyn and the other central bridges, Kazin writes of paintings of them ordering the whole 'merciless, exhausting' city for him: 'Someone had seen a design in New York's bridges and rooftops that locked my whirling city into a frame.' Nevinson, coming by contrast fresh to New York after the First World War, seems to have formed his own judgement of modern city life somewhere on the high pedestrian walkway of Roebling's Brooklyn Bridge.

It is no cause for surprise, in view of this unifying effect that the bridge has for Kazin, Kenneth Clark and others, that bridges of different nations form a prominent part of the design of euro banknotes at the beginning of a new millennium. In his valuable work on the human environment and the way in which we 'read' it, Jay Appleton sees the bridge, always strategically placed within the general lie of the land, as 'a powerful symbol of opportunity' (*The Symbolism of Habitat*, p. 66: see Bibliographical Notes). The two centuries that we have been considering, when Western society entered the modern age of communications, saw bridges ever increasing in scale, number and variety of appearance. 'Bid the broad arch the dangerous flood contain,' wrote Pope in 1731 in his 'Epistle to Burlington' (the architect who was later to be a commissioner of the new Westminster Bridge). Pope's exhortation was the prelude to a period of unparalleled experimentation and risk-taking in bridge construction, as stone arches come to be joined in the industrializing age by the dipping dynamism of metal cables. The risks remind us that in one respect, however, bridges have always been alike: the natural hazards that they prevail over remain unchanged. The verdict of a 'triumph over . . . Nature' that greeted Brooklyn Bridge in 1883 could equally have been applied to Leonardo's bold plan to span the Bosphorus, had it been realized in the early sixteenth century. Artists, no strangers to risk-taking and uncertainty themselves, have found abundant dramatic capital in this unique daring of the bridge.

Notes

1. J.McN. Whistler, 'The Ten o'Clock Lecture', in *The Gentle Art of Making Enemies* (1890), p. 8.
2. The Sketching Society wash drawing *Towered Cities Please Us Then* (1804, Victoria and Albert Museum), after Milton's poem 'L'Allegro', probably borrows architectural motifs from Turner (the pyramid, from Turner's oil *The Fifth Plague of Egypt*, R.A. 1800) and Piranesi (the aqueduct running into the side of a pyramid, as a loggia does in Piranesi's engraving *The Pyramid of Caius Cestius*): see Adele Holcomb, 'The Bridge in the Middle Distance: Symbolic Elements in Romantic Landscape', *Art Quarterly*, vol. 37 (1974), pp. 47–8. Another Sketching Society bridge subject by Cotman is *Dante and Virgil at the Bridge* (Victoria and Albert Museum): see Jean Hamilton, *The Sketching Society 1799–1851*, exh. cat. (London: Victoria and Albert Museum, 1971), p. 25 (reprod.).
3. Telford's London Bridge design (1800–1801) had Gothic decoration as we saw. By then a scholarly rehabilitation of Gothic was also well under way in France, and a seriously archaeological Gothic revival ensued in France, Germany and Britain. Charles Barry's 'Gothic' bridge, designed before 1846 to go with the Tudor Gothic style of his Houses of Parliament in London, although eclectic, was not to be built.
4. D.J. Olsen, *The City as a Work of Art, London, Paris, Vienna* (New Haven and London: Yale University Press, 1986), 'The City as Document', Chapter 18, pp. 303f.
5. In a well-known mural depicting industry in Newcastle painted for Wallington Hall in Northumberland.
6. Charles Dickens, *Dombey and Son* (1847–8), ch. 6.
7. For John Cooke Bourne see A. Elton, 'The Piranesi of the Age of Steam', *Country Life Annual* (1965), pp. 38–40: also F.D. Klingender, *Art and the Industrial Revolution* (St Albans: Paladin, 1972 [1947]), pp. 133f. Bourne's work includes a valuable record of many railway bridges and viaducts in Britain (collection in the National Railway Museum, York). Bourne inimitably stresses the ground-level experience of looking up at dark arches, one which countless trainspotting children will have had. After the death of the poet Ted Hughes in 1998, Seamus Heaney's poem in tribute to him compares a reading of Hughes's 'Birthday Letters' to passing under a railway bridge remembered from childhood: 'the tremor-drip / And cranial acoustic of the stone / With its arch-ear to the ground . . .'
8. Cf. a useful article by Robin Spencer, 'The Aesthetics of Change: London as seen by James McNeill Whistler', in M. Warner, ed., *The Image of London, Views by Travellers and Emigrés 1550–1920*, exh. cat. (London: Barbican Art Gallery, 1987), pp. 49–69.
9. Monet had almost certainly seen the work in 1870–71, when he was in London with Pissarro. But he is only on record as praising it in 1892, when he mentions 'with admiration' Turner's 'railway one' to the American painter Theodore Robinson: see Robinson's Diary, 5 September 1892; cf. F. Lewison, 'Theodore Robinson and Claude Monet', *Apollo*, vol. LXXVIII (1963), p. 211. Cf. also J. House, *Monet: Nature into Art* (New Haven and London: Yale University Press, 1986), p. 113. Monet may have seen *Rain, Steam and Speed* on visits to London in 1888 and 1891.
10. My translation. Cf. also C. Pissarro, *Letters to his Son Lucien*, ed. J. Rewald, 4th edn (Layton, UT: Peregrine Smith, 1980), p. 281.
11. Zola's statement was made to Edmondo de Amicis, the Italian journalist: see his *Studies of Paris* (New York, 1879), pp. 238–40. See also M. Kanes, *Zola's La Bête Humaine, A Study in Literary Creation* (Berkeley and Los Angeles: University of California Press, 1962), p. 8. The Second Empire's faults have been defined as 'self-destructive lack of control, radical instability, an absence of social leadership': cf. B. Nelson, *Zola and the Bourgeoisie* (Totowa, NJ: Barnes and Noble, 1983), p. 20. The relevance of the bridge image in *La Bête Humaine* is recognized by Robert Lethbridge, who notes that 'the novel exhausts the semantic variables of fissure and gap, tunnels and railway cuttings, viaducts and bridges over the void'. See his essay 'Zola and the Limits of Craft' in R. Lethbridge and T. Keef, eds, *Zola and the Craft of Fiction, Essays in Honour of F.W.J. Hemmings* (Leicester, London and New York: Leicester University Press, 1990), p. 137. Further evidence suggests the particular importance of the Pont de l'Europe. While it is clear from Zola's own testimony that one of his purposes in writing *La Bête Humaine* was to present a large station where ten lines meet, each with its own story,

it is worth noticing that a composite photograph of the rebuilding of the Gare Saint-Lazare, issued in 1885, suggestively showed all the railway lines as viewed from the Pont de l'Europe (reprod. in *A Day in the Country*, exh. cat. (Los Angeles: Los Angeles County Museum of Art, 1984), p. 116.

12. In his helpful commentary on Rimbaud's 'Les Ponts' Cohn refers to Rimbaud's experience of the London bridges. Length was a factor associated by Germain Nouveau, who had been in London with Rimbaud, with English bridges, and the bridges in 'Les Ponts' are 'long and light'. Cf. R.G. Cohn, *The Poetry of Rimbaud* (Princeton, NJ: Princeton University Press, 1973), p. 302. 'Les Ponts' is the only poem in *Illuminations* to have the definite article in its title, suggesting a precise source: and that Rimbaud was composing his poem with the London bridges in mind is probably borne out by other references: to the water 'large comme un bras de mer' (the tidal Thames) and the grey skies, 'ciels gris de cristal'. Professor C.A. Hackett, the major authority on Rimbaud, pointed out to me the interesting plural form, 'ciels', which is used in descriptions of paintings, e.g. 'les ciels de Corot': and Rimbaud's phrase in 'Les Ponts' 'un bizarre dessin de ponts' seems to evoke a pictorial source. But perhaps the quality of the long, dark lines of the London bridges stretching across a wide river was in itself enough to strike a visitor from Paris, with its generally shorter, more intimate central bridges: Monet would make much of the length of Charing Cross (Hungerford) railway bridge (opened in 1864; see Fig. 82), as, spectacularly, would Kokoschka in his *London, Large Thames View I*, a subject seen also from the Savoy (oil, 1926, Albright-Knox Art Gallery, Buffalo, New York, reprod. *Oskar Kokoschka 1886–1980*, exh. cat. (London: Tate Gallery, 1986), no. 59. Flora Tristan, *Promenades dans Londres* (Paris, 1840) was too early for the iron Hungerford bridge, but uses the phrase 'formes bizarres' to describe her view of the city with its bridges and domes. The Scottish geologist Hugh Miller, *First Impressions of England and its People*, 12th edn (Edinburgh: Nimmo, 1872), p. 313, describes his view from the top of the dome of St Paul's: 'a long reach of the river, with its gigantic bridges striding across . . . and the bridges grey and unsolid-looking themselves, as if cut out of sheets of compressed vapour, seemed leading to a spectral city'. I am grateful to Professor Hackett for this reference and for help concerning Rimbaud.

13. The rainbow bridge of Norse mythology, Bifrost, occurs in the *Prose Edda* compiled by Snorri Sturluson (1179–1241). Sturluson came from an aristocratic Icelandic family and based his work on the oral tradition of earlier poets or 'skalds'. In the section known as *Gylfaginning* ('The tricking of Gylfi'), a king called High relates that the gods built a bridge from earth to heaven, a rainbow bridge which 'has three colours and great strength' and is built with 'art and skill' to a greater extent than other constructions. It will only break if 'Muspell's lads' (probably giants) ride on it. See S. Sturluson, *Edda*, trans. and introd. A. Faulkes (London: Dent, Everyman's Library, 1987), p. 15.

14. The arc of the rainbow is cleverly contrasted with upward-sweeping forms around and below it: the rocks along the river banks and the Rhine-maidens breaking out of the water.

15. Nietzsche, *Thus Spake Zarathustra*, trans. B. Hollingdale (Harmondsworth: Penguin, 1969 [1961]), p. 42. Munch's posthumous portrait of Nietzsche (oil, 1905–6, Oslo Community Art College, Munch Museum, Oslo) shows the philosopher gazing over the abyss which he had described.

16. In 1906 another recruit to the group, Max Pechstein (1881–1955), produced a woodcut showing three of the founder-members, Kirchner, Schmidt-Rottluff and Heckel sitting under the arch of a bridge: reprod. Horst Jähner, *Künstlergruppe Brücke: Geschichte einer Germeinschaft und das Lebenswerk ihrer Repräsentaten* (Berlin: Henschel-Verlag, 1984), p. 15. The idea of the bridge as means of entry to a new life is implied, as we have seen in the work of earlier artists such as Schinkel (Fig. 55) or Friedrich. It hardly appears with this mystical meaning in the work of the Brücke artists, but a drawing by August Macke (1887–1914), *Rheinbrücke am Abend* (mixed techniques, Bernard Kochler Stiftung, Lenbachhaus, Munich) deserves notice. Dating from 1906, it depicts a thin suspension bridge high above the river and extending across the whole picture space. We are told that Macke was busied at this time with the idea of painting a 'Bridge of Life' (Elisabeth Erdmann-Macke, *Erinnerung an August Macke*, Stuttgart: Kohlhammer, 1962, p. 53). See reprod. in R. Gollek, *Die Blaue Reiter im Lenbachhaus München, Katalog der Sammlung in der Städtischen Galerie* (Munich: Prestel-Verlag, 1982), no. 260.

17. The members had seen van Gogh's work at the Kunstsalon Ernst Arnold, Dresden, in November 1905; Munch's work was seen at the Saxon Art Association, Dresden, in 1906.

18. Reprod. B. Herbert, *German Expressionism* (London: Jupiter Books, 1983), p. 84.

19. See P. Selz, *German Expressionist Painting* (Berkeley and Los Angeles: University of California Press, 1957), p. 259.

20. A fugitive-like figure or figures trudging over a bridge becomes almost a symbol of the twentieth century in literature, photography and film: most recently in television film of refugees seeking asylum at another country's border or army check-points. Such a figure appears in Edwin Smith's Dublin photograph on the cover of James Joyce's *Ulysses* (1922) in the Penguin Twentieth-century Classics edition (1986). A sense of having a goal but not knowing how to reach it is conveyed in the work of T.S. Eliot in London after the First World War, and in *The Waste Land* relates specifically to London Bridge, which he crossed twice a day ('A crowd flowed over London Bridge, so many / I had not thought death had undone so many'). See T.S. Matthews, *Great Tom, Notes towards a Definition of T.S. Eliot* (London: Weidenfeld and Nicolson, 1973, 1974), p. 63. Henri Cartier-Bresson (b. 1908) photographed a dead soldier at the end of a metal bridge, one of the great summings-up of twentieth-century catastrophe, in *French Resistance, Banks of the Rhine* (reprod. *Old and Modern Masters of Photography*, exh. cat., London: Victoria and Albert Museum, 1981, no. 45).

21. Nevinson, responding to currents in European art up to the First World War, painted *The Bridge at Charenton* (oil, 1911–12, Manchester City Art Galleries) in a Post-Impressionist idiom, but also reflected Cubism in the foreground houses of *The Viaduct: Issy les Moulineaux* (oil, 1913, private collection, New York). This gives side-to-side prominence to the viaduct with a train crossing at the top. Nevinson's friend Edward Wadsworth (1889–1949) also showed a picture called *The Viaduct* (perhaps the Issy viaduct also) at the Grafton Galleries Post-Impressionist exhibition in 1913. The machine aesthetic of the Futurists, proclaimed in 1909–10, produced crops of paintings with elements obtained from railway stations, factories, viaducts and high-level walkways. The visionary architecture of Antonio Sant'Elia consciously separated out the walkways of the pedestrian from the roads occupied by motorized traffic. By 1913 Nevinson was turning to Futurism and a more planar abstraction: the charcoal drawing *Factories* (Cooper Art Gallery, Barnsley) incorporated a curved single-arch bridge of immense height, which isolates the figure crossing. At Frank Rutter's Futurist exhibition at the Doré Galleries, London, in 1913, Nevinson showed works with revealing titles, such as *The Departure of the Train de Luxe* and *The Iron Bridge* (both now untraceable). After the war, in which he served as an ambulance driver and from 1917 as an official war artist, he took up subjects in London, Paris and also New York, which he visited in 1919 and 1920. See *C.R.W. Nevinson, Retrospective Exhibition of Paintings, Drawings and Prints* (Cambridge: Kettle's Yard Gallery, 1988), pp. 6f.; also, for reprod. of Nevinson's *Viaduct*, R. Cork, *Vorticism and Abstract Art in the First Machine Age* (London: Gordon Fraser, 1976), vol. I, p. 108.

22. Contemporary comment quoted by A. Tractenberg, *Brooklyn Bridge: Fact and Symbol*, 2nd edn (Chicago: University of Chicago Press, 1979), pp. 18, 118.

23. A. Kazin in *Edward Hopper 1882–1967*, exh. cat. (London: Arts Council, 1980), p. 22.

68

68 and Plate X John Sell COTMAN (1782–1842)
Greta Bridge, Durham
Watercolour, 22.7 × 32.9 cm (9 × 13 in.), 1807

Cotman's stay at Greta Bridge (p. 128) seems to have
represented a kind of summation. The defining
horizontals and verticals of the aqueduct, as previously
seen in Italianate engravings and reduced to two or three
applications of wash at the Sketching Society; the
possible encounter with the real thing at Telford's Chirk;
and the geometry of John Carr's neoclassical bridge over
the Greta of 1773, now combined to transform Cotman's
bridge draughtsmanship. The picturesque irregularity of
Brecon Bridge and the variability of tone of the *Devil's
Bridge* (Fig. 43), both drawings of 1801, are by 1805
replaced by works in which the Rokeby or Durham
woods are made the setting for pristine structures
distantly sited but as sharp to the eye as if hewn by an
axe-stroke (*Greta Woods*, watercolour 1805–6, private
collection; *The New Bridge, Durham*, watercolour 1808,
private collection).

 The climax of the process is the Greta Bridge
watercolour of 1807. Here the civility of the bridge holds
down all that nature can muster. But the niched and
balustraded fullness of Carr's structure is contracted to
virtual two-dimensionality. The irregular, obtusely
angled mass of middle-ground river mud and stone is
played off against the mathematical regularity of the
parapet. The bumpy darks of the foreground rocks are
answered by the 'perfect' half-ellipse of the arch. Mass
answers mass with the inevitability of close-fitting

building blocks, but with far more visual variety.[1] This
effect of architecturally assembled colour patches is the
result of a particularly structural use of the wash
technique. That it should be done with such perfect poise
in the medium of watercolour is Cotman's double
distinction in this classic phase of his work.[2]

1. The lining up of a bridge parallel to the picture plane, as in
 Greta Bridge, had been recently done by Girtin in his *White
 House at Chelsea* watercolour (1800, Tate Gallery); Turner had
 developed the light silhouette of a single-arch bridge against
 dark background in his *Tummel Bridge* (*c.* 1802–3). Cotman,
 like Turner, has a house at the end of the bridge, but achieves
 greater geometrical severity. The Greta Bridge stood at an
 ancient crossing of a major Roman road, as Holcomb notes
 (Adele M. Holcomb, 'The Bridge in the Middle Distance:
 Symbolic Elements in Romantic Landscape, *Art Quarterly*,
 vol. 37 (1974), p. 51) but Carr's massive, niched design would
 have embodied as much as Cotman needed, perhaps, of
 Roman associations.
2. Cotman's simplified images and economy of touch made his
 watercolours difficult for a generation bred on the
 picturesque. The Society of Painters in Watercolours (Old
 Watercolour Society) had been founded in 1804 to promote
 the medium, and had attracted much support from the
 public. But Cotman had failed to be elected to membership in
 1806, in which year he exhibited at the Royal Academy for the
 last time and returned to Norwich. A discerning friend,
 Francis Cholmeley, suggested that an etching by Cotman of
 trees in Duncombe Park overemphasized method rather than
 subject: 'two thirds of mankind, you know, mind more about
 what is represented than *how* it is done'. Cotman's stark (i.e.
 relatively unmediated) separations of light and dark in such a
 work as *Greta Bridge* hardly lessened the problem.

69 John Sell COTMAN (1782–1842)
'Chirk' Aqueduct
Watercolour, 31.5 × 23.1 cm (12 $^1/_2$ × 9 in.), 1806–7

Perhaps it was a kind of imperative to accommodate the real to the ideal, which Yorkshire seems to have released in him, that made Cotman draw out his *Aqueduct, Called Telford's Aqueduct at Chirk*, after the third visit north (Fig. 69a, see also p. 128). As the 1982 Cotman catalogue remarks, his head must have been full of the images seen on his northern travels which had not, so far as is known, yielded an aqueduct.[1] But the persistence of what had earlier impressed him as a motif in Italianate painting had, it seems, to be acknowledged. This aqueduct is quite unlike that of Chirk, and there are echoes of the picturesque, but the way he places the washes puts it well into Cotman's maturity.[2]

Within the next twelve months the watercolour masterpiece now in the Victoria and Albert Museum emerged. This subject also differs from Chirk as built, but if the purpose was to link the real to the ideal this would not be surprising. Compared with the Oxford drawing, this is more 'classical': the structure of the aqueduct is far less textured, more complete. On the other hand, reflections are shown and, with these as centres of interest in themselves, Cotman treats the building itself very simply, with no play of darker washes on the surfaces facing the spectator. The paring down to bare bone recalls the tendencies of neoclassical architects.[3] The formal perfection of the man-made form is suggested, but time has produced irregular patches of weather-worn brick and the perfection is made the more moving for now having no human presence beside it. Each pier and its lower-toned reflection locks into the sloping bank with the precision of a mortice-and-tenon joint. The basic colours of warm ochres, blues and greens are applied in washes of the sparest brevity. As we look at the pattern of light and dark we are aware that Cotman's realization of the aqueduct form was unique in his age. He alone of his creative contemporaries brings this typical motif of the Industrial Revolution and the canal age literally forward, and builds pictures out of it.[4]

1. *John Sell Cotman 1782–1842*, exh. cat., London: Arts Council of Great Britain (1982), p. 75.
2. The Oxford drawing is dateable on style: the complex patterns of foliage to the right would not have been possible before 1805. The tones employed on the aqueduct are part of a kind of counterpoint that is mainly accountable to their pattern value in the drawing. For example, it seems unlikely that the deeper tone which appears on the lower part of all the piers is the shadow of an unseen form in the foreground.
 More probably it is inserted because the pale band of light behind the piers demands a darker contrast.
3. Cf. Adele M. Holcomb, 'The Bridge in the Middle Distance: Symbolic Elements in Romantic Landscape', *Art Quarterly*, vol. 37 (1974), pp. 31–58, where examples of arch designs by George Dance and Soane are cited.
4. It is true that arcades as such, 'in elevation', enjoy attention from artists in this period: the Danish painter Christoffer Wilhelm Eckersberg (1783–1853) produces a very precisely objective view of three arches of the Colosseum in this way *c.* 1815 (oil, Statens Museum for Kunst, Copenhagen, reprod. R. Rosenblum and H.W. Janson, *Art of the Nineteenth Century: Painting and Sculpture*, London: Thames and Hudson, 1984, p. 177). Eckersberg had earlier been a pupil of J.L. David, as well as of the Dane N.A. Abildgaard. Corot was to treat the arches of the ruined Basilica of Constantine in Rome similarly. But Cotman, at 'Chirk', seems to have been inspired by the idea of man's sheer building prowess, relatively little affected by time or association. His aqueduct dominates the landscape and even, through its reflection, the water below it.

69a John Sell COTMAN
Aqueduct, Called Telford's Aqueduct at Chirk
Pencil and grey wash, 20 × 16.1 cm (7 $^7/_8$ × 6 $^1/_4$ in.), 1806. Ashmolean Museum, Oxford

69a

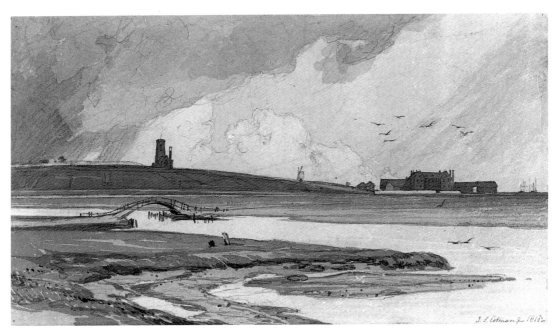

70

70 John Sell COTMAN (1782–1842)
Blakeney Church and Wiveton Hall
Pencil and wash, 17.2 × 28.5 cm (6 3/4 × 11 1/4 in.),
1818

In the later part of his career, from 1810, Cotman becomes
preoccupied with publishing views of architectural
subjects and drawing for engraving. Much time from
1809 is also taken up with the preparation of drawings as
models for his many pupils. Precise, copyable line was
required for both purposes, and topographical exactitude
had to be supplied for patrons who were interested in
local history and antiquarian matters. But inventive use
of the bridge motif was not easily held in. The deceptively
simple-looking wash drawing *Blakeney Church and
Wiveton Hall* was done as one of the illustrations to
Longman's publication *Excursions in the County of Norfolk*
(volume I, opp. p. 155). The small engravings made by
Greig from Cotman's drawings are dull, but the drawings
themselves abound in subtleties of emphasis. Here the
dark, square church tower is placed over a river rendered
as blank paper and a skeletonic bridge with a high curve
reminiscent of the rainbow bridges of China. The yeasty
swell of the hump both enlivens the dark land mass
above and animates the whole drawing, even more than
the flying birds.

Laurence Binyon was perhaps the first to comment on
the 'Chinese' qualities in some of Cotman's work, and
there is a tradition that Cotman owned some Chinese
drawings.[1] The flying strokes and abbreviations of
perspective can indeed recall paintings by Far Eastern
artists of the scholar-amateur tradition. But the
Piranesian elements in Cotman's make-up, in particular
his intimations of the architectural block, are so strong as
to make it likely that the 'Chinese' dynamics of details in
Blakeney Church were an effect of contrast, generated
more out of himself, than as a response to any Chinese
painting he may have seen. Cotman's deliberation in
placing his lightly curving bridge immediately below the
heavy mass of the church tower, and above that of the
foreground bank, also suggests that he was aiming at an
effect of graphic contrast which might look effective in
terms of etching. The device of offsetting the mass of
Wiveton Hall with a 'linear' windmill to the left, sailing
ships to the right, and seabirds above and below, seems to
be pointed towards the same end.

1. In 'Masters of English Landscape Painting: Cotman, Cox and
 De Wint', *The Studio* (1903), p. vi.

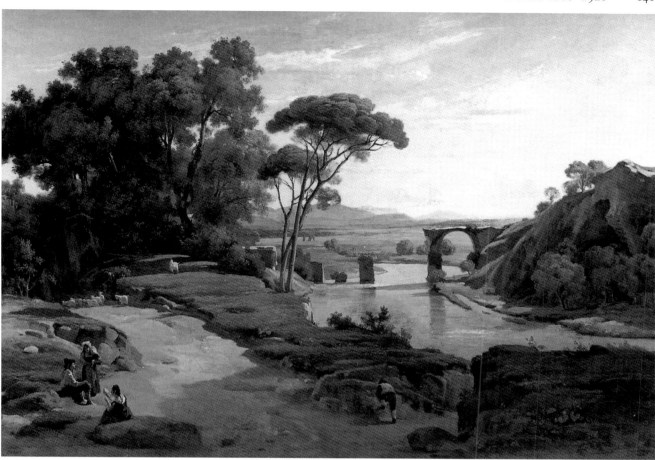

71

71 Camille COROT (1796–1875)
The Bridge at Narni
Oil, 68 × 94.5 cm (26 3/4 × 37 1/4 in.), 1827

The heroically severe landscapes of Poussin, painted in Rome, were still an inspiration to his nineteenth-century artist descendants. Even some of the realist painters of the Barbizon group, notably Jean-François Millet, admired Poussin, choosing aspects of his art which came closest to their own aims, in this case a direct taking up of ideas from nature. A key figure for the modern assimilation of Poussin was Pierre-Henri de Valenciennes (1750–1819), who painted heroic landscapes in the manner of Poussin, but who, in sketch-like views of Rome done in the open air, had set a further objective for the younger *plein-airistes*. The heroic vein of Valenciennes' finished paintings emerges in the work of his pupils Achille-Etna Michallon and Victor Bertin, who were to teach Corot. Corot's descent from the main French classical tradition could hardly, therefore, be more direct; but, as is shown by the dozens of small, sketch-like views of Rome done in his first visit (1825–8), he was also following in the other progressive direction in which

Valenciennes had pointed. He demonstrated his non-conformity by including a view of the Ponte Sant'Angelo from the side opposite to that so often painted by others earlier. He also visited the famous broken bridge at Narni, and exhibited the present view of it.

The solid piers of this bridge, with one standing arch, were an open invitation to artists who were attracted by the idea of the effects of time on a building that had survived from the reign of Augustus. Corot could rearrange in the interests of his own mental ideal, and comparison with the sketch (Louvre), shows that he made the final painting much more classically balanced. Most notably he has introduced a reflection in the water of the main pier, thus doubling the length of the vertical and obtaining greater stability in the pictorial effect.[1]

1. See A. and R. Jullien, 'Les Campagnes de Corot au nord de Rome 1826–1827', *Gazette des Beaux-Arts*, vol. XCIX (1982), p. 188. See also P. Galassi, *Corot in Italy: Open Air Painting and the Classical Landscape Tradition* (New Haven and London: Yale University Press, 1991).

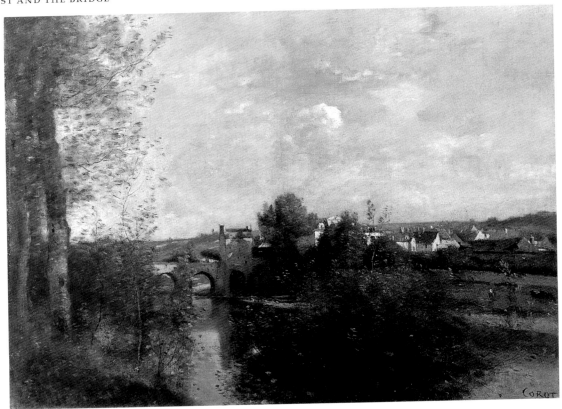

72

72 Camille COROT (1796–1875)
The Seine and the Old Bridge at Limay
Oil, 40.7 × 66 cm (16 × 26 in.), *c.* 1870

Corot, indeed, picks a very individual course between the idealizing traditions of French painting on the one hand and the unidealizing if Romantic earthiness of the Barbizon painters (see p. 128) on the other. He spent a large part of his life, after his first visit to Italy in 1825–8, moving round the French provinces painting landscapes in which towns or the habitations of man, and bridges, often appear. Usually the bridges are old, half buried in overhanging trees and very much integral to their setting. An example which sums up much of their character is the present picture. The tonal relationships are, as always in Corot's best work, exactly caught, but we are also made aware, in a picture which contains a great deal of vegetation, of the clear construction of the composition. The line of the invisible road through the village is even implied, passing the scattered houses on the right and emerging to cross the bridge. The chimney of a gatehouse at the end of the bridge creates a right angle to this horizontal, and its reflection strikes downwards to form, with the bridge parapet and the lower left corner of the canvas, a rectangle which is in ratio to the whole painting. This emphasis on structure and proportion refers back to his time in Rome and also to Corot's close involvement in

the deployment of the 'number, weight and measure' of the French classical tradition.

Late in Corot's working life, therefore, canvases such as *The Seine and the Old Bridge at Limay* and the *Bridge at Mantes* (oil, 1868–70, Louvre), show the ripe results of analysis and selection. In the *Mantes* two bridges are in fact present, one behind the other, but both here and in *Limay* the 'site-specific' elements are subsumed in a broader, timeless definition. By holding the point of balance of the composition the Limay bridge undemonstratively discloses the simple truth that man's overcoming of a natural hazard has become an act of collaboration with nature. Corot's capacity to uncover basic patterns in the ordinary seems to have been in the mind of Camille Pissarro when he wrote of the older artist's process:

> What beautiful pictures old Corot made at Gisors: two willows, a little stream, a bridge . . . what a masterpiece! Happy are those who see beauty in modest places where others see nothing. Everything is beautiful, what matters is to know how to interpret it.[1]

1. My translation, letter of 26 July 1893. Cf. C. Pissarro, *Letters to his Son Lucien*, ed. J. Rewald, 4th edn (Layton, UT: Peregrine Smith, 1980), p. 212.

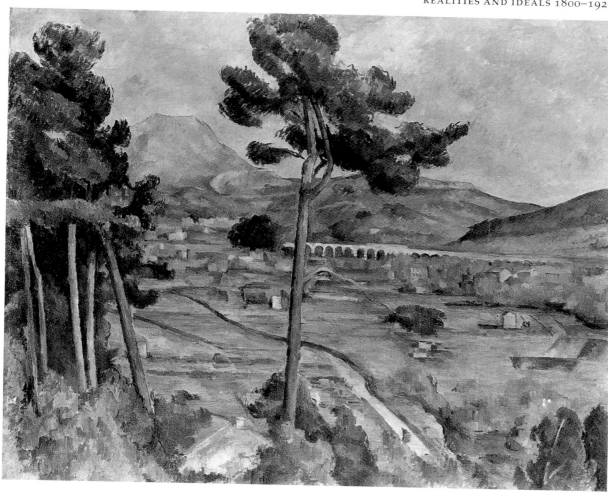

73

73 Paul CÉZANNE (1839–1906)
La Montagne Sainte-Victoire
Oil, 65 × 81 cm (25 ¹/₂ × 32 in.), c. 1885–7

The keen-edged landscape horizontals of Poussin
(sometimes provided by bridges but more often by more
solid buildings), and their association with verticals,
revealed a degree of rigour approached by no other
painter until Cézanne.[1] Some of this discipline is referred
forward from Poussin by such an artist as Fabre (Fig. 46
and Plate VI), and the bones of it show through the
masking foliations in Corot's *The Seine and the Old Bridge
at Limay* (Fig. 72). But Cézanne's paring down and indeed
fusion of a single horizontal and vertical into a basic
bridge-and-tree relationship was to be his personal
concern.

 Though the relationship occurs in Cézanne's *Bridge at
Maincy near Melun* (oil, c. 1879–80, Louvre),[2] it was the
landscape round his native Aix-en-Provence that
provided him with the best conditions for coming to grips
with this problem. A series of works that include the

bridge at Gardanne, south of Aix, come in the mid-1880s,[3] as do several drawings and paintings associated with distant views of Cézanne's favourite subject, the Mont Sainte-Victoire across the Arc valley. In particular, a viewpoint from a hill that was probably at Bellevue, his brother-in-law's estate, provided the idea of combining the mountain with a foreground pine-tree, or group of pine-trees, and a railway viaduct.

The effect of the series is like that of trio or duet movements for different instruments.[4] In the Courtauld Institute's painting mountain and tree are prominent, and the viaduct is subordinate. In the Phillips Collection version (Washington) mountain and viaduct are alike muted. In the Metropolitan Museum picture the mountain recedes while the tree and viaduct clash on equal terms and, by an extraordinary resolution, harmonize. Where the viaduct passes behind the tree one of its white arches becomes in effect a branch of it, which supports a small mass of foliage. Natural and man-made, near and far amalgamate, and the new viaduct, however brash in character, becomes an intrinsic part of the very logic of the painting.

1. R. Verdi, *Cézanne and Poussin, The Classical Vision of Landscape*, exh. cat. (National Gallery of Scotland and London: Lund Humphries, 1990) has many useful comparisons. The appeal of Poussin's 'order' for Cézanne is well known; it was vital also for Degas, who wrote in 1872 of 'dreaming of something well done, a whole well organized (style Poussin) and Corot's old age': see *Lettres de Degas*, ed. M. Guérin (Paris: B. Grasset, 1931), vol. II, p. 11.
2. The horizontal of the central wooden span is interrupted precisely at the left-hand end by two tree-trunks which run from bottom to top of the canvas (ill. in colour, in *A Day in the Country*, exh. cat., Los Angeles: Los Angeles County Museum of Art, 1984, no. 73).
3. A drawing is reproduced in colour in Verdi, *Cézanne and Poussin*, p. 162. See also Erle Loran, *Cézanne's Composition*, 3rd edn (Berkeley, Los Angeles and London: University of California Press, 1963), p. 48, where it is noted that Cézanne brought the bridge and church closer to the trees than they actually were.
4. J. Rewald, *Paul Cézanne: The Watercolours, A Catalogue Raisonné* (London and New York: Little, Brown and Co., 1983): nos. 241, 242 (pp. 142–3) show the Montagne Sainte-Victoire with the viaduct; no. 239 (Albertina, Vienna) has the viaduct without the mountain. Writing of the Albertina drawing, A. Neumeyer, *Cézanne Drawings* (New York and London : T. Yoseloff, 1958), p. 58, had noted that 'the middle ground links to the foreground at the meeting point of the branches of the pine tree with the viaduct'. The Metropolitan Museum painting confirms the idea that was in Cézanne's mind.

74 Auguste-Hippolyte COLLARD (fl. 1850–80)
Landscape near the Chantilly Viaduct
Albumen print from glass negative, 32 × 43 cm
(12 1/2 × 17 in.). From *Album des Chemins de fer du Nord* (1859)

While J.C. Bourne, in Britain, is unsurpassed for his dramatic record of the turmoil involved in building the railway bridges of the age, no more elegant account of the completed structures exists than in the photographs of the Frenchman A.-H. Collard, who was employed by the Ecole Nationale des Ponts to make a record of them at a time when the authors of the French railway system, encouraged by the followers of Saint-Simon, the social reformer, were aiming to draw attention to a new sense of national unity.[1]

In 1855 the distinguished photographer Edouard Baldus (1813–89) was illustrating the railway album *Chemins de fer du Nord: Ligne de Paris à Boulogne*, commissioned in 1855 by Baron James de Rothschild after Queen Victoria had travelled along the line (album now at Windsor Castle). He was long thought to be responsible for the present print, but it now seems to be of a slightly later date. An additional line from Saint-Denis to Creil and Compiègne, opened in 1859, crossed two new viaducts, Commelles and Chantilly, designed by the engineer François Mantion. It was Collard, it appears, who recorded both structures.[2]

While Collard owes much to Baldus,[3] he has his own originality. This large print is entitled 'Landscape': the viaduct is flanked by trees, one of which casts its shadow upon it; more than this, the long horizontal top, tapering piers and darkly shadowed arches are in classic dialogue with the lie of the land that is suggested by the foreground, with its two angles of slope.

What of the locomotive, with its prominent crew? The pace of actual living has, of course, quickened since the heyday of Telford's aqueducts (Figs 44, 69). Town bridges over rivers with crowds on them (Fig. 87a) and bridges and viaducts with trains on them (Figs 65, 81–84) afford a powerful image of nineteenth-century humanity's imposition of itself on its surroundings, yet also of the transitoriness of the moving spectacle that such structures – especially one as massively Roman-looking as the

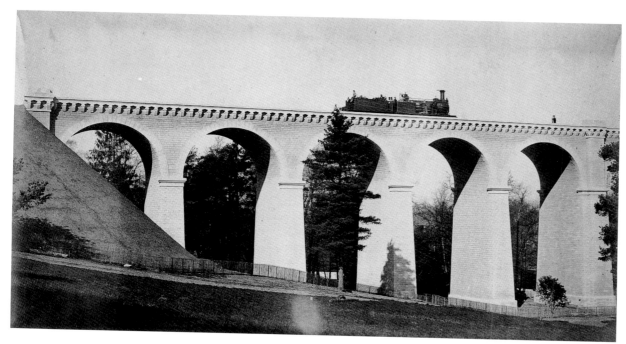

74

Chantilly viaduct – present or imply. 'Modernity', said Baudelaire, 'is the transitory, the fugitive, the contingent.'[4] Photography itself, of its nature, was uniquely suited to reveal facts of modern life. Moreover, the sense of time itself was changing. While railways were to standardize time across whole countries, speeds of 50, 65 and 80 km (30, 40 and 50 miles) per hour – at tree-top height, as the photograph shows – were to give a new meaning to the experience of it. Using the new tool, the camera, Baldus (compare Fig. 87a) and Collard were clear-eyed exponents of the new relationship of rapid change to permanence which bridge-subjects were so well placed to express.

1. See Marc Baroli, *Le Train dans la littérature française*, 3rd edn (Paris: Editions NM, 1969), pp. 11–23; also Malcolm Daniel, 'Edouard-Denis Baldus and the Chemins de fer du Nord Albums', *Image*, vol. 35, nos. 3–4 (1992), pp. 2–37, esp. p. 11. The linking effect of grand viaducts, in the context of national unity, needs no underlining.
2. See Daniel, 'Edouard-Denis Baldus'. This disentangles the contributions of Baldus to the Queen's album and of Baldus and others to a further edition of twenty-five copies, and an album produced for Napoleon III.
3. For Baldus's own bridge photographs, including a later Algerian example of 1864, the Al Kantara Bridge, Constantine (a contemporary construction above an ancient Roman bridge across a ravine), see Malcolm Daniel, *The Photographs of Edouard Baldus*, exh. cat. (New York: Metropolitan Museum of Art, 1994), pp. 84–5, 91–3 and pls 9, 10, 65, 68, 69, 71, 75, 76.
4. Baudelaire, 'Le Peintre de la vie moderne: IV, La Modernité', in *Oeuvres Complètes* (Paris: Editions Gallimard, 1961), p. 1163.

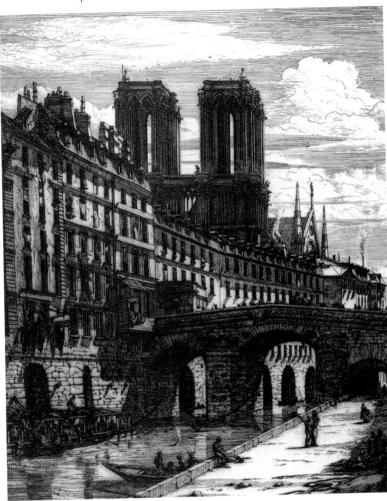

75

75 Charles MERYON (1821–68)
Le Petit Pont
Etching, 24.5 × 18.5 cm (9 3/4 × 7 1/4 in.), 1850

The medieval bridges of central Paris and the Pont Neuf were associated with traditional crossing points of the river (see p. 23) and retained considerable prestige. It is true that several of the central bridges were controlled by unpopular tolls until 1848 (although after that date they were maintained by the city as part of the public way). And their appearance, despite the 'uncovering' of the 1780s (Fig. 12), was sometimes compromised by later accretions, as we see from Meryon's etched image of *The Water Pumping Station on the Pont Notre-Dame seen from the Right Bank* (1852). The famous Pont Neuf had two rows of kiosks enclosing shops fronting its pavements until it was realigned in 1850. But in an etching of 1853, one of several views of the Paris bridges which were undergoing reconstruction, Meryon could view its masonry pier recesses cleared of these additions.

The Petit Pont, built in the early fourteenth century, had been burned in 1718. Major restoration of 'ce précieux débris de Paris ancien', as the periodical *L'Artiste* put it in 1858, had recently been carried out. Meryon's view makes superb play with the three unequal stone spans against the arched openings beneath the houses of the Quai du Marché-Neuf, with the towers of Notre-Dame beyond.[1] He is, moreover, always responsive to harmonies between built-up verticals and arched horizontal curves. Whistler (Fig. 76) and Hopper (Fig. 100 and Plate XVI) would find starting-points here.

1. See L. Delteil, *Le Peintre-Graveur Illustré: The Graphic Works of Nineteenth and Twentieth Century Artists, An Illustrated Catalog*, ed. New York Collectors Editions Ltd (New York: Da Capo Press, 1969), vol. II, Meryon, no. 24.

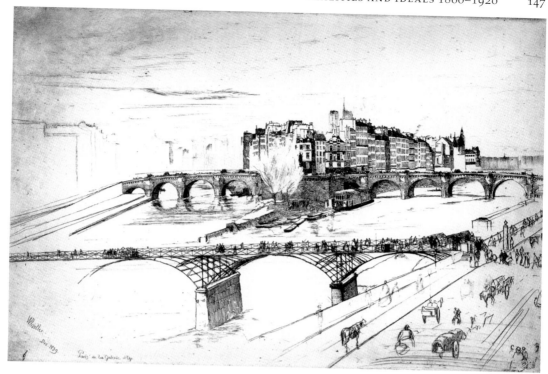

76

76 James McNeill WHISTLER (1834–1903)
Ile de la Cité, Paris
Etching, 20 × 28.8 cm (7 ³/₄ × 11 ¹/₂ in.), 1859

Whistler reached Paris in 1855, with drawing experience gained in an office of the United States Geodetic Survey that had included etching. He was orientated, we must note, towards effects that were graphic and topographical. Meryon's twenty-two *Eaux Fortes sur Paris* (1852–4) were in circulation and, though Meryon's mental illness probably meant that Whistler never met him, the American's print *Ile de la Cité, Paris*, including both the Pont Neuf and the newer Pont des Arts, undoubtedly reflects the older man's approach.

And yet there is a difference: the inclusion of two bridges of markedly different type. Whistler was not so averse to modern bridges as his well-known attachment to subjects like Old Battersea Bridge in London (Fig. 80) might suggest. The skeletonic *passerelle* or footbridge called the Pont des Arts had been completed in metal only half a century before.[1] Sixty-five thousand people had crossed it on its opening day in 1803. In the early 1820s R.P. Bonington had painted it.[2] Besides commanding views which would make it a fashionable observation platform, its role connecting the Left Bank and the Louvre (since 1793 a public museum) was that of a 'Corridor of the Arts'.[3] Much later, in 1951, Nancy Mitford would see it as forming part of the 'most beautiful walk in the world', and in 1968 Kenneth Clark

would open his series of *Civilisation* films on it, with the sense of being at the heart of his subject.[4]

Whistler must often have crossed the Pont des Arts. And it is not hard to see how its openwork iron ribbing over stone foundations would have commended itself to him as a foil to the massive stone bridge beyond. Looking at the way that the foreground drops away beneath this ribbing, we can in fact sense the effect of Japanese prints, which Whistler had encountered in Paris, and which were to influence his art much further (Figs 78 and 80).

1. It was built by Napoleon Bonaparte's engineers, Alexandre de Cessart and Jacques Lacroix-Dillon, in 1801–3. A bridge in this place had been planned by Louis Le Vau in the 1660s to lead on the axis of his Collège des Quatre Nations to the Louvre, but it had not been realized.
2. A. Strolin Coll., Neuilly-sur-Seine, reprod. in P. Courthion, *Paris in the Past, From Fouquet to Daumier* (London, 1957).
3. From 1803 the Collège des Quatre Nations played host to the School of Architecture, and from 1807 it would become the headquarters of the whole Institut de France. The Ecole des Beaux Arts also opened on the Left Bank in that year. On the bridge's role as observation point for river spectacles, see M. Gaillard, *Paris au XIXe Siècle* (Paris: Fernand Nathan 1981), p. 19.
4. N. Mitford, *The Blessing* (1951), in *The Nancy Mitford Omnibus* (London: Hamish Hamilton, 1956), p. 391; K. Clark, *Civilisation, A Personal View* (London: British Broadcasting Corporation and John Murray, 1969), p. 1.

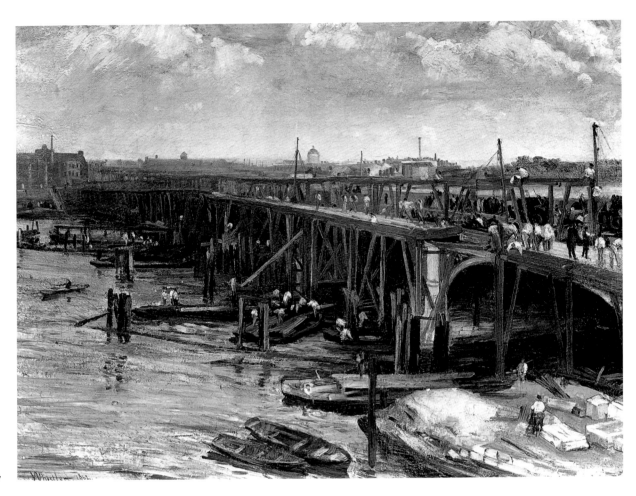

77

77 James McNeill WHISTLER (1834–1903)
The Last of Old Westminster
Oil, 61 × 77.5 cm (24 × 30 ¹/₂ in.), 1861–2

The vintage year 1861 marked for Whistler the beginning of a painting and also a print on the theme of Westminster Bridge, in process of replacement. There were also two further bridge etchings, *Vauxhall Bridge* and *Old Hungerford Bridge*, the latter being of Brunel's suspension-type design of *c.* 1845, which had just been demolished.

The painting was *The Last of Old Westminster*. The 'Bridge of Fools' of Labelye was finally to be replaced by a new structure, a bridge of iron. On 1 March 1860, half the road-width of this new bridge was opened to traffic; on the other half pedestrians, horse-riders, carts and barrows still used the old bridge. Two more years would pass before Labelye's structure would entirely go. Whistler painted his picture from a room that belonged to a friend, Arthur Severn, in Manchester Buildings on the north bank of the river. He accurately renders the new bridge (nearer to the spectator) and the old (carts crossing it can clearly be made out). No other bridge picture manages to convey so vividly both the passing of an era and the dislocation of the moment. It is not hard to agree, however, with Severn, that it was the wooden piles that supported the new bridge 'with their rich colour and delightful confusion', that took Whistler's main fancy: and indeed we can see that the forest of uprights is painted as Severn said they were, with single downward strokes.[1] Whistler the realist seems ready to give way to Whistler the transcender of his material.

1. S. Weintraub, *Whistler* (London: Collins, 1974), p. 77; A. McLaren Young, Margaret MacDonald, Robin Spencer with the assistance of Hamish Miles, *The Paintings of James McNeill Whistler* (New Haven and London: Yale University Press, 1980), text vol., cat. 39.

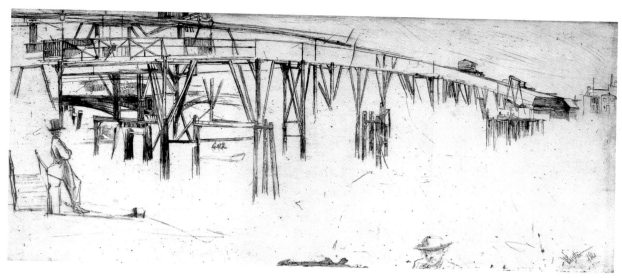

78

78 James McNeill WHISTLER (1834–1903)
Westminster Bridge in Progress
Etching, 15 × 35.3 cm (6 × 14 in.), 1861

Whistler, the son of a military engineer, was as responsive
as any eighteenth-century student of bridge centring to
the strutting beneath the decks, either permanent, as at
Old Battersea, or temporary, as at Westminster. In this
startling print, however, he abandons realism for a much
lighter, more abstracted style. Existing in only one known
impression, it is palpably experimental. Lines jab in
different directions: the whole image appears to hang
from the top edge. The top-hatted figure at the side might
be Whistler himself, and it is his thought 'in progress' that
we seem to be seeing. From this time onwards Whistler's
etched and painted bridge images would become less
perspectival records and more silhouettes of greater or
lesser definition, which cross his surface, as the bridge
nearly does here, from edge to edge.

Though we have seen the edge-to-edge bridge and arch
motif developing much earlier (compare Fig. 69), the
effect of Japanese woodcut prints is unmistakable in
Westminster Bridge in Progress (compare Figs 79a and 80a).
It can be traced also in the more resolved etching of *Old
Hungerford Bridge* of the same year: this has a blank
foreground, places the image high and flattens the space.

Whistler owned Shuntosai's woodcut 'Fireworks over
Bridge' (Fig. 78a), which contrasts the continuous lines of
the bridge with the momentary explosions of light in the
night sky.

78a

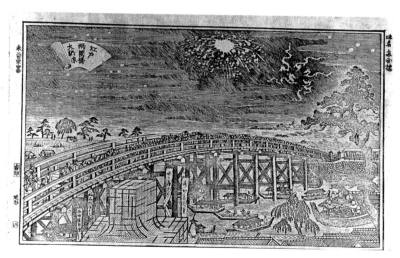

78a SHUNTOSAI
'Fireworks over Bridge'. Woodcut from *Cinsen*, 1857,
8.5 × 12.8 cm (3 3/8 × 5 1/8 in.)

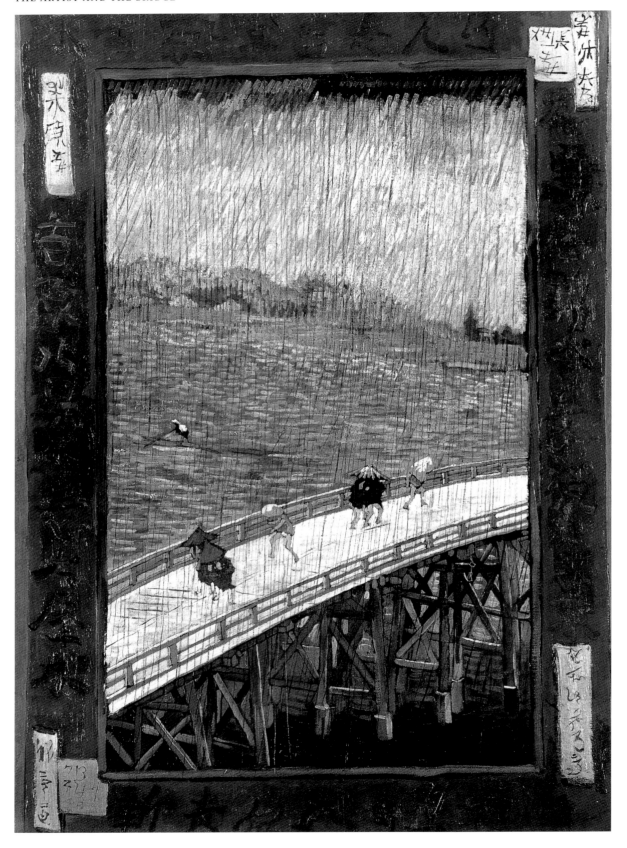

79

79 Vincent VAN GOGH (1853–90)
Copy after Hiroshige's 'Ohashi Bridge in Rain'
Oil, 73 × 54 cm (28 3/4 × 21 1/4 in.), *c.* 1887–8

The bridge plays an important role in the mountainous landscape of Japan, and a creation story concerning the country's origin includes a bridge, Ama-no-Hashidate, which extends from earth to heaven. The god Izanagi and the goddess Isanami lean over the Bridge of Heaven and stir the sea below with jewelled spears. The drops of water that fell from the spears became the Japanese islands. The eighth-century *fudoki* texts recount that the long isthmus in the western part of Kyoto, regarded as one of the three most beautiful places in Japan, was formed from a collapse of the Bridge of Heaven.

In a country where the coastline has many wide inlets, ferries were the commonest means of crossing water: but in the main cities of Edo (Tokyo), Kyoto and Osaka many celebrated bridges were built, and the sophisticated carpentry of their construction formed the kind of contrasting relationship to the free movement of water that the Japanese enjoyed. The print series *One Hundred Views of Edo (1857–8)* by Ando Hiroshige (1797–1858) includes the Nihonbashi ('Japanese bridge'), the starting point of sightseeing in the city and the hub from which many roads fanned out; the Ryogoku-bashi, which many other Japanese artists represented; and Yatsumi-no-hashi, from which views of either of the bridges could once have been enjoyed. It also includes the views of the Kyobashi (Bridge) which almost certainly affected Whistler (Fig. 80a), the bridge at Kameido which probably influenced Monet (p. 159), and the Ohashi bridge seen from above, through rain (Fig. 79a).

Many of the Japanese bridges of stone, bamboo and even earth, had no European precedent. Others, like the Great Bridge of Sanjo, crossed at the end of the two-week walk along the celebrated Tokaido or high road between Edo (Tokyo) and Kyoto, were of the curving wooden type built on strut systems not unlike those which attracted Whistler at first hand at Old Battersea or Putney. But the success of their conversion into the woodblock mode was absolute. Often taking a high viewpoint, the Japanese artist presents the flying curve of this deckline without interruption above the strutting: running from side to side and often coloured yellow- or red-brown, it achieves an unrivalled grip on the composition. Van Gogh was excited enough by the Ohashi bridge print to want to see how the effect worked in oils. He added borders (including some Kanji characters, unrelated to the subject), which emphasize the assault on Western traditions.

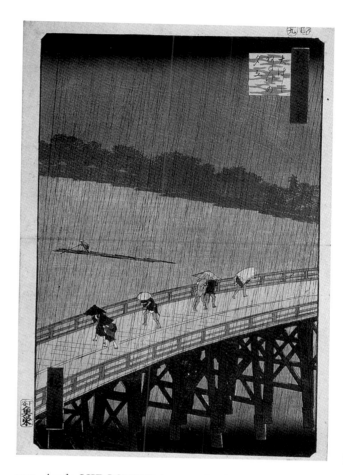

79a

79a Ando HIROSHIGE (1797–1858)
'Ohashi Bridge in Rain' (*100 Views of Edo*, 1857–8)
Woodcut, 33.8 × 21.8 cm (13 1/4 × 8 1/2 in.)

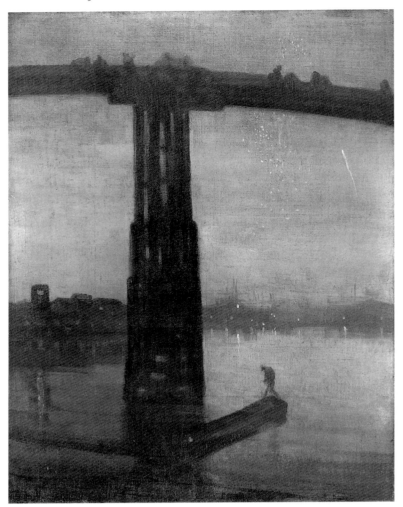

80

80 James McNeill WHISTLER (1834–1903)
Nocturne in Blue and Gold: Old Battersea Bridge
Oil, 66.2 × 50.2 cm (26 × 19 3/4 in.), 1872/3–5

This small work transmits a strange blend of reality and fantasy.[1] The reality is behind the fantasy: Old Chelsea church lies beyond one side of the single pier of the bridge that is shown; the distant Albert Bridge, just built, is now lit and in use on the other side. But the old wooden bridge of 1771, long the only crossing point hereabouts but soon to be demolished, dominates the work, though as an image abruptly truncated at the sides of the picture in the manner of Japanese compositions. The off-centre pier towers exaggeratedly over its shadowy reflection: the deck, with figures crossing, is thinly painted in a slightly descending curve. The device of including one pier only of a bridge, in close-up and from the water, surely owed much to Hiroshige (1797–1858, Fig. 80a) and the Japanese tradition.[2] It is to be carried forward into Whistler's lithographs *The Broad Bridge* (Way 8) and *The Tall Bridge* (Way 9) of 1878. But the actual experience of passing the sentinel-like pier (as the boatman does here) must also have counted.[3]

This painting was, as we saw (p. 127), produced at the Whistler–Ruskin trial of 1878. Whistler evidently set much store by it, and in many ways it is his quintessential bridge painting. He is, as with Old Westminster, concerned with a vanishing past, but far more, here, with a tremulous present: a present which, like the fading rocket in the background, 'gleams and is gone'. In his *Ten O'Clock Lecture* of 1885, as at the trial earlier, Whistler made it clear that the artist's job was to present a heightened reality beyond prosaic fact. His remark about the solitary pier in *Old Battersea Bridge*, simplified by moonlight, as 'not like the piers . . . as you know them in broad daylight' (see p. 127), was no idle one. Choosing night, when the potential of light to transform shapes is especially high, he proved a persuasive advocate of the discovery, to the extent that the notion of 'the Whistler beauty of that bridge' passed into the folklore of an age.

1. Cf. *Blue and Silver: Screen with Old Battersea Bridge* (1872), oil on panel, Hunterian Gallery, University of Glasgow, Birnie Philip Bequest. The bridge here is even more attenuated than in the single canvas of the subject, as there are no people on it

and Whistler has removed the railing. Cf. the pastel in the Freer Gallery of Art, Washington, reprod. in D.P. Curry, *James McNeill Whistler at the Freer Gallery of Art*, exh. cat. (Washington, DC: Freer Gallery of Art, Smithsonian Institution, 1984), p. 246.

2. Hiroshige's 'Yeitai Bridge and Tsukuda Island' (*One Hundred Views of Edo*) includes the motif of a pier filling the height of the picture: reprod. Katherine A. Lochnan, *The Etchings of James McNeill Whistler*, exh. cat. (Toronto: Art Gallery of Ontario, 1984), p. 294.

3. The sense of this was certainly felt by contemporaries. W.E. Henley's poem *Rhymes and Rhythms* (1885–92), dedicated to Whistler, evokes this in lines which seem to refer to Old Battersea Bridge:

> The River, jaded and forlorn,
> Welters and wanders wearily – wretchedly – on;
> Yet in and out among the ribs
> Of the old skeleton bridge, as in the piles
> Of some dead lake-built city, full of skulls,
> Worm-worn, rat-riddled, mouldy with memories,
> Lingers to babble to a broken tune . . .

The poem later refers to 'The terror of Time and Change and Death, / That wastes this floating, transitory world . . .'. These Baudelairean sentiments were accepted by Whistler who, as Denys Sutton notes (*Nocturne: The Art of James McNeill Whistler*, London: Country Life, 1963, p. 70), might have been expected to object to having words (that were not his own) 'added' to his painting. Whistler in fact offered Henley one of his nocturnes as a lithographic illustration to the poem when it appeared in *The London Garland*: see E.R. and J. Pennell, *Life of James McNeill Whistler* (London: Heinemann, 1908), vol. II, p. 166.

4. S. Weintraub, *Whistler* (London: Collins, 1974), p. 468.

80a Ando HIROSHIGE (1797–1858)
'Kyobashi Bridge' (*100 Views of Edo*, 1857–8)
Woodcut, 36.3 × 24.8 cm (14 1/4 × 9 3/4 in.)

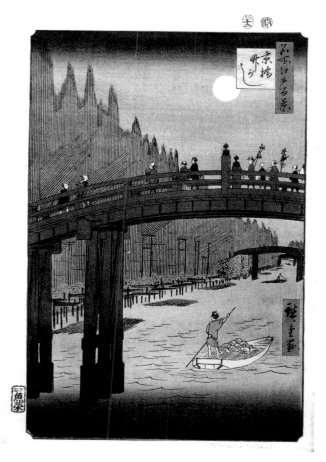

80a

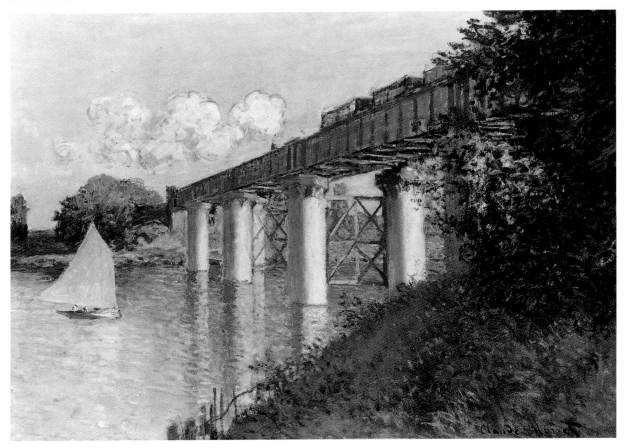

81

81 (another version of Plate XI) Claude MONET
(1840–1926)
The Railway Bridge at Argenteuil
Oil, 54.3 × 73 cm (21 $^1/_2$ × 28 $^3/_4$ in.), *c.* 1873–4

Among Monet's early experiences of bridges, we must
certainly count his period of residence in the small,
flourishing town of Argenteuil, where he settled in 1871
after his return from England and visits to Holland and
Antwerp. This busy industrial centre and weekend
resort, now minutes by rail from Paris, was to become
associated with many of the Impressionists. Artists who
took an interest in bridge subjects could hardly find a
more stimulating place in which to work.

 The old road bridge over the Seine at Argenteuil had
been destroyed in the Franco-Prussian War and the gap
was filled by a hastily erected temporary wooden
structure. This was quickly followed by a new,
permanent iron one. Then there was the iron railway
bridge, which took the line opened in 1851 as part of the
Paris–St Germain-en-Laye route: by Monet's time this
was bringing considerable numbers of visitors hourly
from Paris to sample the boating and picnicking
amenities of Argenteuil itself. Monet was to depict all

three very different structures, even taking the opportunity to paint the temporary bridge during its short life: a small, dramatic picture survives which shows the town in the background beyond a dark rectangle formed by the bridge and its reflection.[1]

Monet's views of Argenteuil and neighbourhood encapsulate several aspects of France in the seventies, from industry to recreational sailing. This foreshortened view of the railway bridge, with a train puffing smoke and a yacht passing beneath, observes not only the contrast between old and new modes of transport (as introduced by Turner into *Rain, Steam and Speed*), but also the coexistence of two facts of modern life: technology and leisure.[2] Another version (Wildenstein 319, Musée d'Orsay, Paris, Plate XI) lacks the yacht but intensifies the insistence of the technology bearing down on the distant bank.[3] And the very form of this bridge-type, a steel horizontal on plain pillar-like supports, was to become one of Monet's preoccupations later in life in London. There it was represented by Charing Cross railway bridge (Hungerford Bridge) that had replaced Brunel's suspension bridge in the early 1860s, and which he had no doubt seen in 1870. While Monet's depicting of the Argenteuil bridges is easily explained as part of a range of subjects arising from his residence there, his repeated visits to London to paint the river and its bridges, in 1899, 1900 and 1901, are less easy to account for: but painting the no-nonsense fixity of this particular bridge-form wreathed round by fog and steam (see Fig. 82) seems likely to have been one of them.

1. Sold Christie's 30 November 1971, lot 24: col. reprod. in J. House, *Monet: Nature into Art* (New Haven and London: Yale University Press, 1986), p. 17. Shortly after moving to Argenteuil Monet had painted another view of the road bridge under repair, *Argenteuil, Le Pont en Reparation* (oil 1872, coll. late Lord Butler of Saffron Walden): this accentuates the wooden scaffolding as Whistler had done in his *Last of Old Westminster*. See D. Wildenstein, *Claude Monet: Biographie et catalogue raisonné*, 5 vols (Lausanne: La Bibliothèque des Arts, 1974–91), vol. 1, 1840–81, Peintures (Cologne: Taschen-Verlag, 1974), nos. 194, 195. Monet painted a distant view of the completed bridge in *Argenteuil Basin* (oil, 1872, Wildenstein 225, Musée d'Orsay, Paris) and a close-up, foreshortened view (oil, 1874, National Gallery of Art, Washington); he also took one pier and part of two arches in a work that is comparable to Whistler's *Old Battersea Bridge* of the same period (*The Bridge as a Single Pier*, oil, 1874, present location unknown). For useful illustrations and further information on Monet at Argenteuil see D. Skeggs, *River of Light, Monet's Impressions of the Seine* (New York: Knopf, 1987). For treatment of the railway bridge, see next note. Renoir painted at Argenteuil in 1873 and later (cf. his view of the road bridge in *Bridge at Argenteuil* (oil, 1882, priv. coll., USA).

Caillebotte, who owned pleasure boats at Argenteuil, painted one arch of the same bridge in 1885 or earlier, see K. Varnedoe, *Gustave Caillebotte* (New Haven, CN: Yale University Press, 1987), pp. 170–71 (col. reprod.).

2. The railway bridge at Argenteuil was also rebuilt after the Franco-Prussian War. Steel was provided by the firm of Joly, ironmasters in the town, who exported cast-iron bridges all over the world. The bridge incorporated a steel box-frame on double concrete piers. Its gauntness was controversial, but Monet clearly found it a stimulating subject, painting it from both ends; for comparative colour reproductions see Wildenstein, *Claude Monet*, vol. II (1979), nos. 279, 318–21. Skeggs, *River of Light*, p. 86, also has a photograph of the bridge. It is noticeable that in these canvases Monet omits the X-mesh of the metal sides, treating them as a consolidated form, as he was later to do at Charing Cross.

3. The American Edward Hopper (see Fig. 100 and Plate XVI) was to paint his own version of this idea in his picture *Queensborough Bridge* (oil, 1913, Whitney Museum of American Art). The measurements of the Musée d'Orsay's Manet (Plate XI) are 55 × 72 cm (22 × 28 1/4 in.).

82 Claude MONET (1840–1926)
Charing Cross Bridge (Overcast Day)
Oil, 60.6 × 91.5 cm (23 3/4 × 36 in.), 1900

'What a succession of aspects!' enthused Monet in 1920, recalling his stay in London in the winters of 1899–1901, when he painted numerous views of the river bridges. Monet's concerted effort to make a series of Thames pictures has long intrigued commentators. What could he find there that he could not find in France? Writers have reviewed as possible reasons for his visits his fondness for England, the presence of his son in the English capital, and England's reputation as a haven for French artists and writers; the wish to take on the challenge of Turner has also been suggested as a likely consideration.[1] As Monet stayed on all three visits in the same sixth floor room of the Savoy Hotel overlooking the river, the particular nature of the usually foggy view was also clearly a factor. Of the three subjects that he concentrated on, apart from the river itself, two were bridges, those of Waterloo and Charing Cross. Rennie's stone structure lay to the north-east and was backed by factory chimneys; the metallic Charing Cross Bridge lay to the south, and the third of his favourite motifs, the Houses of Parliament, were beyond it. Together with a view of Parliament painted from St Thomas's hospital, these formed the subjects of thirty-seven Thames views in Monet's exhibition at Durand-Ruel's in 1904. In all nearly a hundred canvases had been begun of these three subjects.[2]

 In certain views of Charing Cross Bridge Monet includes the Victoria and Big Ben towers of Westminster as vertical foils, but often these are suppressed, and Cleopatra's Needle appears in only two paintings. The bridge is left as a simple horizontal division of the canvas, with gleams of light above and below or, in several versions, puffs of steam from near-invisible trains passing along it. This latter element, united with the fog which was an undoubted attraction of London for Monet, may well indicate a desire to challenge Turner on his own ground.[3] The pencil-thin form of Charing Cross Bridge with its passing trains made up a subject in which subject content and light, as in Turner, were totally merged. Monet was, of course, attentive to the changing effects of the incomparable London fog on objects which, he was

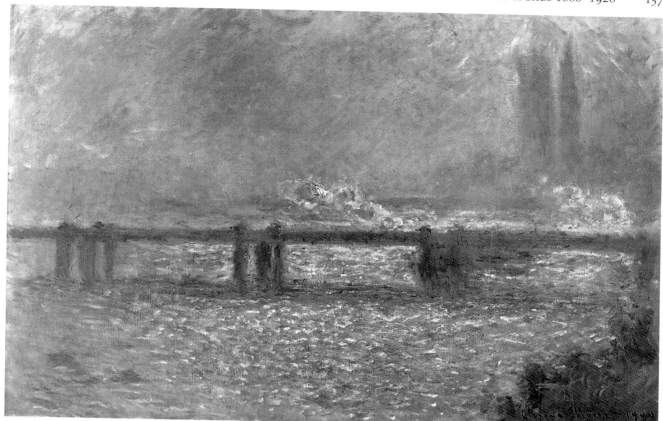

82

convinced, were capable of more rapid visual transformation than in any other atmosphere. However, he scrutinized the thinning effect of light on the horizontal of this bridge. Comparisons with the actual bridge show that Monet compressed the solid and open parts of the deck into a mass that is both more consolidated and more extreme in its horizontality. The strips of dark and light formed by deck, the light above and below it and Westminster Bridge beyond (which appears in some versions of the series) presented a seemingly endless challenge to him, literally to invest them in paint. The contrast between the 'permanent view' and the 'passing spectacle' (see p. 145) must also have delighted him.

1. P.H. Tucker, *Monet in the '90s: The Series Paintings* (New Haven and London : Museum of Fine Arts, Boston, 1989), pp. 258f.
2. Grace Seiberling, *Monet in London*, exh. cat. (Atlanta: High Museum, 1988).
3. J. House, *Monet: Nature into Art* (New Haven and London: Yale University Press, 1986), p. 222, refers to Monet's aim to secure an 'overall coloured unity', which led him at this time to Turner, and perhaps also to Corot, who used mist as an invitation to the eye to penetrate to his main subject.

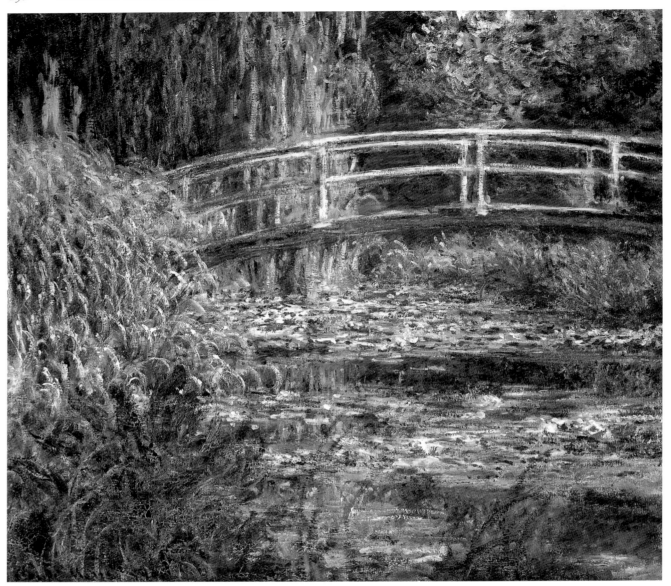

83

83 and Plate XII Claude MONET (1840–1926)
The Water Lily Pond (Japanese Bridge), Harmony in Rose
Oil, 89.5 × 100 cm (35 ¼ × 39 ½ in.), 1900

In 1899 and 1900, while the *London* series was in progress, Monet was also at home working on pictures formed round the subject of his own water garden at Giverny and its Japanese bridge. A denser configuration here took hold, which consisted of the curving members of a wooden bridge (reminiscent of Hokusai or Hiroshige's prints) placed against the impenetrable verticals of Monet's weeping willows.

The *Japanese Bridge* series breaks into two sequences. In the first, of 1899–1900, the bridge is central and extends across the entire width of the picture (examples in the Metropolitan Museum of Art, New York, and the National Gallery, London). In the second, of 1900, the bridge is asymmetrically placed, running off the right-hand edge of the canvas (examples in the Museum of Fine Arts, Boston, and the Art Institute of Chicago).[1] In both sequences the effect is of a serene presence, without visible supports, reflecting the changing lights as they are filtered through the surrounding trees, and allowing through its openwork glimpses of background. In this Musée d'Orsay example, the hooked strokes of the trees at the left provide a physically active foil to the bars of the bridge rising gently behind.

In a detailed commentary Tucker showed that, after the more public themes of the earlier series – even the poplars had a wide connotation as useful land demarcators or aborters of floods – Monet was concentrating in the water garden series on a more private concern for the regenerative powers of nature.[2] And it might be added that in these intensely vital works, with their pullulating spreads of vegetation transfixed by the simple bridge, its role is surely as complementary to this idea as it is compositionally valuable. Monet's bridge itself recalls explicitly enough the contribution which the always surprising Japanese bridge made to European painting. But in a curious way these canvases also manage to associate in consolidated form both Eastern and Western feeling for the experiencing of nature at close quarters, down if need be to the level of water itself. After his

water-garden series, Monet was to concentrate on the waterlilies alone, by which point the bridge had outlived its pictorial relevance (only three versions of it were done in the next twenty years, as Tucker notes).[3] In his water-garden series, however, the bridge had a role to play. Monet almost buries himself among his beloved plants: yellow and green (and in the second sequence red) pulsate at full chromatic strength. No shred of sky (apart from reflection) is permitted in the first sequence, and only a trace in the second. Amid all the vegetative life, it is the airy platform that Monet had built to complement it that in turn complements the pictures.

The conclusion that this bridge made an integral contribution to what contemporaries recognized as the ideal, Eden-like implications of the water-garden series seems almost inescapable. The critic Julien Leclercq, in a eulogy of these pictures and of France's greatness as representing 'the genius of an impassioned and measured people', was reminded of the eighteenth century, 'lucid, welcoming, brilliant', perhaps of Hubert Robert's painting (Fig. 28) of his own rustic bridges in the garden of Méréville?[4] Or Belanger's Chinese Bridge at Bagatelle (pp. 50–51)?

1. Monet produced eighteen paintings of the water garden and Japanese bridge in 1899–1900: twelve were shown at Durand-Ruel's between 22 November and 15 December 1900. There are strong affinities in general disposition with Hiroshige's print *Drum Bridge with Wisteria at Kaimedo* (*Hundred Views of Edo*). See p. 151 above.
2. P.H. Tucker, *Monet in the '90s: The Series Paintings* (Newhaven and London: Museum of Fine Arts, Boston, 1989), pp. 269f.
3. Ibid., p. 279.
4. Cf. J. Leclercq, *Chroniques des Arts et de la Curiosité*, 15 April 1899, pp. 130–31, and 1 December 1900, pp. 363–4.

84 and Plate XIII Darío de REGOYOS VALDÉS
(1857–1913)
Good Friday in Castile
Oil, 81 × 65 cm (32 × 25 ¹/₂ in.), 1904

Born near Madrid, Regoyos was prominent among the
Basque artists who were working in and around Barcelona
in the early years of the twentieth century. Before settling
there, he lived in Paris and Brussels, and exhibited
alongside Monet, Pissarro, Seurat, Cézanne and Toulouse-
Lautrec.[1]

In this little-known work Regoyos drives home a
simple message. A procession of black-robed monks or
penitents, observing the custom of centuries, follows an
image of the Virgin under a bridge as a modern passenger
train goes across it. Processions of near-identical figures,
often seen from behind, had been a notable presence in the
art of Regoyos's great compatriot Goya (1746–1828).
Making use of this motif, Regoyos has also seized on
another characteristic concern of Spanish painters – the
silhouette-value of black.[2]

As the carriage-windows are very dark, we see little of
the train's occupants (unlike those in Turner's *Rain, Steam
and Speed* (Fig. 65), with its open carriages). Swiftly but
passively conveyed, Regoyos's train-travellers
unknowingly cross over the slow-moving but actively
engaged processional group below. The procession in its
turn, ignoring the train, keeps to its own self-appointed
purpose. The bridge itself is painted using the kind of lush
opalescent Impressionist colour patches that Regoyos had
studied in Paris. But it is a spare, economical arch, which
is used to express not only both axes of movement in the
picture, but also the contrast that he wants to draw, in
human terms, between tradition and innovation in the
Spain of his day.

1. The place of Regoyos in late nineteenth- and early twentieth-
 century painting is usefully plotted in the catalogue to the
 exhibition *Tradition and Modernity in Basque Painting
 1880–1939* (Southampton: Southampton City Art Gallery, and
 Bilbao: Museo de Bellas Artes de Bilbao, 1997), pp. 26, 56.
2. Regoyos illustrated the book by the Belgian poet Emil
 Verhaeren, entitled *Black Spain*, published in 1898.

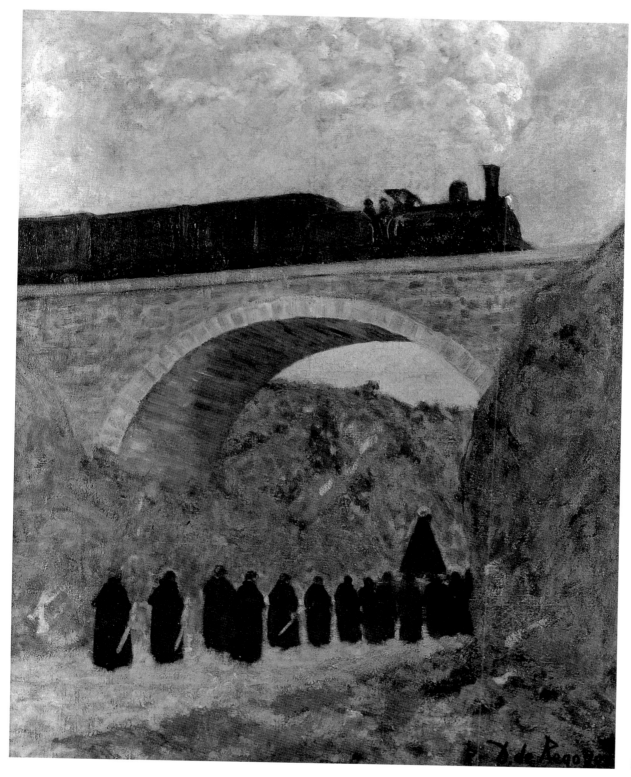

84

85 Roger FENTON (1819–69)
Miner's Bridge, Llugwy
Albumen print from wet collodion negative, 36.5 ×
42.8 cm (14 ¹/₂ × 16 ¹/₂ in.), *c.* 1858

This is one nineteenth-century bridge picture which, once
seen, is not easily forgotten. It is not by a recognized
painter or printmaker at all, but by a photographer, Roger
Fenton.

Fenton has been hailed as probably the greatest British
photographer of his time.[1] After photographing scenes of
the Crimean war, he took up landscape as a subject in
1857 at the time of a visit to north Wales. He specialized
here in boulder-framed vistas, in which deep space seems
to have been gouged out by his camera lens. We are
reminded of Brobdingnag in the objects themselves, or of
Canaletto's wild, bridged mountain landscape (Fig. 17),
in Fenton's elemental vision of Pont-y-Pant on the Lledr
river or Pont-y-Garth near Capel Curig, both of them
plank-bridges joining immense wall-sections of stones.
On the former, however, he places a single human figure,
as in *Miner's Bridge*. Little has been said so far about the
people in the bridge pictures of the later nineteenth
century, but they often have a role which is as positive as
that of the bridge, and can in no way be ignored.

In *Miner's Bridge, Llugwy*, the bridge is of the simplest
kind: two logs across which twenty-three equidistant
steps have been nailed, two side posts, two handrails
which become steepening diagonals linking the banks of
the river. Wright's *Bridge through a Cavern* (Fig. 40) and
Wilson's *Taaffe Bridge* (Fig. 39) are in the picture's remoter
ancestry; though Fenton, as a photographer, has his own
approach. It is in the interplay between the figure in
relative close-up and the space the figure traverses, that
the point of this work lies. The man, leaning forward,
looking down, applies himself to treading the rung-like
steps. The bridge, indeed, sloping upwards, is almost a
ladder, but this is no Jacob's Ladder of promise. The logs
have bent slightly under their own weight and that of
many previous journeys that have been made across
them. The contrast between side-to-side movement and
open-ended space in depth, between the routine
regularity of the man's uphill progress and the irregular
course of the river's downward flow, is perfectly made.[2]

85

1. Valerie Lloyd, *Roger Fenton, Photographer of the 1850s*, exh. cat. (London: Hayward Gallery, 1988), p. 1. Another outstanding work by him is *Double Bridge on the Machno*, in which the bridges are natural: stone slabs below, arching tree above (Lloyd, cat. 74). Among his photographs of manmade bridges, the print of Brunel's Saltash Bridge under construction 1858 (Lloyd, cat. 130) is remarkable in showing the giant metal components lying about a riverscape which appears to have been deserted by its workforce.

2. I. Jeffrey, 'Public Problems and Private Experience in British Art and Literature', in *Landscape in Britain 1850–1950*, exh. cat. (London: Arts Council of Great Britain, 1983), p. 26. Referring to Fenton's *Miner's Bridge*, which was no. 14 in the exhibition, Jeffrey notes a similarity between the bridge with its rungs lying 'like a yardstick' over the stream, and the symbol of scale (measurement) which appears as standard in documentary pictures of the Victorian age (or, for that matter, more recently).

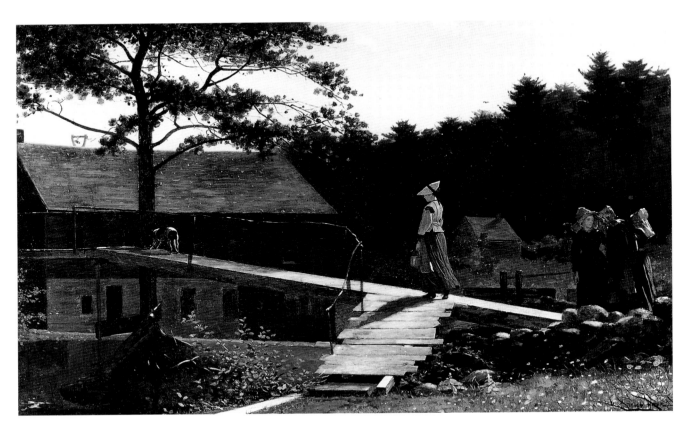

86

86 Winslow HOMER (1836–1910)
The Morning Bell
Oil, 61 × 97.2 cm (24 × 38 ¹/₄ in.), *c.* 1873.
Yale University Art Gallery. Bequest of Stephen
Clark, B.A. 1903

A few years later after Fenton (Fig. 85) had photographed
his miner, the American documentary realist Winslow
Homer (1836–1910) painted another somewhat fragile-
looking bridge, in the present picture. Again a single
figure makes the journey, one that we are to assume has
or may become a routine, the walk in answer to the mill
bell's insistent summons. The group of standing girls at
the beginning of the bridge highlights the decisive action
of the individual mill-girl who walks along it. But the
narrowness and homemade character of the structure
itself (its centre is secured by planks to the tree) works
potently to suggest the circumscribed nature of the
action, and so also to evoke the simple continuity of life
and habit in the Massachusetts community to which the
girl belongs.

Homer represents industrialized life in America only
rarely: but he produced an engraving *New England
Factory Life – 'Bell Time'*, which was published in *Harper's
Magazine* on 25 July 1868. This accompanied an article
about Charles Dickens's favourable opinions on workers'
conditions in the mills of Lowell, Massachusetts.[1] A
'forlorn' element has been seen in Homer's presentation
of the solitary mill-girl and dog;[2] but the cheerful scarlet
of her tunic seems to deny this. The essential point of the
picture probably arises more out of observation than
criticism: the relating of the routine of the girl's daily life
to the symbolism of the walk along the narrow bridge.

1. Marianne Doezema, *American Realism and the Industrial Age*
 (Cleveland, OH: Cleveland Museum of Art, 1980), p. 36.
2. Mary A. Judge, *Winslow Homer* (New York: Crown, 1986), p.
 32.

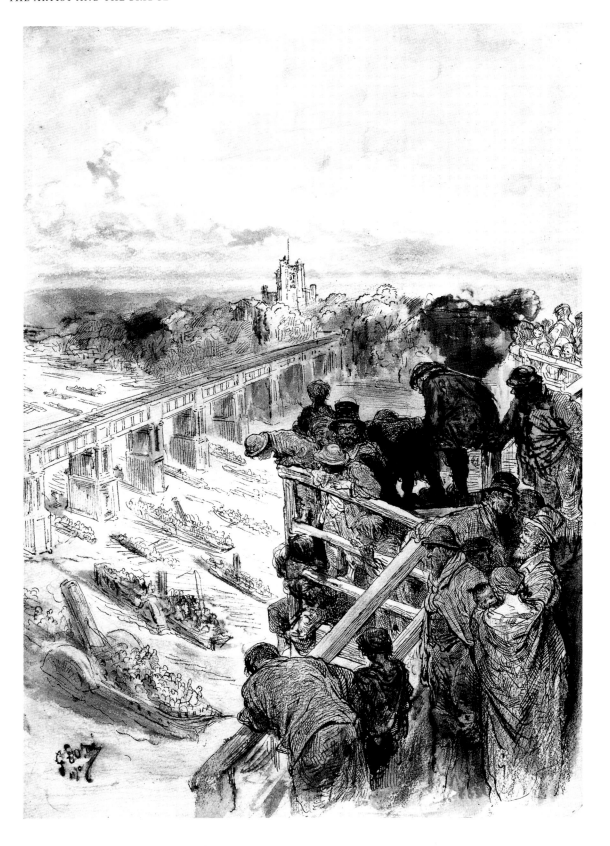

87

87 Gustave DORÉ (1832–83)
Putney Bridge
Pen and black and sepia inks, with grey and sepia
washes and black chalk, 41 × 27.1 cm (16 ¹/₄ × 10 ³/₄
in.), 1870

Views from the bridge can take many entertaining forms.
Edouard Baldus, for instance, wittily shows the
skeletonic Pont d'Arcole (1852) in Paris, its thoroughfare
empty, but with its far balustrade dense with people
craning to watch something in the river that we can only
guess at (Fig. 87a).

Sometimes, on the other hand, the crowd and the object
of their scrutiny can be very specific. In 1756 Nicolas and
Jean-Baptiste Raguenet painted Paris boatmen jousting
on the river, watched by people at every window of the
houses on the Pont au Change. A century later Doré, on
one of his many London trips, drew Putney Bridge in
1870 (the same that Whistler was to depict), thronged
with proletarian spectators viewing an 'elegant' event,
the Oxford and Cambridge boat race. The artist's wish to
make the social point is shown in the way that he vastly
exaggerates the bridge's height, and homes in on the
watchers, stressing the distance from the privileged
supporters of the event in the boats below. The aqueduct,
with its classical columns, more elegant than the
workaday structure on which the watchers crowd, also
lies 'beyond'.[1]

In the engraving that was made from this drawing for
Doré's publication *London, A Pilgrimage* (1872), the height
of the bridge is still considerable, although the spectators
have become less impoverished-looking. Doré's walks
round London produced other bridge-subjects, notably
Outcasts: London Bridge (drawing in pen and sepia,
private collection). Also known under the title *Sur le pont
de Londres*, the drawing shows down-and-outs sleeping in
a recess on the bridge under the protection of a guardian
angel.[2]

1. The aqueduct belonged to Chelsea Waterworks Company.
 The present Putney Bridge, built in 1886, is now on the site.
 See S. Croad, *London's Bridges* (London: Royal Commission
 on Historical Monuments, 1983), fig. 53.
2. Doré's companion Blanchard Jerrold recalled (*Life of Gustave
 Doré*, 1891, p. 153) that he and Doré 'went, once, at midnight
 to London Bridge, and remained there an hour, while he
 meditated over the two wonderful views – that above, and
 that below, bridge' [*sic*]. Doré also produced a pen and ink
 drawing of the same subject in 1871 (private collection) and
 an etching in the 1870s: reprod. with the engraving of Putney
 Bridge in M. Warner (ed.) *The Image of London*, exh. cat.
 (London: Trefoil and Barbican Art Gallery, 1987), nos. 197 and
 193 respectively. The view into one of the bridge recesses that
 Doré depicts clearly represents for the artist a kind of haven
 under the stars.

87a Edouard BALDUS (1813–89)
Hôtel de Ville and Pont d'Arcole, Paris
Albumen print from glass negative, 32.2 × 43.7 cm
(12 ⁷/₈ × 17 ¹/₄ in.), *c*. 1860

87a

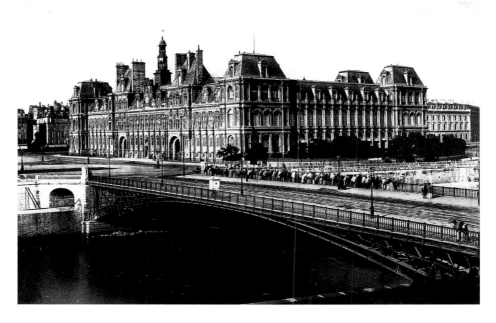

88 and Plate XIV Gustave CAILLEBOTTE (1848–93)
Pont de l'Europe, Paris
Oil, 124.7 × 180.6 cm (49 × 71 in.), 1876

Besides the solitary bridge-users on their way to work or
worship, there are others to consider: passers-by and
loiterers, observers and watchers.[1] The city bridge,
particularly the iron bridge with open sides, provides a
motif of some value for artists in this period, and
important scenes in novels take place on them.[2] One artist
above all others, however, the enterprising painter
Caillebotte, takes up the theme of bridge-walkers
watching events going on below them. Pictorial design
was of pressing importance for him, and the presence of
the railway in the city was also an evident source of
exhilaration, as for Monet (both artists worked in the area
of the Gare Saint-Lazare in the mid-1870s). But
Caillebotte is an entirely individual contributor to the
history of the bridge picture.

A man of wealthy background, Caillebotte first
appeared as a painter in front of the public in 1876, the
year in which the novelist and critic J.K. Huysmans (in his
En Marge) wrote of his belief that a writer, like a painter,
should 'be of his time'. Caillebotte was to become the
subject of Huysmans's praise (in *L'Art Moderne*, 1883) as a
master of the business of painting modern life. The
present picture, which Caillebotte showed at the third
Impressionist exhibition (1877), offers one of his most
striking and surprising contributions to this.

During the Second Empire (1852–70) Haussmann,
Prefect of the Seine, had driven boulevards through the
bottled-up city centre to create a truly modern capital.
The Quartier de l'Europe, where, incidentally, Caillebotte
had a house, consisted of six straight, converging streets
that bore the names of capital cities. Here, around a
central *place*, a vast new iron bridge was constructed in
1865–8. This was the Pont de l'Europe, the Europe Bridge,
beneath which ran the lines leading out of the Gare Saint-
Lazare a few metres away. In the painting we are placed
on an arm of the bridge which is in violent
foreshortening: the picture is virtually divided by a
raking diagonal which has the active shapes of the bridge
structure to the right of it and the glassy, sunlit blankness
of road and broad pavement to the left. Kirk Varnedoe, in
his detailed account of this artist and this picture,[3] has
suggested that Caillebotte may have used the camera to
help achieve the diminution of size and stretching out of
space in the work: if so, no extraneous snapshot clutter
remains and the trim placing of the figures has taken on
the functional tautness of the bridge-members
themselves. The perspective of parapet and trellis, with
its gigantic 4.6-metre-high (15-foot) X-frame units, leads

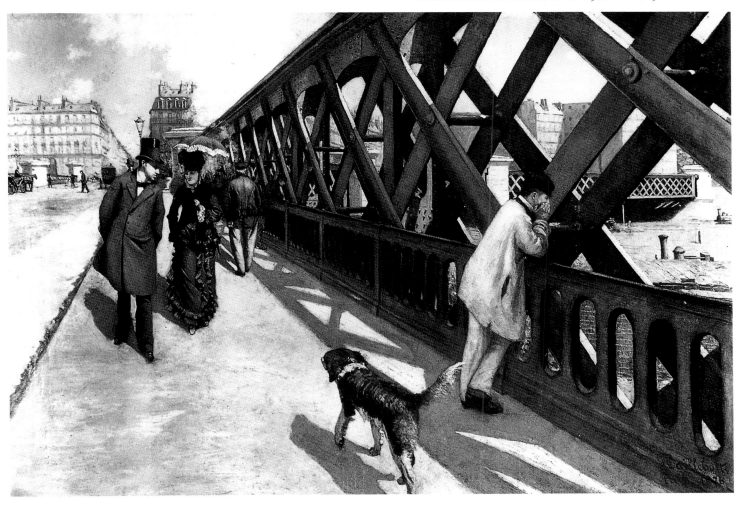

the eye to the advancing man and woman: a family tradition claims the man as a self-portrait of the artist. Varnedoe plausibly suggests that his gaze, connecting with the leaning right-hand figure of a city manual worker who looks down from the bridge, is meant to refer to the rich young artist's concern for the avant-garde and democratic milieu of the Impressionists, whom Caillebotte supported in spirit and in a practical way by buying their pictures.

1. While the practice of watching others at work from the vantage point of a bridge will have applied throughout human history, there was particular reward to be had from it in this mid- to late nineteenth-century period, in cities such as London, where Bazalgette was embanking the Thames in the 1860s, and Paris, where Haussmann was building his boulevards at the same time. See G. Stamp, *The Changing Metropolis: The Earliest Photographs of London 1839–1879* (Harmondsworth: Viking, 1984), no. 112, for a photograph (*c.* 1868) of watchers on Westminster Bridge, and building work going on at 6.40 a.m., to judge from the clock on the Big Ben tower.

2. For Emile Zola's use of this idea see Fig. 89, note 3. Charles Dickens, however (see John Sweetman, *The Enlightenment and the Age of Revolution 1700–1850* (Harlow: Longman, 1998), pp. 164–5), had placed the important meeting of the heroine and Clennam on an 'iron bridge' – John Rennie's Southwark Bridge (1814–19) – in the novel *Little Dorrit* (1855–6). There the contrast is made between Little Dorrit's sense of the freedom of that elevated place and the cramped confinement of her father in the Marshalsea Prison: 'To see the river, and so much sky, and so many objects, and such change and motion. Then to go back, you know, and find him in the same cramped place.' See *Little Dorrit*, ch. 22.

3. K. Varnedoe, 'Caillebotte's Pont de l'Europe, A New Slant', *Art International*, vol. 8, no. 4 (Paris: Archive Press, 1974), pp. 28–59. See also the same author's analysis in K. Varnedoe and T.P. Lee, *Gustave Caillebotte, A Retrospective Exhibition*, exh. cat. (Houston: Museum of Fine Arts, 1976), pp. 97–104. This is available also in Varnedoe's monograph *Gustave Caillebotte* (New Haven and London: Yale University Press, 1987), pp. 72–9.

88

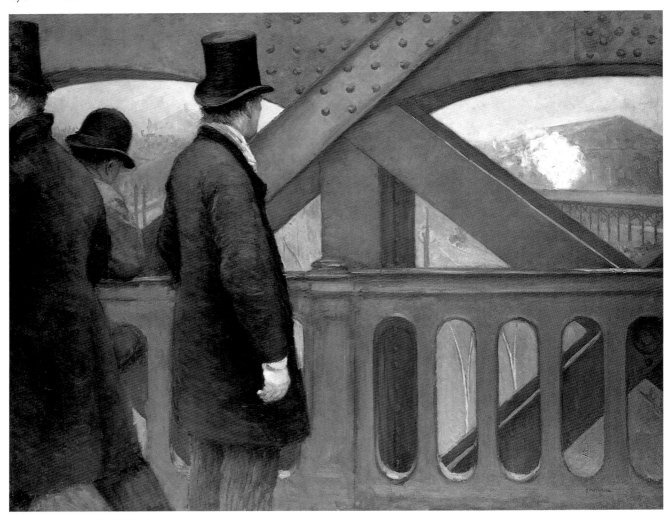

89

89 Gustave CAILLEBOTTE (1848–93)
On the Pont de l'Europe
Oil, 105 × 131 cm (41 ¹/₂ × 51 ¹/₂ in.), 1876 or later

Though we do not see his face, the young watcher in
Caillebotte's large *Pont de l'Europe* (Fig. 88) also arouses
our curiosity about what he is watching. Caillebotte was
clearly interested in providing an answer, for he carried
out this work which presents the railway below the
bridge – only obliquely suggested in the Geneva picture –
with almost painful abruptness. Here are three men, the
parapet and parts of the metal framework in extreme
close-up. At the right one X-frame is truncated: at the left
one of the figures walks off, split by the edge of the
picture. The main figure (likely to be Caillebotte himself)
gazes through the angle of an opening at the arrival hall
of the station: we are allowed to glimpse, through other
openings, the railway lines almost perpendicular to us,
far below. Even these diverge to go their different ways.

Here is a picture which works on two levels. Superficially it appears to sum up its era: the facts of enhanced and rapid travel, of iron bridges and track to facilitate free movement, and the bystander realizing the force of the modern revolution. But there appears to be a deeper level: the unrelenting diagonals wall him in as he looks between them. Piranesi's *Carceri* nightmare (Fig. 19), perhaps, may be reborn in sober steel.

Caillebotte's purpose does not run, as Monet's Impressionism did, to softening the iron framework's emphatic lines with drifting steam or smoke; here he relegates this to the background, as in Fig. 88, and concentrates on the foreground.[1] At the 1877 Impressionist exhibition, in which Caillebotte showed six works, and which also contained Monet's Gare Saint-Lazare series, Zola praised Caillebotte for his courage in not shrinking from taking on 'les sujets modernes grandeur nature [life-size]'.[2] It is an accurate phrase, conveying a truth which the relatively large scale, given in the present picture to a 'small event', makes still more remarkable. And insofar as we share in the vertiginous feeling of looking down at the tracks, the picture relays a life-size sensation.[3]

1. Monet used the giant trellis of the Pont de l'Europe as a powerful motif in his view of it from below: *Pont de l'Europe, Gare Saint-Lazare* (oil, 1877, Wildenstein 42, Musée Marmottan, Paris). But he softens the impact by painting it through vapour. In this connexion the particular property of bridges in cutting off smoke or steam *beneath* them, is recalled by the remarks of Degas, another Realist, on the 'destruction of smoke under the bridges', as part of his wider concern with smoke of many kinds (from pipes, cigars, locomotives, chimneys etc.). Cf. T. Reff, *The Notebooks of Edgar Degas* (Oxford: Clarendon Press, 1976), vol. I, p. 134, ref. to Notebook 30, page 205.

2. E. Zola, 'Notes on the Impressionist Exhibition of 1877', in *Oeuvres Complètes*, ed. H. Mitterand, vol. 12 (Paris: Cercle du Livre Précieux, 1969), p. 975.

3. In his book *Pays Parisiens* (1929) Daniel Halévy records Mallarmé's testimony that, crossing the Pont de l'Europe daily from his apartment in the rue de Rome to reach his teaching job, he was nearly overcome by the desire to jump off onto the tracks as a train was coming. Séverine's situation in Zola's novel *La Bête Humaine* (1890) is different: 'unsure of where to go', she finds herself disorientated on the bridge, looking down on the railway tracks and feeling suicidal.

90 Georges SEURAT (1859–91)
The Bridge at Courbevoie
Oil, 45.7 × 54.7 cm (18 × 21 ¹/₂ in.), *c.* 1886–7

The double function of a bridge, not only a link but a marker, not only joining two sides of a space but spanning a void, presents an ambiguity which seems to become almost stressfully explicit in the work of Georges Seurat. In his book on Rimbaud, Roger Little has described the bridge in general as 'the image of mediation *par excellence*', meaning that it effects a transition between one state and another.[1] Historically, as we have seen, the bridge provided a classic ingredient of the middle distance (for Claude, Poussin, Turner, Corot and others). In Seurat's strange, airless painting *The Bridge at Courbevoie* the bridge fulfils the same function. Its low, widely curving arches beneath a long, horizontal parapet convey the unmistakable sleekness of the engineer Perronet's nearby Pont de Neuilly, with its revolutionary approach a century before to the relationship between span and support (see Fig. 26 and p. 47). But Seurat's bridge is also the most wraithlike middle-distance bridge that we have seen. This faintness, condensing out of the blue and orange colour spots of Seurat's divisionist technique, oddly belies the importance attached to it in the picture's title. One explanation of this may well be its role as a marker or mediator between the differing nature of the banks of the Seine at this point. The bridge connected the island of the Grande-Jatte northward to Courbevoie town on a line leading from the centre of Paris; it thus helped to separate the smart, middle-class residences of Courbevoie from the more industrialized, working-class areas on the Paris side of the river. Seurat will have needed no pretext for a composition which accords so closely with French classical tradition (compare Poussin, Fig. 10, Fabre, Fig. 46 and Plate VI). But his sensitivity to the niceties of the social boundaries and segregation of modern Paris and its *banlieues* may well have been a factor.[2]

The immense difference between the bridge-lifelines in the compositions of Seurat and Fabre lies in the fact that in Seurat no-one seems to be responding to them. His ramrod-like figures betray no awareness of their surroundings, and seem incapable even of movement. All inhabit cells within the squared-off honeycomb of uprights and horizontals of jetty and mast in which Seurat has placed them. Again the point of the bridge becomes evident: its arches leap the space behind the figures who are so confined in it.

The sense of a bridge as a spatial (rather than social) divider as well as link is suggested in a later picture by Seurat, *The Bridge at the Quays, Port-en-Bassin* (oil, 1888, Minneapolis Institute of Arts) which has figures who are themselves isolated from one another, and have a completely unused bridge between them.

Seurat devoted his short working life to producing compositions of calculated and hermetic permanence which stood in sharp distinction from the passing moments seized upon by Monet. But he was also working at a time when Symbolist writers were focusing not only on man's emotional life but on ways in which visions and dream-imagery could be translated into language which was precisely measured and evaluated so as to accord with the original sensations. Seurat's work was seen by the critic Gustave Kahn as reflecting this disciplined, anti-improvisatory approach. In his book on Seurat, Richard Thomson drew suggestive parallels between his highly deliberated paintings of deserted or semi-deserted quays and foreshores and Symbolist concern with solitude and loneliness.[3] When Seurat uses the bridges of Courbevoie or Pont-en-Bassin it is in conjunction with this idea of isolated humanity: but here the sense of separation is all the stronger by virtue of the bridges' presence. Of all the representations of the bridge that is not in use (including those by Giorgione, Fig. 2, and Hopper, Fig. 101) Seurat's have the greatest power to disconcert.

1. R. Little, *Rimbaud, Illuminations* (London: Grant and Cutler, 1983), p. 41.
2. For the *banlieue* as a subject in Naturalist novels (such as those by the Goncourt brothers), and Seurat's interest in it, see R. Thomson, *Georges Seurat* (Oxford: Phaidon, 1985), p. 54.
3. Ibid., pp. 131–2, 178–81.

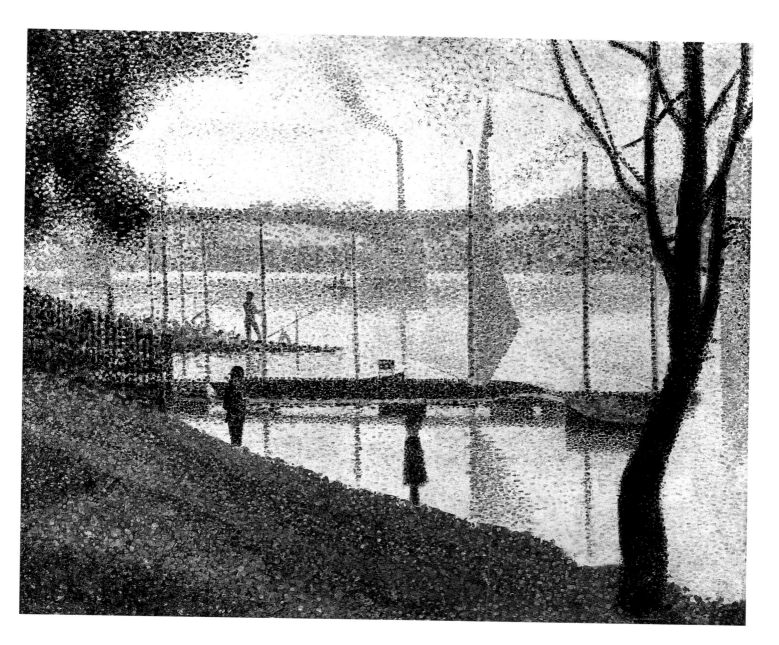

91 and Plate XV Vincent VAN GOGH (1853–90)
Drawbridge at Arles, 'Pont de Langlois'
Oil, 54 × 65 cm (21 1/4 × 25 1/2 in.), March 1888

92 Vincent VAN GOGH (1853–90)
Drawbridge at Arles, 'Pont de Langlois'
Oil, 50 × 65 cm (19 3/4 × 25 1/2 in.), May 1888

The atmosphere of isolated identities in a surrounding
void, which made a compelling study for Symbolists
taking the life of city and suburb as their subject, assumed
heightened personal and ultimately fatal significance
during the short painting career of Vincent Van Gogh.
When, in May 1889, a year before his death, he went of his
own accord into the hospital of Saint Paul de Mausole at
Saint-Rémy-de-Provence, Van Gogh wrote 'I feel quite
unable to take a new studio and to stay there alone, here
in Arles, or anywhere else . . .'[1]

Van Gogh makes limited use of the bridge motif, but
this use follows an interesting course. In his parents'
village of Nuenen, Holland, he had grown familiar with a
countryside of bridges, particularly drawbridges, as we
have noted (a painting of 1885, oil on wood, depicts a
raised drawbridge at Nuenen). Moving to Paris in March
1886, he painted the Seine with the Pont de la Grande-
Jatte (a multi-arched structure with stone piers and metal
spans) and also the railway bridge at Asnières with the
Pont Lavallois behind (oil, Foundation E.G. Bührle
Collection) in the summer of 1887; about the same time he
copied a Japanese print of a bridge in the rain by
Hiroshige (Fig. 79).[2] In February 1888 he moved to Arles,
where, as he wrote to his sister, he found 'no need for
Japanese art: I tell myself that I am in Japan'. Soon after
his arrival, however, he began to be interested in the
prominent drawbridge, the Pont de Reginelle, across the
canal linking Arles with Port-de-Bouc to the south. This
was sometimes called the Pont Langlois after the name of
the keeper. Its general form, very close to Dutch
examples, must have appealed to him on that account,
and the fact that he undertook several versions of it in its
lowered state, including three major oil paintings
together with watercolour and other drawings, proves
that this was no casually selected subject.

The first version (Fig. 91),[3] painted in March, contrasts
the yellow bridge against bright blue sky (see Plate XV):
its construction is carefully indicated in perspective; a
horse and cart approach from the right and pass the
central point; women below wash linen at the side of the
water. After work was started out of doors on a large
canvas of the bridge which came to nothing, he produced
in April a second version of the subject (oil, private

collection).[4] Compositionally this is very close to the first,
but the bridge is drawn even more painstakingly. Both
works were sent to his brother Theo in Paris; letters make
clear the indecision in his mind between having his
brother keep them to form a permanent oeuvre, or selling,
either through Theo or the Dutch market. There is no
doubt that he set some store by the second version
especially,[5] and although other works produced in the
busy summer crowded out the memory of his first two
drawbridge pictures, there can equally be no doubt that
he saw them as a test of competence.[6] The buoyancy of
spirit in the colours is still there, converted into a cooler
key, in a final painting, produced in May (Fig. 92).

The drawbridge, then, emerges as a motif of some note,
even critical note, at this particular stage of his career:
reminiscent of his early Dutch roots in its forms and
location over a canal, but also part of the southern light
that he had left the Paris of the Impressionists to seek. As
with Købke earlier (Fig. 56), an autobiographical link is
surely evident, especially when we consider the order of
the paintings. In Fig. 91 (and the second version) the
bridge appears to advance in full sunlight, and traffic
approaches us from the right: in the latest work the
bridge recedes in contre-jour light and the cart and
woman with parasol depart to the left. It is as if a
challenge has been met and overcome and the artist, in
his own eyes, has established his credentials in southern
France, his new sphere of activity. The persistence of this
subject in those important months is surely no accident.

1. *Complete Letters of Vincent van Gogh*, ed. V.W. Van Gogh (New
 York and London, 1958), vol. II, letter no. 585. This contains
 the significant phrase 'isolated in the studio so often'.
2. The Asnières bridge is presented as a diagonal in a
 composition built up partly of short parallel strokes in a
 Seurat-like manner. Van Gogh's friend Emile Bernard
 (1868–1941) painted the same bridge later in the year, with
 more rectilinear effect (oil, Museum of Modern Art, New
 York).
3. J. Hulsker, *The Complete Van Gogh, Paintings, Drawings,
 Sketches* (New York, 1980), no. 1368.
4. Ibid., no. 1392.
5. The first version was dedicated to Tersteeg, a Dutch dealer in
 The Hague, though Van Gogh withdrew the dedication. The
 second was meant for Theo.
6. For details of this aspect see *Vincent van Gogh: Paintings*, exh.
 cat. (Amsterdam: Rijksmuseum Vincent van Gogh, 1990),
 pp. 100–101. The two works are described there as the 'first
 two examples of his growing competence'.

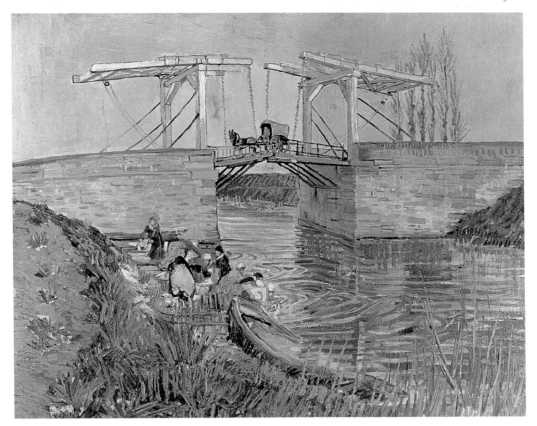

91

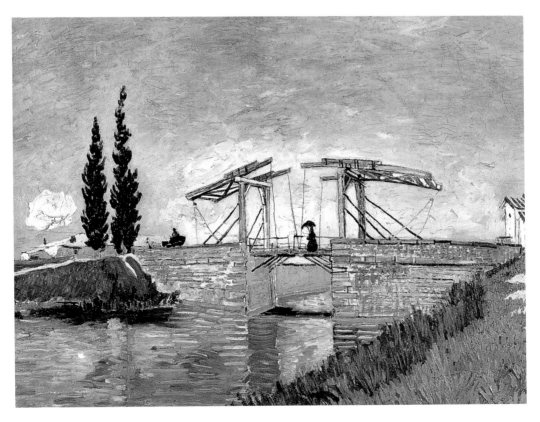

92

93

93 Vincent VAN GOGH (1853–90)
The Trinquetaille Bridge
Oil, 73 × 92 cm (28 3/4 × 36 1/4 in.), October 1888

The anxious summer of 1888 offered few consolations to
Vincent. He despatched consignments of his pictures to
Paris and asked his brother to interest likely dealers,
Athanase Bague (reputed to like rich colour impasto) and
George Thomas. In the middle of September he was able,
with money provided by Theo, to furnish the Yellow
House in Arles sufficiently to make living there possible.
Gauguin, long awaited by Vincent, arrived in October. In
that month he announced a third consignment of pictures
for Paris: this 'will be decisive and we are impatient to
sell', he wrote to Theo. No more drawbridge pictures
emerged it seems, at this time, but other bridge subjects
did. It is not absolutely clear whether the two bridge
pictures *Railway Bridge over Avenue Montmajour* and *The
Trinquetaille Bridge* were to be in the October

consignment. What is evident is the very marked individuality of these works.

The fact that both canvases depict Arles under grey rainy skies is not perhaps in itself as interesting as the disturbing character of the compositional lines. In *The Railway Bridge over Avenue Montmajour* (oil, October 1888, on loan to the Kunsthaus, Zurich), two long perspectives, of road and bridge, violently cross one another. Amidst the multi-directional stresses isolated human figures move or stand, each unseen by the others.[1] *The Trinquetaille Bridge* is less obviously fierce in its composition, but the conflict is more complex. Here a road vista opens on the right under an arch, but steps rise in two directions to the level of the main span of the iron bridge (which in fact crossed the Rhône, here invisible). We look up through the iron skeleton of uprights and crosspieces. There is warm artificial light here and there and prominent touches of bright colour in people's dresses. But the same feeling of human scatter and separation as in the *Railway Bridge* comes through, even more intensely.

Two or three facts help to account for what we see here. First, in the summer of 1888 van Gogh tended to abandon the perspective frame of his first months in Arles, as his work became more experimental; second, in September he appears to have ceased to make preliminary drawings on canvas.[2] The raw nature of these later bridge compositions may, therefore, in part be the result of a turning away both from traditional perspective norms and from his own established method of preparation. There is also a note in an earlier letter referring to other work on the Trinquetaille bridge, in this case including the river. This makes it clear that while van Gogh is sensitive to colour nuance at every point of his work, he is also trying to express his sense of the disparateness and desolation of the figures: 'another very crude effort, and yet I am trying to get at something utterly heartbroken and therefore utterly heartbreaking.'[3] For this purpose, and at the later critical stage of a crowded year, it seems that the permanently closed cage of the Trinquetaille bridge had more to offer than a temporarily open drawbridge like the Pont Langlois.

Aspects of the Piranesian dilemma of the *Carceri* (Fig. 19) are posed afresh in the *Trinquetaille Bridge*: the endless steps, the build-up to high-level walkways which seem to lead nowhere, the clashing perspective lines, the small, lost figures: all reappear. Van Gogh never, it seems, mentioned his bridge pictures again. Friction with Gauguin and the onset of madness in December led to his being admitted to hospital and, though he recovered from his self-administered mutilation there, treatment for his mental attacks began at Saint-Rémy in April 1889. The uptilted road was to recur. Bridges, with their implication of conditions that change once they are crossed, were perhaps less relevant to an artist whose drawings at Saint-Rémy often suggest that by that stage of his experience he preferred the protective perimeter of the field outside his room. And later, at Auvers, he turned to other themes.

1. Reproduced in *Vincent van Gogh: Paintings*, exh. cat. (Amsterdam: Rijksmuseum Vincent van Gogh, 1990), fig. 66. One of these perspectives is that of a sharply rising road, which Van Gogh used many times: here the pavement shoots our eye back in space. The other perspective is the plunging one of the iron bridge and railing at right angles to the road, a movement that is continued by a wall at the left and echoed by telegraph wires. Touches of bright colour emerge from whitened grey-browns: a red sun is partly visible at the edge of an area of white cloud (or steam). The shadowy zone beneath the bridge is divided into two, so that, in all, three vistas open up. The dark stripes of girdering beneath the bridge run in different directions.
2. *Complete Letters of Vincent van Gogh*, ed. V.W. van Gogh (New York and London, 1958), vol. II, no. 552: English translation in *Vincent van Gogh: Paintings* (Amsterdam: Rijksmuseum Vincent van Gogh, 1990), p. 167, from the *Verzamelde brieven van Vincent van Gogh*, 4 vols (Amsterdam and Antwerp, 1973). The original letter has two drawings of the Trinquetaille Bridge, one of which observes a perspective frame, but in the second the complex wide-angle solution of the final painting is presented. On the matter of abandoning the preliminary drawing on canvas, see letter no. 539.
3. *Complete Letters*, vol. II, no. 503.

94

94 Fernand KHNOPFF (1858–1921)
With Grégoire Le Roy. My Heart Cries for the Past
Pencil, coloured pencil and white chalk on grey-blue
paper, 25.5 × 14.5 cm (10 × 5 3/4 in.), 1889

Piranesi (Fig. 13) and Turner (Fig. 60) were responsive to
the reflections of bridge-arches in water, and Turner in
Blenheim uses the approximate circle thus produced as a
dramatic eye-catcher.

In this typically elusive work by the Belgian artist
Khnopff (who always worked from an easel placed in a
gold circle), the circles created by the arches and their
reflections subtly reinforce the main theme of the woman
kissing her own reflection in a circular mirror. This has, no
doubt rightly, been construed as an image that denotes a
turning-in on the self, and a searching of memory, both
traits of so much Symbolist art of the late nineteenth
century.[1]

The city of Bruges was Khnopff's birthplace. It was a
city of immense prosperity and cultural richness in the
fifteenth century, a centre of the art of Jan van Eyck and
other famous Flemish painters. It was now a backwater,
and relished for the fact by the backward-looking
Symbolist writers and painters. Khnopff did not return, it
seems, to carry out his numerous pictures based on the
city: he relied on childhood memories and the novel of his
friend, the Symbolist writer Georges Rodenbach, *Bruges la
Morte* (1892).

The present drawing takes its title from a collection of
poetry *Mon coeur pleure d'autrefois* (1889), by another
friend, Grégoire Le Roy (1862–1941). 'With' signifies
Khnopff's fellow-feeling for his friend. The bridge here[2]
also – though outside the consciousness of the self-
absorbed woman – works 'with' the circular mirror, as its
decreasing curves eddy away, unmarked, like the mirror,
with the white chalk that is reserved for the woman's face
and dress and the insubstantialities of sky and water.

1. See *Impressionism to Symbolism: The Belgian Avant-Garde
 1880–1900*, exh. cat. (London/Ghent: Royal Academy of Arts,
 in association with Ludion Press, 1994), p. 146.
2. The bridge is the Begijnhof Bridge, Bruges.

95

95 Walter CRANE (1845–1915)
The Bridge of Life
Oil and tempera, 96.5 × 152.4 cm (38 × 60 in.), 1884

Though the cosmic bridge was so intimately a part of
Norse and Germanic myth, its context could involve
Renaissance Venice as well as legendary Walhalla. The
sight of crowded Venetian bridges in 1882 suggested to
William Morris's Arts and Crafts disciple and fellow
socialist, Walter Crane, the idea of portraying the passage
of human life itself, fulfilled in its entirety on a bridge.
The result was the remarkable painting *The Bridge of Life*,
which depicted scenes of the sequence of life from cradle
to grave.

Crane had earlier been a studio assistant to Edward
Burne-Jones, whose highly symbolic pictures, such as *The
Mirror of Venus*, had made him the star of the Grosvenor
Gallery, London, opened in 1877. Crane showed *The
Bridge of Life* in the Grosvenor Gallery Summer Exhibition
of 1884, with explanatory verses: 'What is life? A bridge
that ever / Bears a throng across a river.' Describing his
Venetian visit in his *Reminiscences*, Crane recalled 'the
small marble foot-bridges over the canals, approached by
steps each way and the stream of people passing across
them of all ages, while the black gondolas passed to and

fro beneath . . .'. The work had a lukewarm reception
among the pragmatic English, but Crane, undeterred,
toured it in America in 1891; two years later, it proved an
immense success at Berlin, the home of its eventual buyer,
Ernst Seeger. It also succeeded in other German cities, as
it did after its reappearance on the art market in 1990. If
the philosophical reach of the picture was Wagnerian
(Crane subsequently visited Bayreuth in 1893 where he
saw, among other works, *Lohengrin* and *Parsifal*), the
ancestry of the design was Italian Quattrocento. The
marriage of ideas is not entirely happy: the bridge itself
shares a springiness with Mantegna that the figures lack.[1]

1. Mantegna's painting *Parnassus* (Louvre) is reflected;
 Signorelli and perhaps Carpaccio may have had some
 influence, although Leighton's figure style is predominant. I
 am grateful to Ursula McCarthy of Christie's for information
 about Crane's *Bridge of Life*. On the 'Bridge of Life' theme see
 also pp. 131, 135 n. 16.

blank opens on the still water, and the moon (some critics have read it as the sun) is hidden from them behind a huge, dark tree. The effect is of open-ended expectation, with little to hope by. The promise of Købke's Copenhagen drawbridge (Fig. 56) has been replaced by a palpable insecurity, which recalls the lines of Nietzsche's Zarathustra addressing the people: 'A dangerous going-across, a dangerous wayfaring, a dangerous looking-back, a dangerous shuddering and staying-still'.[2] The plank bridge and the crossing of stagnant water, in particular, have an echo in the case-histories of Carl Jung, as related in *Man and his Symbols* (1964).[3]

1. Cf. R. Heller, *Edvard Munch: The Scream* (London: Allen Lane, The Penguin Press, 1973), p. 67. Heller relates Munch's feeling to the statement of the Danish theologian Søren Kierkegaard in his book *Begrebet Angst* (*The Concept of Anxiety*, 1844): 'Anxiety may be compared to dizziness. He whose eye happens to look down into the yawning abyss becomes dizzy. But what is the reason for this? It is just as much in his own eye as in the abyss, for suppose he had not looked down. Hence anxiety is the dizziness of freedom . . .' (Princeton, NJ: Princeton University Press, 1980, p. 61). Munch was drawn to the work of Kierkegaard.

2. Nietzsche, *Thus Spake Zarathustra*, tr. B. Hollingdale (1961, 1969), p. 43. The contrast is worth noting with the confidently stepping girl in Homer's *The Morning Bell* (Fig. 86), where the bridge, though frail, does not cross water and the goal of the mill is firmly in view.

3. Carl G. Jung (ed.), *Man and his Symbols* (London: Picador, 1978 [1964]), p. 210. The particular case-history refers to a woman who dreamt she was crossing a stagnant river 'across which a board or tree trunk had been laid'. A student from a local high school bounces on the board so that it cracks: a small girl on the opposite bank helps the woman to reach safety. The stagnant river stands for the slowing down of the flow of life because of the subject's problems: the plank is the means by which crossing the river can effect a fundamental change of attitude which may help with a solution to the problems.

96

96 Edvard MUNCH (1863–1944)
Girls on a Bridge
Oil, 135.9 × 125.4 cm (53 1/2 × 49 1/4 in.), 1901

The long, receding road, often with a single railing, was to form an almost obsessive motif in the art of the Norwegian painter Munch. This artist is often linked with Van Gogh in terms of spiritual crisis, and his anxieties are funnelled into perspectives over water, most urgently in the famous image of *The Scream* (1893, Nasjonalgaleriet, Oslo). Here the setting (if such a term is appropriate for a work of such intense subjectivity), is a road beside a fjord. In his book on the painting, Heller relates how Munch, late in life, told one of his patrons that he had a horror of open spaces at the time of painting *The Scream*: he even found it difficult to cross a street, and felt dizzy in high, exposed places.[1]

All of this, we might conclude, would have inhibited Munch's bridge experience. By the same token the present picture, which is usually read as a bridge-subject (sometimes a pier), may have gained in tension. Tense it is, with the uprearing plank road, continued uphill at the far bank, and the reinforcing perspective lines of the railing against which three girls lean. The work has been construed as a commentary on the hopes and perhaps destiny of these figures at the outset of their lives. A vast

97

97 Wassily KANDINSKY (1866–1944)
'Cossacks' or 'The Battle'. Sketch for *Composition IV*
Oil, 94.6 × 130.2 cm (37 ¼ × 51 ¼ in.), 1910–11

In this picture, on the verge of abstraction, and in search
of equating colours with musical sounds, Kandinsky
brings in references to shapes in the external world.
Among these is a bridge-like rainbow linking mountains:
he adds lance-like forms which – especially in the light of
his earlier medievalizing subjects – suggest the context of
heroic adventure and challenge in which he is viewing it.

Kandinsky was living at this time in Murnau, in the
Bavarian Alps, where he painted mysterious,
transfigured landscapes which were meant to recreate
opposing extremes of shape and symbol. In particular,
critics have seen in these images of destruction and hope
intermixed.[1] Wagner's use of the leitmotif is praised by
Kandinsky in his book *Concerning the Spiritual in Art*
(1912), and it is possible that it is the legendary rainbow
bridge used by Wagner in *Rhinegold* that takes its place
among the symbols in the ominously combative
Composition IV. At all events, both in the Tate sketch and

final work (Düsseldorf) Kandinsky makes the
ideographic lines for fighting horsemen appear over the
traditional rainbow image of hope, leaving the overall
message as one of conflict, as the subtitle of *Composition
IV*, 'Battle', suggests.[2]

1. See R. Rosenblum, *Modern Painting and the Northern Romantic
 Tradition, Friedrich to Rothko* (London: Thames and Hudson,
 1979), p. 148.
2. See also W. Grohmann, *Wassily Kandinsky, Life and Work* (New
 York: Abrams, 1958), p. 122.

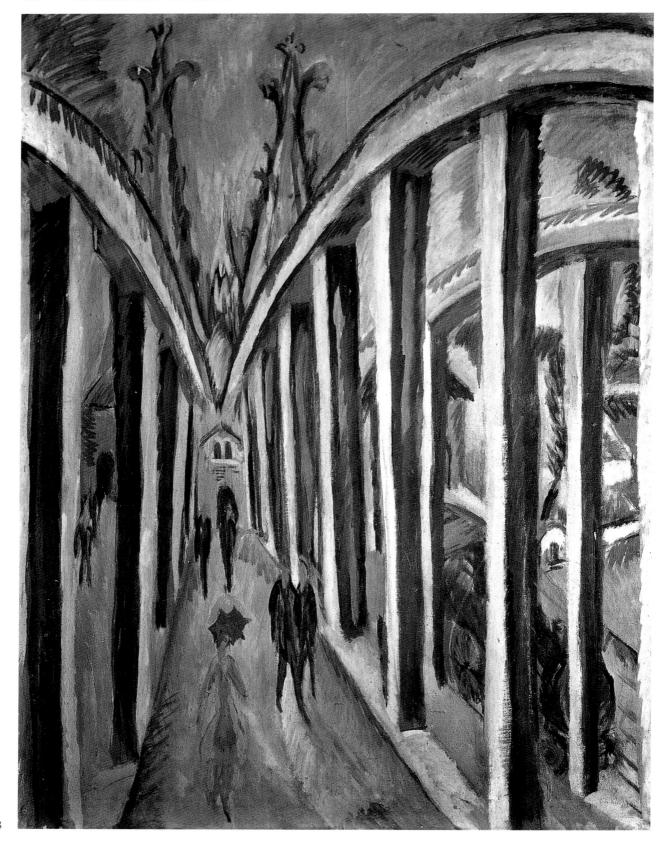

98 Ernst L. KIRCHNER (1880–1938)
The Rhine Bridge, Cologne
Oil, 120.5 × 91 cm (47 1/2 × 35 3/4 in.), 1914

One of the founder-members of the German movement
Die Brücke (The Bridge, see p. 132), Kirchner shows more
than a passing interest in the bridge-form, although the
most enterprising examples come after the dissolution of
the group. In 1906 Kirchner produced the woodcut
'manifesto' which called all youth, 'bearers of the future',
to oppose old-established forces (Fig. 98a, right). While in
1905 Kirchner had done a coloured woodcut of the old
Augustinerbrücke at Dresden with the Frauenkirche to
the left beyond it, and *c.* 1908 had produced a pen
drawing (later worked over in colour), there seems little
doubt, however, that it was a metal bridge, that over the
Rhine at Cologne, which really fired his imagination.

The present picture must go down as one of the most
original contributions of the twentieth century to the
history of the genre. Not only does Kirchner present a
steeply foreshortened view of the deck and the two
enormously enveloping curving spans on either side of it,
but he associates all this strenuous play of line with the
two spires of Cologne Cathedral beyond. Only now, a
hundred years after Schinkel's *Kathedrale* (Fig. 55), the
flow of the people has reversed: they now move outwards
towards the picture surface, as if propelled along the
corridor of the steel cage (and helped by the colour, such
as the rose-pink hat of the woman with umbrella). The
cathedral of Cologne, which had been the focus of
German nationalism from the beginning of its
reconstruction in the 1820s, was to remain one of the two
or three most familiar examples of German architecture
through the Second World War. The dynamic of
Kirchner's bridge picture, however, shares in much of the
urgency of Futurism, the arts movement which, in the
years before 1914, was elevating a mechanized view of
living above the values of the past (but ironically was to
lose momentum during the 1914–18 conflict). Kirchner's
awareness of another Futurist concern – speed – must
have been enlivened in 1914 by the situation of his second
Berlin studio overlooking the busy railway line to
Potsdam, at the point where it was crossed by the
Feuerbachbrücke.[1]

1. *Bridge over Railway* (oil, 1914, Wallraf-Richartz Museum,
Cologne, in D.E. Gordon, *Ernst Ludwig Kirchner* (Munich:
Prestel-Verlag, 1968), no. 378. The view of the
Feuerbachbrücke was preceded by a woodcut in 1914, ill. in
Ernst Ludwig Kirchner 1880–1938, exh. cat. (Berlin: National-
galerie, 1979), no. 200. Among Kirchner's later bridge
pictures are *Bridge at Wiesen* (oil, 1926, Landschaft Davos
Gemeinde, Gordon 844, col. pl. XXIII), and *Frankfurt Cathedral*
(oil, 1926, Städtisches Kunstmuseum, Bonn, Gordon 841,
reprod. in col. in cat., Berlin: Nationalgalerie, 1979, no. 368).
This latter picture also combines a modern suspension bridge
and a medieval cathedral, showing the cathedral rising above
the lines of the bridge.

98a Ernst L. KIRCHNER (1880–1938)
(left) 'Künstlergruppe'. Woodcut, 12.6 × 5 cm (5 ×
2 in.), 1906
(right) 'Programm'. Woodcut, 12.6 × 6 cm (5 × 2 in.),
1906

98a

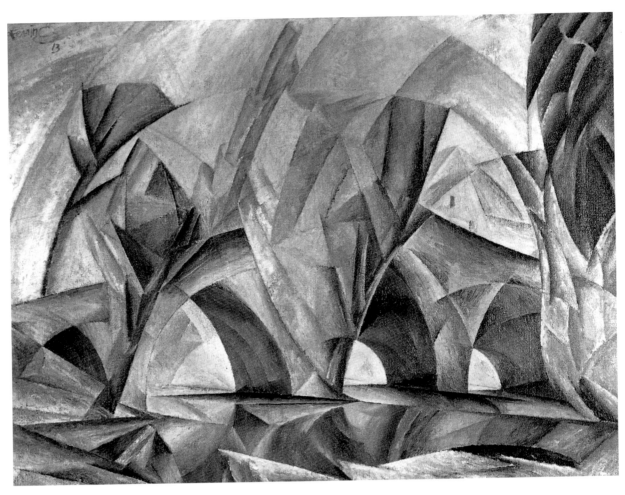

99

99 Lyonel FEININGER (1871–1956)
Bridge I
Oil, 80 × 100.3 cm (31 ½ × 39 ½ in.), 1913

Feininger was born in New York but moved to Germany in 1887 and Paris in 1892. He returned to Germany in 1893 and stayed there till his return to America in 1937. In 1913 he exhibited with the Blaue Reiter group in Munich, and later taught at the Bauhaus.

While the theatrical possibilities of high background viaducts attracted Feininger in his painting of street scenes, it was form and its relationship to space around it that held his chief interest as a painter, as it had held that of the Cubists. While they broke down each facet and plane to re-present the relationship of a solid form – a head, a figure, a still life – on the surface of a painting, it was for Feininger to recognize how much the arched bridge over water had to give to this fragmenting and then redefining and reunifying approach. In *Bridge I* the

arches of the bridge over the Ilm at Ober-Weimar determine the whole pictorial structure, investing the surrounding trees and houses and stilling the movement of the water beneath.

Painted in a summer when, he said, he was 'very happy',[1] the lively pulsations of *Bridge I* were to lead to a series of four further depictions of the same bridge, one (Bridge III, Museum Ludwig, Cologne) composed entirely of straight lines, and the last (Bridge V, Philadelphia Museum of Art) almost wholly abstract.[2]

1. Letter to Paul Westheim, 5 October 1917.
2. Paul Westheim compares *Bridge I* and *Bridge III* in an article 'Lyonel Feininger', *Das Kunstblatt*, I (1917), pp. 67–70. See Ulrich Luckhardt, *Lyonel Feininger* (Munich: Prestel-Verlag, 1989), ills in colour of *Bridge I* and *V*; *III* in black and white.

100 Gaetano PREVIATI (1862–1920)
Ferrovia del Pacifico
Oil, 200 × 143 cm (78 ³/₄ × 56 ¹/₄ in.), 1916

Previati, writer as well as painter, was prominent in the application of the divisionist technique (touches of colour divided to create overall harmony, see Seurat, Fig. 90) to 'ideal' or symbolic themes. After a lifetime of involvement in various art movements, including Futurism, he turned in 1916 to large canvases for the Chamber of Commerce in Milan. These were on themes to do with communications and especially human confrontation of natural obstacles: *Suez Canal, Piercing the Alps, Caravan in the Desert* and the present work.

The achievements of engineering in difficult and remote terrain made an impressive roll-call as railways spread across Asia and westwards from the Atlantic to the Pacific in the Americas and Canada. In the United States, no fewer than seven railroads were built through the Rockies in the fifty years before Previati's painting: the Union Pacific/Central Pacific (1869) to San Francisco; the Northern Pacific (1883) to Portland; the Denver and Rio Grande Western (1883) through the Colorado Rockies (Royal Gorge) from Denver to Salt Lake City; the Aitchison Topeka and Santa Fe (1887) to Los Angeles, through the southern tail of the Rockies (Raton Pass); the Great Northern (1893) to Seattle; the Chicago Milwaukee St Paul and Pacific (1909) to Seattle; and the Western Pacific (1909) from Salt Lake City to San Francisco, with a second route through the Sierra Nevada (Feather River Canyon).

In Canada the Rockies were traversed by the Canadian Pacific Railway (1885) to Vancouver, via the Kicking Horse Pass, and another line (1899), also to Vancouver, via the Crow's Nest Pass; the Grand Trunk Pacific (1914) to Prince Rupert, and the Canadian Northern (1915) to Vancouver, both via the more northerly Yellowhead Pass.[1]

The closeness of these developments to the date of Previati's painting cannot be missed. Thousands of miles of track were to be laid out and, as Klingender noted in his book *Art and the Industrial Revolution* (in Britain), a bridge or viaduct was often to be used by artists for dramatic effect. Previati makes dizzying play here with his vertical format. No picture better expresses, perhaps, the raw opposition of nature and man-made modernity, and the way in which this was to be crystallized by bridges in remote places.

1. I am grateful to John Morris for information on the railways; and also to John Rodway for help.

100

101 and Plate XVI Edward HOPPER (1882–1967)
Le Bistro or *The Wine Shop*
Oil, 59.4 × 72.4 cm (23 ¹/₂ × 28 ¹/₂ in.), 1909

Hopper has had the thought that came to Richard Wilson (Fig. 31) and F.-X. Fabre (Fig. 46 and Plate VI) of running a bridge out of the picture space to the right. But the space he opens up in the centre ground is much more empty than Wilson's, and the dominating human presence of Fabre's work is quite absent.

Hopper, born at Nyack, New York, studied at New York School of Art, and spent much time in Paris between 1906 and 1910. The city's river front fascinated him, particularly the bridges. Paintings exist of many of them, including the Pont Royal (1907 and 1909), the Pont du Carrousel (1907), the Pont Neuf (1909) and the Pont des Arts (1907).[1]

Le Bistro is a memory of Paris begun shortly after he returned to New York in 1909. Two figures are drinking outside a wineshop, set in deep shadow, on the extreme left-hand edge of the canvas. To the right, and filling more than three quarters of the picture, is a deserted riverscape, painted entirely in light tones. A blue-shadowed road leads the eye to a dazzlingly lit arched bridge, which resembles the Pont Royal. But this bridge has also left Paris behind. Four poplars mysteriously placed along the line of the bridge bend away from, and accentuate, the plunge of its arches. It appears to lead beyond the edge of the inhabited world, into a kind of paradisaical light.

The picture marks an early stage in Hopper's interest not only in figures as couples, but also in the contrast between closed human lives and the empty spaces that surround them. Bridges, themselves built over space, were useful to him, and Paris, with its harmonious mixture of old and new bridges, traditional stone and modern, was revealing. At home in New York again, he was to be troubled by what he called the city's 'raw disorder' and *Queensborough Bridge* (oil 1913, also Whitney Museum) makes the new giant steel trusses tower over an old clapboard house. But the slablike simplicities and human scale of the old arched bridges of Paris stayed in Hopper's memory: he deeply admired Meryon's etchings of them (Fig. 75). Another, also brightly lit, emerges in his work as late as 1938, outside the railway carriage window in the picture *Compartment C, Car 293* (IBM Corporation, Armonk, New York). But there too, as here, no-one is on it, and no-one is looking at it.

1. See Gail Levin, *Edward Hopper: The Art and the Artist* (New York: Whitney Museum of American Art, 1980), pls 99, 100, 107, 114, 117, 118, 119 and others.

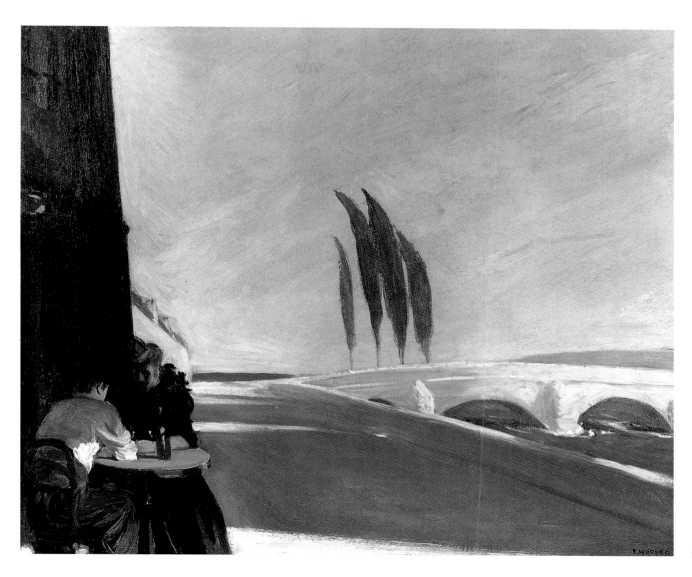

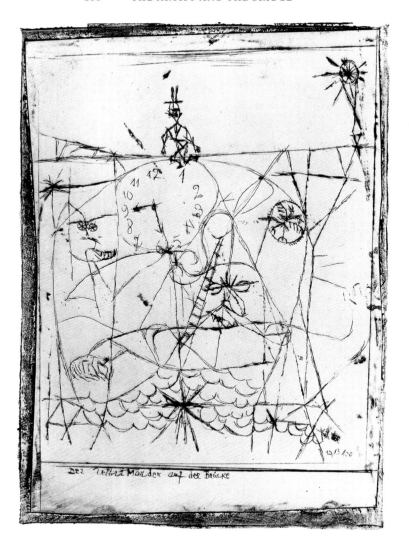

102

102 Paul KLEE (1879–1940)
The Suicide on the Bridge
Etching with gelatine, 21.8 × 15.3 cm (8 ¹/₂ × 6 in.),
1913

This remarkable drawing uses line to convey movement
rather than contour, and to express a dynamic tension
between the opposites of life and death in the centre of a
bridge.

The work was included in a book of Klee's drawings
published by the magazine *Der Sturm* in 1918, but
actually dates from 1913, a year in which Klee was
drawing tormented heads or whole figures which look
like wasps trapped in giant spider's webs (as in the
drawing *Human Weakness*). The *Suicide* etching shows a
top-hatted man who is about to jump off a frail bridge.
Commentators have pointed out that the splash which his
body will make in the water a split second later is already
indicated at the foot of the paper.[1] Time and release from
time, indeed, seem to be the key ideas here. A clock-face
below the bridge marks the fateful hour. Other heads (one
with a cog-wheel form) are, we are to assume, beyond
time and its regulating process. We are a long way from
Winslow Homer's bridge-walk unquestioningly made to
the sound of the morning bell (Fig. 86); or from Fenton's
rung-treading miner (Fig. 85). Only Blake, perhaps, in his
'Pit of Disease' (Fig. 51) had used the joining form of a
bridge to suggest, as Klee does here, such grievous
separation.

1. E.g. Selz, *German Expressionist Painting* (Berkeley and Los
 Angeles: University of California Press, 1957), p. 271.

103 Joseph STELLA (Giuseppe Michele Stella, 1877–1946)
The Voice of the City of New York Interpreted: The Bridge
Oil and tempera, 224.1 × 137.2 cm (88 1/4 × 54 in.), 1920–22

Stella, Italian-born but in America from 1896, combined here the long perspectives of Italian stagecraft and Piranesian vision in a tribute to Manhattan's skyline, seen at the top of the picture. He chooses to view it, however, through the arches and steel cables of the greatest engineering epic of the age: the vast, record-breaking 491.4-metre (1597-foot) central span of New York's Brooklyn Bridge (the Great East River Suspension Bridge).

The bridge, designed by John Augustus Roebling and, after his death following an accident, completed by his son Washington Roebling, was building from 1869 and completed in 1883. It was the climax of eighty years of American engineering interest in the suspension bridge. Two massive 84-metre-high (272 feet) masonry towers support four main cables, each composed of 5700 wires. Road and rail access are complemented by a pedestrian promenade. Thousands crossed on the triumphant opening day.[1]

The resulting structure seemed superhuman, and Stella (teaching in Brooklyn and seeing it constantly) rose to it as a religious icon, writing of the 'bells of a new religion' and the 'stained glass fulgency of a cathedral'. The picture, the culminating image of several by this artist of this subject, gives the soaring steel cables the look of giant bell ropes; while the vertical lines suggest the sweeping strings of gigantic harps.[2] But the mesh of moving lines and light is stabilized by the dark Gothic arches of the towers, which frame the composition as they frame Manhattan. (Compare Kirchner's more centrifugal view associating the openwork metal bridge with a Gothic-style building beyond it, Fig. 98.)

Here was a structure to fire the imagination of countless artists and poets in the twentieth century. The distinguished American painter John Marin produced an explosive watercolour of people crossing it,[3] a subject which also attracted the English Vorticist C.R.W. Nevinson (Fig. 104).

1. See David J. Brown: *Bridges: Three Thousand Years of Defying Nature* (London: Mitchell Beazley, 1993), pp. 84–5; Dell Upton, *Architecture in the United States* (Oxford: Oxford University Press, 1998), pp. 166–7. Also Robert Hughes, *American Visions: The Epic History of Art in America* (London: Harvill Press, 1997), pp. 280–81, 377–8.

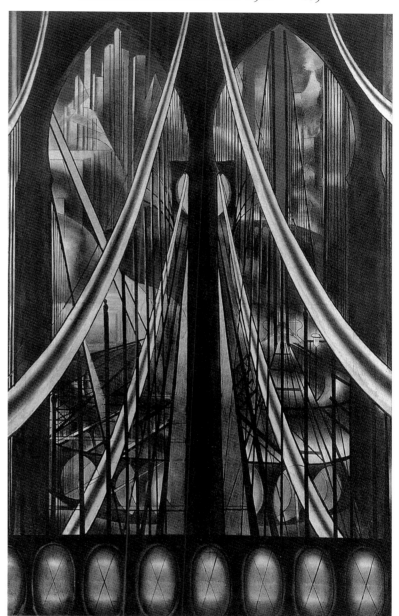

2. 'O harp and altar': so the distinguished American poet Hart Crane apostrophized Brooklyn Bridge in what most critics see as his greatest poem, 'The Bridge' (1930).
3. Hughes, *American Visions*, ill. p. 336.

103

104 Christopher R.W. NEVINSON (1889–1946)
Looking through Brooklyn Bridge
Drypoint, 26 × 17.2 cm (10 1/4 × 6 3/4 in.), 1920–22

If any city could have inspired an image of a suspension bridge, it was New York. And so it proved with Nevinson, together with Marin, Feininger and Joseph Stella, all of whom depicted Roebling's Brooklyn Bridge over the East River (1869–83).

In this drypoint, Nevinson takes up the component shapes of the modern iron frame suspension bridge: the girders, the X-pieces, the steel cables, even the rivets; and constructs a tautly economical grid out of them. He avoids, however, the curving cables: all is rigidly linear. Beyond, the pale outlines of the Manhattan skyline, which so attracted Nevinson, echo the verticals. Among these lines and abstract shapes, human figures appear, seeming to walk rapidly, past each other, in both directions. The diagonals from above, however, far from having the flexibility of the falling rain in Hiroshige's 'Ohashi' (Fig. 79a), fix the walkers in their tracks as firmly as the rungs in Roger Fenton's photograph of 1857 (Fig. 85). The Piranesian echo of the prison (Fig. 19) also comes through, and of Van Gogh's *Trinquetaille Bridge* (Fig. 93). The result is one of the most condensed and evocative of images to come from a century of preoccupation with the modern city as it took shape. 'The world is a bridge: pass over it.' Nevinson seems to ask if this is really possible.

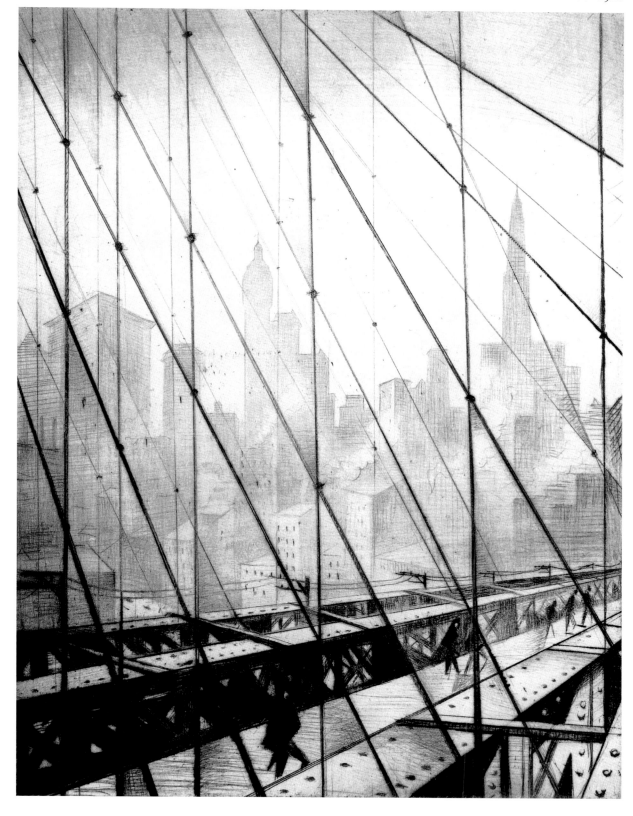

Bibliographical notes

I

Given the ramifications of the subject, a formal bibliography of 'The Artist and the Bridge' is hardly possible, and notes on sources cannot be comprehensive. There are the great repositories of the Ironbridge Gorge Museum, with its collection of prints formed by Arthur Elton, or the Musée Carnavalet in Paris, with the range of material afforded by its many river-paintings and prints of the city. These, however, for the most part, tend to throw light on the documentary aspects of bridge-views as seen by artists whose aim has been no more than to record them. For what the bridge has meant to major creative figures we must seek out the works themselves in art galleries or in the modern monographs which have been cited in the foregoing chapters. Some of these sources will be mentioned again later in these notes.

As for the 'Bridge' aspect, the literature is vast but, with few exceptions, modern writers on bridges have tended to treat them from the standpoint of building technology, and to a lesser extent for their role in history and symbolism. Francis D. Klingender, who wrote *Art and the Industrial Revolution* in 1947 (edited and revised by Arthur Elton in 1967 and republished in 1968 – London: Adams and Dart; also St Albans: Paladin, 1972), was as interested in the art as in the technology, and had much of value to say on bridges of the period and artists' representations of them. But although Turner and Cotman come into his book he, again, was writing mainly of artists and illustrators with more limited aims and means.

At no time, however, were aims and means more elegantly matched to demand. As Klingender pointed out, 'science and the graphic arts were closely linked', and a print such as Figure 38 above clearly makes the point. The illustrations to books of the early bridge-engineers and writers admirably eludicated, in the full, light-relaying sense of the word, texts which were discussing complex new matters. Henri Gautier's *Traité des Ponts* (Paris: A. Cailleau, 1716) and J.R. Perronet's *Description des Projets* (Paris: Imprimerie Royale, 1782–3) were among the most conspicuous examples of many.

The technical advances in bridge-construction which accompanied such publications in France were referred to in the Introduction and Chapters 1 and 2. The encouragement of State enterprise by Louis XIV's minister Colbert had led to the creation of the Corps des Ponts et Chaussées in 1716 and its reconstruction in 1747. The legacy of the Canal du Midi was in fact one of the reasons behind Voltaire's admiration of the period of Louis XIV. But French books powerfully reinforced this authority. Gautier's *Traité des Ponts* became the standard work for over half a century: while the giant pumping installation at Marly (1681–5), which supplied water to the Versailles fountains, was described at length in the *Architecture Hydraulique* (Paris: Jombert, 1737–9) of the engineer B.F. Bélidor. From this practical foundation, consolidated by theory, a profession of civil engineering grew up much earlier in France than in England. Telford and Smeaton learned French in order to read Bélidor. J.R. Perronet's *Description des Projets* made his Neuilly bridge available for Europe to study. The comprehensive École des Travaux Publiques, which incorporated the Ponts et Chaussées at the Revolution, became the

École Polytechnique in 1795. This became a model of its kind for Europe and influenced West Point in America. From the École emerged G.E. Haussmann (1809–91), later remodeller of Paris, and Gustave Eiffel (1832–1923), not least famous for his bridges and viaducts.

It is noticeable, however, that another product of the École Polytechnique, Charles Dupin (1784–1873), felt it worthwhile to visit England in 1816 and publish his findings in *Voyages dans la Grande-Bretagne* (Paris: Bachelier, 1820–24), which became popular on both sides of the Channel. Engineering achievement in Britain had evolved in a more piecemeal way than in France, following from practical experimentation on the part of individuals, and benefiting from private enterprise (such as the Duke of Bridgewater's in relation to his canals). William Shipley's foundation in London in 1754 of the Society for the Encouragement of Arts, Manufactures and Commerce stimulated competition for prizes in the fields of Agriculture, Chemistry, Polite Arts, Manufactures, Colonies and Trade, and the publication of ideas and inventions in the Society's *Transactions* (1783–1851) or in the *Gentleman's Magazine*. The English tradition of 'Free Societies' was to influence French counterparts in the 1770s and 80s (for example at Rouen in 1787). And Britain had been ahead in the use of iron for bridges. In 1772 (before the Iron Bridge) Charles Hutton published *The Principles of Bridges*, the first English text on the subject, which was reissued in 1801 and 1812. Telford wrote the 'History' and 'Practice' sections of the 'Bridge' article in the *Edinburgh Encyclopaedia*, vol. iv (1830). Bridges by Perronet, Mylne, Telford and Burdon (his iron bridge at Sunderland) were illustrated in E. Cresy, *Encyclopaedia of Civil Engineering* (London: Longman, 1847). Thomas Pope, *Treatise on Bridge Architecture* (New York: A. Niven, 1811) was the first major work on the subject to come from a country in which the development of bridges held great promise: America.

A good account of the French and British developments is in W.H.G. Armytage, *A Social History of Engineering* (London: Faber and Faber, 1961): also in C. Singer, E.J. Holmyard, A.R. Hall and T.I. Williams, *A History of Technology*, vol. IV, *The Industrial Revolution, c. 1750 to c. 1850* (Oxford: Clarendon Press, 1958). Both supplement Klingender in that they include illustrations of artists' prints of bridges. F. Klemm, *A History of Western Technology*, tr. D.W. Singer (London: Allen and Unwin, 1959 [original German edn 1954]) is also valuable as the work of an author who is neither British nor French.

In addition, Elizabeth Mock, *The Architecture of Bridges* (New York: Museum of Modern Art, 1949), very successfully balances the technical and aesthetic aspects, and has well-chosen illustrations. David P. Billington, *The Tower and the Bridge: The New Art of Structural Engineering* (New York: Basic Books, 1983) is also useful. David J. Brown, *Bridges: Three Thousand Years of Defying Nature* (London: Mitchell Beazley, 1993) gives a valuable account of the technology, with excellent colour illustrations and a good bibliography of the technical literature.

E. de Maré, *The Bridges of Britain* (rev. and enlarged edn, London: Batsford, 1975 [1954]), provides a readable account which does take in some of the non-British history of the bridge. J. Gies, *Bridges and Men* (London: Cassell, 1963), is breezily written and includes chapters on the bridge at Avignon and the work of Perronet, and useful comparative line drawings. F.W. Robins, *The Story of the Bridge* (Birmingham: Cornish Brothers, 1954), collects myths, customs and anecdotes in extraordinary quantity, but suffers from an inadequate index and referencing which is not detailed enough. Nonetheless, it provides many means of access to the subject.

The important category of 'inhabited bridges' was the subject of an exhibition 'Living Bridges: The Inhabited Bridge, Past, Present and Future' at the Royal Academy of Arts, London, in 1996, developed from research directed by Jean Dethier at the Centre Georges Pompidou, Paris. The exhibition included large-scale models, over an actual channel of

flowing water, of Old London Bridge, the Ponte Vecchio at Florence, the Rialto at Venice, and other historical examples, as well as projects by modern architects. The catalogue (Munich: Prestel-Verlag and the Royal Academy of Arts, 1996), edited by Peter Murray and MaryAnne Stevens, with many illustrations in colour and half-tone, forms a valuable survey of the inhabited bridge and of the possibilities of renewing the idea across the world in the future. Also helpful are Jean Dethier and Ruth Eaton, 'Inhabited Bridges', in a special number, 48, of the periodical *Rassegna* (Bologna: Editrice Compositore, 1991, also in Italian and French editions), and Remy Bougennec, *Ponts et merveilles: ponts habités en Europe* (Landerneau: Carré noir, 1992).

In a category of its own, the anthology *Rethinking Architecture: A Reader in Cultural Theory*, ed. Neil Leach (London and New York: Routledge, 1997) contains extracts from the essays 'Bridge and Door' by Georg Simmel (1858–1918), and 'Building, Dwelling, Thinking' by Martin Heidegger (1889–1976), which discuss the bridge extensively as a fundamental element in modern living and thought.

II

What follows is a summary of sources that are useful for the artists we have been considering, chapter by chapter.

Chapter 1

The collections of the Musée Carnavalet, Paris, and the Guildhall Library and Art Gallery, London, are relevant for the Paris and London material covered in this chapter. One of the best places to feel the impact of the classical Roman bridge on eighteenth-century artists and collectors is the Cabinet Room at Felbrigg Hall, Norfolk (National Trust). Here, displayed in the same positions on the walls which the collector William Windham assigned to his pictures *c.* 1751–2 (after acquiring them on his Grand Tour a decade earlier), are twenty-six gouaches and some oils by Giovanni Battista Busiri (1698–1757). Several include bridges, notably the Ponte Rotto and Ponte Nomentano.

The paintings of Canaletto, Francesco Guardi, Marieschi and other Venetian artists in English country houses testify to the popularity of the Rialto Bridge in Venice in the period. Piranesi's *Vedute di Roma* were also obvious subjects for country house print rooms and the Ponte Molle and Ponte Salario usually figure among them. Numerous illustrations are found in W.G. Constable, *Canaletto, Giovanni Antonio Canal 1697–1768*, 2nd edn rev. J.G. Links (Oxford: Clarendon Press, 1976), Jonathan Scott, *Piranesi* (London: Academy Editions, 1975), and John Wilton-Ely, *The Mind and Art of Giovanni Battista Piranesi* (London: Thames and Hudson, 1978).

On Samuel Scott, there is Richard Kingzett, 'A Catalogue of the Works of Samuel Scott', *Walpole Society*, vol. 48 (1980–82), pp. 1–134 (some illustrations of bridges). The literature on Hubert Robert has treated him very patchily as a bridge painter and the enquirer is still obliged to hunt for reproductions of the pictures in the Witt Library (Courtauld Institute) or, via the *Art Index*, in periodicals such as *Apollo* or *Connoisseur*; but Jean Clay, *Romanticism* (New York and Oxford: Phaidon, 1981), illustrates Robert's Musée Carnavalet sketch of the Pont Neuilly opening in colour.

For George Dance and William Daniell and for reproduction of a number of bridge-views by artists working in Britain, Louis Hawes, *Presences of Nature: British Landscape 1780–1830* (New Haven and London: Yale University Press, 1982), is illuminating.

Chapter 2

On the techniques of bridge-building and the engineer's role (including some reference to French aspects, though concerned with Britain), Ted Ruddock, *Arch Bridges and their Builders 1735–1835* (Cambridge: Cambridge University Press, 1979), is invaluable. This illustrates some of the beautifully lettered engineers' drawings of the period, and many contemporary prints.

On the 'Palladian' bridge, Chapter 4 in C. Hussey, *English Gardens and Landscapes 1700–1750* (London: Country Life, 1967), pp. 49–53 is a sound summary.

For Soane, the drawings in the Soane Museum, London, especially dr. xii, 5, 2–4, are of fundamental interest. The book by P. de la Ruffinière du Prey, *John Soane, the Making of an Architect* (Chicago and London: Chicago University Press, 1982), pays attention to the bridge projects. The same author's article 'Eighteenth-century English Sources for a History of Swiss Wooden Bridges', *Zeitschrift für Schweizerische Archäologie und Kunstgeschichte*, vol. 36 (1979), pp. 51–63, is useful as background.

On the neoclassical bridge and its influence in landscape painting, there is a basic article by Adele M. Holcomb, 'The Bridge in the Middle Distance: Symbolic Elements in Romantic Landscape', *Art Quarterly*, vol. 37, no. 1 (1974), pp. 31–58. Uvedale Price's views on the importance of the bridge in landscape, published in his *Essay on the Picturesque* 1796–8 edn, vol. II, are discussed by Marcia Allentuck, 'Price and the Picturesque Garden', in N. Pevsner, ed., *The Picturesque Garden and its Influence outside the British Isles* (Washington, DC: Dumbarton Oaks, Trustees for Harvard University, 1974), 64–7. M. Andrews, *The Search for the Picturesque: Landscape Aesthetics and Tourism in Britain 1760–1800* (Aldershot: Scolar Press, 1989), presents valuable contemporary material and some illustrations which are hard to find elsewhere.

Of the bridges of industrial England, the Iron Bridge in Coalbrookdale has naturally attracted the most attention. Artists' views of it are conveniently gathered together in Stuart Smith, *A View from the Iron Bridge* (Ironbridge: Ironbridge Gorge Museum Trust, 1979). F.D. Klingender, *Art and the Industrial Revolution* (St Alban's: Paladin, 1972 [1947]), is still indispensable for this period. On the Sunderland Bridge see G.E. Milburn and S.T. Miller, *Sunderland: River, Town and People, A History from the 1780s* (Sunderland: Sunderland Borough Council, 1988). On Telford, the volume based on an Ironbridge Symposium, 1979, *Thomas Telford: Engineer* (ed. Alastair Penfold, London: Thomas Telford Ltd, 1980) is most informative. Prof. A.W. Skempton, who contributed to this, has also published lists of bridge prints: see Alec Skempton, *British Civil Engineering Literature 1640–1840: A Bibliography of Contemporary Printed Reports, Plans and Books* (London: Mansell, 1987). See also *Telford in the Dee Valley* (Clwyd: County Planning Department, 1989) and the County Record Office, Ruthin, Clwyd, for topographical prints (*Wales Illustrated* 1830, etc.) of the Telford aqueducts.

Chapter 3

The very varied responses of the artists discussed in this chapter have produced no previous concerted literature, apart from stray references in individual monographs. Such works as are relevant are cited in the footnotes to the chapter. Geoffrey Grigson, *Britain Observed: The Landscape through Artists' Eyes* (London: Phaidon Press, 1975), notices Agasse and Cornelius Varley.

For the numerous bridge-subjects of Turner, two publications in particular have the necessary wealth of illustration: Martin Butlin and Evelyn Joll, *The Paintings of J.M.W. Turner*, vol. 2,

rev. edn (New Haven and London: Yale University Press, 1984) and Andrew Wilton, *Life and Work of J.M.W. Turner* (London: Academy Editions, 1979). For Constable, I. Fleming-Williams, *Constable, Landscape Watercolours and Drawings* (London: Tate Gallery, 1976), conveniently illustrates the drawings leading to *Waterloo Bridge* and *The Leaping Horse*. Painted versions of *Waterloo Bridge* are usefully illustrated in colour in L. Parris and I. Fleming-Williams, *Constable*, exh. cat. (London: Tate Gallery, 1991), pp. 206, 208, 210–11, 370. Other Constable bridges are illustrated in Graham Reynolds, *The Later Paintings and Drawings of John Constable* (New Haven and London: Yale University Press, 1984). Their topographical origins are discussed in A. Smart and A. Brooks, *Constable and his Country* (London: Elek, 1976).

Chapter 4

For Cotman, Leeds Art Gallery's Kitson Bequest of drawings contains interesting examples. The Arts Council catalogue, M. Rajnai, ed., *John Sell Cotman 1782–1842* (London, 1982) is useful for this aspect of the artist's work. Sarah Cocke and Lucinda Hall, *Norwich Bridges Past and Present* (Norwich: Norwich Society, 1994), including works by Crome, Cotman, Thirtle and other Norwich School artists, is enterprising.

Paris in the nineteenth century has attracted many publishers to produce lavish records. M. Gaillard, *Paris au XIXe Siècle* (Paris: Fernand Nathan, 1981) has useful illustrations. P. Courthion, *Paris in the Past: From Fouquet to Daumier* (London: Skira, Eng. trans., 1957) includes colour reproductions of no fewer than twelve paintings of Paris bridges, including R.P. Bonington's *Pont des Arts and the Cité* (1823–4, A. Strolin Collection, Neuilly-sur-Seine) and Corot's *Notre Dame and the Quai des Orfèvres* (1833, Musée Carnavalet: this shows the Pont Saint-Michel).

Corot's Italian bridge-pictures, including the Narni paintings, are represented in colour and in the discussion of his work by Peter Galassi, *Corot in Italy: Open Air Painting and the Classical Landscape Tradition* (New Haven and London: Yale University Press, 1991), pp. 165f.

For Cézanne, John Rewald, *Paul Cézanne: the Watercolours, A Catalogue Raisonné* (London and New York: Little, Brown and Co., 1983) and Richard Verdi, *Cézanne and Poussin*, exh. cat. (Edinburgh: National Gallery of Scotland, 1990) are helpful.

Among the many books on Whistler and Monet, the following are especially useful for bridge illustration: Katharine A. Lochnan, *The Etchings of James McNeill Whistler*, exh. cat. (Toronto: Art Gallery of Ontario, 1984), and D. Skeggs, *River of Light: Monet's Impressions of the Seine* (New York: Knopf, 1987). Daniel Wildenstein, *Claude Monet: Biographie et Catalogue Raisonné*, 5 vols (Lausanne: La Bibliothèque des Arts, 1974–91; 4 vol. repr., Cologne: Taschen and Paris: Institut Wildenstein, 1997) is indispensable. On the Impressionist bridge-pictures, *A Day in the Country*, exh. cat. (Los Angeles: Los Angeles County Museum of Art, 1984) is outstanding. The exhibition catalogue *The Image of London: Views by Travellers and Emigrés 1550–1920*, ed. M. Warner (London: Trefoil and Barbican Art Gallery, 1987) is also good value.

The highway from Edo to Kyoto in Japan, including the bridges, may be walked in Muneshige Narazaki, *Hiroshige: The 53 Stations of the Tokaido, Masterworks of Ukiyo-e* (Tokyo, New York and San Francisco, 1969). Also on *ukiyo-e*, Frank Whitford, *Japanese Prints and Western Painting* (London: Studio Vista, 1977) has relevant reproductions.

The popular art of railway subjects in the West is well represented in the Elton Collection, Ironbridge, and the J.C. Bourne drawings gathered at the National Railway Museum, York. Bourne's publications, notably *The History and Description of the Great Western Railway* (1846),

feature many views of bridges. For France, Jules Janin's *Guides de Voyageur* are revealing, as are the books of Adolphe Joanne, such as *Paris Illustré en 1870 et 1877*, 3rd edn (Paris, n.d.). Caillebotte now has definitive treatments in Marie Berhaut, *Caillebotte: sa Vie et son Oeuvre*, rev. and enlarged edn (Paris: Institut Wildenstein, 1994 [1975]) and K. Varnedoe, *Gustave Caillebotte* (New Haven and London: Yale University Press, 1987). The latter includes photographs of the Pont de l'Europe, works out Caillebotte's viewpoint for his painting of 1876 and discusses this.

For Seurat, R. Thomson, *Georges Seurat* (Oxford: Phaidon, 1985) includes useful maps of Seurat's Paris.

The range of van Gogh's 'Langlois' drawbridge paintings and drawings is illustrated in J. Hulsker, *The Complete Van Gogh: Paintings, Drawings, Sketches* (New York: Outlet Book Co., 1980), nos. 1367, 1368, 1370, 1371, 1377, 1382, 1392, 1405, 1420, 1421. The centenary exhibition catalogue, *Vincent van Gogh: Paintings* (Amsterdam: Rijksmuseum Vincent van Gogh, 1990), also includes colour reproductions of the oil version at Otterlo and a variant in private hands.

The remarks of Mock (see p. 194 above) on the suspension bridge are worth reading in relation to artists' work on the Brooklyn Bridge and similar structures in the twentieth century. The idea of steel members pulling rather than pushing against a bridge's abutments is well brought out in her text. Dell Upton, *Architecture in the United States* (Oxford: Oxford University Press, 1998) has a useful passage on American suspension bridges (pp. 165–7).

III

It remains to notice certain more general works on the wider, containing field of landscape or townscape.

In his well-known book *Landscape into Art* (London: John Murray, 1976 [1949]), Kenneth Clark includes 'architecture, bridges, and jetties' (p. 48) among the points of reference used by the landscape artist: and Ronald Paulson, in *Literary Landscape: Turner and Constable* (New Haven and London: Yale University Press, 1982) refers to 'the use of cultural signs within nature – the churches, mills, and bridges that relate different parts of the landscape to each other' (p. 8). All recent writers on landscape acknowledge some debt to the pioneering study by Jay Appleton, *The Experience of Landscape*, rev. edn (Chichester: Wiley, 1996 [1975]), which has much to say about artists' responses, and recognizes (p. 119) the bridge's value as a place of prospect, and as one of the 'channels of movement' through landscape which Appleton identifies. His book *The Symbolism of Habitat: An Interpretation of Landscape in the Arts* (Seattle and London: University of Washington Press, 1990), also refers to bridges, pp. 66, 70. None of these writers is concerned with the diverse kinds of association presented by the bridge itself that we have studied in the present book: but each has his perceptions on artists' 'readings' of landscape, and these are texts to return to.

Index